# Europe and Love in Cinema

Edited by Luisa Passerini, Jo Labanyi and Karen Diehl

**intellect** Bristol, UK / Chicago, USA

First published in the UK in 2012 by
Intellect, The Mill, Parnall Road, Fishponds, Bristol, BS16 3JG, UK

First published in the USA in 2012 by
Intellect, The University of Chicago Press, 1427 E. 60th Street,
Chicago, IL 60637, USA

A catalogue record for this book is available from the
British Library.

Cover designer: Holly Rose
Copy-editor: Michael Eckhardt
Typesetting: John Teehan

ISBN 978-1-84150-379-0

Printed and bound by Hobbs, UK

FSC
www.fsc.org
MIX
Paper from
responsible sources
FSC® C020438

# Contents

## Part III – Movements in time-space

## Part IV – Cultural re-inscriptions

# List of illustrations

Figure 1. British publicity material for *The Road to Happiness* (Curtiz, 1926; prod. Sascha/Phoebus). Source: British Film Institute Special Collections.

Figure 2. British publicity material for *Red Heels* (Curtiz, 1926; prod. Sascha). Source: *Kinematograph Weekly*, January 1926.

Figure 3. Crossing the water, traversing boundaries – *La Habanera* (Sirk, 1937; prod. Ufa).

Figure 4. Crossing the water, traversing boundaries – *The Edge of Heaven* (Akın, 2007; prod. Anka Film/Dorje Film/NDR).

Figure 5. Fanny and Allan: the end of the roller coaster ride – *Hindle Wakes* (Elvey, 1927; prod. Gaumont British Picture Corporation).

Figure 6. Shosho and Valentine: 'this is our Piccadilly' – *Piccadilly* (Dupont, 1929; prod. British International Pictures).

Figure 7. Poster for *La dame de Malacca* (Allégret,1937; prod. Régina). Source: Luisa Passerini, Enrica Capussotti and Giuseppe Lauricella (2003), *Moving History* (multimedia CD-ROM), Florence: European University Institute.

Figure 8. Audrey in Hindu dance costume, contemplating herself before wiping the sign of Shiva off her forehead – *La dame de Malacca* (Allégret, 1937; prod. Régina). Source: Luisa Passerini, Enrica Capussotti and Giuseppe Lauricella (2003), *Moving History* (multimedia CD-ROM), Florence: European University Institute.

Figure 9. Poster for *¡Harka!* (Arévalo, 1941; prod. Arévalo P. C./Cifesa), foregrounding the romantic relationship between Carlos and Amparo, which he will renounce for Africa. Source: Filmoteca Española. © Video Mercury Films.

# Introduction

This book brings together the work of cultural historians and film scholars. Its aim is to explore the cultural implications of the treatment of love in a number of European fiction films made in Britain, France, Germany, Spain, Italy and Greece from the 1920s to the present. The book is not a straightforward contribution to film studies – it does not attempt to offer a historical overview of European cinema (many such volumes already exist),[1] nor does it set out to analyse the cinematographic style of the genres and directors discussed. Rather, positioning itself at the interface between cultural history and film studies, it asks what the analysis of film can offer to an understanding of the history of subjectivity. Our concern is not so much with individual subjectivity as with the cultural imaginary of particular societies at specific historical moments. Cinema – and particularly popular cinema – is an especially valuable vehicle for study of the cultural imaginary since it plays to mass audiences.

The premise underlying this volume is that films express powerful fantasies about what is felt to be desirable or undesirable. Given this, it is not surprising that so many fiction films should be love stories, by definition inviting audience identification with particular models of desire, whose success or failure sets up norms for what may or may not legitimately be desired. As so much cultural studies scholarship has demonstrated (in film studies, see for example Stacey 1992 and Kuhn 2002), interpretation involves a negotiation between the possible meanings allowed by the text and the emotional needs of the consumer – a negotiation that is central to the construction of a sense of identity. This is a complex process: in the course of the narrative, films trigger in spectators a series of identifications that are mobile and plural. What matters in a love story is not only the ending (often conventional) but the travails experienced by the protagonists along the way, and one's identifications can move between different characters or attach themselves simultaneously to characters who are antagonists. Nevertheless, while spectatorship is always negotiated and identification is never fixed or monolithic, we should remember Ella Shohat and Robert Stam's reminder that the film apparatus can make spectators identify with characters who do not represent their own interests: non-white viewers, too, find themselves cheering as the cowboys kill the Indians (1994: 347–48).

This collection of essays grew out of the collaborative work for the international research project 'Europe: Emotions, Identities, Politics' based at the Kulturwissenschaftliches Institut, Essen (Germany) from 2002 to 2004. The research team, directed by Luisa Passerini and including Jo Labanyi as a participant, was created thanks to a research prize of the Land of Nordrhein-Westfalen awarded to Luisa Passerini for that period. Several

single-authored and edited volumes from that research collaboration have been published (Passerini 1999; Passerini and Mas 2004; Passerini 2009; Passerini, Ellena and Geppert 2010). Since cinema was a significant focus in this project, a later workshop 'Europe in Cinema, Cinema in Europe' was held at the University of Southampton (UK) in 2005, organized by Jo Labanyi and funded by the European Science Foundation, to further discuss film's potential for European identity formation. Both Luisa Passerini and Karen Diehl participated in the Southampton workshop. *Europe and Love in Cinema* brings together new work by participants in the original project and subsequent workshop. The editors also invited contributions from other scholars in the field of European cultural history and cinema to broaden the range of films and issues covered.

This volume follows the focus of these prior research collaborations, which was not simply to explore concepts, representations and practices of love in Europe but, more specifically, to analyse the ways in which these intersect with ideas of European identity. In taking further the discussion of cinema at Essen and Southampton, this book sets out to examine how this intersection has evolved since the 1920s. The particular kinds of love relationship that have interested us are those that come under the umbrella of 'romantic love': a term which, as will be explained below, came to be conflated with the medieval courtly love tradition which is often seen as inaugurating a specifically European sensibility. The premise of this book, like that of the research collaborations out of which it arose, is that romantic love has, expressly or tacitly, been represented as a specifically European phenomenon – indeed, as a defining characteristic of European culture which, alongside other factors, makes it superior. Cinema has obvious relevance for analysis of the supposition that only Europeans are capable of the emotional refinement inherent in romantic love, given the importance of romantic love in cinema since the earliest fiction films. Indeed, our hypothesis is that the film industry – originating in the western world but transnational from its beginnings – has played a major role in disseminating and 'normalizing' this assumption, to the extent that it has made romantic love the prototype of intimate relations. Love stories in cinema almost by definition conform to the model of romantic love. Also relevant to this book's study of how the conjunction of romantic love and Europeanness plays out in cinema is the fact that so many movies, again since the beginnings of narrative film, have depicted love affairs between Europeans and non-Europeans, or between characters from parts of Europe that are regarded as central and peripheral respectively: that is, as being more fully or less fully European. This volume sets out to critique the Eurocentric assumption that one of the factors that supposedly make Europeans superior is their capacity for romantic love by analysing the ways in which this assumption has been represented or challenged in a number of European films. In exploring, in a variety of ways, the triangulation of the concepts of 'Europe', 'love' and 'cinema', we hope to show how the intersection of these three terms has important implications for the various societies and cultures that make up today's Europe.

4

Before outlining what we see as the main features of this triangular relationship, we will briefly trace the history of the connection that came to be established between European culture and particular ways of loving.[2]

## Europe and love in historical perspective

The claim that Europeanness and the concomitant sense of belonging to Europe are characterized by particular kinds of love relationship, regarded as unique to individuals from that continent, can be traced back to the late eighteenth century when sensibility came to be posited as the basis of sociability. Although specifically modern, this 'structure of feeling' – to use Raymond Williams' term – was back-projected onto Europe's past, allowing it to be seen as a transhistorical feature of European culture. Thus the Romantic[3] sensibility that started to emerge in the late eighteenth century became conflated with Provençal troubadour culture, generally regarded as the founding moment of European culture on the grounds that the twelfth-century Occitan courtly love lyric is the earliest written literary corpus in a European vernacular (as opposed to Latin). In the process, the Romantic elaboration of an individual self, whose authenticity is expressed in its complex inner emotional life, came to be conceived in terms of the particular ways of loving associated with medieval courtly love. The key characteristic of courtly love, as interpreted in the late eighteenth and early nineteenth centuries, is the existence of a distance between the lovers, even when love is reciprocated – a distance that can be bridged only in death. The emotional refinement of such a relationship is the other side of a tragic concept of love which eludes fulfilment. This emotional structure, stemming from the private, personal sphere of intimate relations, took on a public dimension as it came to be seen as a feature distinguishing European civilization from the cultures of Asia, Africa, and indeed America. The love of the couple therefore became a mark of the superiority of one civilization over others.

The definition of Europeanness as characterized by a capacity for a particular type of love was thus always accompanied by the notion of an Other. This provided a contrast in the area of gender relationships, for instance between European and Oriental women, considered respectively as free and as slaves. There is a major irony here since, while Christianity was regarded as setting women free (by endowing them with an individual conscience) and Islam was seen as imprisoning them in the harem (as sex objects), many scholars consider the Occitan courtly love lyric to be derived from the Arabic love lyric tradition, via neighbouring al-Andalus (the parts of Spain under Arab rule from 711 to 1492).[4] A different contrast was frequently drawn between Europeans and North Americans, especially in the twentieth century: while, for some, escalating divorce rates in North America – feared as the possible future fate of Europe – were the result of a sexual license that suggested a deficit of romantic love, for others – including Denis de Rougemont, discussed below – the frequency of divorce was blamed on an excessive

belief in romantic love which, by definition, could not be sustained in marriage. In both cases (the contrast with the Orient and with the United States respectively), particular views of women were used to embody whole civilizations.

Gender is a crucial dimension of the connection between Europe and love in several ways. There is no indication in the original Provençal tradition that the form of love sung by the troubadours was understood to be exclusively heterosexual. Indeed, there are songs by women (*trobairitz*) which can be interpreted as addressed to other women, while the practice of some troubadours was homosexual. Regardless of this, courtly forms of love have been treated as the epitome of heterosexual relationships. In the nineteenth century, the subject of courtly love came to be seen as exclusively male and also, at a time of major European imperial expansion, as exclusively white. Nineteenth-century prudery was also back-projected onto the Middle Ages, leading to the erroneous supposition that courtly love was purely spiritual and not physical.

This conflation of a particular kind of intimate sensibility with the public enterprise of empire affecting relations between Europeans and peoples of other continents remains of the utmost political relevance for today's Europe. It can no longer be assumed that the European subject is exclusively male, white and Christian. An understanding of the historical relation between concepts of Europe and concepts of love is thus crucial to the cultural construction of a Europe that is aware of its debts to the past and openly plural in the present. In what follows we outline some key moments in European history that make clear the cultural and political importance of undertaking a historical deconstruction of the Europe-love equation – an equation produced by the intersection of two very different traditions of thought.

The idea of a united Europe developed in the field of political theory with seventeenth- and eighteenth-century projects for European and world peace, followed in the nineteenth and twentieth centuries by proposals for a federation of European nations put forward by politicians and writers, and by the ideal of a European community which guided the founders of the European Union in the wake of World War II. The discourse on love which evolved over the same period, sometimes interwoven with religious discourse, was elaborated mainly in the fields of literature, literary history, philosophy and, in the twentieth century, psychoanalysis. The concept of courtly love in particular – since the nineteenth century conflated with romantic love, regarded as its latter-day expression – was developed by Romance philologists, novelists and poets. These two discursive traditions – on Europe and on love – have become entwined in varying ways at particular historical junctures.

As mentioned above, one of those junctures occurred with the emergence of the idea that courtly love was invented in Europe, specifically in twelfth-century Provence. This notion became standardized during the Enlightenment, when European intellectuals defined the continent's shared heritage in terms of a particular kind of sensibility, exemplified by heterosexual love. In the eighteenth century, the geographical boundaries of what constituted 'Europe' were, as always, unstable: in his *Lettres persanes/Persian*

*Letters* (1721), Montesquieu did not include Russia, while Voltaire, in his *Essai sur les mœurs et l'esprit des nations/An Essay on the Manners and Spirit of Nations* (1756), excluded the Balkan Peninsula, then under Turkish rule. However, a core definition of European civilization – based on the status of European women and attitudes towards them – became consolidated, although variously interpreted. For Voltaire, the principal difference between Orientals and Europeans was to be found in the way men treated women – giving them freedom in Europe, consigning them to slavery in the Orient. For Montesquieu, the freedom of European women was the source of their impudence, which he contrasted with the modesty and chastity of Asian women, though at the same time he acknowledged European women's spiritedness. This alleged European characteristic, defined through contrast with Asia, encouraged the claim that relations between the sexes had in Europe reached a level of civilization that was unheard of in the rest of the world. However, this cultural difference was at the time explained as resulting from a variety of cultural influences, of diverse origins, which had coexisted in southern France at the start of the millennium.

Respect for women was considered to have been born with chivalry, understood as the foundational institution of European civilization in both the political and cultural realms. This allowed another major contrast to be drawn, this time with classical antiquity, making it possible to define a specifically 'modern' European cultural order. The Chevalier de Jaucourt, who wrote both the 'Europe' and 'Poésie provençale' entries in Diderot and D'Alembert's *Encyclopédie*, regarded the culture of twelfth- and thirteenth-century Provence as a turning-point in the evolution of sensibility, which distinguished the moderns from the ancients and, at the same time, as the origin of all modern poetry. The main Enlightenment figure in this field – Jean-Baptiste de La Curne de Sainte-Palaye, who collected the poems of the troubadours after a long period of neglect – recognized courtly love to be an integral part of chivalry and thus a cornerstone of modern Europe. For him and his English counterpart, Thomas Warton, the 'modern' attitude expressed in Provençal love poetry – conferring authority on women and expressing gallantry towards them – derived from contacts with Celtic, Germanic, Scandinavian and Scythian (Russian) peoples. Warton also attributed the growth of the taste for sentimental romances to contacts with Arabic culture via Moorish Spain.

In the nineteenth century, the discourses on Europe and love underwent significant separate and related changes. Intellectuals like the members of the *salon* held by Madame de Staël at her castle in Coppet (Switzerland) combined a liberal Europeanism, critical of the Napoleonic conquest of Europe, with belief in the European nature of courtly love. With the rise of European nationalisms, the ownership of such ideas became increasingly contested, with different countries, particularly France and Germany, claiming to have invented them. The French were certainly responsible for coining the term that would stick – *amour courtois* ('courtly love') – though at a much later date, since it was proposed by the French philologist Gaston Paris in 1883, the troubadours themselves having preferred other terms such as *fin'amors, amor honestus, cortezia*. The dispute over the possible

Arabic derivation of Provençal poetry and the concept of love it enshrined continued throughout the nineteenth century; a derivation that for many was unacceptable since it contradicted the claim to a European origin.

During the second half of the nineteenth century – the highpoint of European nation-formation and imperialism – the assumed connection between Europeanness and a capacity for romantic love was reinforced by generalized European belief in the superiority of European culture, overriding the cosmopolitanism that had previously tempered this connection. At this point, the Europe-love equation solidified into a concept of Europeanness grounded in Europe's colonial experiences and geared towards the exclusion of all non-European – particularly Oriental and African – influences. This led to increasingly Eurocentric – indeed often racist – formulations, which argued that European practices and discourses of love, in the form of romantic relationships or other kinds of attachment, had constructed particular ways of being that set Europe apart from, and 'above', other parts of the world. Such arguments also served to define some parts of Europe as more European than others.

In the twentieth century, in the interwar period, the struggle over the idea of Europe between fascists and anti-fascists was accompanied by a renewed battle over the idea of love. Nazi propaganda appropriated the association of Europe with love, giving it a particular racist inflection, in a context where Hitler's 'new Europe' seemed increasingly irresistible. A 1942 speech by Baldur von Schirach, the Nazi Party's Reich Youth Leader and Gauleiter of Vienna, made this explicit: '[T]he song that once filled the valleys of Provence and is to this day a triumphal song of Europe and of its civilization – the song of the troubadours as an expression of those higher feelings that distinguish us from the Jews and jazz-playing American negroes – is something that the Jewish mentality can never understand. Its whole ethos is foreign to the Jews' (cited in Lipgens 1985: 103).

In the same period, a major contribution to the debate on the connection between Europe and love was made by the European federalist of Swiss origin, Denis de Rougemont, particularly with his 1939 study *L'amour et l'Occident/Love in the Western World* (1983), translated into many languages and still in print. This text, centred on a reinterpretation of the Tristan and Isolde myth, set out what he saw as the crisis in European culture during the interwar period, proposing salvation via a new kind of relationship of the heterosexual couple – regarded as the bedrock of European civilization. In order to move beyond *eros* – the urge to fusion in the form of a passionate self-surrender associated with the death drive, exemplified by the Tristan and Isolde myth and by totalitarian regimes such as Nazism – de Rougemont proposed *agape*: love based on fidelity between man and wife, thanks to their individual direct relationship with God; a type of love which he considered to be the foundation of democracy and federation. He also contrasted Europe with the United States (the land of divorce), assigning a central role to Europe as a third force interposed between the USA and the USSR. Interestingly for the purposes of this volume, his book on Europe and love had a huge influence on film-makers, especially

those whose films depict 'a passion for night as opposed to day', including Jean Renoir's La règle du jeu/The Rules of the Game (1939) (Amengual 1952: 9; 10n).[5]

The Eurocentrism of this association of love with Europe was challenged in the 1960s, when romantic love came to be seen as a universal sentiment that can be found in all cultures, albeit in divergent forms. The 1960s can be considered a turning-point since it was in that decade that the exclusiveness of the Europe-love equation was abandoned, with some thinkers denying that there was anything unique about courtly and romantic love. This was due partly to the universalist aspirations of the 1960s, and more specifically to the revision of Eurocentric views in the field of romance studies. For instance, Peter Dronke, a specialist in Medieval Latin literature, wrote in the mid-1960s that the sentiments and concept of courtly love could occur in any time or place and at any social level, in popular as well as aristocratic love lyrics (1965–66). This type of literary history paved the way for a new understanding of courtly/romantic love and its role in European civilization, including a more historically accurate understanding of *fin'amors*, and of the importance of women not only as inspirers and objects of love poetry, but also as *trobairitz*: that is, as creators and performers. This in turn led in subsequent decades to new scholarship and discoveries, such as Angelica Rieger's publication of the corpus of poems by *trobairitz* (1991). The regular resurfacing in the European cultural arena of the question of whether women can fully occupy the position of subject in love discourse points to a basic contradiction between formal and substantive recognition of women's equality in Europe.

Feminist theorists in the 1960s and 1970s criticized romantic love on the grounds that its idealization of women was responsible for their subordination. For Shulamith Firestone, romantic love was the crux of women's oppression; a tool of male power to keep women from knowing their condition, since its false idealization masked gender inferiority by putting women on a pedestal (Firestone 1970). For this reason, Firestone argued, gender and class factors conspired to sustain romantic love and its deceptions. For Germaine Greer, Romantic love – stemming from adulterous fantasies on the part of an idle nobility – replaced parental coercion when the Protestant middle-classes started to abandon arranged marriages in favour of free, equal unions. In this sense, romantic love was a prelude to the establishment marriages of modern times (Greer 1970). Juliet Mitchell shifted the ground of the debate by observing that, at the end of the sixteenth and start of the seventeenth centuries, romantic tales started to focus on the woman as love object, whereas previously the focus had been on the man as passionate subject (Mitchell 1984). In the course of this process, she suggested, romantic love shifted from subversive adulterous love in the Middle Ages to become the conformist marital love of modern times, as propagated in mass cultural products such as popular fiction and TV soap opera. These feminist scholars did not, however, challenge the Eurocentric paradigm of romantic love, which by now had become more broadly western-centric, among other things because of its appropriation by Hollywood. The male subject critiqued in their work is implicitly western, but this point is not developed by them.

After the 1960s, despite the political creation of a united Europe and continuing elaboration and dissemination of romantic love by the mass media, it became less common to link the two concepts. The notion that romantic love is connected to particular ways of being European has lost much of its validity thanks to a more widespread awareness of, and desire to avoid, the pitfalls of ethnocentrism. Although the connection is still made, it has undergone important modifications reflecting changes in attitude over the last 40 years. Nonetheless, the fact remains that Europeans have, since the Enlightenment until recently, made this concept of love a fundamental part of their self-image and traces of this habit still linger today.

In criticizing the Eurocentrism of romantic love, the philosopher Irving Singer has stressed the distinction between what people feel and do, and the ideas elaborated about those feelings and behaviours. In Singer's view, what was new in troubadour poetry was the self-sufficiency of human love. He thus considers that the western concept of love, in its heterosexual and humanistic aspects, was, if not 'invented' or 'discovered', elaborated to an unprecedented degree in the twelfth century, although under many influences, including those of Arabic and Sufi writings (Singer 1984). Singer recognizes the centrality of courtly/romantic love to Europe, but argues that it is one of many concepts of love that coexist within European cultures. In the present world, he insists, romantic love cannot be entirely ethnocentric since it is recognized as a universal human tendency (Singer 1987).

A similar position was held by the Nobel Prize-winning Mexican poet and intellectual, Octavio Paz. Under the influence of de Rougemont's *L'amour et l'Occident*, he initially believed that the feeling of courtly/romantic love was exclusive to western civilization, but came to realize that similar feelings existed in Arabic, Persian, Indian, Chinese and Japanese cultures (in addition to his interest in Oriental cultures, Paz was Mexican Ambassador to India in the 1960s). Although Paz affirms that the emergence of love was contemporary with the birth of Europe and that Provençal culture was the first European civilization, he also, like Singer, distinguishes between the emotion of love, which belongs to all times and places, and the idea or ideology of love that characterizes a particular society and period. In the end, love is universal – a cosmopolitan passion (Paz 1993). These two thinkers from different fields – philosophy and literature – thus coincide in stressing the universality of courtly and romantic love, while asserting their centrality to a European tradition dating back more than 800 years.

The deconstruction of Eurocentric notions of love can be, and has been, undertaken from outside Europe by measuring Eurocentric claims against the history of other civilizations. Several scholars have insisted on the existence of a refined kind of 'impossible love', characterized by absence and lack, in non-European cultures. For example, a similar form of love was elaborated by the nomadic poets of the Arabian Desert from the seventh century on, as well as in the Arabic treatises on love written in the tenth and the early eleventh centuries by the Persian Ibn-Sina (known in the West as Avicenna) and the Cordoban Ibn Hazm (Cheikh-Moussa 1993). We should also remember the work of

the Persian poet Nizami, author of the 1188 *Tale of Layla and Maynun* (Kakar and Ross 1992), not forgetting *The Tale of Genji* attributed to the early eleventh-century Japanese noblewoman, Shikibu Murasaki. The universality of romantic love has also been asserted in anthropological studies which have found varieties of it in a wide range of societies, from Australia's Aborigines to the People's Republic of China (Jankowiak 1995).

While research into non-European cultures is useful and inspiring, our approach has been to criticize Eurocentrism from within: that is, by studying the history of its manifestations in order to expose their hierarchical thinking and contradictions. We have therefore adopted as a methodology what the Italian philosopher and ethnographer Ernesto de Martino has called 'critical ethnocentrism', with some modifications to his position. We share with him the conviction that we cannot stand outside our own culture and that a wholly non-ethnocentric perspective is theoretically untenable, and in practice impossible since it implies the ability to exit history. Faced with the diasporic cultures that typify the postcolonial era, we find ourselves in the predicament of wanting to avoid dogmatic ethnocentrism yet also wanting to avoid cultural relativism. 'Critical ethnocentrism' inherits from ethnocentrism the need to consider the existence and importance of centres, and from cultural relativism the radical critique of all claims to cultural superiority, while trying to go beyond both positions by interrogating the sense of belonging of the subject through comparison with the senses of belonging in other cultures (de Martino 1997: 352; 391–98). In our case, the aim is to criticize all forms of ethnocentrism that claim exclusivity, but at the same time to produce hypotheses about the historical centrality of particular emotions to a European sense of belonging, and to make this historical analysis the basis of a non-Eurocentric understanding of possible new European identities.

This explanation of the *longue durée* history of the connection between the concepts of 'Europe' and 'love' hopefully clarifies the premises underlying this volume and, specifically, its concern with the public consequences of private feelings, and with the emotional complexity of (and attachment to) cross-cultural relationships. Given the importance of intimate emotions to identity formation, we have focused on the micro-dimension of cultural processes through a series of case studies that analyse the representation of love relations in particular films. The volume contributes to cultural history in its concern with the historical processes that shape subjectivity; and by 'subjectivity' we understand both emotions and the discourses on them. In this sense, we believe that, given its mass dissemination over more than a century and its concern with the expression and communication of emotion, cinema can play – and has played – a crucial role in conjugating the relationship between Europe and love. The fact that cinema is an intrinsically transnational medium suits it particularly well to exploring the cross-cultural relationships that put to the test the supposition that only Europeans are fully capable of romantic love. Having traced some of the historical connections between Europe and love, we will now consider how cinema comes into the equation. Effectively, cinema can be seen as having constituted, since the beginnings of fiction film, one of the principal discourses on the emotions.

## Europe, love and cinema: a triangular relationship

Cinema is well suited to shed light on the complex interrelations between (and made between) love and Europe for several reasons: its modes of production and reception; its cultural significance for identity formation; the fact that it encompasses both high and popular culture; the way its visual regime can represent reality and simultaneously play with assumptions about it; and the central role that emotion(s) play in its narratives and in its relationship to its audiences.

Given its transnational distribution and (sometimes) production, cinema cannot help but play a role in negotiating and challenging ideas of Europe. Recent studies on the history of cinema production in Europe do not fail to point this out in their introductions (Ezra 2004), and yet the subsequent book more often than not remains largely caught up in national narratives, unless the study focuses explicitly on the European dimension (Higson and Maltby 1999; Vincendeau 2000). It seems that, for lack of a better approach, the historiography on cinema in Europe remains pegged to the notion of the nation. In using cinema as a medium to explore the interrelations between Europe and love on various levels we can make productive use of this contradiction between the reality of transnationalism and the tendency to lapse back into the national as a default position. Thus, several contributions allow us to see how, while some films try to make a national argument in a narrative based on the love relationship between a European and a non-European, their subtexts undo this. For example, films that are predicated on the notion of a superior European capacity for romantic love frequently contain elements that work against or complicate this assumption, as Passerini and Labanyi argue in Chapters 5 and 6. Conversely, other films studied here seem to question the opposition between Europe and the Other, but ultimately affirm it. Thus, films that contribute to today's postcolonial critique of exclusionary national identities can also, as Enrica Capussotti shows in Chapter 9, slip into an unrecognized Eurocentrism in certain respects. It is not, therefore, a matter of distinguishing between films that are complicit with and other films that are critical of the supposition that romantic love is what makes Europeans superior. For many films are both at the same time – in a classic case of the emotional ambivalence that Freud analysed in all his work, and that Homi Bhabha showed to be crucial to the understanding of (post)colonial relations (Bhabha 1994).

Several contributions to this volume analyse the attempts to produce 'European cinema' on a creative and on a political level. Pierre Sorlin introduced his pioneering sociological study on European cinema with the comment: 'Economically and even politically Europe is already a reality. Culturally it is a patchwork [...]' (1991: 3). Today, with the European Union's extension eastwards and particularly with the current economic crisis, the economic and political unity of Europe seems less clear. Our scepticism about whether European Union cultural policies can achieve a measure of cultural commonality or something approximating to a European public sphere has, if anything, increased since Sorlin wrote those words. The question of how European cinema relates to a sense of

European identity has been posed repeatedly by scholars in the double sense of asking what European cinema is and proposing what it might be. Some of the recent attempts by policy-makers to define Europeanness in cinema have been predicated on assumptions that now appear overly optimistic, as Diehl notes in this volume's closing chapter. Indeed, the film industry seems less clear today about what a European film might be than it was at the time of the concerted efforts to create a European cinema in the 1920s – the topic of the volume's second chapter by Andrew Higson. The desire for a European cinema appears to be the story of a permanent dissatisfaction – another form of 'impossible love'.

Given our interest in how cinema contributes to identity formation, we have made a point of focusing not only on art house cinema but also on popular films that impacted on a broad public. As has been pointed out by Dyer and Vincendeau in their introduction to a groundbreaking collection on European popular cinema, while art house cinema is aimed at international audiences (often forming a cosmopolitan élite), popular cinema mainly plays to national audiences (1992: 1), but this need not mean that popular culture cannot attach itself emotionally to frameworks that are not nationally or politically defined. We consider popular cinema to be a particularly valuable resource for cultural history since it often mobilizes gender or racial stereotypes and feeds on nationalist and xenophobic attitudes. At the same time, popular culture – which tends to prefer comedy to tragedy – often plays with identity through cross-dressing and masquerade, eschewing fixed notions of identity. Here we can take note of Bhabha's point that stereotypes are ways of managing contradiction: where there is a stereotype, there is by definition a disavowed ambivalence (1994: 66–84). Finally, audiences might (and do) choose to see foreign films over those produced locally because these films satisfy their emotional needs with respect to cultural consumption. This ability of cinema to address the desires and to fulfil the emotional needs of audiences has been a gradual and intermittent process. Oral history studies have shown that, in the early days of Italian cinema, audiences of the 1920s did not relate to the emotions proffered by the silver screen in the same way as British audiences of the 1930s did (Crespi 1974; Kuhn 2002). But with the development of increasingly sophisticated techniques for producing audience identification, cinema came to be consumed as a fulfilment of desires. Cinema is fantasy, and no other art form has capitalized more on the emotional needs of its consumers; which is another way of saying that no other art form has proved itself to be as successful at fulfilling emotional needs so directly and instantaneously.

If we have chosen to make a critical intervention in the field of European identity through discussion of cinema, it is not least because we consider the medium to have a privileged role in identity formation thanks to its reliance on the visual: that is, on representation of the material, which in turn impacts materially on audiences. As Steven Shaviro has convincingly argued (1993), visuality plays an important part in the production of affect by triggering intense bodily sensations in the spectator (the haptic). Cinema negotiates emotions through the bodies seen on-screen. It also makes the body the central site of desires fulfilled or thwarted. Additionally, it is through embodied elements of *mise-en-*

*scène*, such as gesture or costume, that cinema constructs bodies as signifiers of identity. Bodies of stars can acquire additional layers of meaning when inserted into foreign surroundings, questioning easy assumptions about which body belongs to what identity. The moving image also functions as a crucial site of the imaginary in its connection with the unconscious, whose contents are coded via images.

Cinema also addresses its audiences directly though classification into genres. Film genres promise the delivery of certain narratives and thereby are crucial in shaping and complicating audience response. This can be a straightforward process as in the case of, for example, blockbuster action films released for young audiences in the summer, or Christmas feel-good movies. Here, audiences see the movies they expected to see based on their generic category. However, when a film does not fully conform to a recognizable genre, the corresponding narrative tradition allows new stories to be told in ways that pit form and content against one another, and genre can thereby work subconsciously on both characters' and spectators' expectations, broadening horizons in the process.

The intense and often complicated identifications invited, if not demanded, by cinema – whether through cinematography or through exploitation of the actor's star image – are also a privileged mechanism for producing intersubjective forms of attachment that can extend or challenge the spectator's sense of bounded identity. The pleasure of watching a film does not consist in mastering the image on the screen but in abandoning oneself to it and losing oneself in it, as Shaviro (1993) has argued in his critique of the gaze theory that dominated film criticism from the mid-1970s to the mid-1990s. This in turn allows the spectator to experience pleasure through – momentarily – becoming someone else. Indeed, in the course of the narrative, the spectator becomes multiple other selves: an experience of openness to the Other that has potential for producing intersubjective alignments across class, gender and ethnic boundaries. The identifications encouraged by cinema are crucial in generating in audiences certain forms of desire, for desire is what propels the film narrative forward. Indeed, as Elsaesser shows in Chapter 1, desire for cinema is central to the cinema-going experience, as it is to film studies. In Chapter 3, Tim Bergfelder argues in favour of a cinema of the exotic as an exercise in opening oneself to the Other. This is achieved through a desire for the Other, whose prevalence in cinema suggests that it is wrong to assume that the default position for identity is to seek to enforce body boundaries. As Bergfelder shows, this desire for the Other, frequently illustrated through the trope of travel, makes the term 'boundary' a mobile category. Desire for the Other and the questioning of boundaries can also impact on the heterosexual model of love that underpins the representation of romantic love in cinema. This can integrate homoerotic and homosexual relations into the concept of romantic love (as in several films of Pedro Almodóvar or Derek Jarman), but it can also work subversively as in a film like *The Crying Game* (Jordan, 1992), where a heterosexual couple turns out to be a very different kind of couple. In exploring how the cinematic representation of love relations can call boundaries into question, this book also seeks to explore conceptualizations of romantic love that go beyond the heterosexual paradigm.

Long before the advent of the romantic love plot in narrative feature films, cinema was about emotions. Performed at fairs, in open spaces, as part of theatre and vaudeville shows, this 'cinema of attractions' was about astonishment, awe, rapture, shock or laughter. Cinema has from its beginnings produced strong audience bonding by mobilizing the emotions, and these emotions sprang from the everyday life situations and spaces that audiences themselves experienced and inhabited: workers pouring out of a factory; a train station; the baby at the table or the gardener in his garden. A number of chapters in this book discuss films that depict or include love, not in the sense of romantic love (mostly heterosexual but occasionally homosexual), but in the sense of everyday situations such as friendship or that of attachment to place – whether one's homeland, another land, or (as in the chapters by Lucy Mazdon and Capussotti) the open road or sea as an image of mobility and instability. The importance of cinematic *mise-en-scène* in constructing a sense of place need not, we wish to emphasize, encourage exclusivist forms of attachment. As the chapter by Mazdon shows, the film *Western* by the Franco-Peruvian director Manuel Poirier (1997) lovingly depicts a journey through the Breton landscape in order to work out the attachments of a 'Russian, of Italian origin', a 'Spaniard of Catalan origin', and a character who describes himself as 'from the Ivory Coast, of Breton origin'. Attachment to the local can encompass acceptance of the global.

## The structure of this volume

The book has been structured in four parts, each containing three chapters. Parts 2 and 3 map a historically contingent issue onto films from a particular period. Thus Part 2 explores the repeated representation of 'impossible love' in a range of European films from the 1920s to the 1950s, including one film (Chapter 5) where the 'impossible' is exceptionally allowed to happen. The various chapters embed the films discussed in their historical context in order to prise out the cultural, social or political implications of the insistence on love affairs that flout class, ethnic or gender norms. Part 3 focuses on films from the 1950s to the present which depict love affairs marked by mobility across internal European borders or between the metropole and former colony; in the context of the Cold War and its end with the fall of the Berlin Wall in 1989; or of postwar decolonization and the ensuing migratory flows to Europe, prompting reverse journeys back from Europe to the point of origin. Parts 1 and 4 frame these historically-specific chapters by focusing on issues that cut across historical periods. Thus Part 1 discusses the role of desire in European cinema with regard to the discipline of film studies since the 1960s, the film industry in the 1920s and spectatorship in two films of 1937 and 2007. All of these essays stress the importance of cosmopolitanism and transnationalism to cinema – whether in the form of cinephilia, the mobility of film professionals or the 'Film Europe' initiative – and of desires that call into question notions of national identity. Part 4 examines a range of European films from the 1970s to the present which

depict love affairs in order to rework cultural assumptions – whether assumptions about love, about cinema, or both. If the book opens with a discussion of the desires of film scholars towards their objects of study, it ends by prising out the desires implicit in the rulings of European Union film policy-makers.

In Chapter 1, Thomas Elsaesser traces his own personal trajectory as a film scholar in order to explore the tensions underlying the cinephilia that drove film studies in its pioneering years, and the further tensions that emerged as it established itself as a 'respectable' discipline in the academy. If early film studies was a labour of love, this was a love torn between different love objects: European art cinema and 'classical' Hollywood – the latter a term that bestowed dignity on certain forms of popular cinema, thereby declaring them worthy of the scholar's amorous attentions. As Elsaesser observes, Godard's citations of Hollywood made him the darling of film scholars by making it possible to love both at the same time. Elsaesser notes how the ferociously intellectual nature of much early film theory, from the 1970s on, failed to wean film scholars off their emotional attachment to their object of study despite the incorporation of film studies into the academic mainstream. This process, he observes, has allowed film studies to become an arena for 'passionate engagements' of a less solitary kind, with the study of European cinema serving as a platform for rethinking European identity, history and memory in ways that allow scholars to connect with a broad public.

Chapter 2, by Andrew Higson, examines attempts to create a popular European cinema in the 1920s as a way of offsetting the influx of Hollywood movies into Europe, while also trying to break into the US film market. He notes that these industrial initiatives were driven by a cosmopolitan cinephilia, which promoted the cult of stars whose careers were frequently transnational, employed directors who often worked in more than one European country, featured plotlines crossing European boundaries, and adapted novels by a range of US and European writers. Examining films directed for the Austrian production company Sascha by the Hungarian Mihály Kertész (later Michael Curtiz) as well as a number of British productions, he notes that the aim was not to find a common denominator of European taste, but to produce multiple versions tailored to specific European sensibilities: the treatment of love being the acid test of what was or was not acceptable to different European audiences. While continental audiences were assumed to be less prudish than their British counterparts about the representation of sexual license on-screen, the 'Film Europe' project led to a broadening of sexual permissiveness in British cinema, sanctioned by hiring female stars from other countries.

In Chapter 3, Tim Bergfelder proposes that across the decades European cinema has expressed a cosmopolitanism that goes against efforts to shore up national identities. In particular, he notes that the frequency of transnational love affairs in film plotlines, and the popularity with audiences of such stories, suggests that identity may be defined not by the urge to preserve boundaries but precisely by desire for the Other. This proposal has wide-reaching implications. Questioning some uses of the term 'transnationalism', Bergfelder argues for what he calls a 'vernacular cosmopolitanism' – a concept explored

through analysis of the depiction of love relationships (sexual or filial) in two very different German films: one made in the Nazi period (*La Habanera* [Sirk, 1937]) and a recent 2007 film by the Turkish German director Fatih Akın (*Auf der anderen Seite/The Edge of Heaven*). In the process, Bergfelder encourages us to look at the continuities in European cinema and not only at 'the new'.

Part 2 opens with Laura Mulvey's analysis in Chapter 4 of two 'impossible' love affairs between a working-class girl and her boss (or the son of her boss) in British cinema of the late 1920s: *Hindle Wakes* by Maurice Elvey (1927) and *Piccadilly* by the UK-based German director E. A. Dupont (1929). While class is a key issue in both films, in the second – depicting the affair between a West End club owner and the East End Chinese dancer who becomes his star act – the impediment is compounded by racial difference. If the first film avoids tragedy by having its remarkably modern heroine refuse marriage, the second requires its heroine's death so as to avoid miscegenation. Mulvey stresses how both films develop a cinematic style able to depict the heady pleasures of a modern entertainment culture in which women acquire a new sexual agency, at a time when British cinema was trying to appeal to the more 'liberated' sexual tastes of continental Europe.

Chapter 5 by Luisa Passerini explores the depiction of 'impossible' cross-racial love in French cinema of the 1930s, focusing on one film, *La dame de Malacca/Woman of Malacca* (Allégret, 1937), which, exceptionally, allows the relationship between an English working woman and a Malay Sultan to overcome all obstacles. In choosing this film, Passerini argues that we should be sensitive to the complexity of the representation of colonial love relationships in cinema of this period, since Eurocentrism can take multiple forms. In this respect, she links the film to contemporaneous critiques of colonialism – such as that of André Gide, whose 'voyage to the Congo' was filmed by Allégret – which condemned the excesses of colonialism without breaking with the colonial project. Like Mulvey, Passerini pays particular attention to the representation of female subjectivity, in this case arguing that the film, despite its colonial critique, ultimately confirms a certain kind of Eurocentrism by suggesting that the modern white woman, in return for the fabulous riches gained through marriage to the Sultan, bestows on him the priceless 'gift' of romantic love, seen as an exclusively European phenomenon.

In Chapter 6, Jo Labanyi analyses two Spanish colonial films of 1941 and 1952, set in Spain's protectorates in Morocco and the Western Sahara. In the first film, *¡Harka!* (Arévalo, 1941), the 'impossible love' is that between two officers in the Army of Africa, whose homoerotic attraction to one another is evident. The second film, *La llamada de África/The Call of Africa* (Ardavín, 1952), depicts the exoticized love relationship between a Spanish Lawrence of Arabia figure (of mixed Spanish-Arab origins) and a Tuareg princess – a cross-racial love affair which, unusually, is allowed to produce a future child. The chapter attempts to explain how, at a time of strict censorship under the Franco dictatorship, the transgressive relationships in both films could be treated positively – albeit in both cases cut short by the hero's death in battle – and contrasted

with the negative depiction of an intruding white woman who attempts to break these relationships up. As in Passerini's preceding chapter, Labanyi argues for a reading of these films in terms of a colonial ambivalence that allows a measure of critique within a fundamentally colonial project which casts colonial relations as 'love'.

The chapters in Part 3 are framed by the concept of 'time-space' elaborated by Boyarin (1994) and May and Thrift (2001), who have argued that time and space are mutually imbricated, and that both are dynamic and multidirectional – something that is particularly manifest in the workings of memory. Memory and travel in space and time are variously invoked in all three chapters. In Chapter 7, Seán Allan examines German films of the 1950s and 1960s that depict love affairs spanning the East/West German border, concentrating on films made in the GDR which cast the decision to stay in, or return to, the East as a choice of the future: a format which is radically altered after German unification in 1990, which places the GDR in the past. Allan's detailed discussion of *Good Bye, Lenin!* (Becker, 2003) and *Das Leben der Anderen/The Lives of Others* (von Donnersmarck, 2006) explores how they break with this model by depicting love relationships which work through the relation of the GDR past to the present in complex ways. In the former case, a son's perpetuation of an artificial GDR past – out of love for his mother – allows him to work through the past so that he can both relinquish and continue it by transferring his love to a Russian girlfriend. In the second film, the GDR past is partly 'redeemed' through the Stasi agent's 'conversion' by the strength of the love between the couple he is spying on. In both films, it is love that makes possible a workable relationship to the past – though in both films women have to die to allow this transference or transcendence to take place.

Chapter 8, by Liliana Ellena, explores journeys of return to former colonies in which the travel from France to Africa is a form of time travel. She focuses on two French films which complicate the return scenario by, in *Chocolat/Chocolate* (Denis, 1988), depicting the return 'home' of a white French woman born and raised in Cameroon and, in *Exils/Exiles* (Gatlif, 2004), following the journey to their parents' Algerian homeland of a young couple born in France to former French settlers in Algeria (*Pieds-Noirs*) and Algerian Arab migrants, respectively. Ellena argues that both films use the journey format to question memory's ability to connect with the past. In both cases, the return is built around a love story: in *Chocolat*, the protagonist's attempt to make sense of the sexual attraction between her mother and the African houseboy; in *Exils*, that of the young couple whose relationship is sent in new, uncertain directions by their various encounters with migrants making the journey from south to north whilst they are on their way to Algiers. In tracing the double movement, north-south and south-north, Ellena suggests that *Exils* constructs a dynamic, multidirectional 'third space' which allows the possibility of new, open-ended forms of relationship and understanding. Both films, she argues, are held together by the image of the scar, which covers an invisible wound.

In Chapter 9, Capussotti analyses a Spanish and an Italian film which use the Mediterranean in very different ways: in *Poniente/Wind from the West* (Gutiérrez, 2002),

as a space of death and separation; in *Tornando a casa/Sailing Home* (Marra, 2001), as a mobile space that allows new affective attachments beyond the nation-state. Capussotti questions the parallel drawn in *Poniente* between former Spanish migration to northern Europe and present-day migration from North Africa to southern Spain, through the male protagonist, whose memories of having grown up in Switzerland as the son of a Spanish migrant allow him to offer solidarity to the Moroccan seasonal workers. Capussotti argues that this false parallel fails to take into account the colonial context of relations between North Africa and Europe. If the film's end saves the two white lovers while expelling the Moroccans from Spain, *Tornando a casa* depicts an Italian fisherman who decides to throw his lot in with the immigrants who have saved him from drowning at sea, following them in their forced repatriation to North Africa. Just as *Poniente* depicts male friendship across Spanish-Moroccan lines, so *Tornando a casa* portrays the friendship between the protagonist and his fellow Italian and Tunisian fishermen – a friendship which, in the Italian film, turns the Mediterranean that is their daily habitat into a insecure space which, nonetheless, is 'home' to Italians and North Africans alike. Thus, if both films offer a bleak assessment of the plight of North African migrants to Europe, *Tornando a casa* uses the Mediterranean as a space for the construction of new transnational subjectivities.

Part 4 opens with Luisa Accati's examination, in Chapter 10, of how Buñuel's *Cet obscur objet du désir/That Obscure Object of Desire* (1977) reworks the notion of the Immaculate Conception which has structured Catholic attitudes towards love between the sexes in southern Europe, particularly Spain. As a result, she argues, heterosexual love has been cast in the form of the mother-son relationship, modelled on that between Christ and his Virgin Mother, privileging chastity and making it impossible to imagine that one's birth is the result of copulation between one's parents. Accati argues that this last film by Buñuel, which depicts its male protagonist's frustrated love for an ever-elusive heroine called 'Conception' (Conchita), works through his own complexes resulting from his Jesuit education, finally allowing recognition of the fact of parental intercourse.

Chapter 11, by Lucy Mazdon, explores how the Franco-Peruvian director Manuel Poirier's comedy *Western* (1997) reworks cinematographic paradigms: those of the generic conventions of the road movie and the Western. Much as the Mediterranean functions as a space for transnational affective attachments in *Tornando a casa*, so in *Western* the open road brings together a Catalan, a Russian and later an immigrant from the Ivory Coast in France's 'Far West' (Brittany), whose adventures end with the Catalan and the Russian dining with the latter's new Breton girlfriend and her five children by fathers of different races. The film's generic hybridization matches its elaboration of new hybridized subjectivities, just as its comic mode – rare in films about migration – allows an apparently happy end, achieved by reconfiguring the notion of the family to include diverse ethnicities and male friendship, as well as heterosexual love.

The final Chapter 12, by Karen Diehl, analyses the relationship between two sets of contradictions: those of European film policy, driven by desire for a 'European film' whose definition and realization remain elusive, and those of a number of European films

whose treatment of love – including love for cinema – complicates generic classification. Building on Janet Staiger's notion of 'perverse spectatorship', Diehl examines the unpredictability of audience response to European co-productions or films made in other European countries, while also showing how certain European films 'perversely' work against their own generic format. Discussing in detail films of Italian, Spanish, British and Greek nationality made from the 1980s to the present, and providing statistical information about a broad range of other European films, Diehl deploys genre theory in order to explore the complicated interplay – and frequent disconnection – between the scopophilic desires of European audiences and the desires embodied in EU policy directives. The chapter's exploration of 'perverse' desires – within films themselves and at the levels of audience response and policy-makers' stipulations – brings the volume full circle by taking us back to the centrality of 'impossible desire' in European cinema.

Indeed, the fact that the majority of chapters discuss forms of desire that remain imperfectly realized suggests that the European paradigm of love continues to be largely predicated on lack of fulfilment. We hope that the book's discussion of a range of European films from the 1920s to the present shows that, while the concept of romantic love as a striving for the unattainable has been used to serve Eurocentric designs through the supposition that only Europeans are capable of such transcendence, it can today encourage forms of identification that, because they are always incomplete, are open to new, plural affective investments. The ultimate aim of this volume, beyond its exploration of European cinema, is to further recognition of ways of feeling European that, without denying particularity, are devoid of a sense of superiority and serve to nurture connectivity between cultures and individuals. To this effect, we have focused critical attention particularly on symbolic formations that, consciously or otherwise, construct identifications which are simultaneously European and non-European, recognizing – like Jacques Derrida (1992: 83) – the importance of being 'European among other things'.

## References

Aitken, I. (2001), *European Film Theory and Cinema: A Critical Introduction*, Edinburgh: Edinburgh University Press.

Amengual, B. (1952), *Le Mythe de Tristan et Yseult au cinéma*, Algiers: Travail et Culture.

Berghahn, D. and Sternberg, C. (2010), *European Cinema in Motion: Migrant and Diasporic Film in Contemporary Europe*, Basingstoke: Palgrave Macmillan.

Bhabha, H. (1994), *The Location of Culture*, London: Routledge.

Boyarin, J. (ed.) (1994), *Remapping Memory: The Politics of TimeSpace*, Minneapolis: University of Minnesota Press.

Cheikh-Moussa, A. (1993), 'Le masque d'amour', *Intersignes: L'amour et l'Orient*, 6–7, Spring.

Crespi, P. (1974), *Esperienze operaie. Contributo a una sociologia delle classi subalterne*, Milan: Jaca Book.

de Martino, E. (1997), *La fine del mondo. Contributo all'analisi delle apocalissi culturali*, Turin: Einaudi.

Derrida, J. (1992), *The Other Heading: Reflections on Today's Europe* (trans. P-A. Brault and M. Naas), Bloomington: Indiana University Press.

Dronke, P. (1965–66), *Medieval Latin and the Rise of the European Love-Lyric, 2* vols, Oxford: Clarendon Press.

Dyer, R. and Vincendeau, G. (eds) (1992), *Popular European Cinema*, London: Routledge.

Eleftheriotis, D. (2001), *Popular Cinemas of Europe: Studies of Texts, Contexts and Frameworks*, London: Continuum.

Elsaesser, T. (2005), *European Cinema: Face to Face with Hollywood*, Amsterdam: Amsterdam University Press.

Everett, W. (ed.) (1996), *European Identity in Cinema*, Bristol: Intellect.

Ezra, E. (ed.) (2004), *European Cinema*, Oxford: Oxford University Press.

Firestone, S. (1970), *The Dialectics of Sex: The Case for Feminist Revolution*, New York: Morrow.

Forbes, F. and Street, S. (2000), *European Cinema: An Introduction*, Basingstoke: Palgrave.

Fowler, C. (ed.) (2002), *European Cinema Reader*, London: Routledge.

Freud, S. (1962), *Civilization and its Discontents* (trans. J. Strachey), New York: W.W. Norton.

Galt, R. (2006), *The New European Cinema: Redrawing the Map*, New York: Columbia University Press.

Greer, G. (1970), *The Female Eunuch*, London: McGibbon & Kee.

Holmes, D. and Smith, A. (2001), *100 Years of European Cinema: Entertainment or Ideology?*, Manchester: Manchester University Press.

Jankowiak, W. (ed.) (1995), *Romantic Passion: A Universal Experience?*, New York: Columbia University Press.

Kakar, S. and Ross, J. M. (1992), *Tales of Love, Sex and Danger*, Oxford: Oxford University Press.

Konstantarakos, M. (2000), *Spaces in European Cinema*, Bristol: Intellect.

Kuhn, A. (2002), *An Everyday Magic: Cinema and Cultural Memory*, London, I. B. Tauris.

Lipgens, W. (ed.) (1985), *Documents on the History of European Integration*, vol. 1, Berlin/New York: Walter de Gruyter.

Loshitsky, Y. (2010), *Screening Strangers: Migration and Diaspora in Contemporary European Cinema*, Bloomington: Indiana University Press.

Masierska, E. and Rascaroli, L. (2006), *Crossing New Europe: Postmodern Travel and the European Road Movie*, London: Wallflower.

May, J. and Thrift, N. (eds) (2001), *Timespace: Geographies of Temporality*, London: Routledge.

Menocal, M. R. (1994), *The Shards of Love: Exile and the Origins of the Lyric*, Durham: Duke University Press.

——— (2002), *The Ornament of the World: How Muslims, Jews, and Christians Created a Culture of Tolerance in Medieval Spain*, New York: Little Brown & Co.

Mignolo, W. (2000), *Local Histories/Global Designs: Coloniality, Subaltern Knowledges, and Border Thinking*, Princeton: Princeton University Press.

Mitchell, J. (1984), *Women: The Longest Revolution – Essays on Feminism, Literature and Psychoanalysis*, London: Virago.

Nowell-Smith, G. and Ricci S. (1998), *Hollywood and Europe: Economics, Culture, National Identity 1945–95*, London: BFI Publishing.

Passerini, L. (1999), *Europe in Love, Love in Europe: Imagination and Politics in Britain between the Wars*, London: I. B. Tauris.

——— (2009), *Europe and the Idea of Love*, Oxford: Berghahn Books.

Passerini, L., Ellena, L. and Geppert, A. (eds) (2010), *New Dangerous Liaisons: Discourses on Europe and Love in the Twentieth Century*, Oxford: Berghahn Books.

Passerini, L. and Mas, R. (eds) (2004), *Europe and Love – L'Europe et l'amour*, *European Review of History*, 11: 2.

Paz, O. (1993), *La llama doble. Amor y erotismo*, Barcelona: Círculo de Lectores.

Petrie, D. (1992), *Screening Europe: Imaging and Identity in Contemporary European Cinema*, London: BFI Publishing.

Rieger, A. (1991), *Trobairitz. Der Beitrag der Frau in der altokzitanischen höfischen Lyrik. Edition des Gesamptkorpus*, Tübingen: Max Niemeyer.

Rivi, L. (2007), *European Cinema after 1989: Cultural Identity and Transnational Production*, Basingstoke: Palgrave Macmillan.

de Rougemont, D. (1983), *Love in the Western World* (trans. M. Belgion), Princeton: Princeton University Press. Original French edition, *L'amour et l'Occident* (1939).

Shaviro, S. (1993), *Cinematic Body (Theory out of Bounds)*, Minneapolis: University of Minnesota Press.

Shohat, E. and Stam, R. (1994), *Unthinking Eurocentrism: Multiculturalism and the Media*, London: Routledge.

Singer, I. (1984), *The Nature of Love II: Courtly and Romantic*, Chicago: University of Chicago Press.

——— (1987), *The Nature of Love III: The Modern World*, Chicago: University of Chicago Press.

Sorlin, P. (1991), *European Cinemas, European Societies, 1939–1990*, London: Routledge.

Stacey, J. (1992), *Star Gazing: Hollywood Cinema and Female Spectatorship*, London: Routledge.

Uricchio, W. (ed.) (2008), *We Europeans?: Media, Representation, Identities*, Bristol: Intellect.

Vincendeau, G. (ed.) (1995), *Encyclopaedia of European Cinema*, London: Cassel/BFI Publishing.

Wayne, M. (2002), *Politics of Contemporary European Cinema: Histories, Borders, Diasporas*, Bristol: Intellect.

Wood, M. (2007), *Contemporary European Cinema*, London: Bloomsbury.

## Notes

1. See, for example, Sorlin 1991; Petrie 1992; Vincendeau 1995; Everett 1996; Nowell-Smith and Ricci 1998; Forbes and Street 2000; Konstantarakos 2000; Holmes and Smith 2001; Aitken 2001; Eleftheriotis 2001; Fowler 2002; Wayne 2002; Ezra 2004; Elsaesser 2005; Galt 2006; Wood 2007; Rivi 2007. Masierska and Rascaroli (2006) focus specifically on the European road movie. Uricchio (2008) provides an overview of the European media in general. Berghahn and Sternberg (2010) and Loshitsky (2010) address the representation of migrants in recent European cinema; like Ellena and Capussotti in this volume, Loshitsky analyses the complex negotiation of European identity enacted in such films, but does not address this issue through the lens of love.
2. For a more detailed exposition of the arguments outlined in the following section, see Passerini 1999 and 2009.
3. 'Romantic' with a capital 'R' is used here to refer to Romanticism as a literary movement of the early nineteenth century, by contrast with the transhistorical notion of 'romantic love'.
4. See, for example, Menocal 1994 and 2002. Menocal notes that the Arabic-origins thesis for Occitan courtly love poetry was commonplace prior to Napoleon's conquest of Egypt, which initiated a colonial construction of Arabic culture as inferior. Scholars continue to disagree over the extent to which the Occitan love lyric was indebted to Arabic models.
5. Amengual lists many other films that in his opinion may have been inspired by de Rougemont.

# Part I

Disciplinary and historical contexts

# Chapter 1

Cinema and academia: of objects of love and objects of study

Thomas Elsaesser

## It all started in the Sixties

One of the many remarkable but paradoxical legacies of 'the Sixties' is the transformation of the cinema from an object of (transgressive) love into an object of (normative) study, from 'cinephilia' into 'film studies', and thus the makeover of a passion bordering on addiction into a discipline elevated to one of the 'growth areas' in the humanities. The change raises many questions: about the crisis in the humanities since the 1970s, which required a new subject-mix; about new alliances between language studies, national literatures and visual culture; as well as about the ways that Europe has been redefining itself as both more multicultural in its demographics and more marginal in its geopolitics. In these shifting contexts, cinema has emerged not only as one of the more effective means of asserting a specifically European contribution to 'world culture' (in terms of the continuity of its practice in most European countries and of the consistency of its artistic and critical engagement among film auteurs and intellectuals), but also as one of the most receptive and responsive ways of negotiating the new alignments that typify the European adventure in the twenty-first century: alignments of identity and place, of sharing and belonging, of history and memory. In this respect, love of cinema, however much it may have started as a solitary, furtive form of self-indulgence, can indeed become the symptom of – and conduit for – many other passionate engagements, focused and fixed by the academy, before fanning back out into the urban fabric and community life and cross-fertilizing with cultural politics, whether via film festivals or centres of visual art and cinema.

But here is another paradox: film studies became academically respectable at a point in time when many film-makers, critics and cinephiles proclaimed the 'death of cinema'.[1] Was 'film studies' perhaps an elaborate funeral service for a dying art, and cinephilia – insofar as it survived as that special devotion to the projected image in a darkened room – a culturally sanctioned form of necrophilia? Cinephilia: a nostalgic, melancholy return to eternal adolescence, or the aesthetic conscience of our (much diminished) public sphere? In its latter role, as a legacy and an excess, as a remainder and a reminder, cinephilia may well have been the ingredient that initially gave film studies – compared to its more established sister disciplines like literary studies, art history and philosophy – its special, 'performative' position in the academy, making it at once opportunist and subversive, the antennae of the Zeitgeist and the memory of political resistance to the Zeitgeist. The latter especially would be one of the historical contexts to invoke when trying to understand

the genesis of film studies out of the 'spirit of the Sixties'. In what follows, I want to sketch some of the circumstances that in Britain in the 1970s and 1980s contributed to the re-alignment of cinema as a cultural force both inside and outside the academy, notably around what came to be known as 'identity politics'. This may also explain why, in the new century, film studies has had to cede to cultural studies – and to the love of society in motion – some of the energies initially inherent in cinephilia as the love of the image in motion.

## One particular postwar origin of film studies: cinephilia UK-style

The Brighton film club I joined in 1964 defined itself in the mirror of French auteurism of the late 1950s and worshipped Hollywood. My new friends quickly attacked the German middle-class taste for Ingmar Bergman, Vittorio de Sica and Italian neorealism I had brought with me when moving to the UK. Initially, the idea that a Western with John Wayne might be more serious than *Smultronstället/Wild Strawberries* (Bergman, 1957) or *Det sjunde inseglet/The Seventh Seal* (Bergman, 1957) seemed inconceivable to the aesthetic orthodoxy I grew up with, but they eventually browbeat me into agreeing that Bergman's *Tystnaden/ The Silence* (1963), despite its sexual frankness and existential 'angst', was not as important for the cinema as John Ford's *The Man Who Shot Liberty Valance* (1962).

What made cinephilia so completely distinct from other juvenile obsessions was the encounter with the films of Jean-Luc Godard. Mesmerized by *À bout de souffle/Breathless* in 1960 and *Vivre sa vie/My Life to Live* in 1962, baffled by *Le petit soldat/The Little Soldier* in 1963, it took a screening of *Le mépris/Contempt* (1963) in London in 1964 to make the idea of devoting my life to cinema an urgently felt necessity. *Le mépris* was an exciting film not just in and for the present, but because it opened up the past: it had Fritz Lang playing himself; it was about the movie business; and it made me curious about Vincente Minnelli when Michel Piccoli insisted on wearing his hat at all times only because Dean Martin did so in Minnelli's *Some Came Running* (1958). Godard propelled the wish to reflect on cinema, but he did so in a dramatic/traumatic way. He lodged the desire for a theory of cinema through cinema itself, but his films foreclosed that very possibility, because the standards he set were so far in advance of everything else that had happened in cinema up to that time. The experience was so traumatic, and Godard became so emblematic, because his films fostered the illusion that writing about films was already halfway to making them, and that making films was the most authentic manner of being engaged in the world; in fact, of transforming the world – not only one's own, but that of one's culture and society.

Thus, for anyone interested in cinema in the 1960s, the pull of Paris was irresistible. No sooner had I finished my first university undergraduate degree and begun a doctorate, I enrolled at the Sorbonne. I did not take any courses, but spent my daytime hours at the Bibliothèque Nationale, and the evenings at the Cinémathèque. Armed with a copy of Andrew Sarris' *American Directors and Directions*, I shuttled every night between

the Palais de Chaillot and the Rue d'Ulm. Henri Langlois was famous for his inspired programming, which would combine a rare Mizoguchi melodrama with an Allan Dwan Western, or show Jacques Tourneur's *Build My Gallows High* (1947) on the same evening as Marcel Carné's *Le jour se lève/Daybreak* (1939). I must have seen 600 films in the eight months I spent in Paris, and filled several spiral-bound notebooks with comments scribbled in the dark. No sooner had I returned to England, I started a university film magazine in late 1968, the *Brighton Film Review*. Its slightly better known but relatively short-lived successor was *Monogram*, begun in 1971. The name was chosen to advertise our allegiance to Hollywood (with a nod to Godard who had dedicated his first film *À bout de souffle* to Monogram, a B-movie studio). The fact that *Monogram* promoted Hollywood in the early 1970s, at the height of the anti-Vietnam War protests and in the wake of May '68, was an act of loyalty in the guise of provocation: instead of writing about Glauber Rocha or Michael Snow, we published articles on Michael Powell and Raoul Walsh, Sam Peckinpah and Robert Aldrich. Besides celebrating Douglas Sirk, Vincente Minnelli and Joseph Losey, we also attacked British cinema and David Lean; yet, almost in spite of ourselves, we kept faith with Ingmar Bergman and Luis Buñuel.

What was so special about French cinephilia, and why was it important for what became film studies in Britain? Antoine de Baecque has, somewhat stiffly, defined it more recently as 'a way of watching films, speaking about them and then diffusing this discourse' (de Baecque and Frémaux 1995: 134). De Baecque – himself an editor-in-chief of *Cahiers du Cinéma* in the 1990s – judiciously includes the element of shared experience, as well as the need to write about it and to proselytize, alongside the pleasure derived from viewing films on the big screen. The cinephilia I became initiated into around 1963/4 in Brighton and London did include dandified rituals strictly observed when 'going to the movies', either alone or, less often, in groups. Cinephilia meant being sensitive to one's surroundings when watching a movie, carefully picking the place to sit, fully alert to the quasi-sacral feeling of nervous anticipation that could descend upon a public space, however squalid, run-down or rowdy, as the velvet curtain rose and the studio logo with its fanfares filled the space. But cinephilia was also a gesture towards cinema always already framed by nostalgia and other retroactive temporalities, by pleasures tinged with regret even as they register as pleasures. Without cinephilia, there would not have been film studies, certainly not for my generation in Great Britain, but film studies – some would say – was also the gravedigger of cinephilia.

### Film theory as *Screen* theory: mourning work for cinephilia?

During the same years that I founded a film magazine in Brighton, there also appeared in London *Afterimage, Cinemantics, Cinema Rising, Enthusiasm, Cinema* (Cambridge University), with a little later *Framework* (University of Warwick) and *Filmform* (Newcastle University). They all kept their distance from but certainly felt the gravitational pull of

*Screen*, re-founded in 1971. Pilgrimages to Paris similar to mine (as well as to Rome) had been undertaken a few years earlier by Peter Wollen, Laura Mulvey, Geoffrey Nowell-Smith and Jon Halliday: regular writers for *Screen*, all close to *New Left Review*, and major figures in the emergence of British film studies.

*Screen*'s intellectual lineage was also in Paris, but owed fewer debts to *Cahiers du Cinéma* and Langlois' Cinémathèque than to the journal *Communications* and Christian Metz's and Roland Barthes' seminars at the Centre Nationale de la Recherche Scientifique. By 'Screen theory' we now understand the volatile blend of Saussurean linguistics, Levi-Straussian structuralism, Althusserian Marxism and Lacanian psychoanalysis, which together elaborated a theoretically very sophisticated, but for their opponents hermetically sealed and tautological, critique of bourgeois (psychological) realism, patriarchal modes of gender representation, and the 'realist effect' of the 'cinematic apparatus'.[2] Terms such as 'suture', 'interpellation', 'subject-construction', 'mirror-stage' and 'the gaze' are identified with *Screen* theory, which developed the early insights of Levi-Strauss, Barthes and Greimas in the direction of a theory of gendered subjectivity and vision, which has had an enormous influence on film theory, feminism, visual culture studies and art history.

Yet at the time, *Screen* appeared to me as the dark side of cinephilia: at the National Film Theatre (NFT), where almost all of us editors and writers met, we watched the same films and followed the same directors, but we wrote about them in quite different ways. Were I to analyse *Screen* theory in retrospect from within its own theoretical premises, I might claim to detect a dynamic of desire and its disavowal, as much caught in miscognition and the mirror-phase as that characterizing the viewing subject of *Screen* theory itself. Given the common 'cinephile' origins of almost everyone in British film culture in the 1960s and '70s, the subsequent ambivalence shown towards Hollywood films[3] leads me to conclude that what was at stake were the painful dichotomies of a lover's discourse, as conjugated by Roland Barthes (1978): 'I have loved and love no more'; 'I love no more, in order to better love what I once loved'. In this sense, *Screen* theory's decade-long deconstruction of Hollywood can be seen as a kind of extended funeral service or mourning work for cinephilia, where the very loss of the once-loved object intensifies the effort to master this loss by a theory of 'subjectification' and 'interpellation'.

Therefore, a closer look at the London scene in the 1970s indicates the presence of several kinds of Oedipal ambivalences and of Melanie Klein's good/bad object relations. It may explain *Screen*'s 'discovering' Douglas Sirk (as a 'good' auteur, because of his associations with melodrama and the woman's film), the dissenting reassessments of neorealism, or the rivalries over who 'owned' Hitchcock: *Sight & Sound*, *Screen* or *Movie*? The argument would be that it was a deferred but also disavowed cinephilia which proved part of the driving force behind *Screen* theory. The intellectual brilliance and theoretical difficulties of the theory both covered over and preserved the fact that ambivalence about the status of Hollywood as the good/bad object persisted, notwithstanding that 'love of cinema' was now called by different names: voyeurism, fetishism and scopophilia.[4] Such terms, beyond their technical meaning within Freudian discourse, make it evident that by

1975/76 the cinephilia to which our generation owed its knowledge of cinema had been dragged out of its closet, and revealed itself as a source of disappointment: the magic of the movies, in the cold light of day, had become a manipulation of regressive fantasies and the place for masculinity to protect itself from castration anxiety and sexual difference. It is not altogether irrelevant to this moment in history that Mulvey's call, at the end of her famous essay 'Visual pleasure and narrative cinema', to forego visual pleasure and dedicate oneself to unpleasure was not always heeded.

On the contrary, pleasure, consumption and popular culture became a political issue par excellence in Britain; but not for *Screen*, whose writers had maintained a very explicit commitment to the pared-down Marxist aesthetics of the historical avant-garde (notably Russian constructivism and Brecht) and to the (London-, and to a lesser extent, New York-based) anti-aesthetics of the political avant-garde. As film-makers, Laura Mulvey and Peter Wollen were themselves part of this avant-garde, with films like *Penthesilea* (1974) and *Riddles of the Sphinx* (1977) and as writers of a number of key articles redefining modernism and avant-garde practice for a contemporary and, by the 1970s, highly politicized generation. Godard's own turn away from citing, appropriating and pastiching Hollywood films towards a militant, ascetic and verbal cinema during the years of the Dziga Vertov Group served as an example also for Mulvey/Wollen, occasionally leading to polemical exchanges with film-makers from the London Co-op, such as Peter Gidal, Steve Dwoskin and Malcolm Le Grice, who had a more formalist understanding of film, more in tune both with the New York avant-garde and with film-makers in Germany and Austria, for whom *Screen* showed little interest. Journals like *Afterimage* and *Framework* had a wider coverage of international cinema – including European avant-garde and art cinema, Asian and 'Third' cinema, as well as the new film cultures that began to develop around the smaller film festivals in Italy, Canada and Latin America. Yet, by the same token, these magazines exerted only a limited influence on the formation of film studies as an academic discipline, for which *Screen* and the British Film Institute (BFI) ultimately provided the necessary intellectual pedigree and institutional momentum.

Also apt to be forgotten when focusing only on *Screen*'s foundational influence on academic film studies is one of its great achievements: namely, the bond it managed to forge between theory and practice, between intellectuals and avant-garde directors. In this it renewed a tradition from the 1920s. If, for instance, we trace back film theory to its 'origins', we find that the most significant impulses have come from film-makers (Sergei Eisenstein, Dziga Vertov, Jean Epstein, Louis Delluc, John Grierson) and film critics (Rudolf Arnheim, Béla Balázs, Siegfried Kracauer, Lotte Eisner), with the occasional art historian contributing an important essay (Élie Faure, André Malraux, Erwin Panofsky). The central thrust of this intervention was to defend (and define) film as an art form (and a 'language'), and to free cinema from the stigma of being a mere mechanical reproduction of reality. While it can be argued that the coming of sound put an end to such efforts, the manner in which *Screen* revived this tradition, adopted the rather dry academic discourse of Metz's semiology and adapted it as the weapon for a new militancy

of the cinema as political art, does indeed deserve the epithet 'heroic', however brief this moment was to have been.

By the mid-1980s, a certain turning point was in evidence. *Screen*'s policy of (mainly French) high theory could be seen to have paid off: it had achieved the BFI Education Department's goal to provide the 'texts' and to set the intellectual agenda that enabled one part of this diverse film culture of the 1960s to enter into the university and establish the British version of film studies. But the insistence on this particular theory, which defined films as a language and the spectator as a 'subject' – subjected to miscognition and ideological interpellation – also set the scene for a number of divisions. By then, many of the independent film magazines offering other perspectives (including *Movie, Monogram, Cinema, Cinema Rising, Filmform*) had either ceased publication or appeared only very sporadically, partly because the superior clout of *Screen* – intellectual and institutional – had overshadowed their attempts to evolve alternative approaches to cinema. *Screen* had also split the film-making communities, some of whose members did not feel enabled or empowered by high theory, while others, among them a number of women's film-making collectives (notably the London Women's Film Co-op, the Sheffield Film Co-op and the Berwick Street Collective), did benefit from the high profile that *Screen* had given to feminist issues and the politics of gender, while not necessarily following the theoretical line of *Screen*'s famous contributors.

## Film studies in the university: a Trojan horse?

The initiative for forging a closer alliance between (London-based) film culture and the (regionally-based) new universities began from within the BFI, and was aimed at encouraging universities to formally establish film studies by offering (English literature) departments funding for a three-year appointment, which the university was subsequently to take on and make permanent. The offer was taken up by five new universities, of which three – Warwick, Kent, East Anglia (subsequently joined by Glasgow-Strathclyde, Southampton and Newcastle) – are recognized as the leading film studies departments in the country today. Nevertheless, the difficulties that film studies initially faced even in these 'new' universities were considerable. Most academics in the humanities distrusted a subject so obviously popular and pleasurable, yet without either a list of recognized classic authors and canonical texts, or a secured and proven method for studying them. Here, French cinephilia proved invaluable, because it permitted one to propose a curriculum set up in the mirror image of literature. *Cahiers du Cinéma*'s and Andrew Sarris' pantheon auteurs (Orson Welles, John Ford, Alfred Hitchcock, Fritz Lang, Jean Renoir, Max Ophüls, Howard Hawks, Kenji Mizoguchi), and undisputed masterpieces (*Citizen Kane* [Welles, 1941], *La règle du jeu/The Rules of the Game* [Renoir, 1939], *Sunrise* [Murnau, 1927], *Modern Times* [Chaplin, 1936], *The Big Sleep* [Hawks, 1946], *Vertigo* [Hitchcock, 1958], *Letter from an Unknown Woman* [Ophüls, 1948]), served us well in establishing introductory courses,

while the French passion for *mise-en-scène* criticism allowed us to conduct the kind of close textual reading familiar to students of poetry and the modern novel.

But 'out there' in the world of politicized film theory and the cut-and-thrust of intellectual debate, these very authors, canons and methods were shown to be deeply flawed ways of understanding the cinema and its political-ideological role in perpetuating bourgeois individualism and gendered subjectivity. Had we not been reading Roland Barthes about the death of the author, or Michel Foucault on 'what is an author'? Had we not learnt to deconstruct the textually smooth surface of John Ford's *Young Mr. Lincoln* (1939) – not in order to uncover layers of deeper meanings, nor to recover the personal vision of the director within the studio system, but rather to practice an active reading which focused on the film's structuring absences? The very split between cinephile auteurism and *Screen* theory's ideological assault on Hollywood finally worked in favour of film studies inside the academy, because it answered to literary studies' own crisis in its methodological self-understanding, as well as its own doubts about canon-formation. Film studies' ability to draw on Barthes' structuralism, Saussurean semiology, Lacanian psychoanalysis and Derrida's deconstruction not only made it a useful ally for a younger generation of literary theorists, it also raised the intellectual stakes generally, because the study of a 'low' medium turned out to require 'high theory' from its practitioners and thus gave film theorists a special advantage in the 'identity wars' that began in the early 1980s. It is in this sense that one can speak of film studies as having been the 'Trojan horse' of these wars, introducing structuralism, psychoanalysis, feminism and post-structuralism to the humanities.

## Film studies: a victim of its success?

In some sense, then, this is a double success story. An emerging interest in the serious study of the cinema in the 1960s – sparked off by revitalized European film-making in the form of several *nouvelles vagues*, some outstanding directors, and a new appreciation of 'classical' Hollywood – was able to focus itself for a decade around film magazines, around the BFI (in those years a relatively enlightened, if often divided public institution) and a generation of politically committed, polemically gifted and intellectually hungry men and women, many of whom (and this is the second part of the success story) were able during the next decade – the mid-1970s to the mid-1980s – to find teaching positions in the 'new universities' or at other institutions of higher education, where their theoretical sophistication often gave them a vanguard role with respect to the older, more established disciplines such as literature and art history.

But this success could not disguise a certain paradox or asymmetry. As an academic discipline, film studies constructed its object according to the rules that obtain within the humanities, and these were largely set by literary studies and its realist or modernist discourses (rather than, say, by communication studies, sociology or economics). But

cinema also exists in the culture and the economy at large, as one of the great popular arts and entertainment forms of the twentieth century. Cinema's existence as a profit-oriented but also risk-taking, high-tech industry, and films' presence in society as popular culture and vernacular memory were (and still are) shaped by a dynamic in which academic work plays no part. Our essays and books rarely reached the general reader, and working film critics never had much time for film theory, which they found abstruse, elitist and patronizing. Furthermore, what is striking about the disciplinary conception of the cinema as a body of 'texts' (the canonical masterpieces, the collected works of recognized directors, and the odd 'discovery' in archival vaults) is the degree to which it 'privatizes' the film experience and aligns it with reading a book, not least in order to give the cinema the kind of (modernist) autonomy and (medium) specificity required by works that aspire to be recognized as 'art' in the twentieth century. By contrast, what is striking about cinema as a public sphere and popular practice has been the *loss of autonomy and specificity* that individual films have undergone over the same 30 years: a process which also began in the mid-1970s when Hollywood was able to revive its economic success with a new kind of film experience, namely the blockbuster, combining a different sound-space with spectacle values such as special effects and thrilling action sequences.

As movie theatres became showcases for new products of the ever-growing media entertainment industries, and these products (mainly 'event movies' and blockbuster spectacles) came to be seen as 'content' that could be packaged around different 'platforms' and thus exploited by other media industries (above all, by television, the video game market and the music business), the films themselves, while still the prime experience, had difficulty in retaining their status as either 'texts' or individually 'authored' artefacts. With DVD releases, directors' cuts and bonus packages, films no longer command the space of singularity and closure we traditionally expect of a 'work (of art)'. Not only have the sequel, prequel or series become almost the norm in mainstream film production, but the other aggregate states of the cinematic event just mentioned make up the major part of a film's economic potential, whose commodity status appears further confirmed by the DVD, with its slick packaging and ubiquitous marketing. As we saw, critics (and film-makers) have lamented this loss of autonomy and specificity as the 'decay' or even 'death' of cinema. But the debate not only touches the transfer from photographically based images to digitally shot and edited film, signifying the 'death' of the referential bond that the celluloid based moving image has with reality.[5] It also alludes to the sheer ubiquity and total availability of film, depriving us of the sense of scarcity and value inherent in the unique event and special occasion associated with 'going to the movies' during the reign of cinephilia.

For it is worth recalling here another aspect of cinephilia. If I am right in arguing that (British) film studies emerged out of the cinephilia of the early 1960s, it inherited the habit of valuing not only the singular work and the director as uniquely creative auteur, but also the unique experience of a film's performance as a projected event. This event, as I mentioned above, was tied to a place, a space and a time, usually that of its single

showing at a cinémathèque, or it required the special effort of catching one's favourite film at a second-run cinema or (for the TV generation) on late-night television. Yet however much we now may prize the fond memory of these moments, I also recall the difficulties of renting 16mm copies for teaching: what would we have given in those early days of film studies for a videotape or DVD of an Ozu, Renoir or Welles to be available at home or in the seminar-room! At the same time, one cannot help noticing the paradox that the availability of films on videotape or DVD has left us with: these very technologies of (digital) storage tend to favour the (contentious) 'close textual analysis' as the dominant pedagogical *practice*, while the films' ubiquity in a vastly expanded media space tends to contradict such a concentration on the individual film from the perspective of *theory*. Structuralism and post-structuralism were, in this sense, 'centrifugal' and dispersive theories of textual ensembles, not ways of conferring closure on a text. While, in the early days of film studies, our experience was that of the film as (singular) *performance* and our theory was that of the film as *book/text/narrative*, the experience today is of the DVD as *book* (chapter divisions, pause button, 'leafing through' with fast-forward or rapid scanning), while theory tells us we require a different conceptual vocabulary: often enough one where the *performative*, the 'embodied' and the 'located' play a significant role, and where the cultural context of reception shapes the horizon of analysis.

Maybe we need to go beyond this paradox. In truth, several kinds of division of labour have taken place in the last 30 years, during which 'the cinema' has found itself refigured many times over. Firstly, a different division of film production and film culture has occurred. In the 1970s, one could talk about 'classical Hollywood' and contrast it to 'New Hollywood', which with its love for France and Germany's New Waves paid back the compliment to Europe that 'auteur theory' had extended to Hollywood. Now, there is global Hollywood and international art cinema (disseminated via festival circuits), while politicized Third Cinema has become 'world cinema'. The avant-garde has migrated into the museum and art world, and the auteur has become a creative entrepreneur promoting him/herself as a 'quality brand', while the film festival circuits decide what is 'New Wave' (and thus part of the 'international art cinema' of auteurs) and what is 'world cinema' (and thus part of 'themed' programming on topical issues, such as the environment, torture, Islam and women, urban slums, etc.). Secondly, inside the academy and its institutions, there is 'film studies', 'media studies', 'cultural studies', 'visual theory', 'gender studies', 'art history', 'image anthropology', 'postcolonial studies' and many more disciplines and sub-disciplines, all claiming to have something significant to say about cinema, or using films to exemplify issues of critical concern. Finally, there is the ever-widening gulf between the film critic, working for a newspaper, writing in a journal or curating retrospectives for a film festival, and the film scholar, attending conferences, teaching film classes and writing textbooks or monographs – read almost exclusively by students and fellow scholars.

In this process of specialization, but also in the redistribution of the intellectual 'labour of love' agenda, cultural studies has been an invaluable ally for another counter-movement to 'high theory' also within film studies: namely, the turn to 'cinema history' and 'media

archaeology', as it developed in the 1980s around the study of the 'origins' of cinema, which saw a revival of interest in 'early' and 'silent' cinema at festivals and academic conferences. The history of cinema (as opposed to film history) became an academic paradigm in its own right in the 1990s under the heading of 'cinema and modernity' or 'cinema and visuality', drawing on the work of Walter Benjamin, Georg Simmel and Siegfried Kracauer. Now often also referred to as the 'cinema of attractions', this paradigm around visual culture, spectacle and display offers itself as another version of reception studies, and an alternative to the traditional emphasis in film studies on narrative, narratology and paratexts, inspired by literary structuralism and Gérard Genette. Most of this work in early cinema takes a broadly 'cultural' rather than 'medium-specific' approach, which is to say that it is more interested in the (trans-media, multicultural and media-historical) category of *modernity* than in the (literary and art-historical) category of *modernism*.

Looking back, one can thus speak of two generations of (academic) film studies in Britain, at once related to each other and subtly opposed to each other. In contrast to the first phase of film studies, derived from and ambivalent towards cinephilia, the second phase of film studies, inspired by cultural studies, has broadened its scope both synchronically (by taking in other manifestations of visual and popular culture) and diachronically (by extending its historical reach to include 'pre- and early cinema' and, if the new net-cinephilia is included, digital 'post-cinema'). Film studies as cultural studies is thus able to make good also the demand to pay attention to the materiality and heterogeneity of media practices and media technologies from a perspective that includes the digital media; one of the distinguishing features of 'media theory'. But instead of the latter's tendency towards a post-McLuhan form of technological determinism, film studies as cultural studies aims to rescue the popular-as-progressive from radical theory's disenchantment with both high culture and mass entertainment. Thus it has, for instance, in the wake of Stuart Hall, amply documented the sophistication and discrimination (the traditional hallmarks of educated taste) of popular reading strategies, as well as their subversive, activist, interventionist and deconstructive potential.[6] It has also made axiomatic what in film studies remained contested territory: that cultural production is always 'post-production' – the appropriation and transformation of already existing texts, discourses, and cultural ready-mades. Love – and cinephilia is no exception – often relies on recognition, even mistaken recognition, just as discovery holds special pleasures when it is (experienced as) a rediscovery.

The Birmingham Centre for Cultural Studies provided the most significant intellectual counterweight to *Screen* theory in the 1980s, with a worldwide response which by the 1990s, from Melbourne, Australia to Duke University, North Carolina, had all but eclipsed that first phase of British film studies. The 'identity wars' and 'politics of representation' around race, class, gender and sexual orientation have become such prominent features of academic discourse in the humanities across the disciplines that it would be fair to say that British cultural studies (by now critiqued, modified, adapted, and indeed 'negotiated' by local practitioners in the United States, Australia, and also in northern Europe) has not only 'subsumed' and thereby thoroughly redefined film studies in many

universities; it has also become something of a 'hegemonic' force in the way we approach the manifestations of all culture: be it high culture or popular culture; be it literary culture or media culture; be it the crass commercialism of television and tourism or the slightly more subtle commerce of the art world, event culture and exhibition practice.

From my own perspective as (still) mainly a film scholar, I am somewhat sceptical about claims – whether originating from psycho-semiotics in the 1970s, cognitivism since the 1980s or implicit in cultural studies in the 1990s – that aspire to a totalizing critical or theoretical formation, however much a normative posture may be necessary in order to stake out potential or actual territory in university departments and research allocations. Cinema's comparative insignificance as a 'serious' contender in major research funding exercises sometimes seems a blessing in disguise. The precarious status of film studies within the wider fields of the humanities, where it is at times quite central (modern languages, cultural studies), at times more marginal (art history, philosophy), is thus a challenge and a burden. Called upon to play its part in the opening up of the classic humanities, based mainly on written texts, towards contemporary cultures based equally on sounds and images, film studies responds, in its historiography and hermeneutics, to the dynamics and unstable media environments of globalization. Not only under pressure to legitimate itself within the humanities but asked to build bridges to the hard and social sciences (such as cognitivism, the life sciences and complex adaptive systems), film studies takes considerable risks and may even look like losing itself. Yet by taking risks it also betokens this love of a specific object, of a unique sensation, of an evanescent instant, thus reviving the cinephile moment, and carrying it into the public realm as the aesthetic experience par excellence.

While cinema's 'place' in the disciplinary spectrum and the university curriculum seems largely secure – thanks to the double conjuncture of the moving image's popularity among students, and the perceived social and economic relevance of what is known as 'the media' – the 'space' (discursive, institutional, aesthetic) is, as I have tried to indicate, far from uncontested. This allows its 'study' to be experimental, curious, adventurous, passionate and even promiscuous: in short, 'opportunistic', meaning that it can seize opportunities when they present themselves. Now that the love affair between French intellectuals and Hollywood which began in the 1950s is truly over, and the love of Anglo-American academics for French theory (not only in the field of film studies) has also cooled, it may seem that 'disenchantment' is the most appropriate as well as the most professional response to cinema today as an object of study, in Europe as well as the United States. But that would be to underestimate both the persistence of cinephilia and the ingenuity of those that fall under its spell. New technology, and especially the Internet, have permitted a new generation (of bloggers, of DVD reviewers, of webmasters and list-hosts) to fall in love with cinema, once more and all over again: mostly in parallel with, rather than in opposition to, academic film studies, in the process rediscovering not just new films and new film-makers, but cinema's past, and this past's perennial presence among all those needing to share that primary fascination with a world in motion, and willing to call this fascination 'love'.

# References

Barthes, R. (1978), *A Lover's Discourse* (trans. R. Howard), New York: Hill and Wang.

*Cahiers du Cinéma* (1972), 'John Ford's *Young Mr. Lincoln*', *Screen*, 13: 3, pp. 5–44.

Cherchi Usai, P. (2001), *The Death of Cinema: History, Cultural Memory and the Digital Dark Age*, London: British Film Institute.

Cheshire, G. (1999), 'The death of film / the decay of cinema', *New York Press*, 26 August, 12: 34.

de Baecque, A. and Frémaux, T. (1995), 'La cinéphilie ou l'invention d'une culture', *Vingtième Siècle Revue d'Histoire*, 46, pp. 133–42.

Heath, S. (1976), 'Narrative space', *Screen*, 17: 3, pp. 19–75.

——— (1977), 'Film and system: terms of an analysis', *Screen*, 16: 1–2, pp. 7–77; 91–113.

Jenkins, H. (1992), *Textual Poachers*, New York: Routledge.

——— (2006), *Convergence Culture*, New York: New York University Press.

MacCabe, C. (1976), 'Theory of film: principles of realism and pleasure', *Screen*, 17: 3, pp. 7–27.

Mulvey, Laura (1975), 'Visual pleasure and narrative cinema', *Screen*, 1: 3, pp. 6–18.

——— (2005), *Death 24x a Second: Stillness and the Moving Image*, London: Reaktion Books.

Nowell-Smith, G. (1976), 'Six authors in pursuit of *The Searchers*', *Screen*, 17: 1, pp. 26–33.

Rosen, P. (ed.) (1986), *Narrative, Apparatus, Ideology: A Film Theory Reader*, New York: Columbia University Press.

Sontag, S. (1996), 'The decay of cinema', *New York Times*, 25 February.

Witt, M. (1999), 'The death(s) of cinema according to Godard', *Screen*, 40: 3, pp. 333–45.

## Notes

1. See Sontag 1996; Cheshire 1999; Witt 1999; Cherchi Usai 2001.

2. A good account of *Screen* theory can be found in the introductions and texts assembled in Rosen 1986.

3. This ambivalence is demonstrated by the translation of *Cahiers du Cinéma's* Lacanian deconstruction of John Ford's *Young Mr. Lincoln* ('John Ford's *Young Mr. Lincoln*' 1972), Stephen Heath's (1977) massive two-part essay on Orson Welles' *Touch of Evil* (1958), Geoffrey Nowell-Smith's (1976) debate on Ford's *The Searchers* (1956), Laura Mulvey's (1975) feminist critique of voyeurism in Hitchcock and Sternberg, and Colin MacCabe's (1976) article onLucas's *American Graffiti* (1973), all of which make Hollywood the target of relentless deconstruction and yet the obsessively chosen object of study.

4. See Heath 1976 and Mulvey 1975.

5. The most illuminating account is Mulvey 2005.

6. See for instance Jenkins 1992 and 2006.

## Chapter 2

For love or money: transnational developments in European cinema in the 1920s[1]

Andrew Higson

In the decade-and-a-half between the end of World War I and the establishment of talking films as the standard in European picture houses, those involved in the film business and film culture in Europe were forced to acknowledge the economic strength, audience appeal and increasing market domination of American films. But many also sought to reciprocate that strength and appeal through the creation of a vibrant, dynamic 'European' cinema, a transnational cinema of collaboration and allegiance.

At the heart of this economy was a profound and pervasive love of cinema. Films were watched regularly by audiences in their millions. Those audiences adored their film stars, a love affair that was fuelled by the films themselves, with their narratives so often organized around the formation of the heterosexual couple, their images littered with glamorous close-ups of the narrative protagonists, and the system of looks in the films encouraging both a desiring gaze at and an identification with those protagonists. That love affair between audiences and their film stars was also encouraged by the fan magazines of the period, their pictures, interviews and gossip columns further enhancing the stars' desirability. Another breed of magazine encouraged an emerging intellectual cinephilia. Transnationalism reigned supreme here too, through publications such as *Close Up* (1927–33), published in Switzerland, printed in English, and celebrating first German expressionism and then Soviet montage cinema. Popular film culture was equally transnational, given the adoration across Europe of Hollywood films and films stars, many of whom were of course themselves of European origin.

## 'Film Europe': creating a European cinema

For European producers, the goal was to produce films that might harness this love of cinema to produce popular European films and to generate European stars, a project driven by a desire for a specifically European cinema. Love in itself could not get these films made, however. On the contrary, it was necessary to draw on the resources of a well-funded business infrastructure – production companies, studio resources, contracted creative workers and so on. That infrastructure might be American; occasionally it would be rooted in one of the European national economies – Germany's Ufa (Universum Film AG), for instance; but increasingly through the 1920s there were efforts to create a transnational European infrastructure. In the mid- and late 1920s, only a few years after the end of World War I, there was much talk of a 'film League of Nations' promoting a

genuinely internationalist spirit (Higson 1999a and 1999b: 120 and *passim*). Thus a British trade paper suggested in 1923 'that the photoplay, speaking in an universal language, is capable of being made the ambassador of nations, [for] the advancement of trade, commerce and general security, and the welding into one common brotherhood [...] the peoples of the whole universe' (*The Bioscope* 1923: 42).

In this same period (the mid- and late 1920s), film-makers and film actors frequently moved from one European country to another to make their films. In the late 1920s, for instance, there were numerous non-British Europeans working at Elstree, the studios of the leading British company, British International Pictures, prompting a German trade journalist to observe that:

At Elstree, all the Englishmen speak broken German and all the Germans speak broken English. An international hodge-podge language is emerging; one feels momentarily that a mutual understanding between peoples is possible through film. (Did we ever actually shoot at each other, you Elstree boys?). (Ritter 1930)[2]

A 'universal language', an 'international language', a 'common brotherhood of the peoples of the whole universe': this is heady stuff, but was it ever anything more than an ambitious ideal? After all, the peoples of Europe still spoke in many different languages – and even the film language of silent cinema was never a universal language. In a very broad sense, in terms of how film stories were visually narrated, American film language, with its often fast editing, shallow depth of field and frequent close-ups, was different to European film language, with its often longer takes, richer and deeper *mise-en-scène* and more frequent use of long shots. Even within Europe, there were marked differences between, say, British films and German films in terms of both subject matter and style – even if some British film-makers were eventually influenced by aspects of what is now called German expressionism. And when films moved between different language markets, so the language of the intertitles had to be changed.

Despite the obvious difficulties, concerted efforts were made to establish an economically viable transnational European film trade in the 1920s. Thus various co-production or co-funding arrangements were established on an ad hoc basis between companies in different nation-states. The most ambitious producers sought to make films which, it was hoped, would appeal to a range of European audiences – and ideally to American audiences too. In order to facilitate such arrangements and ambitions, key creative personnel – film-makers and actors – frequently moved across national borders and between companies in different countries. The production of films in itself was not enough, however; it was also necessary to create a market for 'European' films. To this end, various companies negotiated distribution deals with their counterparts in other countries, with the aim of distributing films in a wider range of national and linguistic markets. There were even attempts to create a Europe-wide exhibition circuit, one that might overcome the difficulties producers faced in covering their costs in domestic markets that were tiny by comparison with Hollywood's domestic market.

There was also a series of European film trade congresses, through which such initiatives might be coordinated and the wider principles of cooperation debated (Higson 1999a).

It was these sorts of initiatives and aspirations that some commentators at the time referred to as 'Film Europe'. The argument was that, through such collaborations, the strongest and most ambitious European film companies might be able to establish the sort of critical mass, industrial integration and market size that the Hollywood studios enjoyed. The hope was that this would enable European companies to compete on more equal terms with Hollywood, and especially to regain a greater share of the various European markets. Ironically, during this same period, the governments of various European countries set up trade barriers – quotas, tariffs and the like – designed to protect the national production business, motivated in part by straightforwardly economic concerns, but also often by concerns about the erosion of what were perceived as specifically national cultures.

## National cinema or transnational cinema?

There was much debate at the time about such developments and the situation to which they responded. On the one hand, there was concern about the American dominance of film as popular culture. On the other hand, there was concern about the sorts of films that were produced in Europe as a result of the transnational movement of capital and personnel. Some called for the development and protection of a genuinely national cinema within each nation-state. Meanwhile, the most ambitious film producers were trying to create 'international' films that could work in a variety of markets. If we take the British case, it was not unusual to find critics wondering whether British cinema was British enough. Lionel Collier, for instance, writing in a fan magazine, commented that:

> One of the most extraordinary things about British pictures is that, as a whole, they have never developed what one may call, for want of a better word, a British spirit. In recent years it is possible to count on the fingers the pictures that one can really feel are British and not just weak imitations of what the Americans have seen fit to give us, or else weak imitations of the German psychological and technical influence. [...] There is a tendency in this country to 'Continentalise' or 'Americanise' our productions instead of working out our own salvation in our own distinctive way, expressing our own peculiar qualities, home and general life. (1928: 22–23)

Equally problematic for this writer was 'the tendency [...] to bring over well-known foreign directors, stars and cameramen', for fear that they too will '"Continentalise" or "Americanise" our productions' (Collier 1928: 23). One of the villains in this respect was the German director E. A. [Ewald André] Dupont, who worked in Britain from 1927 to 1930: 'One can hardly expect [this] clever German director [...] to realize the full British

spirit in films, even if he tried to' (ibid.). *Moulin Rouge*, Dupont's first British film, made in 1928, was, for Collier, 'just about as un-English as a film could be' (ibid.).

Internationally-minded producers and film executives argued a somewhat different case. If films were to succeed in world markets, as Ufa's German producer Erich Pommer (1928: 41) put it, they would need to be 'national in setting etc, but international in spirit' (see also Maxwell 1928). In Britain, that internationalism was secured in part precisely through importing foreign talent, and it was certainly the case that a great many continental directors, cameramen, art directors and actors worked in Britain on nominally British films in the late 1920s. The key company in this respect was British International Pictures, the very name signifying the tension between the national and the international.

Given this tension, does it make sense to speak of a 'European' cinema in the 1920s? Did the loosely coordinated series of industrial collaborations that some commentators referred to as Film Europe actually produce a uniquely and distinctively European cinema? What sorts of images, narratives and cultural identities did they promote? Did they produce a body of films that might articulate a sense of European identity, a sense of belonging to Europe or of feeling European? To put it another way, did the Film Europe initiatives create a genuinely transnational cinema, one that might project a cosmopolitan identity and sense of belonging, rather than one defined in terms of the nation-state? Or was it in fact less a transnational than an international project, one that tended to reinforce rather than dissolve national boundaries and national identities? Could Pommer's films that were 'national in setting' really be 'international in spirit', in the sense of creating something that transcended national boundaries, in a period when markets were still strongly regulated by national governments and culture was rigorously policed by nationalist commentators?

## Michael Curtiz, Sascha and the European project

These are not easy questions to answer, but I want to begin to do so by looking at a group of four films released between 1924 and 1927 which embody some of the key features of the transnational or European films of the period: *Die Sklavenkönigin/Moon of Israel* (1924), *Das Spielzeug von Paris/Red Heels* (1926), *Fiaker Nr. 13* (aka *Einspänner Nr. 13*)/ *The Road to Happiness* (1926; see Figure 1) and *Der goldene Schmetterling/The Golden Butterfly* (1926). The director of all four films was the Hungarian Mihály Kertész, who moved to Hollywood in 1926 where he became Michael Curtiz, prolific director of *The Adventures of Robin Hood* (1938), *Casablanca* (1942), *Mildred Pierce* (1945) and *White Christmas* (1954), among many others.

The production of the four films from the 1920s was coordinated by Sascha, the leading Austrian company of the period. The first was a co-production between Sascha and Stoll, the leading British company of the time; indeed, Stoll claimed in publicity that all four films were Stoll-Sascha co-productions, although they probably had no real involvement in the last three films beyond owning the UK distribution rights. The evidence of the

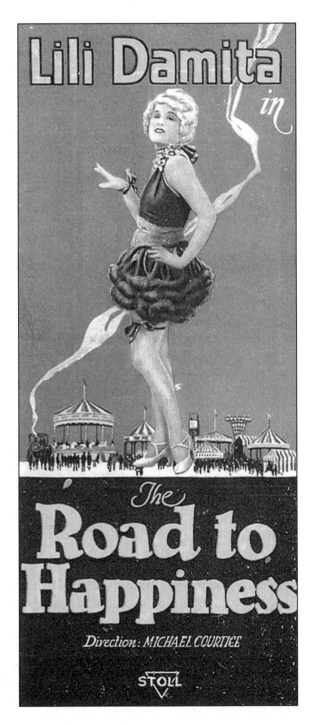

Figure 1. British publicity material
for *The Road to Happiness*
(Curtiz, 1926).

German and Austrian trade press is that the final two films were in fact co-productions between Sascha and a German company, Phoebus, a part of the Ufa combine. Sascha had had close links with the German film business for some years, with Ufa having a significant financial interest in the company since 1918. By the early 1920s, Sascha had studios in Vienna, several production branches throughout the former Austro-Hungarian Empire, one of the largest Austrian distribution concerns – including the rights to distribute Paramount films in Austria – and its own American distribution company, the Herz Film Corporation. Sascha was, then, an ambitious company with international aspirations that went beyond Europe (Büttner and Dewald 1999; Loacker and Steiner 2002; Fidalgo 2009; Higson unpublished; *Kinematograph Weekly* 1924b; 1926a; 1926c).

The first of these four films, *Die Sklavenkönigin*, is a costume drama on an epic scale about the persecution of the Jews under the Pharaohs. The other three films are all love-triangle stories with contemporary settings, with the story of *Der goldene Schmetterling* taking place mainly in London, and the other two in Paris, and all of them making the most of the opportunities provided by lavish, exotic scenes in theatres, cabarets, balls and the like. The source material and production teams for all four films were decidedly cosmopolitan/ European. Three of the films were versions of British stories: *Die Sklavenkönigin* was an adaptation of an H. Rider Haggard adventure novel; *Das Spielzeug von Paris* was an adaptation of a Margery Lawrence story; and *Der goldene Schmetterling* was reworked from a tale by P.G. Wodehouse. The fourth film, *Fiaker Nr. 13*, was adapted from a novel by the French writer, Xavier de Montepin. The producer and the cameraman for all four films were Austrians; the director was of course Hungarian; the scriptwriters were all central Europeans; and the art director on the last two was German. These were, then, 'international' films produced for the export market, in the sense that there was little self-consciously Austrian about them, and in their use of multinational casts and crews, their Egyptian, French and English settings, and their English and French source material.

*Die Sklavenkönigin* was a product of Sascha's strategy in the early 1920s of producing hugely expensive and spectacular films – *Monumentalfilme* – designed to secure distribution in markets across Europe and the USA, following in the footsteps of earlier Italian, German and American epics. Sascha's *Monumentalfilme* were made on an extravagant scale, with magnificent and elaborate sets, exotic costumes and huge crowd scenes – made possible in part by the prevailing conditions of rampant inflation and severe unemployment in Austria, ensuring a ready workforce and low wages. The *Monumentalfilme* included adaptations of novels by Mark Twain, Rider Haggard and Gustave Flaubert – respectively, American, British and French – as well as three stories with biblical sources (Loacker and Steiner 2002; von Dassanowsky 2005: 25–37).

*Die Sklavenkönigin* itself involved location shooting in Luxor – and a scene of Moses parting the Red Sea, with special effects that many compared favourably to the same scene in Cecil B. DeMille's Hollywood film of 1922, *The Ten Commandments* (*Kinematograph Weekly* 1924a). The cast was chosen for its international appeal, with the Hungarian Maria Corda, by now a big star in central Europe, the Chilean actor Adelqui Millar, the French

actress Arlette Marchal, and the Austro-Hungarians Ferdinand Otto and Oszkár Beregi. *Die Sklavenkönigin* was, then, part of a very bold production schedule on Sascha's part, with its internationalism writ large. But it proved unsustainable since they could not secure sufficient distribution in the vital American market, and the European market alone was unable to support such grandiose budgets. The final three Sascha-Kertész films thus had to be produced on a much more modest scale, but still retained international pretensions.

*Das Spielzeug von Paris* (see Figure 2) was shot partly at Sascha's studios in Vienna, and partly in Paris. Again, the cast was multinational, with the French actress Lili Damita in the lead role, supported by the Swedish actor Eric Barclay, the French actor Georges Tréville, the Italian actress Maria Asti, and the German Theo Shall. *Das Spielzeug von Paris* involved location work in Paris and studio work in Berlin, with impressive sets designed

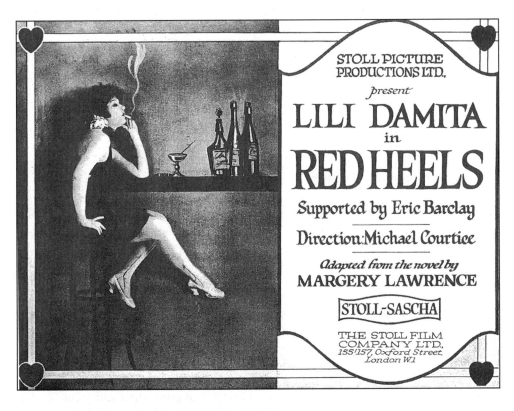

Figure 2. British publicity material for *Red Heels* (Curtiz, 1926).

by Paul Leni. Lili Damita again starred, while alongside her were three German actors – Paul Biensfeld, Karl Ebert and Walter Rilla – and a German-born and latterly Germany-based Briton, Jack Trevor. *Der goldene Schmetterling*, the last of the films Kertész made before going to Hollywood, was shot on location in London and Cambridge, and in Berlin studios arranged by Phoebus. Again the production neatly embodies the transnationalism of the Film Europe years, with its Hungarian director, German art director and Austrian cameraman working in a German studio for an Austrian company on an English story, with the French star, Lili Damita, appearing alongside a Danish-Swedish leading man, Nils Asther, the Anglo-German Jack Trevor and the German Curt Bois.

But if all of these films were in some way what Erich Pommer would have called 'international films', each was also carefully tailored to specific markets. The range of stars in each production enabled the films to appeal to a range of national audiences. Stoll, the British collaborator, was at pains to explain that they had carefully re-edited *Die Sklavenkönigin* for British distribution (as *Moon of Israel*), and had engaged the author of the source novel, Rider Haggard, to write the intertitles. Considerable efforts were made to ensure authentic Parisian street scenes for *Fiaker Nr. 13*, based on a French novel, and to secure Cambridge, Henley and central London locations for *Der goldene Schmetterling*, adapted from English source material. And for *Das Spielzeug von Paris*, Kertész actually shot two different endings for markets with different moral sensibilities. In the more moralistic version, Lili Damita's character is effectively punished for her sins and the film ends in tragedy. This was the version released in Austria, Germany and Britain. For the French and Spanish markets, however, Damita's character is allowed to live and to enjoy her promiscuous lifestyle (*Kinematograph Weekly* 1924b; 1926b; 1926c: 32; Fidalgo 2009: Chapter 4).

## Coping with cultural difference

Even if we see these four productions as examples of Pommer's 'international film', it is difficult, despite the cosmopolitan make-up of the creative team, to see them as articulating a 'European imagination', enabling audiences to imagine themselves as European or even as belonging to Europe. The goal was not to produce 'European' films that stood above national interests. On the contrary, the goal was to produce films that were carefully tailored to the perceived interests of audiences in different national or language markets, films that might appear to those audiences as national films, thereby effectively undermining any pretensions towards internationalism. Films could be further 'localized' or 'nationalized' at the point of distribution, through retitling the film, through producing a new set of intertitles, or through promoting one particular familiar star rather than another. Translation in its broadest sense was thus vital. What this underlines is the importance of addressing not simply questions of production and textuality, but also questions of distribution, promotion and reception: how films were sold in different markets and how different audiences responded to those films. Such films may look

excitingly transnational at the point of production and distribution, but they are often designed so that they appear comfortingly local at the point of reception.

In practice, things were more complex than this, with efforts to establish a national setting in international films coming across to some audiences as inauthentic – so that, say, Germanic representations of Englishness would appear simply as un-English, as was claimed of another of the German Dupont's nominally British films, *Piccadilly* (1929) (see Chapter 4 in this book). Of course what is one audience's 'national setting' is for another audience an exotic foreign location – as in the Parisian setting of Dupont's earlier film *Moulin Rouge*, or *Das Spielzeug von Paris* or *Fiaker Nr. 13*. For French audiences, these films may have appeared inauthentic. To British or central European audiences they may have reinforced reductive expectations of the exotic foreign place depicted. This suggests less an international spirit or a European sensibility, and more a fascination with cultural difference, a voyeuristic fascination with an exotic 'Other' (see Chapter 3). *Die Sklavenkönigin* also confronts the problem of how to present cultural difference, and again figures it precisely as exotic spectacle. This was in fact a very familiar feature of European films of the period. On the one hand, efforts would be made to 'localize' a film, whether at the point of production or at the point of distribution and marketing. On the other hand, the non-local, the non-national – that which could not be translated – would appear precisely as foreign or exotic, and would very often play on well established and inevitably reductive stereotypes.

In this same period, film-makers did endeavour to develop various models for projecting a sense of multiculturalism, multinationalism or transnationality within a film, but they tended to be limited in scope and often fell short of imagining a pan-European identity. *Die Sklavenkönigin* perhaps goes some way towards articulating a common European heritage with the biblical aspects of its story; although ironically, in order to present a narrative that might speak to a wide range of European audiences, it has to be situated outside Europe itself. Among other cinematic models connected with the British film industry are films like *Piccadilly* (dir. E. A. Dupont) or *Nachtgestalten/The Alley Cat* (dir. Hans Steinhoff), both 1929 releases made in Britain by German directors and set in a London of cultural contrasts, pitting an upper-class West End world of luxury against a working-class East End world of low-life and the cultural strangeness of the ethnic Chinese community. Then there were films like *L'appel du sang/The Call of the Blood* (Mercanton, 1921), *The Bondman* (Wilcox, 1929) and *The Woman He Scorned* (Czinner, 1929) – nominally British films made variously by a Frenchman, an Englishman and a Hungarian, with their narratives moving between two or more European countries and featuring characters of different nationalities. In such films, love is often both a means of bringing together people of different ethnic groups, and the cause of the narrative trouble that ensues. In Mercanton's beautifully-shot *The Call of the Blood*, for instance, Ivor Novello plays a Briton with a Sicilian grandparent who becomes involved in an adulterous affair while travelling in Italy. Such films articulate a sense of transnationality, their narratives exploring cultural difference, but often in a negative sense, as tight-knit local communities struggle and often fail to embrace strangers.

A more open, cosmopolitan sensibility tends to be the preserve of the upper-classes or bohemians, as in *The Constant Nymph* (Brunel, 1928), where a European pastoral idyll in the Austrian Tirol shows a more artistic sensibility, with folk culture and a childlike unruliness standing in sharp contrast to the middle-class English decorum of what an intertitle presents as 'tasteful Chiswick'. As in so many such films, continental Europeanness licenses a love that is difficult to play out within the rigid social confines of England and Englishness. Within the context of British (for which read English) cinema, a move to continental Europe often signals a more sophisticated and adult approach to love and romance, as in Harry Lachman's witty sex comedy *Weekend Wives* (1928), set in Paris and Deauville, or the transnational romance of *The Call of the Blood* (1921). For the more anxious, conservative British commentators of the period, this licensing of socially transgressive love and sexual promiscuity inevitably constituted a problem: this aspect of the 'continentalizing' effect on British films could be as worrying as 'Americanization'.

## Imagining Europe, narrativizing love

It was certainly the case that in numerous British films of the 1920s that had some sort of continental European link, whether at the level of production or of setting, considerable efforts were made to project a glamorous exoticism, a fetishization of the female body, and a concomitant intensification of desire. Film-makers seemed far more willing to fetishize the bodies of European female stars than of their British counterparts, as can readily be seen in films such as *Der goldene Schmetterling* (Lili Damita), *Moulin Rouge* (Olga Tschechowa), *Tesha* (Maria Corda; dir. Victor Saville, 1928), *The Informer* (Lya de Putti; dir. Arthur Robison, 1929) and *The Woman He Scorned* (Pola Negri) – although both Corda and Negri came to Britain via Hollywood, while the Chinese American Anna May Wong performs the same exotic, sexualized function in *Piccadilly* (see Chapter 4).

A key means of producing a dramatically heightened sense of romance or desire in such films was through the plot device of the love triangle. In *Moulin Rouge*, for instance, the Russian actress Olga Tschechowa plays a beautiful French cabaret star who is reunited with her daughter (played by an Australian actress). Meanwhile, the daughter's fiancé, played by the Frenchman Jean Bradin, falls in love with the mother – with disastrous results. Love triangles also featured in three of Kertész's Sascha films – *Das Spielzeug von Paris*, *Fiaker Nr. 13* and *Der goldene Schmetterling* – as well as in *The Call of the Blood*, *The Rat* (Cutts, 1925), *Tesha*, *The Bondman* and *The Woman He Scorned*. Occasionally, as in *The Call of the Blood* and *The Bondman*, the love triangle involves people of different ethnic or national identities. In other films, such as *Moulin Rouge*, the transnational interplay is confined to the production process rather than the narrative, since all the characters in this film are ostensibly French and all the action takes place in France.

Whether the transnational interplay occurs at the level of production or the level of narrative, such films are often marked by their creative geography. Thus sequences shot

in Berlin and Venice are cut together in *The Man Without Desire* (Brunel, 1923), and Cambridge and London locations are intercut with German studio scenes in *Der goldene Schmetterling*. In *The Call of the Blood*, real and virtual scenes of London, Paris, Rome, Sicily and North Africa are seamlessly edited together, while in *The Woman He Scorned*, Cornwall can stand in for the Channel Islands and Marseille for a northern French port. With actors often also playing characters of a different nationality to their own, identity becomes a fluid and unstable category, in which perception and (mis)recognition play a vital role.

Such films call into question the possibility of speaking of a collective European identity as opposed to local, regional or national identities. *The Bondman*, for instance, moves between the Isle of Man and Sicily, but both locations remain decidedly local: thus community and identity on the Isle of Man are established in terms of rural village life and ancient historical tradition, which is marked simply as 'Other', as different from Sicilian life. The emphasis not simply on the local but on the marginal, on love at society's edge, is often a feature of these films. In both *The Woman He Scorned* and *Cape Forlorn* (Dupont, 1931) the female protagonist is caught up with a lighthouse keeper, for instance. Even when the films seem to shift to a more central position within high society, as in *The Rat* or *Piccadilly*, it is the romantic liaisons with low-life characters well outside this society that create the drama. These are not exactly ideal models for articulating a sense of European community or a positively valued transnational or transcultural identity.

One might argue that a common European identity emerges as a form of resistance to Americanization. But there are two problems with this argument. Firstly, we might note how much of European popular culture already embraced America in the 1920s: American films and American stars were enormously popular across Europe, even if local films also attracted audiences. Secondly, if the transnational aspirations of Film Europe were in part about building an industry that could compete with Hollywood on an equal footing, the other main form of resistance to American domination of European markets was the erection of trade barriers by national governments across Europe, in order to restrict the distribution of foreign (primarily American) films within their borders. There was little intergovernmental cooperation in developing these barriers, tariffs and quota systems: on the contrary, as I have already suggested, this was the reassertion of nationalist policy in an increasingly globalized economy. If creative workers, modes of representation, cultural goods and the means of production moved across national borders and between nation-states, that movement was deliberately restricted and its products denigrated and challenged.

## The difficulty of creating a European cinema

What we can see in these debates and developments in and around European cinema in the 1920s is, then, a series of tensions: between the local and the cosmopolitan; between nationalism and cultural imperialism; between cultural imperialism and internationalism; and between internationalism and transnationalism. From a nationalist

point of view, the aggressive distribution of American films in European markets was a symptom of cultural imperialism. The erection of national trade barriers was both an assertion of national sovereignty and a failure to recognize the international dimensions of the problem. At the level of representation, the local was often more prominent than the national, and only rarely are communities represented as cosmopolitan. The League of Nations vision of a universal film language in effect sought to erase difference in its idealistic assertion of internationalism. The various European Film Congresses of the 1920s were also internationalist in design, with the nation-state central to their make-up, since they were founded upon the principle of bringing together trade associations and trade representatives from different countries precisely as national representatives. Meanwhile, the collaborations between the strongest or most ambitious film companies across Europe, and the flow of capital, cultural goods and personnel across national boundaries, represented a form of transnationalism with few of the initiatives dependent on the actions of the governments of particular nation-states.

The introduction of talkies in Europe in 1929 temporarily threatened the international film business. Hollywood was worried that it would lose its European markets. But the idea of a pan-European cinema and of film as the new international language was also very much thrown into question. Films were now language-specific, while Europe was made up of a series of often very small, linguistically delineated markets. In the long run, of course, dubbing and subtitling became the norms, but for a short period at the turn of the decade the language problem was solved by the multilingual film. In the early sound years, British International Pictures was probably the European company most involved in the production of multilingual versions of their films. Dupont again led the way, with his films *Atlantic/Atlantik/Atlantis* (1929), *Two Worlds/Zwei Welten/Les deux mondes* (1930) and *Cape Forlorn/Menschen im Käfig/Le cap perdu* (1931) each being made in three different language versions (English, German and French), with different casts for each version but the same storyline and sets. These multilingual versions, with their multinational casts and crew, and their co-production and co-distribution arrangements, can in many ways be seen as emblematic of the Film Europe developments outlined above, in particular the way in which the international film would be tailored – in this case, literally translated – for specific national or linguistic markets (Higson 1999b; Vincendeau 1999).

The transnational migration of creative workers in the European film industry of the 1920s undoubtedly produced a cosmopolitan production force, but in some ways the demands of the different national and linguistic markets that made up the European market undermined the production of a cinema able to transcend national borders and sensibilities. On the one hand, the films produced might unsettle traditional national identities, with English reserve displaced by a 'continental' approach to romance, desire and the representation of the body, for instance. On the other hand, such 'international' films often reasserted stereotypical national identities, since these had the most purchase in international markets, being easily consumed by the diverse audiences of different nation-states. Or, to put it another way, if films asserted a sense of cultural difference,

the culturally different often figured as the object of a voyeuristic gaze. At the same time, the need to reach particular markets meant stressing the familiar, finding ways of nationalizing international co-productions. The Film Europe project may for some have represented a means of articulating a pan-European cultural identity, but in practice commercial imperatives often meant that other European identities were constructed simply as exotic love objects.

## References

*The Bioscope* (1923), 'Internationalising the film', 25 October, p. 42.

Büttner, E. and Dewald, C. (1999), 'Michael Kertész. Filmarbeit in Österreich bzw. bei der Sascha-Filmindustrie A.-G., Wien, 1919–1926', in F. Bono, P. Caneppele and G. Krenn (eds), *Elektrische Schatten: Beiträge zur Österreichischen Stummfilmgeschichte*, Wien: Filmarchiv Austria, pp. 101–38.

Collier, L. (1928), 'Wanted! – a British spirit', *The Picturegoer*, September, pp. 22–23.

Fidalgo, M. (2009), *Michael Curtiz: Bajo la sombra de Casablanca*, Madrid: T&B Editores.

Higson, A. (1999a), 'Cultural policy and industrial practice: Film Europe and the international film congresses of the 1920s', in A. Higson and R. Maltby (eds), *'Film Europe' and 'Film America': Cinema, Commerce and Cultural Exchange, 1920–1939*, Exeter: University of Exeter Press, pp. 117–31.

——— (1999b), 'Polyglot films for an international market: E. A. Dupont, the British film industry, and the idea of a European cinema', in A. Higson and R. Maltby (eds), *'Film Europe' and 'Film America': Cinema, Commerce and Cultural Exchange, 1920–1939*, Exeter: University of Exeter Press, pp. 274–301.

——— (unpublished), 'Film Europe under the microscope: The Anglo-Austrian Stoll-Sascha collaboration, 1924–26', unpublished paper.

*Kinematograph Weekly* (1924a), 'Advertisement for *Moon of Israel*', 13 November, p. 5.

——— (1924b), 'Stoll enterprise', 30 October, p. 81.

——— (1926a), 'Next week's trade shows', 7 January, p. 71.

———— (1926b), 'Next week's trade shows', 15 July, p. 36.

———— (1926c), 'Reviews of *The Golden Butterfly*', 22 July, pp. 32– 34.

Loacker, A. and Steiner, I. (eds) (2002), *Imaginierte Antike: Österreichische Monumental-Stummfilme*, Wien: Filmarchiv Austria.

Maxwell, J. (1928), 'The international film', *The Bioscope*, special issue on British Film, December, p. 56.

Pommer, E. (1928), 'The international film', *Kine Weekly*, 8 November, p. 41.

Ritter, K. (1930), 'Die deutschen Filme in Elstree', *Film Kurier*, 7 June. Reproduced in *Cinegraph/Metropolis* (n.d), 'Film-Europa 1930', programme brochure.

Vincendeau, G. (1999), 'Hollywood Babel: the coming of sound and the multiple language version', in A. Higson and R. Maltby (eds), *'Film Europe' and 'Film America': Cinema, Commerce and Cultural Exchange, 1920–1939*, Exeter: University of Exeter Press, pp. 207–24.

von Dassanowsky, R. (2005), *Austrian Cinema: A History*, Jefferson, NC: McFarland.

## Notes

1. This chapter was previously published in a slightly different form in *Transnational Cinemas*, 1: 1 (2010). I would like to thank Miguel Fidalgo for making extracts of the manuscript of *Michael Curtiz: Bajo la sombra de Casablanca* available to me prior to publication, and Ivan Mace-Tessler for translating material from German for me.
2. Translation from the original German by Peter Kramer and Nick Riddle.

# Chapter 3

Love beyond the nation: cosmopolitanism and transnational desire in cinema

Tim Bergfelder

## From the transnational to the cosmopolitan

In this chapter I want to reflect on the use of the term 'transnational' in recent film-theoretical debates, expanding and moving beyond ideas I explored in a previous essay (Bergfelder 2005). In keeping with the theme of this book, my contribution marks a shift from transnational cinema's primary concern with issues of globalized production, and an attempt to reframe the debate around modes of reception and affect. Drawing on case studies from different historical contexts – a film from the Nazi period and a more contemporary example – I shall consider the expression of transnational desire in European cinema as a response to a 'vernacular cosmopolitanism'. My argument is that this concept can offer a more productive access to the emotional and ethical investment in transnational exchanges than a blanket equation of transnationalism with issues of globalization or monolithic ideology.

Transnationalism has become an academic buzzword over the last two decades, its ascendancy following the term's initial usage in theories of postcolonial hybridity (Bhabha 1994; Appadurai 1996; Spivak 1999), sociology (Hannerz 1996) and anthropology (Clifford 1988; Ong 1999). Arguably the most common definition attaches the transnational to the experience of increased globalization following the end of World War II. Randall Halle summarizes this relationship: 'If we distinguish the material economic processes [...] as belonging to the dynamic of globalization, in transnationalism we find a term to designate [...] the dynamic of culture' (2008: 5). For the editors of an anthology on transnational film, the term 'comprises both globalization – in cinematic terms, Hollywood's domination of world film markets – and the counter-hegemonic responses of film-makers from colonial and Third World countries' (Ezra and Rowden 2006: 1). If this suggests that *all* cinema is transnational, why do we need the term? What makes it distinctive from categories such as 'international', 'multicultural', or 'world' cinema (Shohat and Stam 2003; Dennison and Lim 2006)? It is no surprise that, for some scholars, the transnational is regarded as a rather hollow phrase at best, and, at worst, a term that is in danger of homogenizing cultural difference and critical opposition (Higbee and Lim 2010).

Used in a productive sense, 'transnational cinema' never refers to a single or universal phenomenon; instead it is always about specific transnational practices in the plural: co-productions between national or regional film industries; the mobility of film personnel (whether enforced or by choice); or the export and reception of films between one territory and another. Representing historically mutable instances of cultural exchange, such

practices involve multiple localities and encounters. Understanding this diversity leads us to challenge assumptions about how 'global' cultural traffic across borders actually is, and it allows more complex histories and definitions of micro- and macro-encounters across borders to emerge (Hjort 2010). However, the use of transnationalism as a critical concept can also be problematic. First, despite occasional claims on universality, in the study of transnational cinemas the concept of 'nation' remains the ultimate backbone of identity and cohesion. This subsumption of the transnational under the overarching boundaries of the nation echoes the way in which the ideal of multiculturalism is often co-opted in state initiatives for cultural integration. As Kira Kosnick has argued, multiculturalism in Europe has been 'conceptualized as the endpoint of migratory movements that produce cultural mosaics' (2009: 36), while the wider (state/national) framework for such 'mosaics' remains a given and unchallenged. A similar tendency can be observed in writings on 'transnational cinemas', which remain firmly rooted in fixed notions of national identity.

Secondly, studies of transnational cinema focus on a select range of privileged experiences. The most prominent ones are instances of (primarily postcolonial) migration and diaspora, which have been championed for their emancipatory potential. They overlap to some extent with the condition of exile, related to the trauma of loss and displacement, and are more firmly distinguished from consumption-led modes of mobility such as tourism. The suggestion that diasporas constitute a vanguard in opposition to prevailing hegemonies is now a mainstay in cultural studies, and in film studies finds its expression in Hamid Naficy's (2001) discussion of diasporic film-making as an accented style.

The celebration of postcolonial migrancy as a privileged site of progressive ethical and creative agency has not remained uncontested. Scholars have pointed out that development in many regions of the world is inadequately represented by a schematic linear trajectory from the colonial to the postcolonial, and from modernity to postmodernity (Ong 1999; García Canclini 2005). Another charge is that, far from subverting hegemonies and ushering in a humanistic, postnational utopia, some forms of modern migration actively contribute to nationalist or ethnocentric projects, while most are directly implicated in the advancement of global capitalism (see, for example, Ong 1999; Cheah 2006). Finally, the type of postcolonial migrant (film-makers, writers, artists) that has been privileged in critical discourse invariably belongs to educated and affluent élites. This excludes the experience both of economically less privileged migrants and of non-migratory majorities. More fundamentally, the championing of a particular type of migrant experience implies a problematic essentialism regarding non-migrants against which the migrant's 'progressive' hybridity is defined. This implied essentialism in turn aids the resurgence of defensive notions of culture, nation and identity, and simultaneously serves to maintain the perception of migrants as distinct 'Others'.

It is no coincidence in this context that the term 'cosmopolitan' has been making a comeback. Looking back at a long, contested history the concept has in recent decades been invoked to mean, among other things, a philosophical outlook (Beck 2006), an ethical choice (Nussbaum 1994), and a legal-political template (Habermas 1997). The

latter definition, in particular, and its origins in Kantian idealism have come under attack for shoring up neo-imperialist global power relations (Cheah 2006; Douzinas 2007). Cosmopolitanism's historical closeness to Eurocentrism has also been criticized. As is widely acknowledged, a universal ideal underpinned the cultural eclecticism and mobility among European intellectual élites (including film-makers) in the first half of the twentieth century (Wollen 1994; Passerini 1999; Hagener 2007). In parallel, a 'cosmopolitanism of the periphery' characterized Latin American writers such as Jorge Luis Borges and Mário and Oswald de Andrade (Prysthon 2002), or the Chinese author Eileen Chang. However, while acknowledging the complexities of modernist cosmopolitanisms, Ackbar Abbas concludes that 'the vision of "one world" culture was only a sometimes unconscious, sometimes unconscionable, euphemism for "First World" culture' (2000: 771). Martin Stollery (2000) has critiqued the European cinematic avant-gardes of the 1920s on similar grounds.

Given this intellectual and political legacy, the idea of a vernacular cosmopolitanism may seem like an oxymoron. Historically speaking, the two terms have been perceived as opposing 'modes of literary (and intellectual, and political) communication directed toward two different audiences [...] one is unbounded and potentially infinite in extension, the other is practically finite and bounded by other finite audiences' (Pollock 2000: 212). Originally coined by Bhabha (1996), the use of the term 'vernacular cosmopolitanism' to date has rarely attempted to bridge the division between these 'two different audiences'. But, as Abbas has warned, in order not to fall into a Eurocentric trap once more, cosmopolitanism today can no longer just acknowledge the 'privileged transnational [...] as an Olympian arbiter of value' (2000: 786), but must also account for a more diverse range of experiences.

Mica Nava proposes an alternative understanding of vernacular cosmopolitanism, employing it as a set of quotidian attitudes that signal a 'loosening of national identifications and a positive engagement with difference' (2007: 5). Charting the development of such attitudes in twentieth-century metropolitan Britain, Nava reminds us that cosmopolitanism 'constituted a countercultural revolt against "traditional" cultural forms and regimes' (2007: 5). In contrast to the 'cartographic' gaze of the – often male – cosmopolitan expert or 'connoisseur' (Szerszynski and Urry 2006), who was one of the key protagonists in Edward Said's famous attack on western Orientalism (1978), Nava posits the mobile gaze of the – particularly female – mass consumer. The latter's negotiation of mediated exoticist imaginations corresponds to a lived cosmopolitanism of public and domestic arrangements, and of private as well as political choices. These extend from the sphere of consumption into sexual preferences and personal ethics: Nava's case studies include, apart from her own exilic family history, the promotion of cosmopolitanism through London's department store Selfridges from the 1910s, and the rise in interracial relationships during and after World War II.

Noting that psychoanalytically informed cultural criticism has traditionally focussed on the repudiation of otherness in the process of identity construction, Nava argues that not enough attention has been paid to the ways in which otherness can also be a powerful

object of attraction and identification at an emotional level – resulting in what Nava refers to as 'visceral cosmopolitanism'. Another important argument that Nava makes is that a 'normalisation of difference' is a gradual, transhistorical process of both collective and private emotional education, while she also reminds us that this process has coexisted with either latent or dominant forms of xenophobia and racism.

Nava's understanding of cosmopolitanism offers an attractive model to rethink debates on transnational cinema. One of the advantages in the context of cinema of looking at attitudes instead of economic networks or demographic flows is that the former are not only bound by actual instances of geographical and spatial movement or specific social groupings, but also involve attitudinal (emotional, affective, ethical, imaginative) mobility. This may help to sidestep some of the problems inherent in theorizing the transnational flagged up earlier, in particular the essentialist conception of and rigid distinction between migrants and non-migrants, the over-determination of economic contexts, and the seemingly inevitable recourse to and reaffirmation of the nation.

Unlike existential experiences of exile and diaspora, cosmopolitan attitudes and desires can be shared – in fact, the idea of a visceral cosmopolitanism is predicated on the necessity of encounter, dialogue and libidinous engagement with the Other, breaking down the distinction between mobile and sedentary, self and Other, and between 'migrant' and 'native'. Visceral cosmopolitanism is thus less conducive to be mapped onto neat ideological oppositions or clear sociological identities. The concept's valorizing of personal agency over and against national determinism and ideological or economic co-option is reasonably well received when applied to Nava's self-consciously termed 'mongrel' populations in post-millennial Britain, but becomes more problematic when applied to other contexts, including an institutionally racist and totalitarian environment such as Nazi Germany. In the rest of this chapter I shall test the problems and potential for using cosmopolitanism as a critical framework with recourse to two examples: Douglas Sirk's 1937 film *La Habanera*, and a recent film by Fatih Akın, *Auf der anderen Seite/The Edge of Heaven* (2007). I have chosen to discuss two films that have received prior academic attention in order to highlight the methodological and interpretative divergences between different critical approaches. The contrast between the two case studies is meant not merely to illustrate how sensibilities change across different periods, but also to show how cosmopolitan discourses can run counter to official ideological certainties in a given context, including those certainties prescribed by a too narrow understanding of what constitutes 'transnationalism'.

## Loving the Other: a subversive desire?

Douglas Sirk's 1937 film *La Habanera*, made shortly before the director's departure from Nazi Germany to Hollywood, has over the past few decades become one of the key texts within studies on Third Reich cinema and one of the most contested, which may be one of the reasons why this relatively innocuous exotic melodrama has garnered more academic

attention than some of Nazi cinema's more virulently hateful productions. Outside its German context, *La Habanera* remains one of Sirk's lesser-known films compared with the melodramas he made in Hollywood in the 1950s, which were taken up by Anglophone post-structuralist and feminist film theory from the 1970s onwards; thus it is worth briefly sketching its context and plot.

Produced by Ufa, *La Habanera*'s screenplay was written by Gerhard Menzel, whose other credits during the Third Reich include the notorious anti-Polish drama *Heimkehr/ Homecoming* (Ucicky, 1941), and *Wien 1910/Vienna 1910* (Emo, 1942), a biopic of Vienna's turn-of-the century anti-Semitic mayor Karl Lueger. *La Habanera* was one of two lavish melodramas – the other being *Zu neuen Ufern/To New Shores* which Sirk (then Detlef Sierck) directed that year – which were designed to make the Swedish singer Zarah Leander a box-office star, and to set her up as a composite substitute for Greta Garbo and Marlene Dietrich. One of the ironies of Third Reich popular cinema was that, despite the state's racial exclusion policies and nationalist rhetoric, a disproportionate number of its best-loved film stars were foreigners. Aided by cinematographer Franz Weihmayr and Ufa's costume department, Sirk designed a glamorous image for his star, which Leander adhered to for the rest of her career. An established stage diva and recording artist prior to her film career, Leander was famous for her deep, contralto voice, which Sirk showcased in several musical numbers. The songs have remained evergreens in Germany to this day (on the vocal aspects of Leander's star image, see Koepnick 2002: 72–98; Carter 2004: 173–213), while drag performers and gay fans have kept Leander's memory alive at a subcultural level (Kuzniar 2000: 57–69).

Both of Sirk's Leander vehicles involve the heroine leaving her home country for a new life elsewhere. Whereas in *Zu neuen Ufern*, this migration is involuntary (Leander's character, a music hall star in Victorian London, is sent to an Australian penal colony), in *La Habanera*, the move is motivated – at least initially – by transnational desire. The film's main protagonist is a Swedish tourist who, during a Caribbean cruise, falls in love with the island of Puerto Rico (the film's title refers to the song form, not the capital of Cuba). For the enthusiastic heroine the island and its people represent an antidote to an emotionally frozen and dreary life in Sweden, and she develops a sexual attraction to the landowner and bullfighter Don Pedro (Ferdinand Marian), the island's most powerful man. Enchanted, she decides to stay. The narrative fast-forwards ten years, finding her trapped in a joyless marriage to a jealous Hispanic husband. The film registers Leander's rejection of the tropics, and her desire to return to Europe with her young son. Plans to escape become more concrete when a former suitor from Sweden arrives; a biologist tasked with finding an antidote for a tropical fever that is ravaging the island. Corrupt officials, under orders from Leander's husband, try to suppress information about the existence of the disease and sabotage the doctor's endeavours. Eventually Leander's husband succumbs to the illness and dies. Leander returns home.

On the one hand there is enough material in the film to merit a postcolonial critique of *La Habanera* as a Eurocentric fantasy, replete with imperialist gazes and with inauthentic

and demeaning representations of the colonized Other. One can equally identify a number of elements that explicitly align narrative and images with Nazi ideology. The film appears to be structured around distinct racial hierarchies: heroically selfless, rational and reserved Scandinavians are set against corrupt, irrational or overemotional 'Caribs', while the whole film can be read as a morality tale warning northern Europeans what might happen to them if they get seduced by the foreign Other and permanently leave their *Heimat*.

At the same time, the film is littered with so many ambiguities, excesses and ellipses that its narrative opaqueness (whether intended or not) positively encourages multiple and conflicting readings. One of *La Habanera*'s most widely discussed scenes in this respect is its ending. As the ship leaves the harbour to the sound of the song that initially enchanted Leander and which has been the film's signature tune throughout, her gaze clouds over and she says to her companion: 'When I first arrived here I thought it was paradise. Then I believed it was hell. But I have no regrets'. She casts a last, longing look back (see Figure 3). Does Leander's gaze suggest that her desire for the island is not extinguished, and that she will be as miserable in northern Europe on her return as she was when she first left it? One could argue that Leander's yearning gaze in the closing moments of the film registers at last the recognition that, in returning home, she is giving up a freedom that expatriation offered her and a desire that she wasted until it was too late – the modalities of 'too late' and 'if only' are of course typical of melodrama's narrative economy (Neale 1986). If one chooses to read the ending in this way, it undermines a sense of 'home', and in denying an affirmation of *Heimat* it can be seen to champion, albeit *ex negativo*, a cosmopolitan desire.

Some scholars (for example Babington 1995; Lee 2008) have attempted to recuperate such a progressive meaning, and have argued that the left-leaning auteur Sirk (who went into exile shortly after *La Habanera*'s premiere) introduced 'Brechtian irony' in the film, amounting to an act of aesthetic resistance. Given the way film projects in the Third Reich were monitored by the state, and considering the industrialized and highly collaborative nature of studio production, one has to question the possibility of the director 'smuggling in' subversive material without anyone noticing. Eric Rentschler (1996) has argued that seeming ideological ambiguities at a textual level are not uncommon in Nazi cinema, but that does not negate the latter's overall function within the coercive structure of the Third Reich. Addressing Leander's predicament of 'ending adrift, forever unreconciled' in *La Habanera*'s final moments, Rentschler suggests that her character embodies:

[…] an impossible desire, a desire that becomes possible only in terms of fantasy representations and never-ceasing postponement, a desire that exists only so that it can never be satisfied, a desire one enacts on-screen and thereby transforms into a source of vicarious pleasure, the pleasure of female audiences whose wish for a heightened existence will never be answered except in their dreams. (1996: 145)

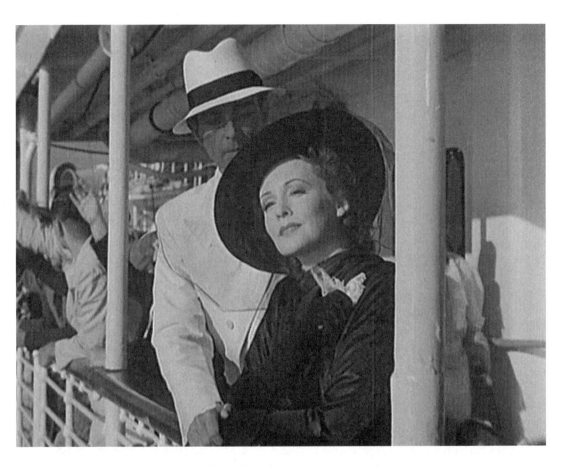

Figure 3. Crossing the water, traversing boundaries – *La Habanera* (Sirk, 1937).

Rentschler is describing here not just the dynamic of Sirk's film, nor its specific function within the cultural politics of the Third Reich. His quote constitutes a critique of the economy of desire in melodrama and in popular genre cinema more generally, which is regarded as politically impotent and capable only of engendering social conformism. According to such a view, popular cinema becomes merely a tool for controlling a malleable audience through the genre's safe and regulated dispensation of desires and pleasures (including

those that are potentially transgressive, such as the desire to escape the *Heimat*). Similar conclusions, informed by Adorno and Horkheimer's discussion of the totalizing effects of the capitalist culture industry, have been drawn by other scholars discussing Sirk's German films (for example Coates 1991; Koch 1999; Koepnick 2002; Sandberg 2009). Thus, while acknowledging that Leander's films may at first not appear to conform to 'essentializing definitions of what it meant to be German', Koepnick concludes that they 'exploited desire for the unknown with the intention of segregating self and other and making the individual body disappear in lager constellations of power' (2002: 83).

In between attempts to rescue Sirk's reputation as a leftist auteur within Nazi cinema, and the rejection of any possibility that films such as *La Habanera* are ideologically redeemable, there is a third strand to the academic debate regarding Sirk's German films and Third Reich popular cinema more generally, exemplified by the work of Linda Schulte-Sasse (1996), Thomas Elsaesser (2000), and Sabine Hake (2001). They suggest that the choice between films being either aesthetically resistant or politically compromised constitutes a false dichotomy, arguing that textual incoherence always corresponds to incoherences beyond the text. These are due to the fact that, despite its fervent pursuit of total control, both within the film industry and in society at large, the Nazi regime did not manage to achieve its aim completely (Elsaesser 2000: 385). Pointing to patterns of everyday life in the Third Reich, Hake and Elsaesser emphasize the cultural continuities from the Weimar Republic which could not be eradicated overnight after Hitler's rise to power in 1933, and which underwent a gradual process of transfer and transformation (Hake 2001: 124). Both also stress that, at least in the period between 1933 and 1938 when the film industry became effectively nationalized, companies such as Ufa faced a precarious balancing act in needing to reconcile ideological demands and economic imperatives, especially given the ongoing competition with the industry's perpetual rival – Hollywood.

Erica Carter has admonished that the ambiguities that characterize Third Reich cinema 'should not detract entirely from Nazism's drive for "hegemony": its project [...] to forge a common (*völkisch*, militarist, fascist) culture across the regime's multifarious domains of sociocultural operations, including film' (2004: 5). Nevertheless, while it is important to chart the development of Nazism's hegemonic discourse and how it translates into cultural policy and aesthetic practice, one of the retrospective 'successes' of this discourse is that it has rendered actual cinema-goers of the time invisible. Existing evidence about audiences and their response to films is fragmentary (to be found in autobiographies, family memories and similar sources) and mainly at anecdotal level; but it suggests that, while film viewers were not necessarily or always subversive and resistant, they also were no passive dupes, and they articulated their preferences with some degree of independence.

Unlike in a democracy where print media – for example, fan magazines – might help in illuminating audience preferences (Staiger 1992), such a task is more difficult in a situation where no press freedom exists, where independent film criticism has been replaced by prescribed descriptions, and where all aspects of the cinema-going experience

are tightly regulated (including, from 1938 onwards, when Jews were banned from entering theatres, the decision regarding who is allowed to go to the cinema). Both Carter and Hake have documented the ways in which the Nazi press rebuffed or attempted to contain unruly audience responses. While one might infer preferences by looking at the strategies through which a totalitarian state deals with audience responses, an absence at the core of the argument remains.

It is noteworthy that a number of essays on *La Habanera*, most notably Babington's, take recourse to fictional film-goers, and analyze a scene in Edgar Reitz's TV series *Heimat* (1983), where two female characters watch and try to emulate Leander. Supporting this strategy, Hake has suggested drawing on 'autobiographies, memories, letters, oral histories' since these forms help to 'illustrate the power of cinema in articulating private dreams and desires', and since 'audiences must be treated as participants in a extended field of multiple and often contradictory meanings' (2001: 85).

The methodological problems of the audience's absence can be illustrated by the quote from Koepnick cited earlier, which interprets *La Habanera* as 'exploiting the desire for the unknown with the intention of segregating self and Other'. This reading is based in the main on a comparison between two songs in the film, the titular *habanera*, with its origins in Latin and Afro-Caribbean musical genres, and a 'Teutonic' Christmas carol. With regard to the former, Koepnick suggests that it 'espouses an exoticized other as a playground for the imagination to underscore that there is no place like home' (Koepnick 2002: 84), This analysis constitutes a straightforward textual interpretation similar to those by Babington, Coates and Lee, and given the opaqueness of the narrative one can either agree with this reading or not.

Discussing the carol, on the other hand, Koepnick cites contemporary reviews which 'deemphasized Leander's *habanera*' in favour of the European song with its 'straightforward tonality and rhythmic uniformity' (2002: 85). The use of the reviews not only serves as empirical evidence for the film's project of rejecting otherness and reaffirming ethnic particularity, but, more importantly, it also implies that this is the only legitimate way of reading the film – then or later. Indeed, Koepnick goes on to claim that if there were readings of Nazi cinema 'against the grain' among audiences in the Third Reich at all, these could merely function as a 'pleasurable experience of consumption itself' (2002: 88). Be this as it may, it is worth pointing out that the *habanera* became a signature hit for Leander over the next decades, whereas the Teutonic carol was forgotten.

The reference to the afterlife of Third Reich cinema and popular culture is relevant in this context. As pointed out previously, Leander's songs and films have survived into the new millennium, partly through subcultural ('camp' or 'queer') appropriation but also as part of a wider nostalgia that unites, as Elsaesser has noted, 'Nazi parents, Sixties sons and daughters, and New Age grandchildren' (2000: 383). One way of dealing with this continuity is to segregate modes of reception. Focussing on the postwar gay repurposing of Leander, Kuzniar argues that the terms of the debate 'shift dramatically once the audience becomes a subcultural one' and that 'because the reception is after 1945, the

issue of Nazi mass manipulation falls by the wayside' (2000: 61–62). One could of course argue precisely the opposite; namely that any re-appropriation of Nazi artefacts marks at best a regressive continuity, and at worst a trivialization of fascism with the potential of indoctrinating subsequent generations with a pernicious ideology. This was one of the reasons why the Allies in the immediate postwar years issued a blanket ban on the exhibition of productions made during the Third Reich. Elsaesser has suggested that the revival of Nazi entertainment films and music might act as a psychological 'shield' which 'speaks to the unvoiced question of what it was like to have lived through those times and "not known", i.e. successfully disavowed reality and protected [...] one's innocence' (2000: 384).

But there is another possible explanation for why a film such as *La Habanera* might resonate with contemporary audiences, and of how it might have been received originally. This brings me back to the central theme of the film and to my concern in this essay more generally: transnational, or rather cosmopolitan, desire. As Carter has suggested, Leander's interwar films coincided with a boom period in Germany in terms of international tourism, which had its origins in the Weimar period, and thus the films can be seen 'as feeding popular appetites for frontier-crossing [...] across and beyond the borders of the Reich' (2004: 205). With reference to Leander's songs' fusing of different cultural registers into a hybrid musical idiom and the star's dressing up in ethnically diverse costumes, Carter also notes the roots of this in the cosmopolitanism of the Weimar period, but argues that ultimately the films' narratives and Leander's specific performance style work towards repudiating this tradition. Carter concludes that the songs 'may well evoke the polymorphous sexualities, the exotic ethnic affiliations and gender transgressions of Weimar, but the lyrics remind Leander's listeners of the imperative that such desires end in renunciation' (ibid.: 212).

In view of the hegemonizing project of Nazi cultural theory and policy that saw its *telos* in the marshalling of all state resources (including cinema) towards genocide and total war, this is an appropriate comment. However, once again we are left with an impasse regarding the interpretative options open to audiences. While it is plausible that some viewers in the 1930s will have followed the discursive template as suggested by Carter's reading, others may not. Carter refers to Leander's films as 'celebrating' the defeat of Weimar's legacy (2004: 212). But what if this defeat may have registered not triumphantly with audiences, and more in terms of mourning a loss; of transgressive opportunities and of a peaceful cosmopolitanism that marked the antithesis of the imperialist expansionism that was becoming increasingly prominent in the run-up to war? Many scholars, irrespective of their understanding of the message of Sirk's film, have pointed to the melancholy of its narrative and musical numbers. Hake and Schulte-Sasse have argued that Nazi cinema (particularly during the 1930s) allowed for interpretative gaps to emerge in its elliptical narratives that audiences could fill as a kind of 'reflective space'.

Revisiting the question of Sirk's authorship, but linking this question with possible frameworks of reception at the time, Hake suggests that 'the German melodramas of

Detlef Sierck can be described best in the registers of resignation and retreat, but without the positive connotations associated with the conditions of exile' (2001: 126–27). This hardly qualifies as a position of heroic resistance and may at best be related to a stance of 'inner emigration'. But at least it demonstrates awareness rather than a blanket disavowal of reality. Thus, one strand of the postwar reception of Leander and Sirk's German films could be seen not so much in terms of replicating a disavowal of reality (and responsibility), but rather as identifying and rediscovering a cosmopolitan sensibility whose very repression *La Habanera* registered.

In conclusion to this section I would argue that Sirk's Nazi-era melodramas have retained their fascination, both for general audiences and critics, because their ideological meaning, which centres in large parts on the representation of cosmopolitan desire, remains defiantly unresolved. As I have demonstrated, a completely different interpretation emerges depending on whether one approaches *La Habanera* as an auteurist defender of Sirk, or as a chronicler of the processes by which Nazi cultural policy attempted to achieve hegemony, or as a historian of the contradictions of everyday life as experienced by Third Reich film audiences. The problem with each of these approaches is not so much that the resulting readings are not legitimate within their respective conceptual framework, but what is omitted from each perspective. In the case of auteurist analysis, industrial and wider political contexts are sidestepped in order to determine a director's personal agency, motivations and stylistic trademarks. Those favouring a hegemonic reading of the Nazi film industry tend to hypothesize an implied spectator and overestimate the state's reach in influencing the public through propaganda-laced entertainment. Conversely those insisting on the potential for audience 'resistance' are prone to overstate the interpretative freedom available to historical audiences.

What above approaches share is their propensity to see films locked within a singular meaning, which is contained within a particular historical moment. But while films are certainly dependent on their immediate (and often highly contradictory) contexts of production and exhibition, they are also always placed on a transhistorical continuum, or possess what Barbara Klinger (1997) refers to as film's 'diachronic' trajectory, containing and reflecting upon influences from earlier periods, while radiating into the present in terms of ongoing viewers' reception. This is why I suggest that a shift in focus towards *La Habanera*'s cosmopolitan origins and legacies might be particularly productive in opening up new possibilities of meaning as well as new forms of appropriation, instead of closing them down. Methodologically, the emphasis on a specific sensibility (in this case cosmopolitan desire) can aid in maintaining such a transhistorical perspective, and account for the continuing appeal of films across very different historical experiences and cultural periods. Such an approach would then not merely be able to register successive and separate forms of reception, but instead attempt to trace transhistorical continuities, affinities and dialogues.

## Cosmopolitanism versus 'minority' film-making: Fatih Akın's *Auf der anderen Seite*

To switch from the Nazi period to the multicultural present and from popular, industry-produced genre film to transnational European art house cinema may seem a daring leap, but there are reasons to compare Sirk's case with that of contemporary German film-maker Fatih Akın in the context of this discussion of cosmopolitanism in European cinema. In the first instance, as Elsaesser has pointed out (2008), one can trace a direct 'genealogical' continuity between the two directors. Akın has frequently acknowledged the influence of Rainer Werner Fassbinder who in turn is well known to have drawn on Sirk's use of melodrama. In this respect one can construct a lineage of cosmopolitan and anti-cosmopolitan narratives in German cinema that runs from the exoticist fantasies of the Wilhelmine and Weimar periods (on the latter, see Nagl 2009) via *La Habanera* through Fassbinder's take on Sirkian melodrama in *Angst essen Seele auf/Fear Eats The Soul* (1974) to Akın. At the same time, a comparison between Sirk and Akın makes it possible to document the differences in how cosmopolitanism is expressed across historical periods. Moreover, the comparison between the two case studies once again draws attention to questions of methodology, and, as in Sirk's case, Akın's career illustrates problems inherent in auteurist discourse.

Since his feature film debut, *Kurz und schmerzlos/Short Sharp Shock* (1998), Akın has become one of European cinema's hottest properties. This is evidenced by a string of prizes and awards at festivals, including Berlin and Cannes, as well as a nomination in the Academy Awards' foreign film category. Elsaesser argues that 'not unlike Lars von Trier, Kim Ki-duk, or Wong Kar-Wai, his name may be associated with a national cinema, but he is equally at home in the entrepreneurial (and stylistic) *lingua franca* of the film festival and art-house circuits' (2008). While I agree with the latter part of this statement, Akın's association with national cinema needs unpacking.

On the one hand Akın was born in Germany, and his aesthetic formation, like those of other German film-makers since World War II, betrays the multiple influences of German and American popular culture, as well as national and international art cinema traditions. On the other hand, unlike von Trier or his German near contemporary, Tom Tykwer, Akın has been perceived less in terms of a transcending auteurist vision, and more often according to an essentialist (albeit complex) sociocultural identity, alternatively defined as 'Turkish-German', 'migrant/diasporic', 'German-born Turkish', but rarely as 'German' (the assignation Akın himself prefers). It is notable that Akın films that either feature a 'non-hyphenated German' protagonist (the European road movie *Im Juli/In July* [2000]), or which do not touch on a Turkish-German theme (the family saga *Solino* [2002]) have received considerably less critical and academic attention.

Deniz Göktürk has warned against a critical tendency to compartmentalize 'migrant' cinema, and to see the work of film-makers with multiple ethnic affiliations merely as a reflection of their biography (Göktürk 2000; 2002; 2008). In particular, Göktürk has taken issue with a discourse of migrant cinema that is structured around binary oppositions

such as empowerment versus oppression, and cultural difference versus integration. In contrast Göktürk has championed films (including Akın's) that disrupt the certainties of identity politics on both sides, especially through strategies of irony. Many subsequent studies, however, continue to compartmentalize 'migrant' or 'diasporic' film-makers, now within a new framework of 'transnationalism', where minorities and their particularities (sexuality, ethnicity, gender) remain structurally 'Other'.

Akın and his films have been enthusiastically adopted by this kind of rhetoric, but at the same time illustrate its limitations. On the one hand, Akın is undoubtedly a transnational director in the sense of working across different countries, employing multinational casts and crews, and being part of a transnational distribution and exhibition circuit. Moreover, his films often feature narratives of migration, border crossings and characters who balance multiple cultural affiliations. On the other hand, one has to resist a reductive tendency to collapse modes of production, cinematic style, narrative content and a director's biography into a neatly unified object of study that can be analysed from a quasi-ethnographic or sociological perspective. The latter approach risks reifying exactly the kind of segregation and 'Othering' that discussions of 'diasporic', 'migrant' or 'accented' cinema originally meant to overcome. Thus, rather than ghettoize Akın within the boundaries of a quasi-genre of 'migrant' or 'transnational' cinema, I propose to discuss his films in their articulation of and engagement with broader notions of cosmopolitanism. His 2007 film *Auf der anderen Seite* is particularly pertinent in this respect.

*Auf der anderen Seite* has a complex and self-consciously formalist narrative structure and multiple protagonists. Told in four different 'chapters', which although running consecutively are meant to overlap or coincide in real-time, and moving between locations in Germany and Turkey, the narrative recalls similar cinematic experiments with overlapping time and space structures such as Akira Kurosawa's *Rashomon* (1950) and Alejandro González Iñárritu's *Babel* (2006).

The film introduces one father-son pair and two pairs of mothers and daughters. The first pair comprises the Turkish guest worker Ali (played by Tunçel Kurtiz, famed for his collaborations with Turkish directors Yılmaz Güney and Erden Kiral), originally from the Black Sea Coast, and his son Nejat (Baki Davrak), a university lecturer in German literature. The second pair are Yeter (Nursel Köse), originally from south-eastern Anatolia, who works as a prostitute in Germany, and her daughter Ayten (Nurgül Yesiçay), a radical left-wing activist in Istanbul. The final couple is made up of middle-class German Susanne (played by Fassbinder's favourite actress Hanna Schygulla), and her globetrotting student daughter, Lotte (Patrycia Ziolkowska).

In the prologue that opens the film, we see Nejat driving along Turkey's Black Sea coast, stopping at a petrol station – in fact this marks the end of the story, as the film will return to this locale in its conclusion. The narratively opaque but visually striking sequence, which Akın has described as being influenced by Antonioni (Kilb and Körte 2007), centres on the forecourt attendant telling Nejat about the singer Kazım Koyuncu (a member of a local ethnic minority, the Caucasian Laz people) and his death from

cancer, a legacy of the Chernobyl disaster. The prologue is followed by the first chapter, whose title, 'Yeter's Death', pre-empts in Brechtian fashion its ultimate outcome. It details how Ali makes Yeter's professional acquaintance and how he persuades her to move in with him. In the course of an argument, he accidentally kills her and is sent to prison. Nejat rejects his father and travels to Turkey to find Yeter's long-lost daughter, planning to finance her studies as a form of atonement. The second chapter, 'Lotte's Death', also moves towards its inevitable conclusion. Ayten flees police persecution in Turkey and becomes an illegal immigrant in Germany. While searching for Yeter, she meets Lotte, moves in with her, and they begin a lesbian relationship, under the disapproving eye of Susanne. The police uncover Ayten's status, and she is deported back to Turkey where she is arrested. Lotte follows to help her, and by coincidence finds accommodation with Nejat, before being killed in an accidental shooting. In the final chapter, the grieving Susanne arrives in Istanbul, decides to stay and strikes up a friendship with both Nejat and Ayten. Nejat travels to the Black Sea to make up with his father, who, after being released from jail in Germany, has been deported to Turkey.

As can be surmised from this plot synopsis, the film gains its main dynamic from the emotional interaction of and structural affinities between its set of protagonists. Characters double, mirror, and substitute for each other, and scenes are replayed in new configurations, most poignantly in the two scenes where Yeter and Lotte's coffins are offloaded from the plane at respectively Hamburg and Istanbul airports. There is an obvious symmetry between the different pairs – all of them comprise incomplete nuclear families: Nejat's mother died when he was a child; Ayten's father is never mentioned; while Lotte's father has left the scene some time ago and, although invoked once by Lotte, remains absent. Disconnection is as important as connection: Ayten is looking for Yeter but never finds her, although in one scene they pass each other without recognition. A similar encounter of non-recognition occurs when Susanne and Ali pass each other at the airport and only the spectator is able to establish their connection. Similarly Nejat's search for Ayten remains futile, despite them having a mutual acquaintance in Susanne, and despite the fact that, unbeknown to either, Ayten has attended a lecture by Nejat in Germany. The possibility of an eventual meeting between the two (which would reveal the full extent of their connectedness to all the surviving characters) remains unrealized at the film's end, as does the reconciliation between Nejat and his father.

Although Akın self-consciously references European art house traditions such as Antonioni, Fassbinder, Güney, and others, the film can also be read as a traditional melodrama of the kind that Sirk used to make in Nazi Germany and later Hollywood. This can be seen in the film's fateful encounters and missed opportunities; in its positioning of the spectator in a perspective of superior knowledge vis-à-vis the protagonists' helplessness in influencing the narrative's trajectory; in its focus on dysfunctional family units; and in its particular concern with mother-daughter relationships. Seen that way, the triangle of Susanne, Lotte and Ayten works as a contemporary variation of the class and ethnic divisions in Sirk's final film *Imitation of Life* (1959), while Ayten and Yeter's

relationship replays the theme of a 1930s fallen woman's melodrama such as *Stella Dallas* (Vidor, 1937). Despite the unrelenting presence of death in the narrative, *Auf der anderen Seite* is surprisingly optimistic about the transformative potential of love and cultural exchange. Some critics, especially Elsaesser (2008), have emphasized that death in Akın's film always implies punishment for transgression, yet this determinism is counteracted by the fact that the legacy of the dead and their desires are internalized by the survivors and taken forward into the future.

*Auf der anderen Seite* also offers an astute and sometimes bitingly ironic political analysis of different models of cosmopolitanism, and of how appropriate, effective or desirable these are in dealing with and living in a globalized world. One particular version of cosmopolitanism opens the first chapter, which begins with a May Day trade union march in Bremen, with banners proclaiming the old slogan of Socialist international solidarity: 'Proletarians of the world unite!' Replete with brass band and uniforms, the march's ordered pageantry seems to usurp the political meaning of the occasion, reducing the public demand for international solidarity to a harmless folkloristic event cheered on by well-meaning but apathetic onlookers. One of these is Ali, who is only momentarily distracted in his search for a prostitute. Socialist internationalism is presented as an anachronism, underscored in the contrast between this march and the more violent protest in Istanbul that opens the second chapter. The clash between camouflaged radicals and riot police represents the antithesis of the earlier march, as well as the backlash of a resurgent nationalism against both a hollow notion of international solidarity and globalized capitalism.

Aside from these two moments where collective politics prominently enters the narrative, *Auf der anderen Seite* locates its discourse about cosmopolitanism at the level of individual ethical choices and interpersonal interactions. In Yeter we find a cosmopolitanism that is reduced to a pure commodity. When Ali first meets her and asks her whether she performs oral sex ('doing it French') she replies 'French, Italian, Greek. I'll do it international for you'. However, Yeter can only sustain this 'international' persona as 'Jessy', the ethnically indeterminate prostitute with a blonde wig, because without this disguise she opens herself to threats from local Islamists trying to uphold moral standards among their ethnic communities. It is worth recalling in this context that the latter are merely exercising yet another version of cosmopolitanism in the sense that Islam demands 'transnational and transethnic commitment' (Hemelryk Donald, Kofman and Kevin 2009: 1). Even the nationalist group that Ayten belongs to in Turkey is dependent on international support networks as well as on international media coverage of its activities.

Although at first presented in terms of opposing models of cosmopolitanism, Lotte's New Age 'one-worldism' (travelling to India, buying into ethnic chic, listening to world music) and Ayten's hardline nationalism are ultimately superficial, interchangeable and open to revision. Initially naïve and without direction, Lotte finds her destiny in concretely helping her lover, while Ayten in the end abandons her revolutionary stance. Successive scenes of the two characters crossing the Bosporus by ferry function as a visual

metaphor for the crossing of boundaries, not just physical and geographical, but also psychological and in terms of changing sensibilities (see Figure 4). The multiple ironies involved in negotiating the ethical and political choices of a lived cosmopolitanism are demonstrated when Ayten pontificates to Susanne about the evils of globalization and the need for national resistance. Yet minutes earlier she is seen alongside Lotte consuming in a German disco a side-product of globalization, dancing to the 'Bukovina Dub', a remix of a Gypsy song and part of the Balkan Pop phenomenon that has more recently been coopted in one of the most quintessentially global media phenomena of recent years – Sasha Baron-Cohen's *Borat* (Charles, 2006). Discussing the ironic effect of Akın's use of melodramatic conventions in *Gegen die Wand/Head-On* (2004), Göktürk has pointed to the 'fusion of strategic distancing and emotional underscoring' which she locates in the pointed employment of popular music within the film (2008: 159; see also Siewert

Figure 4. Crossing the water, traversing boundaries – *The Edge of Heaven* (Akın, 2007).

2008). A similar approach can be detected in *Auf der anderen Seite*; however, here also by means of editing, in particular the way in which scenes and shots comment ironically on preceding or subsequent events.

Perhaps the most interesting figure in the film with regard to cosmopolitanism is Nejat. Among the main characters, he is most at ease with cross-cultural mobility – indeed he is frequently filmed travelling by car or train. He is also associated most closely with the classical Enlightenment ideal of cosmopolitanism as a universal ethics referred to earlier in this chapter; an ideal that Akın views with scepticism and irony. Nejat is firmly placed within this tradition early on in the film when he is shown lecturing to students on Goethe's reasons for not condoning revolutions. It is in this scene that we first encounter Ayten, soundly asleep at the back of the lecture hall during Nejat's elaboration of ethical arguments by Germany's greatest national poet and thinker. Moreover, the scene is immediately followed, after an abrupt cut, by Ali and Yeter having sex, further undermining the lofty ideals expressed seconds earlier. Here and later, the film links political and ethical idealism with indeterminate sexuality. Nejat, whom Akın described in an interview as 'androgynous' with maternal elements (Kilb and Körte 2007), remains romantically unattached in the film, deliberately evading his father's question 'who are you screwing?'

Nejat's idealism is tested further after he travels to Istanbul and tries to find Ayten. Learning from a cynical policeman about the latter's political affiliation, Nejat pronounces with true Enlightenment fervour that 'knowledge and education are human rights'. Yet, once again, Akın ironically deflates the impact or relevance of this statement in the following scene where Nejat and his Turkish cousin pass by a German bookshop. Asked whether he has seen this shop before, the cousin's response reveals the social and intellectual gap between him and Nejat: 'I don't understand books. Especially not in German'. Far too wrapped up in his own pursuits, Nejat ignores this comment, despite his earlier vocal commitment to universal educational equality. Nevertheless, the discovery of the bookshop, and his decision to buy it and give up his academic position in Germany, marks an important departure in Nejat's personal development and cosmopolitanism.

The encounter between Nejat and the German bookshop owner Obermüller (Lars Rudolph) is staged as a mutual recognition and an uncanny mirroring that is almost erotically charged. But there is also a deftly ironic touch to Akın's characterization of the German expatriate. Having lived in Turkey for the past ten years and able to speak the language, Obermüller cannot overcome his homesickness, the reason why he is willing to sell up and go back to Germany. His bookshop is pictured as a national enclave, replete with miniature desktop flag, a Bach CD playing in the background, and an unseen Turkish assistant preparing tea behind the scenes. Both the flag and Bach's music will disappear when Nejat takes over the shop, while the unseen assistant remains. Obermüller is in many ways the heir to Leander's character in *La Habanera*, attesting to the continuity into the present of a sensibility that is forever torn between homesickness and transnational desire. The latter drew Obermüller away in the first place and, as with

Leander, will make it unlikely that he resettle happily back in the *Heimat*. His quasi-Kantian cosmopolitanism remains a pure ideal, and with no concrete object his transnational desire remains melancholically suspended. For Nejat, on the other hand, the acquisition of the bookshop marks a turning point, after which his own cosmopolitanism changes from being abstract and idealistic to becoming concrete, personal and vernacular. At this stage in his consciousness Nejat is met by Susanne, who arrives at a similar state of mind from a different point of departure.

As I have argued in the above reading, *Auf der anderen Seite* provides an ambitious and complex discussion of different models of cosmopolitanism adopted by people of varying backgrounds within a contemporary European and global context. By offering a critique of those models which remain articulated at the level of pure idealism (whether in the guise of Enlightenment traditions or in the multiple forms of ideological radicalism), Akın sides with a pragmatic, everyday cosmopolitanism grounded in concrete affective relations and flexible ethical choices that shares many similarities with the visceral cosmopolitanism discussed by Nava.

In his focus on cosmopolitan identities and practices, Akın moves beyond reductive dichotomies of migrants versus non-migrants, and suggests less what transnational cinema *is* than what transnational cinema may be *about*. The narrative and visual devices of overlapping and simultaneous action are crucial in this respect. Although the film's German title literally translates as 'On the Other Side', the film argues that there is in fact no other side. Instead the film presents us with a globalized environment without real distance, a world whose inhabitants inhabit the same space all the time, although they (and by extension we as spectators) may be unable to recognize this. This scenario is played out in the repeated scenes of misrecognition and miscommunication throughout *Auf der anderen Seite*, which also serve to map and draw our attention to globalism's spatial and cultural hierarchies. In this respect, the phrase 'On the Other Side' reflects (much better than the misleading religious connotations of the English title, *The Edge of Heaven*) the film's qualified commitment to cosmopolitanism. In a perceptive essay that discusses the film's engagement with questions of globalization through its employment of multilingual dialogue, David Gramling has commented that, beyond indexing a location 'on the other side' of some presupposed 'here', the German title also suggests Protagorean antilogy – a philosophical commitment to the notion that two contradictory arguments may be held simultaneously, as in the English expression 'on the other hand' (Gramling 2010).

The implications of Akın's intellectual project do not yet appear to have registered fully in the academic debate on his films. Thus, even essays that acknowledge *Auf der anderen Seite*'s engagement with more universal questions still attempt to fix the film's meaning and its director's objectives and identity within narrow definitions of a 'migrant cinema' genre (see, for example, El Hissy 2009: 179–86). Yet I would argue that what Akın articulates in *Auf der anderen Seite* is precisely not a 'new phase' in migration or European migrant cinema (ibid: 186), but, as I have suggested throughout this chapter, an ongoing contestation of competing ethical and emotional attitudes towards the Other

in a wider global arena. This needs to be separated from simplistic conflations of auteurist biographies and narrative concerns, and be placed in longer, but not always synchronous, discursive as well as cinematic historical continuities.

## References

Abbas, A. (2000), 'Cosmopolitan de-scriptions: Shanghai and Hong Kong', *Public Culture*, 12: 3, pp. 769–86.

Appadurai, A. (1996), *Modernity at Large: Cultural Dimensions of Globalization*, Minneapolis: University of Minnesota Press.

Babington, B. (1995), 'Written by the wind: Sierck/Sirk's *La Habanera* (1937)', *Forum for Modern Language Studies*, 31: 1, pp. 24–36.

Beck, U. (2006), *Cosmopolitan Vision*, Cambridge: Polity Press.

Bergfelder, T. (2005), 'National, transnational, or supranational cinema: rethinking European film studies', *Media, Culture & Society*, 27: 3, pp. 315–31.

Bhabha, H. (1994), *The Location of Culture*, London and New York: Routledge.

——— (1996), 'Unsatisfied: notes on vernacular cosmopolitanism', in L. García-Moreno and P. C. Pfeifer (eds), *Text and Nation*, London: Camden House, pp. 197–207.

Carter, E. (2004), *Dietrich's Ghosts: The Sublime and the Beautiful in Third Reich Film*, London: BFI Publishing.

Cheah, P. (2006), *Inhuman Conditions: On Cosmopolitanism and Human Rights*, Cambridge, MA: Harvard University Press.

Clifford, J. (1988), *The Predicament of Culture*, Cambridge, MA: Harvard University Press.

Coates, P. (1991), *The Gorgon's Gaze: German Cinema, Expressionism, and the Image of Horror*, New York: Cambridge University Press.

Dennison, S. and Lim, S. H. (eds) (2006), *Remapping World Cinema*, London: Wallflower Press.

Douzinas, C. (2007), *Human Rights and Empire: The Political Philosophy of Cosmopolitanism*, Oxford: Routledge-Cavendish.

El Hissy, M. (2009), 'Transnationaler Grenzverkehr in Fatih Akıns *Gegen die Wand* und *Auf der anderen Seite*', in H. Schmitz (ed.), *Von der nationalen zur internationalen Kultur. Transkulturelle deutschsprachige Literatur und Kultur im Zeitalter globaler Migration*, Amsterdam: Rodopi, pp. 169–86.

Elsaesser, T. (2000), *Weimar Cinema and After: Germany's Historical Imaginary*, London and New York: Routledge.

——— (2008), 'Ethical calculus: the cross-cultural dilemmas and moral burdens of Fatih Akın's *The Edge of Heaven*', *Film Comment*, 44: 3, http://filmlinc.com/fcm/mj08/heaven.htm. Accessed 25 November 2009.

Ezra, E. and Rowden, T. (eds) (2006), *Transnational Cinema: The Film Reader*, London and New York: Routledge.

García Canclini, N. (2005), *Hybrid Cultures: Strategies for Entering and Leaving Modernity* (trans. C. L. Chiappari and S. L. López), Minneapolis: University of Minnesota Press.

Göktürk, D. (2000), 'Turkish women on German streets', in M. Konstantarakos (ed.), *Spaces in European Cinema*, Exeter: Intellect, pp. 64–76.

——— (2002), 'Beyond paternalism: Turkish German traffic in cinema', in T. Bergfelder, E. Carter, and D. Göktürk (eds), *The German Cinema Book*, London: BFI Publishing, pp. 248–56.

——— (2008), 'Sound bridges: transnational mobility as ironic drama', in M. Christensen and N. Erdogan (eds), *Shifting Landscapes: Film and Media in European Context*, Newcastle: Cambridge Scholars Publishing, pp.153–71.

Gramling, D. (2010), 'On the other side of monolingualism: Fatih Akin's linguistic turn', *German Quarterly*, 83: 3, http://ww.faqs.org/periodicals/2010007/2129933661.html. Accessed 4 December 2010.

Habermas, J. (1997), 'Kant's idea of perpetual peace, with the benefit of two hundred years' hindsight', in J. Bohamn and M. Lutz-Bachmann (eds), *Perpetual Peace: Essays on Kant's Cosmopolitan Ideal*, Cambridge, MA: MIT Press, pp. 113–53.

Hagener, M. (2007), *Moving Forward, Looking Back: The European Avant-garde and the Invention of Film Culture, 1919–1939*, Amsterdam: Amsterdam University Press.

Hake, S. (2001), *Popular Cinema of the Third Reich*, Austin: University of Texas Press.

Halle, R. (2008), *German Film after Germany: Toward a Transnational Aesthetic*, Urbana and Chicago: University of Illinois Press.

Hannerz, U. (1996), *Transnational Connections: Culture, People, Places*, London and New York: Routledge.

Hemelryk Donald, S., Kofman, E. and Kevin, C. (eds) (2009), *Branding Cities: Cosmopolitanism, Parochialism, and Social Change*, New York and London: Routledge.

Higbee, W. and Lim, S. (2010), 'Concepts of transnational cinema: towards a critical transnationalism in film studies', *Transnational Cinemas*, 1: 1, pp. 7–22.

Hjort, M. (2010), 'On the plurality of cinematic transnationalism', in N. Durovicova and K. Newman (eds), *World Cinemas, Transnational Perspectives*, New York and London: Routledge, pp. 12–33.

Kilb, A. and Körte, P. (2007), 'Interview with Fatih Akın: Keine Angst vor Islamismus in der Türkei', *Frankfurter Allgemeine Sonntagszeitung*, 2 September, http://www.faz. net/s/Rub8A25A66CA9514B9892E0074EDE4E5AFA/Doc~EAF2656812E1C41D EA18144FCF5C25FD0~ATpl~Ecommon~Scontent.html. Accessed 20 November 2009.

Klinger, B. (1997), 'Film history terminable and interminable: recovering the past in reception studies', *Screen*, 38: 2, pp. 107–29.

Koch, G. (1999), 'From Detlef Sierck to Douglas Sirk' (trans. Gerd Gemünden), *Film Criticism*, 23: 2–3, pp. 14–32.

Koepnick, L. (2002), *The Dark Mirror: German Cinema between Hitler and Hollywood*, Berkeley: University of California Press.

Kosnick, K. (2009), 'Conflicting mobilities: cultural diversity and city branding in Berlin', in S. Hemelryk Donald, E. Kofman and C. Kevin (eds), *Branding Cities: Cosmopolitanism, Parochialism, and Social Change*, New York: Routledge, pp. 28–44.

Kuzniar, A. (2000), *The Queer German Cinema*, Stanford, CA: Stanford University Press.

Lee, D. E. (2008), 'A flash of enlightenment: a Brechtian moment in Douglas Sirk's *La Habanera*', *Monatshefte*, 100: 3, pp. 400–14.

Naficy, H. (2001), *An Accented Cinema: Exilic and Diasporic Filmmaking*, Princeton: Princeton University Press.

Nagl, T. (2009), *Die unheimliche Maschine. Rasse und Repräsentation im Weimarer Kino*, Munich: edition text+kritik.

Nava, M. (2007), *Visceral Cosmopolitanism: Gender, Culture, and the Normalisation of Difference*, Oxford and New York: Berg.

Neale, S. (1986), 'Melodrama and tears', *Screen*, 27: 6, pp. 6–22.

Nussbaum, M. (1994), 'Patriotism and cosmopolitanism', *The Boston Review*, 19: 5, http://bostonreview.net/BR19.5/nussbaum.html. Accessed 20 November 2009.

Ong, A. (1999), *Flexible Citizenship: The Cultural Logics of Transnationality*, Durham, NC: Duke University Press.

Passerini, L. (1999), *Europe in Love, Love in Europe*, London: I. B. Tauris.

Pollock, S. (2000), 'Cosmopolitanism and vernacular in history', *Public Culture*, 12: 3, pp. 209–52.

Prysthon, A. (2002), *Cosmopolitismos periféricos: ensaios sobre modernidade, pós-modernidade e Estudos Culturais na América Latina*, Recife: Bagaço.

Rentschler, E. (1996), *The Ministry of Illusion: Nazi Cinema and its Afterlife*, Cambridge, MA: Harvard University Press.

Said, E. (1978), *Orientalism*, Harmondsworth, UK: Penguin.

Sandberg, C. (2009), 'Far from home? Functions of escapism and portrayal of the tropics in *La Habanera* (1937)', *Studies in European Cinema*, 6: 1, pp. 63–76.

Shohat, E. and Stam, R. (eds) (2003). *Multiculturalism, Postcoloniality, and Transnational Media*, New Brunswick: Rutgers University Press.

Siewert, S. (2008), 'Soundtracks of double occupancy: sampling sounds and cultures in Fatih Akın's *Head On*', in J. Kooijman, P. Pisters and W. Strauven (eds), *Mind The Screen: Media Concepts According to Thomas Elsaesser*, Amsterdam: Amsterdam University Press, pp. 198–208.

Spivak, G. C. (1999), *A Critique of Postcolonial Reason: Towards A History of the Vanishing Present*, Cambridge, MA: Harvard University Press.

Staiger, J. (1992), *Interpreting Films: Studies in the Historical Reception of American Cinema*, Princeton: Princeton University Press.

Stollery, M. (2000), *Alternative Empires: European Modernist Cinemas and Cultures of Imperialism*, Exeter: University of Exeter Press.

Szerszynski, B. and Urry, J. (2006), 'Visuality, mobility and the cosmopolitan: inhabiting the world from afar', *The British Journal of Sociology*, 57: 1, pp. 113–31.

Wollen, P. (1994), 'The cosmopolitan ideal in the arts', in G. Robertson, M. Mash, L. Tickner, J. Bird, B. Curtis and T. Putnam (eds), *Travellers' Tales: Narratives of Home and Displacement*, London: Routledge, pp. 187–96.

# Part II

Impossible loves

## Chapter 4

Love in two British films of the late silent period: *Hindle Wakes* (Maurice Elvey, 1927) and *Piccadilly* (E. A. Dupont, 1929)

Laura Mulvey

At first glance these two films would not appear to have much in common. One, *Hindle Wakes*, is set in the industrial north of Britain, the other, *Piccadilly*, in the heart of metropolitan London. One was directed by an indigenous director, a good craftsman with a long-standing career in British cinema; the other by a supreme stylist of German cinema supported by some of the most skilled technicians of contemporary Europe. One is performed naturalistically; the other is dominated by the exotic presence of a major movie star. The two films, however, are both love stories, belonging to a genre in which romance drives and is central to the plot. But, beyond the question of genre, both films were made at a time when the depiction of love, and more particularly the love *affair*, could take on special social significance due to the contested and changing status of young women in the modern world. The films, despite their differences, reflect that moment and their female protagonists belong, iconographically and emotionally, to the 'mentality' of modernity.

Furthermore, as *Hindle 'Wakes* and *Piccadilly* both tell the story of affairs between a working-class girl and her boss (or, in *Hindle Wakes*, the son of her boss) both confront the class boundaries deeply embedded in British society. They are not about an idealized 'true love', nor 'grand passion', nor even the working-class girl seduced and abandoned by a man from the upper-classes (Hardy's Tess, for instance, or Effie Deans in Walter Scott's *Heart of Midlothian*). Nor are Fanny (Estelle Brody) in *Hindle Wakes* and Shosho (Anna May Wong) in *Piccadilly* scheming seducers, although something of the *femme fatale* might cling to Shosho towards the end of the film. These 'love affairs' are transitory and primarily erotic, and their depiction of love makes a gesture towards a world in which women's sexual relations need neither be the subject of eternal love nor victimized by class exploitation. The feminist anarchist Emma Goldman in her book *The Social Significance of the Modern Drama* recognized this aspiration in the original 1912 play *Hindle Wakes* by Stanley Houghton, and her endorsement is quoted on the DVD box:

> It is beginning to be felt in ever-growing circles that love is its own justification, requiring no sanction of either religion or law. The revolutionary idea, however, that woman may, even as man, follow the urge of her nature, has never before been so sincerely and radically expressed [...]. The message of *Hindle Wakes* is therefore of inestimable value, inasmuch as it dispels the fog of the silly sentimentalism and disgusting bombast that declares woman a thing apart from nature – one who neither does nor must crave the joys of life permissible to man. (Goldman 1914)

While this aspiration to erotic equality between men and women could be found in socially advanced literature before World War I, the 1927 film version naturalizes and generalizes Fanny, giving her the attributes associated with the young modern woman of the 1920s. Shosho's sexual modernity is similarly established through the recognizable fashions and iconographical traits of the flapper.

Both films are thus characterized by the modern, liberated sexuality of their heroines and by tropes of movement between and across social divisions: those of class in *Hindle Wakes* and those of class and ethnicity in *Piccadilly*. From this perspective the two films conform to Andrew Higson's argument in Chapter 2 that the British film industry needed to move away from films depicting traditional and thus 'stuffy' 'Englishness', particularly in relation to romance, in order to appeal to a transnational audience. As Britain aspired to join in the nascent formation of 'Film Europe', its cinema had to find a way of moving beyond its own stereotypes, its relegation of the lower-classes to crude caricature, and its characteristic inhibitions with regard to sex. As Higson says: 'The films this period produced might unsettle traditional national identities – with English reserve displaced by a "continental" approach to romance, desire and the representation of the body, for instance.'

These two films are, to my mind, emblematic of this move in British cinema towards more 'European' forms of representation of love relations. Furthermore, both are exemplary of 'vernacular modernism', the term coined by Miriam Hansen (2000) to evoke the way that the cinema of this period gives particular attention to those details of places, objects, clothes, transport and so on, that can reflect modernity for the recognition and enjoyment of those that know it, and also reveal its 'vernacular' to those still deprived of it. The cinema was able to display these emblematic and telling details in close-up while also, through its own movement, conveying the energetic movement of the urban environment, filming from trains, motor cars and, in many cases, the rides of a funfair. As Hansen puts it: 'It was not just *what* these films showed, what they brought into optical consciousness, as it were, but the way they opened up hitherto unperceived modes of sensory perception and experience, their ability to suggest a different organization of the daily world.' (2000: 344)

In the first part of this chapter, I will outline ways in which these films persistently privilege modern female subjectivity, materialized through styles and sites, iconographies and attributes of modernity. In the second part, I will discuss how these signifiers affect the films' narratives. Shosho (*Piccadilly*) and Fanny (*Hindle Wakes*) are both very much in control of their sexuality and preserve their own agency throughout their affairs. But, ultimately, the cultural origins of the two films determine their different dramatic modes and the diverging fates of their heroines. Stanley Houghton's 1912 Ibsen-inspired play remains within a realist register, with an ending that emphasizes 'life goes on'. *Piccadilly*, devised as it was as a vehicle for its star Anna May Wong, ultimately depends on melodrama and the heroine's death to deal with an affair that is interracial as well as trans-class.

## Sites of feminine pleasure: topographies of modern romance

In both films, romance is closely associated with and enabled by specific sites; the Blackpool funfair in the case of *Hindle Wakes* and in *Piccadilly*, the nightclub, the Piccadilly Club. The Blackpool funfair (to which everyone goes during 'wakes week', the one week of the year that the factory closes) provides an environment removed from the everyday and dedicated to pleasure, one that enables the meeting between Fanny, the working-class factory girl, and Allan (John Stuart), the son of the factory owner. In *Piccadilly*, Valentine Wilmot (Jameson Thomas) is the urbane sophisticated owner of a fashionable nightclub in which Shosho is initially employed as a scullery maid. But the environment of the Piccadilly also creates a world outside that of the everyday, one in which a scullery maid can become a glamorous star and *amour fou* can overtake the upper-class Englishman and the girl from Limehouse.

These sites of entertainment, pleasure and romantic opportunity set the respective love affairs in motion. But they are also, in themselves, expressive of modern femininity as sites of 'vernacular modernism' in which the economic, the cultural and the social criss-cross and intertwine. During the 1920s, the entertainment and leisure industries expanded due, in the first instance, to the economic boom, but also in response to the demands of their most significant new market: young, unmarried women eager to spend their wages on pleasures representative of their newly acquired freedoms. In particular, the new wage earners brought into being a new concept of entertainment, in which pleasure was far removed from the louche underworld occupied by men and prostitutes. Entertainment was standardized, commercialized and feminized: women were no longer consumed as a commodity but became themselves the consumers of pleasure. For instance, dance halls mushroomed as places of fun, flirtation and the spectacular exhibition of the new modern femininity. It was, if not exclusively, very much the young modern woman who wanted to dance, followed the new dance crazes, listened to hits on the radio, bought the records and took her boyfriend out to the dance halls. In the images of modern femininity key to *Hindles Wakes* and *Piccadilly*, the phenomenon is similarly driven, if divided, by class difference. The Piccadilly Club's key appeal to women is clearly stamped on the film's opening sequence, significantly sited in the sumptuous setting of the ladies' restroom. One elegant upper-class flapper says to another: 'What! Never seen Vic? Without him there would be no-one in the place [...] not a woman that is'. The male half of the Club's star attraction, the dancing partnership Victor (Cyrill Ritchard) and Mabel (Gilda Grey), is thus established specifically as providing 'visual pleasure' for the female audience as it took time off the dance floor to enjoy champagne and male spectacle. In *Hindle Wakes* the mass popular phenomenon of modern dance is established as hundreds of couples, locked in each other's arms, move rhythmically around the huge space of the Blackpool Ballroom.

Conceptually and socially these sites of pleasure and entertainment evoke Michel Foucault's idea of a heterotopia (1986): a place recognized by general consensus to function outside traditional time, dominated as it is by the routines of work and the everyday.

These sites are, on the contrary, dedicated to specific rituals of pleasure, such as dancing and drinking, reconfigured into the feminized culture of consumption and flirtation. In his updating of the 1912 play and his earlier 1918 film version, Maurice Elvey specifically responds, in 1927, to this cultural shift, dedicating a considerable amount of screen time to the Blackpool origins of Allan and Fanny's affair. It is in these sequences of ritualized pleasure that both films develop a cinematic style appropriate for their heterotopic content, as though the movement of, for instance, dance or funfair rides depicted in the content of the screen should be conveyed through camera movement to the spectators in their own semi-heterotopic site of the cinema. Style and visualization, particularly in Dupont's flamboyant *Piccadilly*, could give audiences the extra thrill derived from the fictional scenes' translation into a specifically cinematic form on the screen. The film opens with flowing camera movements in the Club's ballroom that pan in to a close-up across the expanse of the bar as champagne bottles are opened and glasses filled. Furthermore, crane shots swoop elegantly through the space of the ballroom, sweeping down the long, double staircases, across the expanse of the dance floor and the galleries of spectators. These exhilarating shots use the physical presence and excitement of the cinema itself to capture the actual physical excitement of the scene depicted. In *Hindle Wakes*, the ballroom scene is similarly characterized by a mobile camera, alternating views of the expanse of the space with close-ups of dancing feet. Its most beautiful effect comes with the release of thousands of snowflake-like pieces of paper that catch the light and transform the depth of the space into a shimmering surface that echoes the attraction of the screen itself. As these sites and scenes are characteristic of 'vernacular modernism', enhancing the signifiers of modernity and 'unperceived modes of sensory perception and experience', to cite Hansens's words again, the modernity of the cinema itself gives an equivalent form to the filmed content. In *Hindle Wakes* and *Piccadilly* the heterotopic locations provide appropriate narrative settings redolent of the market for feminized consumption of pleasure; but as the camera celebrates these settings, it also transforms and translates them cinematically into something beyond the particularity of character, place and event.

In *Hindle Wakes*, the scenes on the roller coaster demonstrate another form of imbrication between the heterotopic setting, romantic content and a transcendent camera that embodies and translates the thrill of movement and excitement to its spectator. The romance between Fanny and Allan begins with a casual, chance encounter in a crowded area of the Blackpool funfair. Each with a male and female friend respectively, they catch sight of each other at a distance, chat slightly awkwardly and then agree to enjoy the funfair together. The encounter once again draws attention to the change that had overtaken the social significance of unaccompanied women in public space. While once this kind of chance pick-up would have marked a woman as prostitute, the freedom and equality that Fanny assumes for herself prefigures the independence that she asserts at the end of the film. As in so many other contemporary movies, the ambivalent, heterotopic environment of the funfair, at one and the same time respectable and romantic, part of

the everyday but removed from it, carries a high sexual charge. With the roller coaster and other rides, the thrill and excitement of speed, in which the participants scream and clutch each other in fear, leads onto and easily merges with the thrill and excitement of sex. Here the metaphoric understanding of desire as movement is realized in the actual movement of the roller coaster: Fanny and Allan emerge from their ride entwined in each other's arms (see Figure 5). Thus, in terms of the fiction, this section of the film acts as a threshold that carries Alan and Fanny from the moment of chance meeting towards their affair. But beyond the fiction, the movement of the roller coaster also merges with and accentuates the mobility of the cinema itself. During this sequence, although Allan and Fanny appear fleetingly on the screen, the camera by and large takes up its own and the audiences' perspective, shooting up the highest hills and then dropping down dizzyingly on the other side. The sequence is so elongated and so directed towards audience participation, that it becomes an attraction in its own right: a moment in which the fiction falls into the background and the power of the cinema, as well as its symbiotic relationship with the pleasures and speeds of modernity, asserts its own transcendence.

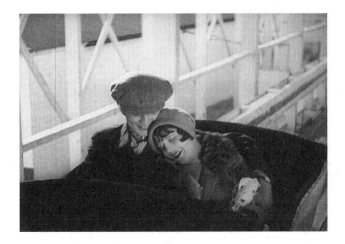

Figure 5. Fanny and Allan: the end of the roller coaster ride – *Hindle Wakes* (Elvey, 1927).

*Hindle Wakes* uses the Blackpool attractions to map the couple's relationship into three phases in which flirtation develops into sex. If the roller coaster literally sets in motion the initial erotic excitement, the dance hall then allows the couple extended physical intimacy, an excuse for moving closer together (thus, Allan and Fanny progress from a lively chat to dancing cheek-to-cheek). Finally, the couple go outside to watch the famous Blackpool Lights, spectacular illuminations that had been recently installed. Here, as they sit on a bench, Allan and Fanny pay more attention to each other than the lights; when Allan whispers his proposal into Fanny's ear, she hesitates, then she nods and they kiss.

In *Hindle Wakes*, the separation between the everyday (the factory, the cotton town of Hindle) and the space of holiday romance (Blackpool) is marked by the topographical gap between the two, separating out the drama's own separation into the initial sequence of romance and its return not only to the everyday life of the factory, but also the consequences of Fanny and Allan's affair. In *Piccadilly*, the heterotopic site of the Club functions more as a backdrop to the central romance. Here, questions of space are organized around an overarching topographical trope, echoing the way that London's

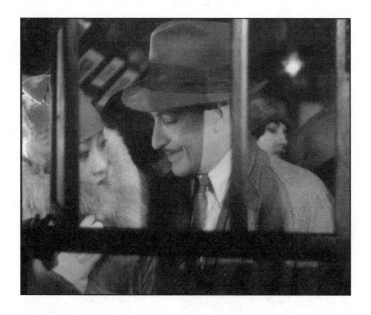

Figure 6. Shosho and Valentine: 'this is our Piccadilly' – *Piccadilly* (Dupont, 1929).

class division is inscribed into its geography: culture, privilege and wealth are clustered in its West End while the East End is the site of poverty and deprivation. As Limehouse, in the East End, had long been home to a small Chinese community, Shosho can be easily and credibly integrated into this geography. While she crosses over to the West End at the beginning of the story, their romance takes Valentine on an equivalent journey to the working-class space of the East. This 'mirroring' of the two is accentuated through the scene in which Shosho takes Valentine to an East End pub that she describes as 'our Piccadilly' (see Figure 6).

## Iconographies of modernity and the problem of narrative closure

The iconographies of the two female protagonists ultimately differ according to the films' style. Estelle Brody plays Fanny without any pretence at stardom, investing her character with a transcendence that comes simply from the energy, intelligence and confidence of the modern girl. Anna May Wong, on the other hand, is not only essentially a star but her image is further enhanced by her exoticism. However, Shosho is far from a victim until the very end. The specifically located working-class background of Limehouse naturalizes Wong's exoticism: Shosho and her boyfriend Jim (King Hou Chang) move easily between their Chinese community and the cockney East End. Shosho is also cool and confident throughout, and quite capable of negotiating her own terms when she agrees to dance at the Piccadilly Club. In reply to Valentine, she answers simply, 'No sir, I won't be frightened'. When Valentine suggests that a suitable costume could be found in Soho, she insists that he go personally to Limehouse to buy, at an exorbitant price, the only costume she will dance in. Once Shosho becomes the star attraction of the Piccadilly Club, the contradictions of her image necessarily reflect those of Anna May Wong herself, leading to the particular form in which the romantic plot of *Piccadilly* develops.

Anna May Wong brings to the part of Shosho the democratic 'flapper' style that had already been part of her image in her Hollywood days, off-screen rather than on. As the flapper image rapidly travelled across the world and flourished in China during the late '20s and into the '30s, Wong's modernity reflected both her American and her Chinese identities. Shosho's image builds on Wong's own gamine look, and her fashionably slim and slightly androgynous figure. Fanny's short skirts and cropped hair also mark her flapper image. The transition from worker to flapper is conveyed in a scene immediately after the factory whistle blows to announce the beginning of wakes week: a row of young women are shown kicking off their working clogs and fastening the straps of fashionably elegant, high-heeled shoes. But Fanny and Shosho's modern femininity goes beyond fashion. Both young women encapsulate a modernity of mentality, demonstrated by their intelligence, independence, confidence and courage. In both films, these attributes are enhanced by a contrasting female iconography: Fanny's energy and easy unconventionality is contrasted with Allan's fiancée Beatrice (Gladys Jennings), passive, long-suffering and long-haired.

Similarly, Gilda Grey's Mabel (the dancer who is in love with Valentine, who he will replace with Shosho at the Piccadilly Club) has an essentially fussy glamour. Her feathers and furs and tight-waisted costumes associate her more with older, pre-World War I fashions. As Shosho and Valentine's romance develops, Mabel succumbs to jealous fainting fits and hysterics, reminiscent of an old-fashioned Victorian femininity in contrast to Shosho's cool and collected self-sufficiency.

But the films' differing aesthetic modes determine their actual depiction of romance and their heroines' diverging fates. The second part of *Hindle Wakes* is a close adaptation of the original play and is concentrated on the aftermath of Fanny and Allan's affair, leaving the week of their actual romantic involvement off-scene. The point of Stanley Houghton's play lies in its closing moments: Fanny rebels against the two families' decision that she and Allan should marry for the sake of respectability. Left alone together during the family 'conference', Fanny explains the concept of sexual equality to Allan (to his mix of apprehension and admiration) and the actual nature of their affair. 'You're a man, and I was your little fancy. I'm a woman and you were my little fancy.' Fanny's modernity, therefore, lies not only in her flapper style and her sexual freedom, but also, and indeed more so, in her ability to analyse the relationship, locating it in gender terms and equality of the sexes in sex. She also understands that her personal, and thus her sexual, independence is based on her economic self-sufficiency. As she leaves her parents' house she rejects offers of help saying: 'I'm a Lancashire lass and, as long as there're spinning mills in Lancashire, I can earn enough to keep myself respectable'. However, the ultimate message of *Hindle Wakes* is that, for Fanny, life goes on. The film's final scene shows her approached by a fellow worker as she tends the spinning machine; in answer to his question 'Coming to the pictures tonight, Fanny?' she looks at him approvingly and says 'Ay, 'appen I will'. The film uses Fanny's character as an icon of modernity first of all in terms of content and event but also through its use of contrasting styles of acting: both Allan and Fanny's parents are played by established actors of an older generation, whose reactions and gestures all tend towards exaggeration and theatricality; while Estelle Brody's Fanny is played with a simplicity and naturalism that clearly belongs to the cinematic age.

While both *Hindle Wakes* and *Piccadilly* belong, in principle, to the genre of romance, both films use their modernity to suggest that the female consumer of the love story had moved beyond a traditional 'happy ever after' ending. But in contrast to the naturalistic, 'life goes on' aesthetic of *Hindle Wakes*, the aesthetic of *Piccadilly*, on the contrary, is essentially inflected by the presence of Anna May Wong and the nature of the production itself. The romantic involvement between Shosho and Valentine, depicted on-screen as a smouldering *amour fou*, equally avoids a happy ending but is overtaken instead by the death-ending implicitly necessitated by interracial sex: a necessity which underlies all three chapters in this second part of the volume devoted to 'Impossible Loves'. Thus, while Wong's star presence enabled the film to be made, her ethnicity brought with it a 'difficulty' that had affected her own career and the narrative structure of the films in which she performed. The background to her career and her, on the face of it, strange

presence in a British production bring together the external constraints on the depiction of romance with their realization in narrative and on the screen.

Anna May Wong was born to a third-generation Chinese family in Los Angeles. Growing up during a period in which the racism and discrimination that haunted the United States also deeply affected the Chinese community, Wong found her Hollywood career restricted by the paucity of parts available to her. Over and over again, the problem of 'miscegenation' left her in supporting roles, unable to form part of the central romantic coupling essential for Hollywood stardom. However, she gained a certain international recognition and left Hollywood for Berlin in 1928 (the German industry being the only rival to the US at the time). In Germany, although 'exoticized', she was also received as American, modern and a Hollywood star. Films were constructed specifically for her, her image was celebrated and her access to leading roles and stardom was assured. Wong's success in her Ufa films led British International Pictures to offer her a contract in a collaborative deal with several European companies. Inevitably, only a love story could do justice to her particular charisma and glamour and thus fulfil the purpose behind the various commercial expectations at stake in this deal. Arnold Bennett was brought in to construct a London story for a Chinese actress, presumably due to his wide popularity in the UK; but more importantly, he had a large following and considerable reputation in the US – confirmed by a very successful lecture tour just before World War I. Were the film to succeed commercially, it would have to succeed in America where the rules about on-screen representations of so-called 'miscegenation' were strict. Thus scenes implying sexual relations between the couple could only be limited and, indeed, Valentine and Shosho's kiss, although shot, was cut from the final version of the film (Anna May Wong specifically mentioned her regret that this particular taboo could not be broken). From this perspective, once the romance between Valentine and Shosho became fully sexualized, Shosho's persona would have to be subordinated to the otherness that leads to narrative 'execution'.

Despite the ending, the power of the story depends not only on the erotic relationship that develops between Valentine and Shosho, but also on its cinematic figuration. Shosho/Anna May Wong's first appearance on-screen is carefully dramatized, using the topography of the Piccadilly Club to give her erotic presence extra significance, evoking the unconscious nature of desire. An incident in the Club disrupts its special attraction – a nightly dance act, a mixture of sophisticated ballroom and solo performances by Victor and Mabel – when a tipsy customer (Charles Laughton's first appearance in film) complains loudly about a dirty mark on his plate. When the *maître d'hôtel* explains to Valentine that this is not the first incident of this kind, the latter embarks on a journey of investigation. He descends down the Club's social scale from restaurant to kitchen to the scullery, to find the workers, distracted from their washing-up, watching entranced as a young Chinese girl dances for them. Valentine's journey echoes the opposition between East End and West End that marks his relationship with Shosho, but also evokes the topography of the psyche, in which the conscious mind shores up its defences against its own 'lower depths'. In a kind of carnivalesque reversal, Shosho has transformed the site of

degraded labour into a mirror of the heterotopic space 'in front'. If the mark on the plate has functioned initially as a sign of the abject and of collective transgression, it mutates into a signifier of Shosho herself, leading Valentine into 'another world' of erotic desire.

That same night, Valentine fires Victor for making a public advance to Mabel and, without her caddishly suave partner, the business loses its main draw and soon begins to fall into decline. To try to save the fortunes of the club, Valentine remembers Shosho's mesmeric dance and decides to present her as a 'speciality act'; she is an immediate hit. Shosho and Valentine are visibly drawn to each other, leaving Mabel and Jim consumed with jealousy.

Valentine and Shosho's mutual attraction is depicted mainly through an exchange of looks, and this erotic balance is maintained by underplaying any opportunities for a voyeuristic gaze. Their physical relationship develops around a series of isolated gestures, which lead up to the final love scene. When Shosho first returns to the Piccadilly Club after Valentine asks her to perform, he glances at her while sketching her face and repeatedly writing her name. This seems to be a gesture of displaced voyeurism, a capturing of the woman, but through her face and name rather than as sexualized spectacle.

Just as the camera had enhanced the heterotopic spaces of the funfair and the nightclub, so the film makes Anna May Wong into the supreme point of attraction, beautifully lit, framed and filmed. *Piccadilly* essentially celebrates Anna May Wong's *photogénie* – the quality that French theorists of the 1920s identified as specific to the cinema, encapsulated in the relation of the camera to, for instance, an object, a landscape or a face. The love story itself further enhances *photogénie*: emotion is materialized in its turn. This is a lingering cinema, delayed by affect rather than driven by action, in which the literal figure of the star has to mutate into a figuration of feeling. Wong's performance in *Piccadilly* revolves around details of gesture and look, mediating between the texture of the film and the emotional events of the story.

Tim Bergfelder, in an article on Anna May Wong's European image, comments on the way that its inherent contradiction had a particular significance in the context of the contemporary film industry. He says:

> The fact that her image was bound up in contradiction and conflicting cultural perceptions was not an obstacle but contributed to the success of her image. In other words, Wong's persona functioned to some extent as a free signifier, which could be imbued with various meanings. From the beginning, Wong's European producers and directors aimed at rendering her exotic identity indeterminate and therefore easily consumable. (Bergfelder 1999: 321)

But beyond Wong's qualities as 'free-floating signifier' she also brought to her image the specific resonances of the young modern woman. Furthermore, her press build-ups and publicity throughout her European career all emphasized Anna May Wong's own personal, off-screen modernity, her stylishness, her engagement with contemporary

culture, and, very particularly, that she was an American star, a Hollywood star. In their depiction of love relations through the lens of modern femininity, *Piccadilly* and *Hindle Wakes* could make a key contribution to the transnational mode of address to which the British film industry of the late '20s aspired.

## To conclude

The love story as a genre tends to address a female audience, to revolve around desire, leading to questions about the relative freedoms and constraints associated with women's sexual autonomy. Love stories touch certain social nerves and leave behind, even at their most clichéd, questions about the kinds of barriers and taboos that their fictional couples can or cannot transcend. Sentiment, the 'soppiness' of the love story, may thus also be intensely social – as feminist theorists of the melodrama have been pointing out for some time. Following the Women's Liberation Movement's slogan 'the personal is political', the analysis of love, sentiment, sexuality, emotion and so on in film and literature have been crucial in illuminating the 'poetics' of women's emotional discourses, translating 'feeling' into historical and social context, and underlining, if by a knight's move, Freud's insistence on the central place occupied by sexuality and its complications in human life.

Finally, I would like to return to the economic and industrial background laid out by Andrew Higson (in Chapter 2) in which he describes the contemporary crisis in the British film industry. Just as the modern confronts tradition, the trans-class romance draws attention to barriers and celebrates challenges to them. These love stories that feature couples from diverse social, national or ethnic backgrounds were made as British cinema was reaching towards Europe and European cinema was itself attempting to cross national barriers. These films, very 'English' in their settings and stories, are also emblematic of the tension in national cinemas at the time: how to make films that would be relevant to their own citizens but would also find a language, conceived at the time as 'universal', that would allow them to travel internationally. I would suggest that the modernity of *Piccadilly* and *Hindle Wakes*, encapsulated by their female protagonists, their topographies and their particular love stories, emerge materially and symptomatically out of this economic and even political substructure.

## References

Bergfelder, T. (1999), 'Negotiating exoticism, Hollywood, Film Europe, and the cultural reception of Anna May Wong', in R. Maltby and A. Higson (eds), *'Film Europe' and 'Film America': Cinema, Commerce and Cultural Exchange, 1920–1939*, Exeter: Exeter University Press, pp. 302–24.

Foucault, M. (1986), 'Of other spaces', *Diacritics* 16, pp. 22–27.

Goldman, E. (1914), 'The English drama: Stanley Houghton, *Hindle Wakes*', in *The Social Significance of the Modern Drama*, Boston: The Gorham Press, http://sunsite. berkeley.edu/Goldman/Writings/Drama/hindle.html. Accessed 29 May 2010.

Hansen, M. B. (2000), 'The mass production of the senses: classical cinema as vernacular modernism', in C. Gledhill and L. Williams (eds), *Reinventing Film Studies*, London: Arnold, pp. 332–50.

# Chapter 5

## *La dame de Malacca* or Eurocentrism's dream of omnipotence[1]

Luisa Passerini

L*a dame de Malacca/Woman of Malacca*, directed in 1937 by Marc Allégret and starring Edwige Feullière and Pierre Richard-Willm, belongs to the sizeable corpus of European films that deal with colonial relationships.[2] This European film genre is of particular interest for study of the European colonial imaginary since it offered audiences a concrete vision of a colonial world of which, for the most part, they had only an abstract notion. Cinemas – in addition to the circulation of colonial imagery in advertising (McClintock 1995) – were the principal places where the mass public was able to see images of Europe's colonies, which thereby took on material form in their minds (Sorlin 1991–92). In the late 1930s, cinema attendance in France, although smaller than in Britain or the United States, had reached substantial levels at around 220 million visits a year, against a total population of around 40 million; that is, an average attendance of 5–6 times a year per head of population (Crisp 1997: 213). *La dame de Malacca* was highly popular with audiences in its day, as we shall see. Analysis of the models of colonial love relationships offered to spectators by this film can, thus, help us to understand the French colonial imaginary of the 1930s. The film is relevant to this volume since, as I hope to show, it contributes to the widespread notion – discussed in the introduction – that courtly/ romantic love is a uniquely European phenomenon which occurs only exceptionally in relationships between Europeans and non-Europeans.

There are several other reasons why critical discussion of this particular film can contribute to historical understanding of attitudes towards love-relationships between Europeans and non-Europeans in the 1930s. First, *La dame de Malacca* is one of the few French films of that decade that allow a love story between a European woman and a man of a different race and culture to have a happy end.[3] Countless other French films of this period tell stories of impossible love, not only between whites and people of colour but also between people of colour from different cultures. This reflects and reinforces the generalized taboo on mixed unions, the *couple interdit* being a touchstone of racism and discrimination (Poliakov 1980). Abdelkader Benali has noted that the 'couple impossible' is a feature of French cinema, observing that, in films set in the Maghreb, relationships between a white woman and a Maghrebi man appear very rarely; their union is never sexually consummated, while unions between a white man and a Maghrebi woman can be explicitly sexual (1998: 271–88). In the latter case, the relationship is possible only if the woman rapidly assimilates. Furthermore, the mixed couple can exist in the metropole but not in the colonies, where it comes up against all manner of cultural, political and moral obstacles.

This pattern is no different in literature. Colonial novels are sad, writes Alain Ruscio, because most of the time colonial loves were sad. According to his broad survey of French literature on this topic, happy love relationships between colonized and colonizer, except when absolutely ephemeral, are quite exceptional, occurring only in a tiny number of narratives. These happy exceptions mostly involve love relationships between a female colonized and a male colonizer (Ruscio 1996: 15–17). *La dame de Malacca* is an exception both to overall French cultural production of the time, and to Allégret's own cinematic *oeuvre*, in which happy endings are rare.

*La dame de Malacca* complicates the vision of colonialism often assumed by postcolonial theory in that it extends the range of colonial positionalities and shows the complex relationships between them. A postcolonial gaze should be able to see not only subordination and oppression (Mezzadra 2008), but also areas of disagreement between the oppressors and the existence of different forms of oppression – something that is crucial if we are to appreciate the complexity of postcolonial scenarios (Blanchard, Bancel and Lemaire 2005) and their challenge to the totalization of imperialist discourse (Gandhi 1998). This film has been chosen as a case study because its analysis can contribute to a more nuanced postcolonial history of European subjectivity and to a critical history of the emotions in a European colonial context. It is not without relevance here that Allégret had firsthand knowledge of colonialism as André Gide's travel companion on his famous 1925–26 voyage to the Congo.

A further reason for choosing *La dame de Malacca* as an object of study is that its relationship to its source text – the 1935 popular novel of the same title by the Paris-based Belgian writer, Francis de Croisset[4] – is particularly suggestive for an understanding of the cultural imaginary of the period. On the one hand, the relationship between the literary and cinematic versions and the audience response to both tell us much about the role of audience identification in promoting certain readings of the mixed-race plot. At the same time, the changes introduced by Allégret in his film adaptation are indicative of his priorities, as well as of the constraints on – and advantages of – cinema as a medium.

The film's interest for the cultural history of reception is also relevant to an understanding of changing attitudes towards the relation between conceptions of love and conceptions of Europeanness. Although highly successful on its 1937 release, after World War II the film fell into total oblivion. It is interesting to note the contrasting fate of another film – *Gribouille/The Meddler* (aka *Heart of Paris*) – made by Marc Allégret in the same year. Both films played in major Paris picture houses in 1937 (Vuillermoz 1937). But *Gribouille* remained popular and is mentioned in several histories of cinema, while *La dame de Malacca* disappeared from cinematic circuits and discourse. Even at the time, some critics preferred *Gribouille*, which they found more moving and better made; for example, the magazine *Pour vous* gave *La dame de Malacca* only a 'mention B' as a commercial comedy. Probably not irrelevant here is the fact that, by contrast with *La dame de Malacca*, *Gribouille* does not allow a happy end to the central mixed relationship – intra-European in this case. The French male protagonist – the 'fool' of the film's title – fails

to cope with his desire for the young Russian woman he has introduced into the family and strikes her violently. The film's ending holds out two possible solutions: expulsion of the stranger in order to preserve the identity of the family and the nation, or her ambiguous incorporation through marriage to the male protagonist's son, a solution which encourages the protagonist's fantasmatic incest (Burch and Sellier 1996). This denial of a happy end to a Russian-French love relationship evidently continued to connect with audiences in the post-1945 Cold War climate, whereas *La dame de Malacca*'s positive representation; of a mixed union in the colonies may have become unpalatable after World War II, at a time when the decolonization process was getting underway.

Indeed, *La dame de Malacca* was recovered only recently, extant copies being in very bad condition, with half the soundtrack lost. In the early 1980s the film distributor Nicole Osso decided to restore it. The music and sound effects were recovered from the German version, with the original novel providing some of the dialogue. A young deaf-mute woman clinched the reconstruction of the dialogue by reading the actors' lip movements, and the original actress Edwige Feuillère then dubbed herself. The final re-editing was done with the help of the German version.

The technical invention of dubbing dates back to before this film, since in 1931 it became possible to mix separate audio tracks and to synchronize voice and lip movements, and from 1932 dubbing and subtitling started to be routine (Bordwell and Thompson 1994: Chapter 9). However, the previous system of multilingual versions was still used for *La dame de Malacca,* filmed simultaneously in French and German by two different casts, using the same set.[5] The decision to shoot separate French and German versions was probably taken so as to cater to different national tastes by using different actors for each version. It was also a way of coming to terms with Europe's cultural diversity (Garncarz 1999), and of coping with the fact that a national cinema is defined principally by its degree of intertextual reference to the respective national culture and its dominant narrative patterns (Vincendeau 1999).

The film's restoration was completed in 1986, when it was screened on French television's third channel, attracting interest and praise as a 'délicieux mélo' ('delightful melodrama') (de Maulde 1986). The decade of the 1980s was a time when postcolonial theory was starting to make its mark. That a colonial film which had been highly popular in the 1930s should be forgotten after World War II but be recognized in the mid-1980s tells us something about the evolution over this period of attitudes to mixed-race love relationships in a colonial setting.

## Allégret, Gide and benevolent colonialism

Allégret had known André Gide, a family friend, since childhood (he called Gide 'Uncle André'). They became close in 1917 when Marc was 17, and their correspondance dates from this year. In June 1918, Gide took him on a trip of several months to England; this

aroused the jealousy of Gide's wife, who in retaliation burnt the numerous letters Gide had written to her. In 1925–26 Gide and Allégret went on another trip – the famous 'Voyage au Congo' recorded in a 1927 film made by Allégret, and in Gide's notebooks, both bearing that title. According to Durosay (1992), the Congo represented for Gide a Baudelairean dream world, where natural freedom, spontaneous eroticism and sensuality reigned. Gide later wrote (1927) that his eyes opened in the course of the trip, adding that one did not travel in the Congo for pleasure and that, to understand the country, one had to expose oneself to risk and be free from commercial or religious interests. The social and economic problems in French Equatorial Africa prompted Gide to start a vigorous polemic denouncing French administrative corruption and abuses, and defending indigenous rights. Although Gide's position was not strictly anti-colonial, it influenced anti-colonial movements. Colonization is bad, Gide wrote, if the moral and material interests of the colonized and the colonizer are not harmonized. He attacked the franchise system which gave rise to extreme exploitation, and denounced the scandalous conditions whereby companies obtained monopoly concessions over the entire produce of immense regions, which until then had belonged to the native people. The local population was thereby driven into forced labour, without the hygiene or other measures promised by the companies as part of their 'civilizing mission'. This system, Gide noted, had a disastrous impact on families, birth rates, culture and the country's general welfare, leading to atrocities sometimes perpetrated by indigenous militias but instigated by the companies' agents. The companies should thus, Gide insisted, be held accountable for these crimes.

Allégret's vision of the relationship between colonizer and colonized was also influenced by contemporary cultural events. From his correspondence it seems certain that he visited the first Paris exhibition of 'Art Nègre et Océanienne' in May 1919. He also saw Robert Flaherty's documentary film *Nanook of the North* (1922), which inspired him to make his film reportage on the Congo (Houssiau 1994: 65). Allégret inserted into this documentary the fictional love story of a young couple beset by economic hardships, thus contributing to the then new genre of *documentaire-fiction* (Houssiau 1994: 69). Allégret claimed to have had good relationships with the Africans, including erotic liaisons (notwithstanding his closeness to Gide, he always felt free to have amorous and sexual relationships with women). When he presented *Voyage au Congo/Journey to the Congo* in Brussels in 1928, he declared: 'Many of these peoples' customs are very like our own and testify to the same needs and concerns' (ibid.: 72–4).[6] Allégret aestheticized his admiration for the local peoples, observing that, while Europeans were constricted by clothing, the natives, who had always been naked, moved with the same grace, precision and restrained energy which we admire in tigers or cats; he also produced a collection of photographs of naked bodies (ibid.: 73). This aestheticization of African bodies, with its insistence on elegance and grace rather than on violence and barbarity, differed from traditional European depictions of African sexuality. However, such exoticizing and paternalistic comments, while articulating a complex mix of colonial attitudes, reveal the Eurocentric and ultimately racist vision underlying Gide's and Allégret's benevolent colonialism.

Between *Voyage au Congo* and *La dame de Malacca* Allégret treated race relations in other films, for instance in *Le blanc et le noir/White and Black* (1931) and *Zouzou* (1934). The former, based on a Sacha Guitry stage comedy, helps us understand how sensitivity to racial issues in the 1930s differed from today's sensibilities. The male protagonist of the film – whose wife, in revenge for his infidelity, has had a one-night stand with a singer at their hotel, not realizing in the dark that he is black – takes it for granted that he cannot accept the black baby to which his wife gives birth. He has no qualms about disposing of the child, who simply disappears from the plot when he replaces it, unbeknown to his wife, with a white baby procured from the local orphanage. It is likewise presented as entirely normal that the male protagonist should fall in love with the white baby, despite it not being his own child. Reviewers – who found the film too theatrical, although well acted – did not seem to notice the racist implications of much of the dialogue, not to mention the plot (Amony 1931). That the subject of race could be treated in such a frivolous and ironic fashion (the comic husband was played by Guitry himself) is telling. The configuration of exoticism, benevolent racism and Eurocentrism was a widespread way of feeling white/European at the time, and was not perceived as being incompatible with progressive attitudes.

*Zouzou*, too, is relevant for the representation of race. The protagonists Zouzou and Jean are played by the African American performer Josephine Baker – whose starring role made this Allégret's best-known film – and the French movie star Jean Gabin. The film (a musical) offers a variation on the theme of the impossibility of sexual union between the races: Jean, who dearly loves Zouzou as a friend and sister (both are adopted children), never sees her as a possible romantic attachment, despite her transformation from laundry girl to music-hall star (compare Anna May Wong's role in the 1929 film *Piccadilly* analysed in Chapter 4). Baker plays a wonderful Zouzou, who tries in vain to reach Jean's heart. Her charm is limited to the stage, where as a dancer she 'exercises a special fascination over the tired white man for whom joy is often only a word', as one reviewer put it (Escoube 1934). This limitation is well represented in her final spectacular singing act imprisoned in a cage hanging from the stage rafters. Her body is portrayed as sexual and innocent at the same time, both elegant and graceful, reproducing the stereotype Allégret had conveyed in *Voyage au Congo*. The fact that Zouzou is presented as much more attractive – though not for the common man played by Jean Gabin – than the white female protagonist of *La dame de Malacca* tells us much about the colonial gaze. But the film's hero played by Gabin cannot be accused of straightforward racial prejudice since he regards Zouzou as his beloved sister.

In addition to Allégret's interest in depicting mixed-race liaisons in his films, he was also involved in efforts to produce a French national cinema which could be defined as genuinely European, in 1930 being co-founder of the shortlived production company Film Parlant Français (FPF). The other co-founders included the writers André Gide, Jean Giraudoux, Roger Martin du Gard, André Maurois, Paul Morand and Jules Romain (Durosay 1992). These two interests were evidently felt to be compatible, for the depiction of mixed-race liaisons was understood as a way of expressing Frenchness.

## The written, the visual and beyond

Consideration of *La dame de Malacca's* relation to its source text by Francis de Croisset can tell us a great deal, not only about the choices Allégret made in his cinematic representation of the novel's mixed-race love plot, but also about the audience identification facilitated by cinema: an identification that is crucial to spectators' internalization of the racial attitudes conveyed. The novel, published in a first edition of 1500 copies, was very well received by critics and the public and had 21 reprints before 1948.

Critics generally praised the cinematic adaptation of the novel. Georges Champeaux congratulated the scriptwriters, Claude-André Puget and Georges Lustig, for having added scenes which did not exist in the book but which faithfully captured the novel's spirit by ingeniously translating analytical passages into images. Indeed, he noted that this was done so successfully that spectators who had read the novel became convinced that these added scenes had figured in the original literary text (Champeaux 1937). This remark shows how, in the case of literary adaptations, audience reception sets up a two-way relationship between the written and the audio-visual: on the one hand, the film is interpreted in the light of its source text; on the other hand, the original novel comes to be visualized retrospectively in terms of the film version. This circular relationship was developed by viewers' imaginings and critics' interpretations, but it was set up even before the film was viewed thanks to the lead actors' star image. The critic Odile Cambier, in the magazine *Cinémonde*, quoted excerpts from a letter to Edwige Feuillère from a Miss J. G. of Brussels:

> I await your new film, *La dame de Malacca,* with the greatest impatience. When I learned that you play the lead role, I bought the book and, as I read it, gave the characters the looks of Edwige Feuillère and Pierre Richard-Willm. Reading a book this way is hugely enjoyable, because I am so used to seeing the two of you perform that I had the impression I was watching the action on-screen. (Cambier 1937a)

This kind of audience response to the film – and even to the mere announcement that the film is being shot – helps us understand how spectators' identification with its stars may have affected their reading of the mixed-race romance plot of both the film and its source text.

Film magazines encouraged this exercise of the imagination. For instance, *Cinémonde* published two full pages of stills with a montage of letters by the protagonist Audrey – non-existent in the novel and film – to her friend in Europe (Cambier 1937b). These letters, invented by the journalist (Cambier again), add to the exoticizing views attributed to Audrey, who in them describes visiting the native town and there finding intact her dream – induced by her readings – of exotic smells, songs and dances. Audrey exclaims: 'So that wonderful novel setting really existed!' The film magazine thus 'invents' letters which reproduce the trope that what Audrey sees (and the film audience sees with her) has

a literary original. We may remember here Hamid Naficy's observation that epistolarity within the film diegesis suggests and evidences distance (2001: 150–51). This magazine feature seems to play with distance since Audrey's letters emphasize it, but also encourage readers to identify with her travel to distant lands at the same time as creating a bond between the Orient and Europe.

The film cuts many of the novel's descriptions of the characters' emotional and sexual life, such as Audrey's romantic relationship with a previous fiancé, her brief adventure on the boat with a young officer, the sex imposed on her by her husband, and the allusion to her sexual relationship with the Sultan (Selim) when she recovers from her illness. In the film, the Sultan never appears with his wives nor is it mentioned that they will be repudiated when he realizes he is in love with Audrey. Furthermore, while in the novel the Sultan wears a European suit with a toque and earrings plus other jewels, in the film these Oriental trappings are absent. If the censorship of these emotional and sexual aspects can be attributed to period tastes and anxiety about their explicit visual representation, the other cuts concern elements that would have constructed the Sultan visually as too Oriental. The intense audience identification with two white stars, known for playing on-screen couples, reminds us that audiences viewing their on-screen romance were all too aware that the two lovers were 'really' both white, allowing acceptance of a plot that is likely to have been found unacceptable had the Malay male protagonist been played by a non-white actor. Indeed the film adopts the opposite strategy: making Selim look European (see Figure 7).

This is consistent with the type of emotion around which the story is centred. While readers of the novel are free to envisage the protagonists in their imagination according to their own inclinations, the film has to present a visual representation of the two lovers that is acceptable to all audiences. Not only is the Sultan European-looking and taller and more fair-skinned than Audrey's husband, but the physical contact between the two lovers is reduced. While one scene shows Audrey avoiding sexual contact with her husband by pretending to be asleep, the attraction between her and the Sultan is visually devoid of any sexual element. Selim touches her only when she is in danger: during the storm on the boat, he embraces her in order to drag her away from the deck; in Rahajang, he does the same twice: in order to save her from an enraged crowd and when he enters the hotel room in which she is lying unconscious. The night-time scene in which the Sultan and Audrey take part in the local festival has a highly-charged erotic and exotic atmosphere, yet it is conspicuously lacking in explicit sexual references: the figures of the two would-be lovers stand out against the dark background, radiating light and reflected in the water, but the contact between their bodies is chaste. Selim shows evident signs of erotic desire when he asks Audrey whether she really does not mind his race, and hugs her tightly trying to kiss her, but she cries out that she is not free and runs away. The contrast could not be stronger with the book, in which the same scene includes a burning kiss. In the film, as Selim recaptures Audrey and implores her not to deprive him of her presence (a very 'courtly' phrasing), the camera does not show them but focuses on the festive locals, including smiling women with bare breasts entwined with young men, as if to insist on the

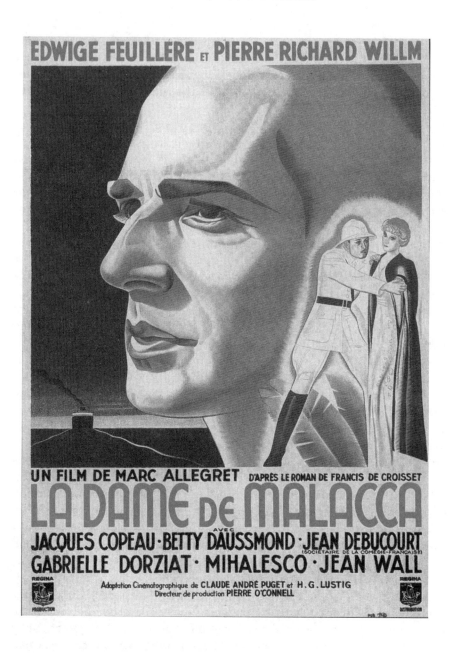

Figure 7. Poster for *La dame de Malacca* (Allégret,1937).

divergence between free local customs and the rules of western love. The novel closes with half a page devoted to the description of Audrey's and Selim's 'avid' repeated love-making, while the film's end leaves us with the image of an algid, ethereal Audrey interviewing the Sultan about interracial love, with only a tender conjugal hug between the two.

The film's adaptation of its literary source text thus adheres to a stereotypical understanding of courtly love as implying a lack of physical contact between the lovers, and with the woman having the status of remote love object rather than active subject of the love discourse. As I have noted elsewhere (Passerini 2009), this reductive interpretation of courtly love, although historically inaccurate, was prevalent in 1930s Europe, including France. Allégret's film strengthens the element of distance between the lovers and underlines the aristocratic exceptionality of his protagonists' love relationship. Audrey's romance is not with any Oriental man; it is with a prince, who will make her a Sultana. From a historical point of view, one should remember that, in most colonial film comedies, which typically reproduce attitudes associated with the bourgeois couple, love was represented in a disembodied fashion, suggesting rather than representing eroticism and sexual desire. This was not necessarily the case in the popular literary genre of the colonial novel, which did not have to deal with the issue of visual explicitness.

In any case, de Croisset's novel lends itself particularly well to cinematic adaptation because it not only contains many references to films, but its characters are impregnated with film culture and look at things through cinematic eyes. The novel also insists on its own fantasmatic nature. Its author warns readers at the start that the Sultanate of Udaigor and the city of Rahajang are invented names, and that the reality they designate is itself fantastic and prodigious: 'in the Far East, truth and legend are mixed' (de Croisset 1935: 55). Even before they meet, Audrey is presented in the novel as enamoured of the Orient as an escape from European moral strictures. Thus, in a sense, the Far East functions for Audrey and for the novel's readers as a kind of cinema: that is, an imaginative projection of desire.

The film does, however, pick up the novel's stress on Audrey as a modern woman, appropriately given that cinema is a modern medium. She earns her own income by writing and taking photographs for the press. She smokes, which in the film provokes a reproach from the head of the strict boarding school where she teaches in Le Havre: it is this reproach that pushes her into marrying the military doctor Herbert, so she can leave for the Orient with him. She has left Europe for cigarettes, she tells the Sultan when they first meet in the film, and he asks a question that she prefers not to answer: 'Are you happy to have left Europe?' Selim too is portrayed as modern, which in his case means that he champions western technology and planning: he is responsible for bringing irrigation, the railway and hospitals to his kingdom. He is tolerant and respectful of other people's beliefs: for instance, although as a Muslim he is the religious head of his people, he secures permission for Audrey not to renounce her own religion on celebration of their wedding according to the traditional Muslim rites. His modernity is thus presented in Eurocentric terms, as if modernity were an exclusively European phenomenon.

In the novel, we are regularly reminded that Audrey is Irish and that she partly owes her rebelliousness to her Irishness. However, in the film she is English. This considerably affects the representation of the Sultan, who in the film is surprised to find himself confessing to having been a victim of racial prejudice in England when studying at Oxford University. The following exchange, which takes place on the Sultan's yacht at the film's end, is completely absent from the novel. In playful mood and in a ravishing dress, Audrey pretends to interview Selim for the *Daily News*:

'What do you think, My Lord, of marriages between Malays and Europeans? No, no, don't laugh, it's a serious issue.'
    'If it's a love marriage, then there's no problem, I know from my own experience.'
    'Even with an Englishwoman?'
    'Especially with an Englishwoman: you know very well that hatred is always close to love.'
    'Then do you authorize me to say that you are happy?'
    'I do.'

This dialogue is a double dig: at hang-ups about mixed marriages and at journalistic reportage. At the same time, it introduces the topic of love-hate relationships: that is, of the attraction towards the racial Other, which is central to the film.

Another significant scene that the film added to the novel is that of the cockfight: a ritual of huge symbolic importance for establishing a contrast between Europeans and Orientals.[7] In *La dame de Malacca*, Allégret shared anthropologists' interest in this practice, which was studied in Bali in the 1940s by Gregory Bateson and Margaret Mead. According to Clifford Geertz (1993) – who attended a cockfight in Bali in 1958 – this sport was an intrinsic part of Balinese male identity; one of the few cases of a single-gender public activity, although European women might occasionally be present. Despite the colonial government's ban on cockfights in the colonial period, the practice persisted among the poorer classes, while the local élites tended to consider the sport primitive. Participating in cockfights was thus an entry ticket to a society that was extremely hard to penetrate. If we transpose these observations to the scene in which Audrey and the Sultan watch the cockfight, the episode takes on the highly symbolic meaning of introducing her, dangerously, to the exotic world of the Orient. This was also a way for Allégret to revisit – ten years after his trip to Africa – the *documentaire-fiction* genre, understood as a contribution to visual anthropology (Pennacini 2005). This ethnographic intent pervades the whole film, which documents the trip from Le Havre via Port Said to Colombo and finally to Rahajang, showing images of local life at each port.

Finally, the film is more successful than the novel in achieving a balance between its central love story and its political subplot, introducing an element of colonial critique. In the film, the Sultan accepts the Japanese request to allow a military outpost on his territory (explicitly intended to target the British military base, under cover of a rubber factory) at an

early stage of the story, already on the boat out to the Orient, while in the novel this political element is introduced only at the end, when Audrey is already ill. Therefore, in the novel the decision of the Sultan appears to be taken largely for personal reasons, in order to blackmail the British governor and thus help Audrey take her revenge on his wife, who had hounded her. Thus the film's plotline more credibly conveys the idea of the Sultan's uneasy relationship with the British colonial authorities, one of simultaneous collaboration and conflict: that is, a love-hate relationship, echoing Selim's final words to Audrey. Moreover, the British colonial governor openly threatens to bomb the factory-fortress if the Sultan does not have it destroyed, backing his threat with a display of aerial and naval military might. Allégret thus incorporates a denunciation of British colonial domination into his romantic comedy. This is not an example of anti-colonial sentiment; rather, the denunciation of British gunboat diplomacy implicitly affirms the need for a superior benevolent colonialism.[8]

## Passivity/activity as a way to omnipotence

The depiction of Audrey as a dreamer not only represents her as passive – like the female object of desire of courtly love – but also, paradoxically, gives her a Eurocentric omnipotence. Passivity and activity can thus merge in the imaginary of the audiences as the dialectic poles of a type of western feminine power exalted by courtly and romantic love.

Film audiences embraced the dream of the couple united by romantic love, especially but not exclusively in the case of female spectators. In the 1930s, film critics and journalists regularly marveled at the mass infatuation with movie stars, noting that fans' 'impossible faithful love' for stars was directed particularly at screen couples, such as Fred Astaire and Ginger Rogers or Edwige Feuillère and Pierre Richard-Willm (Cambier 1937a). In the numerous fan letters to Feuillère and Richard-Willm which the two stars showed her, Cambier found a recurrent sentence: 'I'd like to see you together again.'[9] Letters, written largely by women, came from Bordeaux, Lausanne and Rio de Janeiro. One was sent to Richard-Willm from Berck, in northern France, by a sick teenage girl: 'I am only seventeen but I often think of what the life of an adult woman can be like. [...] for me the future has an ideal face: the couple that you form with Edwige Feuillère. I read in a newspaper that I will see you soon in *La dame de Malacca* and I am avidly waiting for that joy.' The fan letters reported in the magazines show that female spectators responded actively to the films they saw (as they previously had to the theatre), confirming Stacey's argument (1994) that female spectators' practices of cinematic consumption and modes of perception are not entirely recuperable by patriarchal culture, and provide an escape from the drudgery of domesticity and motherhood.

Some 1930s film magazines confirm the appeal particularly to female spectators, with their advertisements largely aimed at women and their assorted beauty tips, encouraging women to consume but also to fashion themselves in the image of the stars they adored.[10] Blurring of the boundary between stars' lives and those of the characters they played

was encouraged by articles written 'on the set', with journalists visiting the actors at the Épinay studios while they were filming. This merging of the real and the fantastic makes the whole film-making operation fabulous, with film spectators encouraged to enter this dream world through an intense identification with the stars whose fictional and actual lives they followed loyally. The point that needs stressing here is that the daydreaming allowed by the cinema is – like all dreaming – a passive-active operation.

Audrey too is a dreamer, representing the connection between the world of dream and that of romantic love, as well as the correspondence between the dreamer's apparent passivity and the woman's role as the object of courtly love (see Introduction). In the filmic version, Audrey's reduction first to total immobility, and then to a dreamy, infantile state where she is spared the need to take any decisions, is significant. In the film, she is shown lying ill in her room in the Chinese hotel, locked from the inside, and, at the end of both the novel and the film, she will reach a steady dreamlike state, prolonged by the Sultan's attentions, and characterized by the mix of activity and passivity that is specific to dreams. Every move is planned for her by the Sultan, who buys her a house and a car, sends money to her girlfriend in Europe for her ticket, and plans Audrey's divorce on the grounds of non-consummation of the marriage. In the novel, she tells Selim: 'My love, it seems to me that I am living in a fairy tale of which you are the magician' (de Croisset 1935: 279). Of course, Audrey's job has to be dropped in this situation: such activity, which the Sultan previously found a coquettish whim, earning her a small salary which he found amusing by comparison with his vast wealth, is now incongruous with the status she has gained through a phantasmatic passivity. But she revives her competence, transposed onto the private sphere, when she interviews Selim in the film's final scene.

Her extreme passivity is originated by the shock of being hounded by her peers – the white women colonizers. She gains the sympathies of others, such as the young Chinese woman who, when Audrey first entered the hotel, had looked like a call girl descending the stairs, but who takes on a simple and domestic demeanour when she stops a sailor from playing a record which might disturb Audrey on her sickbed. This gives a new insight into Oriental women, as we pass from an external to an internal vision. However, Audrey cannot have an equal relationship with the Chinese woman, who cannot save her. It is the Sultan who saves her, transporting her to a second life in which she has to do nothing except see her dreams realized. But by this passivity she actively detaches herself from the other white women in the colony as well as from the native women, reaching a third space in which she can be united with a non-European man and become a Sultana.

Activity and passivity must be understood here as opposites whose pairing is fundamental to instinctual life and therefore to sexual life, according to Freud, in the formulation given by Laplanche and Pontalis (1973: 8–9). At the fantasy level, every passive position is inseparable from its opposite, and the simultaneous or alternating presence of the two poles of passivity and activity can always be found. According to Freud, every instinct is a case of activity, and activity is put into operation by the instinct for mastery. Laplanche and Pontalis insist on the constant distinction between two levels

in instinctual life: the level of explicit behaviour and the level of underlying fantasies, and point to the fact that the final stage towards which instinctual activity leads – that is, a situation which provides satisfaction – is not attained unless the subject manages to take up a position in which s/he is at the mercy of the other. This is the case for both masochism and exhibitionism, as well as for other instances of sexual life.

The representation of activity/passivity can be seen as a way of 'negotiating spectatorship' (Shohat and Stam 1994: 347–59). If media spectatorship involves a three-way communication between texts, spectators and communities existing in discursive relation to one another, in the case of *La dame de Malacca* the concept of negotiation of spectatorship is geared to creating a privileged relation between European women and the female protagonist. European female viewers of the film, encouraged to identify with its protagonist, are offered the possibility that abandoning themselves to their fantasies or dreams – states of apparent passivity – can lead them to mastery. In the film's colonial context, Freud's term 'mastery' implies not just activity but actual domination and omnipotence.

Audrey's mix of activity/passivity can be connected with Laura Mulvey's (1989) views on the overlapping for female spectatorship of two modes of identification: as victim and as hero. Women who see the film or read the novel have the possibility of identifying with the active/passive Audrey and eventually – in a not unusual schizoid manner – with the Sultan in his role of saviour and avenger. All of this has a strong Eurocentric flavour, since the protagonist succeeds in uniting in herself the best of Europe and the Orient, whilst Selim's role is to save her. Spectators can identify with Audrey in the sense of recognizing in her dreams their own dreams and in her weaknesses their own weaknesses. At the same time they can identify with her Eurocentric superiority, understood as a capacity for conjugating modernity and romantic love.

As argued in the introduction to this book, this combination was regarded as unique to Europeans and as a hallmark of European identity. Audrey goes beyond the mean, cruel or ridiculous aspects of colonialism – represented by her first husband and the British colonial wives – and incarnates the possibility of promoting a better world through an emotional colonization, achieved by propagating the notion that romantic love is the West's gift to the non-western world. Thus she gains the highest prize: reciprocal love with a fabulously wealthy prince who unites in himself the Orient and the Occident, but who could never fully accomplish that fusion without her. Since she could not be rescued from her unhappiness were it not for her princely saviour, spectators are also invited to identify with him as the facilitator of this blissful union. Through this double identification with both Audrey and Selim, the film's European viewers are invited to participate in the Eurocentric dream of omnipotence: the dream that Europeans can save the world and that colonialism, while bad forms of it exist, can advance the global progress of humanity. The European concept of romantic love is crucial to this redemptive colonial enterprise.

## Eurocentrism and racial masquerade

*La dame de Malacca* is set in a highly multiracial environment. De Croisset's novel tells us that the town of Rahajang is inhabited by 70,000 Malays, 400,000 Chinese, 50,000 Hindus, 8,000 Japanese, 8,000 Eurasians, 10,000 miscellaneous nationalities, and 7,000 Europeans of whom 5,000 are British – of these only 2,000 are part of respectable society (de Croisset 1935: 92). In this context, the French word *race* has two very different meanings. In the novel, Prince Selim asks Audrey whether she shares British prejudices against his race, reminding her that he might have children as black as his father, and wanting to know whether she could love a man of colour. However, 'in her eyes, he was not a man of colour. She had seen in Ireland and France men who were equally dark but less handsome' (ibid.: 185). The novel plays with another meaning of the French term *race*, close to the English term 'pedigree', which indicates extreme beauty and style. In this sense, Audrey has *race*; that is, an innate style which she cannot lose, and so does the Sultan: 'Quelle race il a!' a woman exclaims when the Sultan appears at his own wedding dressed in an 800-year-old costume. This *race* has something to do with the fact that the prince's mother was white: a Georgian aristocrat who had fled after the Bolshevik Revolution – not by chance had he told his father that he wanted a 'woman white like my mother' (ibid.: 172). In this context these details have a double meaning: not only the psychoanalytic sense of a love that reproduces the mother-child relationship, but also the racial sense of a desire to join the white (mother) race. In the novel, this desire restores 'mother right', correcting the degeneration represented by the Russian Revolution. In the film, the mention of Selim's mother occurs early on, in a conversation during a card game on the boat out to the Orient in which Audrey is informed that the Sultan's mother had been 'just as white as' she is.

The Eurocentric connection between love of the couple and whiteness is strongly present in the novel, which claims that love is unheard of in Oriental marriages. When the previous Sultana dies and Audrey inquires whether she and the Prince had had a 'happy marriage', everyone in her circle laughs and her first husband explains: 'Happy marriage is not an expression found in the Far East' (de Croisset 1935: 91). But Audrey's dream of the Orient inserts love into the picture, transforming it magically. It is not only love between two individuals; it is also love between the races, so long as those concerned are well bred. This is conveyed in *La dame de Malacca*, particularly in the film version, through the trope of disguise, which operates as a symbolic means of mixing different peoples and cultures. Masquerade can easily be connected with love since love is supposed to make one able to take the place of the other, allowing osmosis and reciprocal identification.

In the film, a central role is given to masquerade, in a sociological rather than psychoanalytic sense: that is, as a form of cultural identification (Pizzorno 2005; Sassatelli 2005). For the ball on the ship taking her to the Orient, Audrey wears a Hindu dancer costume, which wins the first prize. She has daubed her skin with a brown liquid, extended her eyebrows, and painted her eyelashes black, and has also painted a round sign on her

forehead. When her husband sees her, he exclaims: 'You are somebody else.' And she will become that somebody else. As soon as she goes out of her cabin in this disguise, she meets the prince, who reproaches her for wearing the sign of Shiva on her forehead: that's not an ornament, he admonishes, it's a religious emblem, which the English don't care about but other people do. Audrey, sensitive to this reproach, wipes the sign off her forehead (see Figure 8).

She can thus be seen as a symbol of the European's dream of omnipotence as benevolent colonialist. Audrey in fact is the bearer of a form of love that is unknown to Orientals, which the Sultan might have desired but has not known. Hence she is the emissary of a higher form of civilization, which implies a more refined type of relationship between the sexes. This gives her an active superiority, which allows her to cross boundaries between one culture and the other in a fusion of the best of both worlds. In this sense, her story is symbolic of the European dream of being able to become everybody, disguising under a so-called universalism what in practice is assimilation. Audrey can assume all identities, incarnating the images suggested by her penchant for exoticism and indulging

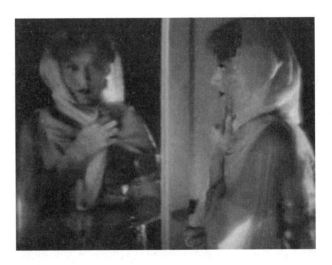

Figure 8. Audrey in Hindu dance costume, contemplating herself before wiping the sign of Shiva off her forehead – *La dame de Malacca* (Allégret, 1937).

in masquerade at her will. She becomes the Other and indeed something even better than the Other – teaching an Oriental man to love, and becoming a Sultana. In this fantasy, Europeans can teach Orientals (provided they are sufficiently aristocratic) to love 'properly', and can impersonate Orientals better than the natives, in the sense that their impersonation makes Orientals more modern, more open and capable of greater happiness. Cinema lets such a dream come true through its technical apparatus, ignoring or disguising everything which appears too openly Oriental to European eyes and yet appropriating the Orient's fabulous riches. Thus cinema updates the myth that romantic love is the unique prerogative of Europeans by giving it a global reach, albeit limited to the colonized upper-classes.

In *La dame de Malacca*, the most evident performance in this sense is that of the Sultan, played by Pierre Richard-Willm. No amount of make-up can conceal the shape of his nose and his pale eyes, to the extent that spectators would never guess that he was an Oriental prince if the film dialogue did not say so. In order to impersonate him, Richard-Willm had to wear a flat black wig. This failed to give him an Oriental look, but he was one of the seven or eight stars that the distributors had asked for. The notion that a French actor could masquerade as an Oriental was indicative of the supposition that European culture, being dominant, could assimilate other cultures to it. By contrast, all the critics agreed that the indigenous extras were wonderfully realistic: no make-up, no disguise, they were real Asians, not actors who needed glue to stretch their eyes (Holeane 1937).

This notion of the Orient as masquerade was reinforced by the sets. According to Feuillère, Allégret and the producer had promised her and Richard-Willm a trip to Malaysia, but for financial reasons they found themselves filming at the usual studios at Épinay-sur-Seine, by the same canals constructed a few months earlier for Feyder's *Kermesse Héroïque/Carnival in Flanders* (1935), a setting easily modified by adding a few junks and the Asian extras (*Excelsior* 1937). The critics responded very positively to the sets, constructed by Jacques Krauss with Alexandre Trauner responsible for the 'décors exotiques', noting that many episodes were so picturesque and the proportions so realistic that viewers forgot they were studio constructions (Regent 1937). Special praise was given to 'the realistic sea storm which gives us a sense of the Far East, its light and its turmoil'. Critics also singled out the atmospheric score composed by Louis Beydts, which reinforced the illusion of the Orient (Vuillermoz 1937).

According to Champeaux, spectators were genuinely disconcerted by the sets: for instance, they did not immediately understand the Chinese hotel, because it was so unconventionally represented. It was the first time, the critic claimed, that a French film about the Far East had succeeded in creating a genuine sense of estrangement (the French term is revealing: *dépaysement*, meaning 'detachment from one's country'). From now on, he declared, 'when someone talks about a Chinese hotel, this is what will come to my mind' (Champeaux 1937). Indeed, when Audrey enters the hotel, we get the impression that she is plunging into a different world (not for nothing was the German version of the film entitled *Andere Welt*). According to Champeaux, the film succeeded – unlike other

films such as *Port-Arthur* (Farkas, 1937) or *Yoshiwara* (Ophüls, 1937) – in conveying a 'sense of exoticism' through its refusal (only partial when viewed today) to make Oriental images familiar by transforming them to suit western tastes.

This type of exoticism was biased and naïve, yet it differentiated Allégret's colonialism from other versions by including a proposal to reform it: a reformist proposal designed to make colonialism more humane by transforming it into a genuine encounter of peoples, which Allégret shared not only with Gide, but with other European intellectuals of the time. Notwithstanding the illusory character of this project, it holds interest for us today as an illustration of a specific historical juncture and as an attempt to expose the evils of a certain kind of colonialism. Both the novel and the film testify to this goal. For instance, when in the novel Herbert yells at somebody in Aden who offers his service as a guide, ordering him to leave, the man replies: 'I cannot go away, sir, I am in my own country' (de Croisset 1935: 58) In the film, this remark is transposed from Aden to the moment of arrival in Malaysia with stronger effect. Herbert, so servile with the British governor's wife, is rude to the servants, meeting Audrey's disapproval. She, by contrast, is kind to them and they will help her when she decides to flee her British colonial home.

In his classic analysis of exotic cinema, Leprohon (1945) noted that the genre first expressed itself in newsreels and then in documentary, only subsequently being taken up by fiction film (*cinéma romanesque*), and that in this field the French were able to use the resources of their empire as a fitting setting for exaltation of the colonial mission. However, *La dame de Malacca* differs from examples of colonial cinema filmed as an explicit instrument of political propaganda in countries like 1930s Italy (Farassino 1999), where such films were made by state-owned production companies. Allégret's film, more subtly, shows romantic exoticism to be a powerful resource for articulating a specific type of Eurocentric colonialist subjectivity, while at the same time projecting the image of a benevolent colonialism contrasted with a mean and oppressive variety. This demonstrates that exoticism's relation to the reinforcement of colonial ideology was multivalent. It could be employed to justify imperial interests and foster racism, but it could also be used to critique the West, at least partially (Bergfelder 1999). The example of *La dame de Malacca* shows how it could be used to critique racism in the sphere of love of the couple.

## Conclusion

In this chapter, I have used a film as a case study in order to critique the association of courtly/romantic love with Europeanness. This involves a positionality located in the ill-defined territory between the disciplines of film studies and cultural history. I hope that this exercise – based on the assumption that visuality is crucial to the negotiation of identities (whether through love or coercion), and that film is a powerful tool for manipulating emotions – has been able to provide some insight into the history of European subjectivity, as manifested in France in the interwar period. The principal finding has been that there

is a convergence between what can be called benevolent colonialism and belief in the supposedly unique connection between love and European identity. This convergence is in line with the European claim to incorporate the colonies into 'universalist' cultural norms by, among other things, exporting the notion that courtly/romantic love comprises the most advanced form of relationship between man and woman. Bringing love into the colonial equation in no way reduced colonial violence; on the contrary, it implied that even private relationships had to be regulated, replacing traditional customs by 'modern' forms of subjectivity. This was tantamount to a declaration of omnipotence in the sense that the European could become or absorb anybody anywhere in the world, reforming non-European cultures by offering them the benevolent gift of love.

## References

Allégret, M., Rabel-Jullien, C. (ed.), and Durosay, D. (intro. and notes) (1987), *Carnets du Congo. Voyage avec Gide*, Paris: CNRS.

Amony, A. (1931), 'Review of *Le blanc et le noir*', *L'Intransigeant*, 30 May.

Benali, A. (1998), *Le cinéma colonial au Maghreb*, Paris: Cerf.

Bergfelder, T. (1999), 'Negotiating exoticism: Hollywood, Film Europe and the cultural reception of Anna May Wong', in A. Higson and R. Maltby (eds), *'Film Europe' and 'Film America': Cinema, Commerce and Cultural Exchange, 1920–1939*, Exeter: University of Exeter Press, pp. 302–24.

Blanchard, P., Bancel, N. and Lemaire, S. (2005), *La fracture coloniale. La société française au prisme de l'héritage colonial*, Paris: La Découverte.

Bordwell, D. and Thompson, K. (1994), *Film History: An Introduction*, New York: McGraw-Hill.

Burch, N. and Sellier, G. (1996), *La drôle de guerre des sexes du cinéma français 1930–1956*, Paris: Nathan.

Cambier, O. (1937a), 'Je voudrais vous revoir ensemble!', *Cinémonde*, 467, 30 September.

——— (1937b), '*La dame de Malacca*', *Cinémonde*, 470, 21 October.

Capussotti, E., Lauricella, G. and Passerini, L. (2004), 'Film as source for cultural history', *History Workshop Journal*, 57, pp. 256–62.

Champeaux, G. (1937), 'Review of *La dame de Malacca*', *Gringoire*, 8 October.

Chantal, S. (1977), *Le Cinémonde*, Paris: Grasset.

Crisp, C. (1997), *The Classic French Cinema, 1930–1960*, Bloomington: Indiana University Press.

de Croisset, F. (1935), *La dame de Malacca*, Paris: Grasset.

Cutter, R. J. (1989), *The Brush and the Spur: Chinese Culture and the Cockfight*, Hong Kong: The Chinese University Press.

Durosay, D. (1992), 'Le film parlant français. F.P.F. et N.R.F.: l'Eldorado du cinéma', in D. Durosay (ed.), *Marc Allégret cinéaste et critique. Extrait du Bulletin des Amis d'André Gide*, 98, April, pp. 263–77.

Escoube, L. (1934), 'Review of *Zouzou*', *Pour vous*, 319, 27 December.

*Excelsior* (1937), 'Review of *La dame de Malacca*', 8 October.

Farassino, A. (1999), 'Cosmopolitismo ed esotismo nel cinema europeo fra le due guerre', in G. P. Brunetta (ed.), *Storia del cinema mondiale*, vol. 1: *L'Europa*, Turin: Einaudi, pp. 485–508.

Feuillère, E. (1977), *Les feux de la mémoire*, Paris: Albin Michel.

Feydeau, A. (1983), *Edwige Feuillère*, Paris: PAC. Revised edition with more photographs 1991.

Gandhi, L. (1998), *Postcolonial Theory: A Critical Introduction*, New York: Columbia University Press.

Garncarz, J. (1999), 'Made in Germany: multiple-language versions and the early German sound cinema', in A. Higson and R. Maltby (eds), *'Film Europe' and 'Film America': Cinema, Commerce and Cultural Exchange, 1920–1939*, Exeter: University of Exeter Press, pp. 249–73.

Geertz, C. (1993), *The Interpretation of Cultures*, London: Fontana.

Gide, A. (1927), 'La détresse de notre Afrique équatoriale', *Revue de Paris*, 15 October, pp. 721–32.

Holeane F. (1937), 'Edwige Feuillère. *La dame de Malacca* reçoit', *Cinémiroir*, 30 July.

Houssiau, B. J. (1994), *Marc Allégret découvreur de stars. Sous les yeux d'André Gide*, La Léchère: Cabédita.

Kemp, R. (1951), *Edwige Feuillère*, Paris: Calmann-Lévy.

Laplanche, J. and Pontalis, J. B. (1973), *The Language of Psycho-Analysis*, New York: W. W. Norton.

Leprohon, P. (1945), *L'exotisme et le cinéma*, Paris: Susse.

Limouzin-Lamothe R. (1961), 'Croisset', *Dictionnaire de Biographie Française*, vol. 9, Paris: Letouzey.

de Maulde, F. (1986), 'Une archéologue de l'écran', *Le Matin*, 7 November.

McClintock, A. (1995), *Imperial Leather: Race, Gender, and Sexuality in the Colonial Contest*, New York: Routledge.

Mezzadra, S. (2008), *La condizione postcoloniale*, Roma: ombrecorte.

Mulvey, L. (1989), 'Afterthoughts on "Visual pleasure and narrative cinema"', *Visual and Other Pleasures*, London: Macmillan, pp. 29–38.

Naficy, H. (2001), *An Accented Cinema: Exilic and Diasporic Filmmaking*, Princeton: Princeton University Press.

Passerini, L. (2009), *Love and the Idea of Europe*, Oxford: Berghahn Books.

Pennacini, C. (2005), *Filmare le culture. Un'introduzione all'antropologia visiva*, Rome: Carocci.

Pizzorno, A. (2005), 'Saggio sulla maschera', *Studi culturali*, 2: 1, pp. 85–109.

Poliakov, L. (ed.) (1980), *Le couple interdit. Entretiens sur le racisme. La dialectique de l'altérité socio-culturelle et la sexualité*, The Hague: Mouton.

Regent, R. (1937) 'Visite à *La dame de Malacca* sur un paquebot naviguant dans les mers de Chine', *Pour vous*, 446, 3 June.

Richard-Willm, P. (1975), *Loin des étoiles. Souvenirs et dessins*, Paris: Pierre Belfond.

Ruscio, A. (1996), *Amours coloniales*, Brussels: Complexe.

Sassatelli, R. (2005), 'La maschera e l'identità. Conversazione con Alessandro Pizzorno', *Studi culturali*, 2: 1, pp. 69–84.

Scott, G. R. (1983), *The History of Cockfighting*, Hindhead, UK: Triplegate.

Shohat, E. and Stam, R. (1994), *Unthinking Eurocentrism: Multiculturalism and the Media*, New York: Routledge.

Sorlin, P. (1991–92), 'L'impero immaginario. Il cinema francese e il colonialismo negli anni trenta', *Materiali di lavoro*, 9: 2–3/10: 1, pp. 249–66.

Stacey, J. (1994), *Star Gazing: Hollywood Cinema and Female Spectatorship*, London: Routledge.

S.V. (1937), 'Review of *La dame de Malacca*', *Pour Vous*, 464, 6 October.

Vincendeau, G. (1999), 'Hollywood Babel: the coming of sound and the multiple-language version', in A. Higson and R. Maltby (eds), *'Film Europe' and 'Film America': Cinema, Commerce and Cultural Exchange, 1920–1939*, Exeter: University of Exeter Press, pp. 207–24.

Vuillermoz, E. (1937), 'Review of *La dame de Malacca*', *Le Temps*, 16 October.

## Notes

1. *La dame de Malacca* has been analysed in a multimedia CD-ROM produced for didactic purposes at the European University Institute, Florence (E. Capussotti, G. Lauricella and L. Passerini [2003], *Moving History*, San Domenico di Fiesole: EUI). The images reproduced here are taken from this CD-ROM. See also Capussotti, Lauricella and Passerini (2004).
2. It is a story of a young English woman, Audrey (Feuillère), who teaches in a Le Havre boarding school run by two stern spinsters, in which she is allowed very little freedom. To escape this situation, she agrees to marry a military doctor, Herbert, and to follow him to his colonial destination, an imaginary kingdom in Malaysia. On the boat to Rahajang, she meets the Sultan of the kingdom, Prince Selim (Richard-Willm), and establishes a friendship with him. During the trip, the Sultan accepts the requests of the Japanese to build a military post in his territory under the cover of a rubber factory. Herbert is a mean, servile character, and disagreement between husband and wife grows when they reach the colony. Audrey is too independent for

the social environment of the British expatriate community; she earns her own income as a journalist and she maintains her friendship with the Sultan. After a false rumour that she is his lover is spread by a jealous English woman, Audrey is expelled from a charity meeting by the British governor's racist wife. Audrey runs away in shock and falls ill in a Chinese hotel, where she risks dying. But the Sultan arrives to save her and, in exchange for closing the Japanese post, gets the governor to force his wife to publicly recant her previous behaviour. Herbert is promoted to a higher post in another colony, and Audrey and the Sultan can marry happily. (Marc Allégret's younger brother Yves was also a film director. All references in this chapter to 'Allégret' without a first name are to Marc.)

3. Three other examples come to mind. *Baroud* (Ingram, 1931) tells the story of a French Spahi who falls in love with the sister of his Arab comrade and friend; after overcoming countless obstacles, the seemingly impossible becomes possible and the couple are allowed to pursue their relationship. In *Caïn/Cain* (Poirier, 1930), a stevedore steals money from a passenger and jumps ship. He ends up on a small island where he captures a native woman and lives with her and their child. When offered the chance to go back to 'civilization' he turns it down. *L'esclave blanche/White Slave* (Sorkin, 1939) – a remake of a 1927 film by Augusto Genina made under Pabst's supervision – tells the story of Mireille, a young Parisian woman who has married a Turk. In Constantinople, the Sultan gives her husband a second wife, but he decides to leave with Mireille.

4. Francis de Croisset was the pseudonym of Franz Wiener (1877–1937). He wrote many light comedies for the Paris stage, becoming very successful in the decade before World War I. The author of several *récits exotiques* ('exotic stories'), he travelled widely in Russia, India, Africa, America and the Far East (Limouzin-Lamothe 1961). His novel *La dame de Malacca* was inspired by one of his trips to Insulinde (another name for Malaysia), where he claimed he learned of the story; Malacca is a small state in the south of the Malay Peninsula. The novel's fictional kingdom of Udaigor and its capital Rahajang are situated in the state of Malacca. Croisset died shortly after Allégret's film version was released.

5. The German film, entitled *Andere Welt*, was directed by Allégret and Alfred Stoger, with the actors Käthe Gold, Karl Ludwig Diehl and Franz Schafheitlin.

6. All translations into English are the author's own.

7. Cockfighting has for many centuries been a social sport in the Orient (as in other parts of the world), the earliest references to it being traced back to China in around 500 BC (Cutter 1989). In many countries, such as Britain, it was banned in the nineteenth century; however, in some colonies, it continued despite being banned by the colonial powers (Scott 1983).

8. The critique is aimed particularly at British colonial women, reproducing the recurrent stereotype of 'perfidious Albion' (Burch and Sellier 1996: 28). Both film and novel converge in their misogyny, representing women as more perfidious than men and at their worst in the colonies. It is a woman, wanting revenge because her husband is attracted by Audrey, who spreads the false rumour that Audrey is the Sultan's lover. It is a woman – the governor's wife – who expels her from the charity committee, with the other women colluding. If British women are presented as more racist than men, by contrast two native women show compassion and solidarity towards Audrey when she falls ill after her expulsion. Burch and Sellier have noted the connection between the crisis of European masculine identity and the misogyny found in popular literature of the early 1940s, but suggest that, on the contrary, cinema offered a regenerative vision of the feminine (1996: 17). This thesis is not confirmed by our example.

9. The two had been together in various films such as *Barcarolle* (Lamprecht and Le Bon, 1935) and *Stradivarius* (Valentin and Bolvary, 1935). Richard-Willm, born in 1895, was originally a stage actor, only in 1930 starting to work in cinema (Richard-Willm 1975). Like Richard-Willm, Feuillère wrote an autobiography (1977) and had many books written about her (Feydeau 1991; Kemp 1951). She too was originally a stage actress, at the Comédie Française, subsequently working for radio, cinema, television, and the recording industry. In 1937 she starred in another major film, *Marthe Richard au service de la France/Marthe Richard*, directed by Eric Stroheim.

10. This seems to have been more the case with *Cinémonde* than with *Pour vous*, both founded in 1928 (October and November respectively). According to Suzanne Chantal, for many years chief editor of *Cinémonde*, this magazine was in direct competition with *Pour vous*, which was more cerebral, used technical jargon and had a more theoretical approach. *Cinémonde* wanted to be closer to the public and expressed a visceral love of cinema. Its contributors had open access to all the film studios, and the stars confided their secrets to them (Chantal 1977). Nevertheless, *Cinémonde*'s contributors included André Maurois and Paul Valéry. *Cinémonde* and *Pour vous* were the best known and longest-lasting French film magazines of the time, with a readership of many thousands (Crisp 1997).

# Chapter 6

## Love and colonial ambivalence in Spanish Africanist cinema of the early Franco dictatorship

Jo Labanyi

This chapter examines two Spanish colonial films set in Spanish Morocco and Spanish Sahara respectively: *¡Harka!* (Arévalo, 1941) and *La llamada de África/ The Call of Africa* (Ardavín, 1952). Any discussion of these films has to ask how these two films were able, at a time of strict censorship under the Franco dictatorship of 1939–75, to offer a positive depiction of the unorthodox same-sex and mixed-race love relationships which they depict – in both cases triangulated by a love for Arab culture on the part of the Spanish male protagonists. It is also necessary to ask why both films, while explicitly exalting the Spanish colonial enterprise in north and north-west Africa, give a negative representation of the white woman newly arrived from Spain who attempts to break up these unorthodox relationships. To answer these questions – insofar as they can be answered – requires an understanding of Spanish fascist ideology and of the specificity of Spanish colonial discourse. It also involves asking how these films relate to a longstanding European tradition which equates Europeanness with forms of love that transcend the body and find their highest realization in death: a Christian paradigm which in these films is expressed in terms of military values.

Given the high degree of ambivalence shown in both films towards Arab culture – subjected to colonial control yet passionately loved – my discussion will draw on the postcolonial critic Homi Bhabha's (1994) work on the conflictive nature of the colonizer's attitude to the colonized. Bhabha's analysis of colonial mimicry will be set against the somewhat different concept of colonial mimesis elaborated by the anthropologist Michael Taussig (1993). The complex relation between sameness and alterity is central to both films, not only in terms of the colonial relationship between Spaniards and Arabs, but also in terms of gender: both replace heterosexual reproduction with a process of same-sex reproduction whereby males reproduce themelves in other men. Above all, both films offer a model of colonial relations as love: a love that is sincerely felt but is able to further empire because it is based on structures of domination and the surrender of self to a higher cause. In this respect, the chapter will further draw on Klaus Theweleit's (1989) psychoanalytical discussion of the psychology of Nazi 'soldier males', as well as on film scholar Richard Dyer's (1997) examination of the relation of whiteness to embodiment – the notion that the body is inhabited by a spirit that is separate from it – and to death. The unorthodox love relationships in both films have to be terminated through death because, while furthering empire, they also threaten it. What makes the colonial enterprise possible is impossible love.

## Spanish-Arab relations and Spanish colonial film production

In a 1936 interview, given in the year he launched his military occupation of Republican Spain from Spanish Morocco, General Franco declared: 'Without Africa, I can scarcely explain myself to myself' (cited in Rein 1999: 197). Franco's meteoric military career had been made in the Spanish Protectorate of Morocco, where he served for most of the period 1912–26 (from 1923 as Commander of the Spanish Foreign Legion), coinciding with the violent colonial war of 1909–27.[1] It was as Commander of the Army of Africa – comprising the Foreign Legion and the regular indigenous forces (units of local mercenaries commanded by a Spanish officer, known in Morocco as *harkas*) – that he announced the July 1936 military rebellion. Although the ensuing Civil War of 1936–39 was seen by the nationalist insurgents as a Christian crusade, they relied on around 70,000 Moroccan mercenaries – a contradiction Franco smoothed over by stressing the common cause of Christian and Muslim believers against atheism (de Madariaga 2002: 345–64). In the immediate postwar, Franco made a point of appearing in public escorted by his mounted 'Moorish Guard'. This colonialist stance went together with a policy, during the Civil War, of arabizing education in the protectorate, building mosques and supporting Muslim festivals (including contracting a ship for the annual pilgrimage to Mecca), and favoring Moroccan nationalists (Elena 2004: 19–21; de Madariaga 2002: 347–56; 360–61). Once installed in power, Franco courted Arab support to relieve ostracism by the western democratic nations, while at home enforcing an aggressive National Catholicism which demonized Spain's medieval Islamic past (Aidi 2006: 72–74; Rein 1999).

This ambivalent attitude towards Arab culture is reflected in cinematic production of the early Franco dictatorship. It should be clarified that, unlike fascist Italy and Germany, the Spanish film industry remained in private hands, though subject to stringent state censorship. The Moroccan War of 1909–27 triggered an appetite in the mainland for documentary reportage, especially after Abd el-Krim's victory at Annual in 1921, which left over 8,000 Spanish troops dead. Morocco's importance in the Spanish Civil War would revive this documentary production, most notably with the Flaherty-influenced ethnographic film *Romancero marroquí/Moroccan Ballad Book* (Rodiño and Velo, 1939), edited in Nazi Germany and aimed at maintaining Moroccan recruitment for Franco's rebel army (Elena 2004; 2010: 26–31, 45–9). The peak period of documentary production on the Spanish Protectorate of Morocco was 1946–51, coinciding with a similar boom in French documentary films on its North African possessions, and with the United Nations' boycott on Franco's Spain, which led Franco to increase his efforts to procure Arab support (Elena 2001: 120–22). The period 1938–52 saw the parallel and related production of fiction films set in Spain's African possessions (Spanish Morocco, Spanish Sahara and Equatorial Guinea).

The first of the two fiction films discussed in this essay – Carlos Arévalo's *¡Harka!*, filmed mostly in Spain's Moroccan protectorate – was accused of 'stealing' ethnographic footage from *Romancero marroquí*. While this is not true (Elena 2004: 65), certain scenes

do have an ethnographic 'look': the panning of the Moroccan mercenaries making tea in their encampment; the Arab market, with untranslated dialogue in Arabic, as Moroccan mercenaries try to procure new *harka* recruits; and the tour of Tetuán, capital of Spanish Morocco, which Arévalo offers spectators as the camera follows the Spanish officer Carlos' (Luis Peña) courtship of the newly arrived Amparo (Luchy Soto). This last sequence is notable for its use of montage, with the couple's image superimposed on scenes of Arab life in Tetuán's streets in a way that stresses the mediation of their relationship by Arab culture, while at the same time depicting them as ghostly presences hovering over the Arab city. As Alberto Elena notes (2010: 103), Arévalo's prior directing experience had been in documentary film. Unused ethnographic footage from the second film examined here – César Fernández Ardavín's *La llamada de África*, shot entirely in the Protectorate of Spanish Sahara – was used by the director for his 1953 documentary *Con los hombres azules/ With the Blue Men*: a reference to the blue veils worn by male Tuaregs (the nomadic Berber inhabitants of Spanish Sahara).[2] The ethnographic sequences of *La llamada de África* – which follow the nomadic camel trains, and depict a Tuareg festival with its oral storyteller, snake-charmer, kohl-painted female dancers and javelin-throwing contest – are dramatic, enhanced by the film's repeated use of dialogue in untranslated Hassaniya (the local dialect of Arabic). We are reminded here of the ethnographic intent which marks several sequences of Allégret's colonial romance, *La dame de Malacca* (Allégret, 1937), discussed in the previous chapter.

Several Spanish fiction films set in an Arab or Berber context involve a love interest between a Spanish male and an indigenous female. One film, *La canción de Aixa/Hinter Haremsgittern/Aixa's Song* (Rey, 1939), depicts the love triangle comprised by a mixed-race female (with Spanish father and Arab mother) and two Arab males (both princes and cousins). *La canción de Aixa* is exceptional not only in focusing on a half-white female's marriage to an indigenous male, but also in allowing its mixed-race romance a happy ending, achieved by having the heroine renounce a wayward cosmopolitanism (she is a cabaret singer in Tetuán) for Islamic female submission. On the surface an Orientalist musical fantasia, the film is a parable about the need for Spanish women to abandon the emancipation granted by the Republic and return to patriarchy (spectators remain aware that the actors are Spaniards, especially in the case of the female lead, Imperio Argentina, Spain's biggest-grossing star of the time). What is extraordinary about this film is that it was made in Nazi Berlin by the Spanish-German co-production company, Hispano-Film-Produktion, created in 1937 with Goebbels' approval as Nazi Minister of Propaganda. Its Moroccan setting no doubt fed both Spanish and German dreams of colonial expansion in North Africa: the following year (1940) Spain would occupy Tangiers (an international zone since 1923) and Franco attempted to negotiate with Hitler significant expansion in north-west Africa and the Gulf of Guinea, unsuccessfully since Hitler had African designs of his own (Goda 1999; Martin-Márquez 2008: 250–51). But, curiously, the film's mixed-race plot, in which a half-white woman's love is won by an Arab who rejects western civilization (thereby proving superior to his decadent, westernized cousin), supports the

fascist rejection of a degenerate capitalist modernity at the expense of flouting Nazi racial policies.[3]

Susan Martin-Márquez has noted that Spanish foreign policy influences several romantic film narratives of the early Franco period that have African settings (2008: 224). ¡Harka!, set in contemporary Spanish Morocco, was made just six months after Spain's occupation of Tangiers in June 1940, on the fall of Paris to the Nazis (Martin-Márquez 2008: 250). Shot with assistance from the Spanish colonial authorities and regular indigenous forces, the film dramatizes the central trope used to underscore Francoist claims to Morocco: that of a Spanish-Moroccan blood brotherhood – as explicitly stated by the film's opening title. For the rest of 1940, Franco attempted to negotiate with Hitler the annexation by Spain of part or all of French Morocco (Goda 1999). The subtext of ¡Harka! is justification of an expanded Spanish role in Africa. The plot dramatizes the intense bond between two officers in the Army of Africa, triangulated by their mutual love of Arab culture. Like the documentary Romancero marroquí, it shows the Spanish military's reliance on Arab foot soldiers. And like La canción de Aixa, it rejects a decadent western modernity, in this case – even more extraordinarily – for an Arab culture that sanctions love between men. The action of La llamada de África, although made in 1952, also starts in June 1940, coinciding not only with France's fall to Germany but also with the start of World War II's North African Campaign, though this did not reach north-west Africa until two years later. In late 1940, Franco's Foreign Minister offered to enter World War II on Germany's side in return for multiple territorial concessions in Africa, including an extension of Spanish Sahara southwards into French territory (Goda 1999: 74). Thwarted by Hitler's own expansionist claims in the area and as the war turned in the Allies' favour, Franco switched to courting US support and – alarmed by the claim Hitler had made on one of the Canary Islands during their 1940 failed negotiations – in 1944 granted the US military use of Spanish Saharan coastal installations, including Cape Yubi where the airstrip in La llamada de África is located (Goda 1999: 176–77; Martin-Márquez 2008: 251; 253–55). The film's adventure plot hinges on the attempt by unspecified 'Nordic' gangsters operating from the French colony of Mauritania to the east and south (at the time under the collaborationist Vichy Government) to sabotage the airstrip which is being built to allow Spanish military protection of communications with the nearby Canary Islands.[4] The intertwined romance plot depicts the love relationship between a Lawrence of Arabia figure – a mixed-race but white-skinned officer in the nomadic police (the camel-riding equivalent of Spanish Morocco's harkas) who has 'gone native' – and a Tuareg princess who will, after the film's end, have his child. In April 1952, a month before the film's première, Franco's Foreign Minister had toured the Middle East, extolling the common blood, culture and destiny shared by Spain and the Arab world, and offering Franco as an ally against a socialist Israel (Rein 1999: 206–09; Aidi 2006: 72–73).

¡Harka! was generally well received by critics and audiences, though some critics found the plot development unconvincing (Elena 1997: 134). While there are conflicting

reports of audience response to *La llamada de África*, it played for 43 days at Madrid's central Cine Callao – the third longest-running film of the year (Elena 2010: 113; Martin-Márquez 2008: 252–53). It was criticized by reviewers for lack of clarity in its exposition but – after lobbying by Luis Riera Ferrer, a former aide to the Governor of Spanish Sahara and military advisor for the film – was awarded the top state rating 'In the National Interest' (Zumalde Arregi 1997: 310). Critics' unease about both plots suggests that the character relationships were found problematic, though there were no specific complaints about the male-male or mixed-race liaisons. However, as we shall see, the original script of *La llamada de África* contains scenes involving the mixed-race couple that were eliminated from the film – presumably because of censors' objections. (Directors had to submit filmscripts to the censors before being allowed to start shooting; most changes or cuts were made at this stage. Once the film was made, it required the censors' approval for release.) The two sections that follow will consider the implications of the fact that, despite the eliminaton of certain scenes in *La llamada de África*, both films appear – extraordinarily – to condone their male-male and mixed-race love relationships.

### *¡Harka!*: homoeroticism, sacrificial love and the colonial reproduction of the Same

Scripted by a former member of the Spanish Foreign Legion, Luis García Ortega, *¡Harka!* explicitly postulates a bond between the Spanish military male and the Arab warrior, whose hierarchical symbiosis is exemplified by the *harka* units' structure of native mercenaries under Spanish command. This bond is linked to the repudiation of women, which the film's two Spanish officer heroes learn from the Arab world, constructed in the film as an all-male culture. The dramatization of the junior officer Carlos Herrera's ditching of his fiancée Amparo to return to Africa to take up the mantle of the now dead Santiago Balcázar (Alfredo Mayo), the senior officer with whom he had established an intense homoerotic bond, cannot be attributed to misogyny on the director's part: Arévalo's next film, *Rojo y negro/Red and Black* (1942), is the contradiction-in-terms of a Falangist feminist apologia, in which the Falangist heroine surpasses the men in daring and courage (Labanyi 1997a).[5] Amparo, however, far from sacrificing the self to the nation, is the modern liberated woman who lives for pleasure, enjoying sport and luxury hotel ballrooms. As an embodiment of the egoistic individualism of a decadent, 'feminized' western modernity, she thinks only of what Carlos' military role in Africa will do to her, incapable of appreciating his needs or those of the fatherland. This indictment of a 'feminized' modernity is typical of Spanish fascist rhetoric, as of fascist rhetoric elsewhere. It also corroborates Theweleit's analysis of the terror of women expressed in the writings of Nazi soldiers, which he reads as a fear of loss of male body boundaries: a fear countered by constructing impermeable body armour through military discipline (1989: 143–252).

The film's exaltation of the fascist ideal of service to the nation is illustrated most clearly by the principal hero Santiago's refusal not only of relationships with women but of all forms of intimacy: he repeatedly refuses leave, for he has no private life. When Carlos – upbraided by him for leaving the Army of Africa to marry Amparo – retorts by asking if he has never felt a need for affection and tenderness, Santiago responds by violently grabbing a prostitute and dancing with her stiffly. His body language is rigidly erect throughout, in keeping with Spanish fascist rhetoric's emphasis on verticality: the conversion of the male body into a permanently erect phallus that is never allowed discharge, as analysed by Theweleit (1989: 43–61). This verticality is based on self-control as well as the domination of others. The actor who plays Santiago, Alfredo Mayo, was typecast as the fascist warrior hero in Spanish cinema of the early 1940s. By contrast the younger officer Carlos is played by Luis Peña, known for his roles as romantic lover: his soft features contrast strikingly with Mayo's sculptural profile – a contrast that detracts from the verisimilitude of Carlos taking on Santiago's mantle after his death, but which shows Santiago's need to find some kind of outlet for his self-imposed emotional rigidity (see Figure 9; Santiago's erect figure, set against spiky cacti, is placed above that of Carlos, set against feminine flowers). The male-male relations permitted – indeed, required – by the army, and associated with Arab culture, provide such an outlet for Santiago because they are sanctioned by military discipline. Theweleit notes that the Nazi soldiers whose writings he analyses find release through battle and military drill (1989: 143–206). This is a form of emotional release characterized by a sacrificial ethos because it is marked by non-fulfilment: that is, the continued maintenance of body boundaries – or so we assume, since, although Santiago and Carlos are shown sharing a tent, Carlos is at the time leaving to marry Amparo back in Madrid. The film's glamorization of Santiago as *harka* leader – through repeated close-ups and takes of him riding ever upwards against the skyline – comes close to fusing the fascist ideal of service to the nation with what is represented as an Arab tribal notion of personal allegiance. The film is here picking up on one of the ambiguities of fascism, whereby the abstract notion of service to the state is channelled through devotion to a charismatic leader. Carlos's final return to Africa to assume the role of a now dead Santiago allows this personal devotion to be elevated to an abstract level. Specifically, Santiago's death allows Carlos to express his devotion to him without risk of consummating a homosexual relationship.

Bhabha has argued, in *The Location of Culture*, that the colonizer is torn between fear and desire towards the colonial Other – an ambivalence that involves juggling opposing emotions (1994: 66–84). In ¡*Harka!*, the Moroccans are both enemies and allies: the *harkas* were the instrument of a colonial divide-and-rule policy whereby the Spanish military formed alliances with particular warlords so as to recruit their men to fight against rival warlords. The potential of the local populace to swing between the roles of enemy and ally is illustrated in the scene when Santiago engages in a psychological duel with the warlord who had previously injured him in battle in order to convince him to provide men for the new *harka*. In this episode, the relationship between the two men is shown, through

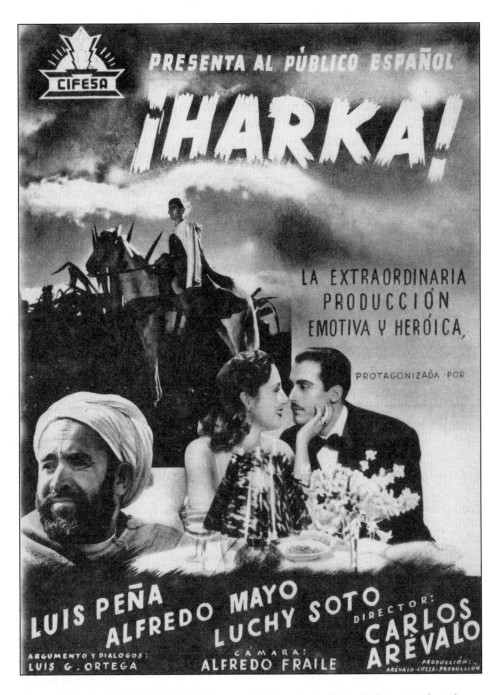

Figure 9. Poster for *¡Harka!* (Arévalo, 1941), foregrounding the romantic relationship between Carlos and Amparo, which he will renounce for Africa.

the interplay of gazes, to be one of mutual respect between enemies: a relationship of chivalry. Nonetheless, Santiago is for most of the scene placed higher in the frame.

Bhabha's analysis of colonial ambivalence is based on his personal experience of the British colonial legacy in his native India, which maintained racial segregation while encouraging the colonized to 'mimic' British culture. For Bhabha, the colonizer's objective in fostering this mimicry is to construct the colonized as 'white but not quite' – that is, Anglicized rather then English (1994: 85–92). In ¡Harka! – unlike La llamada de África, as we shall see – there is no mimicry of Spanish culture by the colonized, who are depicted as wholly Other: rarely individualized, and on the battlefield not even given a face (Elena 2010: 104). Although Spanish colonial discourse was generally characterized by a policy of enforced incorporation of the Other through evangelization – developed under Spain's early modern empire in America and Asia (1492–1898) – this was not the case in Spain's twentieth-century North African protectorates, where, as noted above, Islamic practices were tolerated, particularly in the late 1930s. Martin-Márquez notes that, if Spain's colonial war in Morocco was in the 1920s marked by extreme brutality, in the late 1930s and early 1940s Spanish texts set in North Africa – including ¡Harka! – become suffused with 'a dreamy Orientalism that exalted and eroticized fraternal relations between Spaniards and Moroccans' (2008: 206). In ¡Harka!, the mimicry is that of the colonial army officers Santiago and, less visibly, Carlos through their attraction to Arab culture. What characterizes Santiago is not so much a conflictive attitude towards the Arabs he is commanding or fighting – as in Bhabha's theorization of the colonizer's ambivalent fear/desire towards the Other – but rather a hierarchical symbiosis of both Spanish and Arab cultures: Arab culture is harnessed for Spanish colonial ends. In Santiago's case, this symbiosis takes the form of his imitation of Arab horsemanship, customs (tea-drinking rituals) and dress (wearing a djellaba over his Spanish military uniform for much of the film). Santiago is also the only army officer depicted as wearing the Army of Africa fez rather than a standard officer's cap. These imitative practices, while expressing a passionately felt identification with Arab culture, allow him to win Arabs over to the Spanish cause, represented by the army uniform he wears next to his skin.[6]

In this context, the theorization of colonial mimicry by Taussig in his book Mimesis and Alterity (1993) – published the year before Bhabha's The Location of Culture and treating the very different context of hemispheric relations in the Americas – may be more helpful as an interpretive tool than Bhaba's conflictive model of colonial ambivalence. Taussig's original contributions are, first, his emphasis on the colonizer's fascination with the colonized's mimicry of himself (something we will explore in the analysis of La llamada de África) and, second, his perception (relevant particularly to ¡Harka!) that mimicry and alterity, far from being in conflict, reinforce each other in a specular fashion. Both Bhabha and Taussig regard the colonized's imitation of the colonizer as confirming the former's otherness. But Taussig puts forward the converse proposition that the colonizer's mimicry of the Other confirms the colonizer's membership of the (white) hegemonic order of the Same, since one can only mimic what one is not. Colonial mimicry, far from blurring boundaries,

reinforces both the colonized's alterity and the colonizer's sameness. Thus, in *¡Harka!*, Santiago's and Carlos's mimicry of Arab culture is not in conflict with the perpetuation of the colonial project but, paradoxically, what allows it. This defines the colonial project as the reproduction of the Same through the mimicry of alterity.

This colonial reproduction of the Same is clinched when, at the end of *¡Harka!*, Carlos becomes Santiago. The film dramatizes two kinds of mimesis: Santiago's imitation of male Arab culture (the Other), and Carlos's imitation of Santiago (the Same). In imitating Santiago, Carlos is imitating his imitation of Arab culture (that is, imitating the Same imitating the Other). Although we never see Carlos wear Arab dress or imitate Arab warrior prowess on a horse, he tells Santiago, during their first intimate encounter, that he too feels partly Arab:

> I came to Africa seeking what you've just said: risk, the chance to fight. I gradually started to get interested in the people's customs, I learnt a smattering of Arabic [...]. And now I'm here, perhaps because I feel a bit like them.[7]

It is significant that, of the four newly arrived *harka* officers, Carlos is the only one who has not come from Spain but from the Foreign Legion: his Africanist vocation made him opt for service in Africa immediately on graduation. As Peter Evans has noted (1995: 219), this first inimate encounter between Santiago and Carlos, in which Santiago wears his *djellaba* and fez, is filmed like a love scene, the two men's heads framed so they almost touch. As Carlos says 'perhaps because I feel a bit like them', we cut to an extreme close-up of Santiago's face, illumined by soft-focus lighting recreating the play of light from the camp fire, as he lowers his eyelids. At this point, Oriental rhythms take over the musical soundtrack. The shot reverse shot sequence then cuts to a similar extreme close-up of Carlos.[8] This is the moment of bonding, mediated by Arab culture as internalized Other. As Carlos leaves, asking if 'my captain' has any orders for him, Santiago replies, 'Yes, call me by my first name'. This is a complicated kind of intimacy, legitimized by being granted in the form of a military command, and made possible by the triangulation afforded by Arab culture as the third term in the relationship. In this triangulation process, public and private forms of love merge. For this *is* love. Santiago is first introduced to us, before he appears on-screen, via his fellow officers' conversation about his love for Africa:

> [...] noble, loyal but incomprehensible [...]. Africa! Valcázar is in love with this land. He lives in it and for it. No one understands better the psychology of the Moroccan, so identified with it is he. Sidi Absalam Valcázar, they call him.[9] And yet no one is more Spanish than Santiago Valcázar.

This symbiosis of Spanish and Arab qualities is presented as strange and mysterious, for the mimesis reinforces the alterity that obtains between the two cultures. The power relations are complex because the surrender to the lure of Africa is what allows Santiago

to control the indigenous inhabitants. In incorporating their culture into himself, he is incorporating them into empire.

The incorporation of the Other is a typically Francoist rhetorical trope, found in the more conventional sense of cultural assimilation through evangelization in Spanish missionary films of the time. These films – despite Franco's alliance with Hitler in the Spanish Civil War – contradict Nazi policies of the exclusion if not extermination of racial Others, by dramatizing a kind of spiritual miscegenation which reinforces hierarchy (Labanyi 1997b; 2001). In this spiritual miscegenation, the relationship is not between man and woman but between figurative father and son: an all-male bond which makes women unnecessary to the reproductive process since the father reproduces himself in the son.[10] Klaus Theweleit has analysed this megalomaniac fantasy of male self-reproduction in the writings of Nazi soldiers, seeing it as a way of avoiding the heterosexual relations that are feared as a breach of body boundaries (1989: 95; 241; 243). The same rhetorical trope, based on a homoerotic act of mimesis that permits the colonial reproduction of the Same, is found in both ¡Harka! and La llamada de África. In the missionary film genre, the homoerotic nature of this trope – as 'love of the Same' – is attenuated since, although it is enacted between two men, they are usually from different races (colonizer and colonized); as we shall see, this scenario is dramatized in La llamada de África. In ¡Harka! the homoerotic implications of the trope are taken to their logical conclusion, as the sacrifice of the individual self to secure the reproduction of the Same is enacted between two military officers in the colonial army – one senior, one junior – with the colonized Other relegated to the sidelines as a third term. This homoerotic reproductive pact is at least as much about the need to incorporate the Arabs into a Spanish imperial design as it is about the relationship between Santiago and Carlos. For their homoerotic pact signals the continuation of the colonial mission, whereby the alterity of Arab culture is rendered part of the colonial self. The words of induction to the new harka officers uttered by the commander at the start, and repeated at the end by Carlos as he assumes Santiago's role, are:

> To be a good harka officer, you have to understand the Moroccan, identify with him in a way, and love him […]. To be a good harka officer, there are many requirements but only one is indispensable: to have a greater heart than the fiercest harka warrior.

This trope of homoerotic symbiosis between colonizer and colonized makes it possible to believe that empire is based on love: a paternalistic love by the father for his wayward children. Carlos tends a wounded Arab boy soldier with the solicitous gestures of a father. The trope of the father's love for the wayward child is reproduced in Carlos' homoerotic relationship with Santiago, for the former succumbs to a life based on self-gratification (sport and ballroom dancing in Spain with Amparo), only to learn the error of his ways and to return to Africa to continue the colonial process of reproduction of the Same. The turning-point for Carlos is when, in a frivolous gesture, Amparo puts on a party

hat in the form of a fez at the end of a montage sequence in which scenes of modern western decadence in Madrid (represented by jazz playing on the dance floor) are rapidly intercut with scenes of the fighting back in Morocco. In one of these intercut scenes, the Arab warlord who had pledged military support for Santiago insists on remaining at his side to die with him: a colonial, homoerotic *Liebestod* that seals the mimetic pact. Carlos is now honour-bound to take up Santiago's previous injunction to assume his role as Sidi Absalam Valcázar by becoming Sidi Absalam Herrera. On issuing this injunction, Santiago had insisted, 'I've loved you like a brother, almost like a son, because I thought you were like myself.'

In the film's final scene, Carlos tears up his photo of Amparo precisely as he inducts the new *harka* officers who reproduce his own position at the film's start. In so doing, he replaces modern western heterosexual love (based on self-gratification) with colonial homoerotic reproduction (based on sacrifice of the self). This sacrificial form of love transcends the personal in order to provide the affective underpinnings of empire. *¡Harka!* occupies a key role in the prehistory of representations of homosexuality in Spanish cinema, but it should not be forgotten that its depiction of love between men is a political exploration and justification of the nature of colonial power. The film's investment in the equation of love with renunciation ensures that the love between Santiago and Carlos marks them out as superior to the Arab culture they seek to emulate. Indeed, the film coyly suggests, in its depiction of two adolescent boys flanking the Arab warlord whose military aid Santiago solicits, that in Arab culture love between men is not an impossible ideal but a mundane reality. The film constructs the superior male as the Spaniard who rejects western modernity by incorporating the Arab Other into the self but he must not become an Arab, since the point of this mimicry of the Other is reproduction of the colonial order.

## La llamada de África: 'going native' and the seductive power of western technology

The mixed-race hero of *La llamada de África*, born of a Spanish military father killed at Annual and a distinguished Moroccan mother from Tetuán, was acted by a former Nazi officer, Gerard Tichy, who after World War II had escaped from a French prisoner-of-war camp and sought refuge in Spain. Tichy had first been hired by Ardavín to play the German submarine captain in the 1949 film *Neutralidad/Neutrality*, now lost, which he had scripted and co-directed with his film director uncle, Eusebio Fernández Ardavín (Martin-Márquez 2008: 253). This film depicted the rescue by Spaniards of survivors from battling German and American submarines in World War II, attempting to dissociate Spain from support for fascism at a time of international boycott by stressing the Spaniards' non-partisan rescue of crew members from both vessels. While we could criticize Tichy's lead role in *La llamada de África* as a piece of miscasting, it is more productive to consider the effects of having a blond Aryan play the role of the mixed-

race Lawrence of Arabia figure, Captain Andrade. This casting certainly complicates the relation between sameness and alterity: Andrade becomes Other (non-Spanish) both in his imitation of Saharawi culture and in his whiteness, represented by a German actor. Tichy's Aryan looks make us ever conscious of Andrade's whiteness, despite his assumption of Tuareg clothing and his mixed-race origins (revealed only towards the film's end). At the same time, we are made aware that race is a matter of performance; indeed, the spectacle of a Lawrence of Arabia figure of mixed origins played by an escaped Nazi officer could be seen as something of a joke. Zumalde Arregi has noted that Andrade's Galician family name is that taken by General Franco (himself Galician) as his pen name for the script he wrote for the 1941 film *Raza/Race* (dir. José Luis Sáenz de Herredia), and that, like Andrade in *La llamada de África*, Franco was reputed to be miraculously immune to Arab bullets (Zumalde Arregi 1997: 311). As an officer in the nomadic police (made up of natives under Spanish command), Andrade occupies a similar position to that held by Franco as *harka* commander during his early career in Spanish Morocco. While Franco did not 'go native',[11] there is a similar camouflage going on with his overtures to the Arab world as their 'blood brother' at the time the film was made. When one considers Franco's chameleonic shifts of foreign policy during World War II, the idea of a Nazi playing a Lawrence of Arabia figure starts to sound less far-fetched.

The film stresses the good relations between the Spanish military and the local nomads: when Andrade first appears, in Tuareg dress on camelback, he is hailed by a series of Tuareg herders as 'Sidi Andrade!', 'Sidi! The good chief!', 'The son of the sun!' The nomads speak in Hassaniya, mostly left untranslated, as do Andrade and the other Spanish officers, Lieutenant Ochoa and Lieutenant Hurtado, when addressing them.[12] Andrade's mimicry of Tuareg culture, like Santiago Valcázar's mimicry of Arab culture in *¡Harka!*, makes him a mystery to the other characters (both Spanish and Saharawi), constructing Andrade's 'marriage' of the two cultures, embodied in his love relationship with the Tuareg princess Halima (Irma Torres), as exceptional. Although Ochoa has not 'gone native' like Andrade, he too is in Africa's thrall, and refuses his leave. When the newly arrived ensign Gelmírez, fascinated with Africa since childhood, says 'It seems so different,' Ochoa replies that he needs to:

Understand this land and its people. [...] Remember the words of St. Augustine the African: 'undo the dark that covers the abyss of my understanding, so that understanding I may see you. And understanding I may know you, and knowing you I may love you, for anyone who knows you loves you.'

The similarity of this induction into military service in Africa to that which occurs near the start of *¡Harka!* is striking: both emphasize the need to love Africa, thereby inducting spectators into the same sentiment. Ochoa reminds us that St. Augustine was a North African; in quoting St. Augustine out of context, he puts Africa in the place of God. If Augustine converted to Christianity, it is implied that the Spanish colonizers need to

convert to an appreciation of African culture – a notable reversal of Spanish missionary rhetoric.

When Andrade rejects Magda – the Spanish journalist niece of the Spanish commander, arrived from the mainland, and an epitome of modern woman (in addition to her career, Germanic-sounding name and short blonde hair, she is described throughout the script as 'the European woman') – he insists that his love for the Tuareg princess Halima is part of something bigger: his love for Africa. What triggers his rejection of Magda (shared by viewers, given the film's idealization of him) is Magda's overt racism – that is, her failure (like Amparo in ¡Harka!) to love Africa. She upbraids Andrade incomprehendingly:

What do you find in these wretched lands? In these souls so different from us, so incomprehensible? How could you come to love a woman who is barely distinguishable from the rest of them?

The film's fetishization of the figure of Halima – played by Mexican actress Irma Torres – is exoticist (she looks much like a darker-skinned versión of Vivien Leigh's Cleopatra in Gabriel Pascal's 1945 Hollywood blockbuster, *Caesar and Cleopatra*), positioning her clearly in the role of racial Other. In her first encounter wth Andrade in the film, she is stretched catlike on the luxurious rugs in her Tuareg nomad's tent, in a dark tunic baring one shoulder, gazing avidly up into the eyes of Andrade, who sits cross-legged in Arab fashion and placed higher in the frame, the light playing on his dazzling white Arab cape (see Figure 10). The script primitivizes her by describing her movements as feline, indolent and statuesque; by stressing her sexual availability (she initiates the kisses) and her 'gentle' yet 'terrible' and 'disturbing' beauty. But, contrary to Magda's allegations, she stands out as highly individualized, not only through her spectacular looks but also through her characterization: viewers enter into her subjectivity through use of point-of-view shots and empathize with her fears for Andrade's safety. In a key scene, she is juxtaposed with Magda, wearing jodphurs and flexing a whip, filmed with low-angle shots as she towers over Halima crouched tiger-like on the floor of her tent. Throughout this scene the script refers to them as 'the European woman' and 'the Saharawi woman'. Magda's imperiousness is visually critiqued through her masculinization (almost always a negative sign in Spanish cinema of the Franco period), particularly since the low-angle shots depict her from Halima's level, though not always from her point-of-view. Her evident sense of superiority (which the script describes as making her 'merciless') is further undermined when she holds out her hands for Halima to read. Halima replies: 'I can't read those hands, they're white. I've never seen such white hands! They're the colour of death. [...] Your only strength is the colour of your skin.' Here Halima not only intuits the association between whiteness and death that Dyer (1997) theorizes, but also perceives that this, far from being a liability, is what gives Europeans their power.

In the ensuing dialogue, Magda and Halima argue over whether Andrade's hands are white like Magda's or darker: the script clarifies that here Halima is painfully remembering

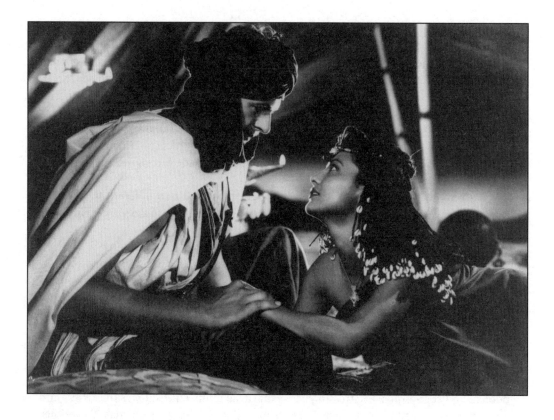

Figure 10. Captain Andrade and his Tuareg princess lover, Halima – *La llamada de África* (Ardavín, 1952).

an earlier dialogue with Andrade, when they had discussed the likely colour of the child Halima is expecting by him.[13] When Halima had insisted that the baby would be dark like herself or a bit lighter like the palms of her hands, he had interjected, 'Whiter, much whiter'. At that point Halima, visibly upset, had spotted the religious medallion round his neck which Magda had given him when he had said it was like the medallion his father was wearing when killed at the Battle of Annual. As Halima moved to touch it, he had chided her, 'Leave that alone; you don't understand such things'. Beneath Andrade's 'going native' there appears to be a belief in the superiority of the white man, embodied in his father who gave his life for Spain. Indeed, his brief attraction to Magda seems to have

been motivated by her whiteness: 'I didn't think your hands could be so white,' he says to her. When, later in the film, we learn of Andrade's mixed-race parentage – Ochoa tells Madga 'there is something dark, obscure about his birth', upon which, in keeping with her racist views, she stops pursuing him – we start to suspect that Andrade's motivation in 'going native' may be shame at his mixed-race origins, driving him to embrace African culture and an African woman as a form of self-punishment. Here we have a complex example of mimesis of the Other in order to denigrate the Other within the self, thus confirming the superiority of the Same. However, this desire for self-punishment is not presented as undermining Andrade's passion for Africa (and for Halima) but, on the contrary, as justifying it. Again we have an exaltation of love as self-renunciation – as in ¡Harka! allied to a military sacrificial ethos. Lieutenant Ochoa tells the engineer, who had previously deserted the military, that 'those who truly serve are those who are able to abase themselves, because the soldier surrenders for good not only his body but all his thoughts and passions'. In La llamada de África, this military ethos takes on an explicit religious dimension through the medallion round Andrade's neck.[14] As he dies at the film's end, machine-gunned by the 'Nordic' gangsters (the Saharawis, who revere him, refuse to fire), he asks Lieutenant Hurtado to tell the chaplain he thought of him in his last moments. Andrade rides alone towards certain death, filmed in medium shot against the dawn sky, with a Christlike sense of mission; he dies in the Spanish commander's arms in an all-male Pietà. Interestingly, his last words enquire not after Halima, but after his white she-camel, Jedha, with whom, throughout the film, he has been depicted as having a symbiotic relationship.

Whenever Andrade and Halima appear together, the script refers to him as 'the white man': his apparent self-abasement through his relationship with a Saharawi woman has the additional merit of affirming his whiteness by contrast. Here, the sameness confirmed by mimesis of the Other is evident. But we should not forget Andrade's rejection of the white Magda for despising Halima as a woman of colour. The film clearly represents Magda's modernity as threatening; she is the white woman who cannot understand Africa because she is incapable of renunciation. In the script, the scene of Magda leaving to go back to Spain is preceded by a scene in which Halima, in profile and visibly pregnant, looks down from a hilltop at Andrade's burial, then rides off slowly with her camel train into the desert. This scene does not appear in the film, nor does the earlier scene when Andrade comes to say goodbye to Halima, kissing her tenderly, before going on his military mission to save the airstrip.[15] The effect is that Halima is airbrushed out of the narrative halfway through the film, her last appearance being the scene when Magda, with her whip and masculine riding attire, humiliated her. It appears that the censors needed to rid the film's second half of Halima's presence so that it would not complicate the Christlike depiction of Andrade's self-sacrifice, and that they particularly needed to eliminate the final reminder to viewers that Halima will bear Andrade's child after his death.

Andrade dies saving the airstrip from the 'white agents' originating from Vichy-controlled Mauritania. Here the colour white is associated with evil: the 'white agents' –

in black leather jackets, shot against dark backgrounds – are dressed and filmed as gangsters. In a key scene, Lieutenant Ochoa tries to uncover the 'white agents' who have infiltrated the Tuareg camel caravan by asking the riders to show their hands: dark hands signify loyal Saharawis, white hands signify the enemy (who open fire, killing Ochoa). In the film it is unclear what nationality the 'white agents' are: Zumalde Arregi assumes they are Nazis, given the film's mention of the 'trouble' likely to come from Mauritania after the German occupation of France (1997); Martin-Márquez describes them as speaking a German-sounding language (2008). The script specifies that they are speaking French with a 'Nordic' accent, and gives their names as Stasser, Vajda, Massaryk, and Radlyz (seemingly German, Hungarian and Czech). Goda shows that Franco's 1940 negotiations with Hitler were marked by fear of Gaullist activity in France's African colonies (1999: 178; 180). Goda also notes repeated Spanish complaints in 1940 about German agents operating covertly in Spanish Morocco (ibid.: 183–5). The plot is indeed incoherent, as contemporary critics noted, but it corresponds to the multiple rumours about undercover political activity in North Africa at the time of the film's setting. What is clear is that the goal of these Nordic whites is destruction of the Spanish airstrip designed to protect communication with the Canaries. The whitest characters in the film – the gangsters, Magda – are the most negative. We might then say that Andrade is idealized because, despite his extreme whiteness (played by a German actor), he carries Africa within, though not, it seems, without a sense of racial stigma.

Whiteness is viewed negatively also by Halima's little brother Ahmed, the bugle boy for the Spanish military. When Lieutenant Hurtado shows him a photo of an officer's wife back in Spain, he responds, 'She's white, too white.' And yet the dark-skinned Ahmed's goal is to be like Lieutenant Ochoa; on finding Ochoa's dead body, he takes his place, risking his life for Spain by going on a lone mission to warn the airstrip of the impending attack. If Andrade's 'going native' ultimately reinforces his Spanishness – a Spanishness placed precariously between the white and the African – Ahmed's identification with Ochoa merely confirms his assimilation into the colonial order. Unlike Andrade, poised conflictively between alterity and sameness, Ahmed has to live at the film's end to ensure the Other's reproduction of the Same: that is, the male-male reproduction process whereby the Spanish military reproduce themselves in the colonized. Ochoa had previously told Ahmed, in a direct reference to the words of the Spanish fascist anthem,[16] that fallen Spanish soldiers go to a star in the sky. The film's last words consist of Ahmed telling the engineer that one day he will join Ochoa on a neighbouring star. He does this after handing the engineer the officer's stars bequeathed to him by the dead Andrade: the engineer, redeemed from his former desertion by his newly acquired spirit of self-sacrifice, now takes Andrade's place. Ochoa similarly reproduces himself at the end with the arrival of his younger ensign brother. The fact that Ochoa reproduces himself in both the bugle boy Ahmed and his younger brother allows him, in a complicated way, to reproduce himself as both Berber and Spanish. The arrival of Ochoa's younger brother is a replay of the earlier arrival of the ensign Gelmírez to whom Ochoa had quoted St.

Augustine to induct him into the need for the Spanish military to love Africa: Gelmírez repeats verbatim to the young ensign Ochoa the older Ochoa's previous words to himself. As in ¡Harka!, the injunction to love Africa is replayed in a cyclical structure whereby fallen colonial heroes reproduce themselves in younger men. Although *La llamada de África*, unlike ¡Harka!, does not explore homoeroticism, it replicates the same structure of male-male reproduction associated with love for Africa. In the case of *La llamada de África*, the film ends with multiple examples of men reproducing themselves in other men. The pregnant Halima had to be removed from the film's end so that reproduction can be presented as an exclusively male process. But this is not an excision of mixed-race reproduction, for her little brother Ahmed becomes Ochoa: a male-male reproduction process whereby the Other becomes the Same.

While both ¡Harka! and *La llamada de África* depict the colonizer's mimicry of the culture of the colonized, effectively confirming both alterity and sameness through mimesis, *La llamada de África* additionally portrays the western fascination with the indigenous population's fascination with western culture, as manifested through technology – the theme which Taussig develops progressively throughout his book (1993). The specularity of this process, as the white man looks at the 'native' reflecting back at him his own whiteness, is suggested by the play with Halima's hand mirror in *La llamada de África*, particularly the disconcerting shot which shows us Andrade and Halima via their reflection upside down in the mirror lying on the tent floor: they are both looking at us looking at them (reproduced in Martin-Márquez 2008: 264). Although Halima, unlike her little brother Ahmed, does not assimilate (she reproaches Ahmed for using the Spanish first name Ignacio given him by the military; the film always calls him by his Arab name), she is depicted as fascinated by the western gadget which Andrade brings her as a present in the first scene in which she appears: a music box that, when its lid is lifted, plays western dance music, and which terrifies her when the music gives way to a human voice. This scene enacts what Taussig sees as the classic colonial moment when the colonizer (in this case, the Spanish viewer as well as Andrade) sees the superiority of his own culture reflected back at him through the colonized's view of it as 'primitive' magic.

The scene is especially curious since, later, Andrade brusquely stops the western music that Magda is playing on a gramophone, saying, as he goes on to flirt with her, that he hates civilization. Yet he is not averse to using the music box with its western music to reflect back at him, through Halima's fascinated play with it, the superiority of a whiteness about which he seems to feel ambivalent. Halima, reputed to have magic powers, concedes defeat in the face of this 'magic' box whose workings she cannot fathom. By contrast, for the acculturated Ahmed, the music box holds no mystique. A related trope with a self-reflexive twist is performed when the engineer tells Magda that the sound of the Sirocco is like 'the murmur of people coming out of the cinema': here viewers are asked to recognize the 'magic' power of the cinema through analogy with an unstoppable African force of nature (the Sirocco is blowing through much of the film's violent finale). In both

cases, Spanish viewers are reassured of the superiority of their own culture, by seeing it reflected back at them in the form of primitive magic and nature. Andrade's seduction of Halima with his music box is cinema's seduction of Spanish viewers by affording them the pleasurable spectacle of the colonized's seduction by superior western technology. Spanish viewers are thus seduced by Halima's seduction. In the process, cinema is confirmed as a kind of 'modern magic'. Elena has suggested that the hinging of the film's plot on the military's attempt to save the airstrip represents an exaltation of Spain's *mission civilisatrice* (2010: 111). Perhaps the point is that the military are exalted by being aligned with a technology – they are throughout the film shown using radio transmitters – that has the power to seduce both the colonized and the colonizer into accepting western superiority. Technology too is an object and instrument of love.

## Death in the desert

*La llamada de África* ends with an image of the stars which can be read as the bugle boy Ahmed's point-of-view shot, following his closing words which announce that one day he will join Ochoa on a neighbouring star. We now realize that the voice-over at the film's start, over an aerial shot of the Spanish fort in the desert 'where I spent three years before I lived here', is that of the dead Ochoa speaking from his star.[17] This materialization of the Spanish fascist anthem opens a story in which miscegenation is presented positively, but at the same time as a form of self-abasement akin to the self-denial required by military service. In the same way, *¡Harka!* shows love between men to be noble provided it is – again in a military context – based on renunciation. The self-punishing urges evident in both Santiago and Andrade drive them to find release in death. Both films relate this association of fulfilment with death explicity to the Spanish army in Africa: the soldiers of the Spanish Foreign Legion were notorious for calling themselves 'death's bridegrooms'. Although religion is absent in *¡Harka!* and minimally present in *La llamada de África*, there is an evident Christian substratum to this notion of fulfilment in death, exemplified in the description of the fascist warrior as 'half-soldier, half-monk' by the founder of the Spanish Fascist Party, José Antonio Primo de Rivera. This chimes with Dyer's analysis of the Christian notion of 'embodiment', which regards the body as the base container of a superior spirit (1997: 14–40) – a notion that he shows to be central to the repeated association of whiteness with death (ibid.: 207–23). Only by suppressing the body can fulfilment be attained. It is this that allows *¡Harka!* to present Santiago's and Carlos' homoerotic bond as in no way transgressive. On the contrary, their homoerotic bond is what marks them out as superior to the other Spanish officers, for it renounces bodily gratification. Elena has noted that Santiago is driven by an urge to self-punishment (1997: 134). Although Andrade's relationship with Halima is clearly sexual, it is 'purified' by the fact that it appears to be a form of self-abasement, aimed at working through his complex about his mixed-race origins. Near the start of the film, Andrade is depicted as

experiencing mystical ecstasy when he tests a knife by cutting his forearm whilst looking heavenward; the fact that the knife has been given him by a Berber brings a colonial dimension into this rapture. Andrade's Christlike death brings him ultimate purification from the taint of Halima. The death drives of both Santiago and Andrade construct them as white heroes. If both Halima and Ahmed shrink from whiteness as the colour of death, by the end of *La llamada de África* Ahmed has, it seems, learnt from Ochoa's example that whiteness signifies a superior embrace of death.

In loving Africa, Santiago and Carlos and Andrade and Ochoa are in love with the desert. On the one hand, the desert beckons with the glorious promise of death. *La llamada de África* has recurrent images of men – including the dying Andrade at the end – sifting the sand through their fingers like an hourglass. On the other hand, the desert can be seen as an image of the voiding of the self for which the white male military heroes of these films are striving. In both *¡Harka!* and *La llamada de África* the 'call of Africa' is, in the end, not so much the lure of Arab culture as the call of whiteness: a whiteness that can be attained only by rejecting the love of white women (self-gratification) for love of the desert.

# References

Aidi, H. D. (2006), 'The interference of al-Andalus: Spain, Islam, and the West', *Social Text*, 24: 2, pp. 67–88.

Ardavín y Ruiz, César F. (1951), *La llamada de África*, Madrid: Hesperia Films/Imp. Laguno.

Bhabha, H. (1994), *The Location of Culture*, London: Routledge.

de Madariaga, M. R. (2002), *Los moros que trajo Franco... La intervención de tropas coloniales en la guerra civil española*, Barcelona: Martínez Roca.

Dyer, R. (1997), *White*, London: Routledge.

Elena, A. (1997), '*¡Harka!*', in J. Pérez Perucha (ed.), *Antología critica del cine español, 1906–1995*, Madrid: Cátedra/Filmoteca Española, pp. 132–34.

——— (2001), 'Cámaras al sol. Notas sobre el documental colonial español', in J. M. Catalá, J. Cerdán and C. Torreiro (eds), *Mirada, memoria y fascinación: Notas sobre el documental español*, Málaga: Festival de Cine Español, pp. 115–24.

——— (2004), '*Romancero marroquí': El cine africanista durante la Guerra Civil*, Madrid: Filmoteca Española.

—— (2010), *La llamada de África. Estudios sobre el cine colonial español*, Barcelona: Bellaterra.

Evans, P. W. (1995), 'Cifesa: cinema and authoritarian aesthetics', in H. Graham and J. Labanyi (eds), *Spanish Cultural Studies: An Introduction*, Oxford: Oxford University Press, pp. 215-22.

Goda, N. J. W. (1999), 'Franco's bid for empire: Spain, Germany, and the Western Mediterranean in World War II', in R. Rein (ed.), *Spain and the Mediterranean since 1898*, London: Cass, pp. 168–94.

González Alcantud, J. (2003), *Marroquíes en la guerra civil española: Campos equívocos*, Barcelona: Anthropos.

Hay, J. (1987), *Popular Film Culture in Fascist Italy: The Passing of the Rex*, Bloomington: Indiana University Press.

Labanyi, J. (1996), 'Women, Asian hordes and the threat to the self in Giménez Caballero's *Genio de España*', *Bulletin of Hispanic Studies*, 73, pp. 377–87.

—— (1997a), 'Gender and history: cinema in the early Franco period', *Journal of the Institute of Romance Studies*, 5, pp. 211–23.

—— (1997b) 'Race, gender and disavowal in Spanish cinema of the early Franco period: the missionary film and the folkoloric musical', *Screen*, 38: 3, pp. 215–31.

—— (2001) 'Internalizations of empire: colonial ambivalence and the early Francoist missionary film', in L. E. Delgado and R. J. Romero (eds), *Imperial Disclosures*, monographic issue of *Discourse*, 23: 1, pp. 25–42.

Landy, M. (1998), *The Folklore of Consensus: Theatricality in the Italian Cinema, 1930–1943*, Buffalo: State University of New York Press.

Martin-Márquez, S. (2008), *Disorientations: Spanish Colonialism in Africa and the Performance of Identity*, New Haven: Yale University Press.

Rein, R. (1999), 'In pursuit of votes and economic treaties: Francoist Spain and the Arab world, 1945–56', in R. Rein (ed.), *Spain and the Mediterranean since 1898*, London: Cass, pp. 195–215.

Taussig, M. (1993), *Mimesis and Alterity*, New York: Routledge.

Theweleit, K. (1989), *Male Fantasies*, vol. 2, Cambridge: Polity.

Viscarri, D. (2002), '¡*Harka!*. Representación e imagen del africanismo fascista', *Revista de Estudios Hispánicos*, 36: 2, pp. 404–24.

Zumalde Arregi, I. (1997), '*La llamada de África*', in J. Pérez Perucha (ed.), *Antología crítica del cine español, 1906–1995*, Madrid: Cátedra/Filmoteca Española, pp. 309–11.

## Notes

1. In addition to its long-standing control of the urban enclaves of Melilla and Ceuta (held since 1497 and 1580 respectively), Spain had had a colonial presence in Morocco since the 1859–60 'African War'. In 1912, the Berlin Conference divided Morocco between France and Spain. In 1956, both Spain and France ceded independence to their Moroccan territories.

2. Spain first established a protectorate in the coastal strip of Western Sahara, south of Morocco, in 1884, subsequently expanded and its boundaries defined as 'Spanish Sahara' in 1924. In 1975, shortly before Franco's death, as independence was about to be granted, Spanish Sahara was annexed by Morocco.

3. Imperio Argentina was invited to Berlin on a contract with Hispano-Film-Produktion partly because she was one of Hitler's favourite stars, although this has been somewhat mythologized (he granted her a private audience). An additional curiosity is that, in the first film she made in Berlin, *Carmen, la de Triana/Carmen from Triana* (Rey, 1938), she played the gypsy Carmen, again flouting Nazi racial policies. For discussion of both films, see Labanyi 1997a; for *La canción de Aixa*, see Martin-Márquez 2008: 234–49.

4. Goda stresses that Hitler's expansionist plans in Africa should be seen as the context to his October 1940 meeting with Franco at Hendaye, noting that, just before this meeting, Franco had raised Spanish troop levels in the Canaries as well as Morocco (1999: 179).

5. The Falange was the Spanish Fascist Party, founded in 1933.

6. Viscarri sees Santiago's *djellaba* as unimportant since he wears his Spanish officer's uniform underneath (2002: 413). I agree that Santiago's Spanishness is paramount, but would argue that, paradoxically, it is his imitation of Arab culture that allows him to further Spanish interests.

7. All translations in this essay are my own.

8. This shot, including the play of light, replicates a scene in the Italian colonial film, *Lo squadrone bianco/The White Squadron* (Genina, 1936), set in Libya, in which the profligate junior officer bonds over a camp fire with his fascist military captain. In Genina's film, premièred in Spain in May 1940, the junior officer also rejects his decadent westernized female lover from the metropole, to assume the fascist warrior role of his military superior on the latter's death. See Hay 1987: 188–92 and Landy 1998: 194–97. I thank Liliana Ellena for pointing out this intertextual reference, also noted in Elena 2010: 106.

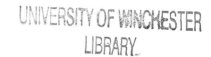

9. González Alcantud notes references to General Franco in Spanish Africanist discourse as 'Sidi Franco', appropriating the Arabic honorific 'My Lord' (2003: 167–8; 202). The Spanish military hero of *La llamada de África* is similarly acclaimed as 'Sidi Andrade' (see below).
10. For this trope in Spanish fascist writing, see Labanyi 1996: 84–5.
11. One contemporary report alleges that Franco flew from the Canaries to Morocco, the day before he launched his military uprising, dressed in an Arab cape, *djellaba* and turban (González Alcantud 2003: 167).
12. The script has inserts giving Spanish translations, presumably for the censors' benefit.
13. Martin-Márquez also discusses the white hands/dark hands motif in the film (2008: 252–68).
14. *¡Harka!* was made at a time (1941) when the Falange dominated Francoist propaganda. *La llamada de África* (1952) coincides with the period (1945–59) of maximum church influence in the regime.
15. Martin-Márquez also notes the excision of the pregnant Halima at the film's end (2008: 268).
16. 'Face to the sun […] death will find me […] in the ranks of my comrades standing sentinel over the morning stars'.
17. This narrative frame is not present in the script.

# Part III

Movements in time-space

# Chapter 7

## The love-lives of others: reconstructing German identity in post-war and post-unification cinema

Seán Allan

'Even today our view of love is already quite different from that in [...] bourgeois society' (Maetzig 1987: 243).[1] Written as part of an article entitled 'Where are all the love stories in our films?' and published in the East German national press on 1 February 1953, the words of Kurt Maetzig, one of the pioneering directors of GDR cinema, serve as a reminder of the important role played by the discourse of love in creating two contrasting concepts of German national identity during the Cold War. He continues: 'Everybody wants to see love stories in our films [...] and if we in DEFA[2] don't respond to this demand, then people will turn instead to the often trivial, sentimental films imported from the West' (ibid.). The desire to break with the melodramatic cinematography of the so-called 'Ufa-style'[3] that had dominated German cinema throughout the 1930s and 1940s is evident in Maetzig's programmatic article for *Neues Deutschland* in which he outlines his vision of a new 'post-bourgeois' concept of on-screen love:

> In the current great struggle between the old and the new world orders, each of us helps the other to overcome the legacy of the past and embrace the new. This desire to lend the other a helping hand and raise him or her to a new level is evident in every genuine love relationship today. That's why real love stories reflect the social, moral, physical and intellectual changes taking place at the moment. (ibid.: 245)

In his own film *Roman einer jungen Ehe/Story of a Young Couple*, released the previous year in 1952, Maetzig had already hinted at the form such on-screen romances might assume in socialist cinema. Set in the immediate aftermath of World War II, the film traces the fortunes of Agnes Sailer (Yvonne Merin), a young actress from the East, and her husband, Jochen Karsten (Hans-Peter Thielen), an actor from the West. As the artistic and political divide between the two power blocks becomes increasingly pronounced, so too their marriage is strained to the point that Agnes decides to turn her back on the opportunities in the West – a decision that leads to the breakdown of her relationship – and return to East Berlin. Yet, somewhat predictably perhaps, *Roman einer jungen Ehe* ends happily when Jochen, now unemployed and disillusioned with life under capitalism, decides to join his wife in the GDR rather than go through with their impending divorce.

Although Maetzig's film offers a fascinating insight into the cultural policies of postwar Germany (see Allan 2010: 124–27 and 2011), its rigid ideological structure and the way in which, as John Urang has pointed out, 'it makes the protagonists' love contingent upon their politics' (2006: 89) suggest that *Roman einer jungen Ehe* is perhaps better seen as

a symptom of the difficulties with which East German film-making was beset during the early 1950s rather than as a possible solution to them. During the mid- to late 1950s director Gerhard Klein and scriptwriter Wolfgang Kohlhaase, two GDR film-makers heavily influenced by the postwar Italian neorealists, made a concerted attempt to break with the teleological aesthetics of socialist realism by producing a series of more open-ended love stories in such films as *Eine Berliner Romanze/A Berlin Romance* (1956) and *Berlin - Ecke Schönhauser/Berlin - Schönhauser Corner* (1957). However, the explicitly schematic love relationship embodied in Maetzig's *Roman einer jungen Ehe* was a model to which East German directors would periodically return in times of political crisis. Nowhere is this more evident than in the attempt to mirror the division of Europe in the politicized love triangles so typical of DEFA films produced immediately after the building of the Berlin Wall in August 1961. In two of the best known – Frank Vogel's ... *und Deine Liebe auch/And Your Love Too* (1962) and Heinz Thiel's *Der Kinnhaken/The Uppercut* (1962) – the central female protagonist is forced to choose between two male rivals for her affection; a choice that, at another level, represents an emphatic rejection of western capitalism in favor of Eastern Bloc socialism.[4]

## Love in a divided Germany

It is hardly surprising that directors from both East and West should look to the discourse of love as a means of exploring the vicissitudes of the postwar partition of Europe during the Cold War. On the one hand, for those working within the bourgeois traditions of mainstream cinema in the West, the representation of love as a transcendent realm in which the contradictions of mutually opposed political ideologies might be resolved is often deployed as a means of attacking the alleged 'inhumanity' of Eastern Bloc regimes generally; on the other hand, in radical socialist cinema it is precisely by highlighting the different political contexts in which these love affairs are embedded that the illusion of love as a 'transcendent' realm is most cruelly exposed. Nonetheless, it is clear that East German film-makers were confronted with the more difficult task. For as Maetzig's comments above suggest, not only did they have to wean audiences away from the sentimental clichés of Hollywood and Ufa cinema with which so many cinema-goers in both East and West had grown up, but they also faced the difficulties of reshaping the traditions of romantic narrative in a way that would promote a radically new sense of German identity: namely one constructed from an eastern, rather than western, European perspective.

Of the many attempts to address such a challenge, perhaps the most memorable is Konrad Wolf's *Der geteilte Himmel/The Divided Sky* (1964), a film indebted to the radical aesthetics of the French *nouvelle vague* generally, and to Alain Resnais' exploration of the interplay between the discourses of love and memory in *Hiroshima mon amour* (1959) in particular. Through the use of montage, Wolf sought to embed an objective

representation of everyday life in the GDR within the subjective framework of Rita's retrospective narration, and thereby provide a bridge between the aesthetics of socialist realism and developments in European New Wave cinema. However, for all the boldness of the director's attempt to integrate such modernist elements into his film, *Der geteilte Himmel* ends on a familiar note: following Manfred's (Eberhard Esche) decision to emigrate to the West, Rita (Renate Blume), the central female protagonist, breaks off her relationship with him and returns to the East and the bosom of the collective. At first sight it would appear that, in contrast to Maetzig's *Roman einer jungen Ehe*, there is no happy end, for the story of this broken love affair is narrated from the perspective of a convalescent Rita following her nervous breakdown. And yet, as one of the delegates speaking at a 1964 conference on the film staged by the East Berlin Academy of Arts observed, the collapse of this relationship should be seen not as a critique of the GDR, but rather as a precondition for the emergence of a radically new form of subjectivity:

> The contradiction between the two forms of social organization on German soil runs right through [Rita's] love relationship. [...] Rita derives the strength she needs to overcome the conflicts in her life from her insight that the resolution of these contradictions in socialism and the GDR represents a resolution in favor of real human beings, humanity and indeed the future itself. The viewer is left with the firm conviction that, while a love relationship has had to be brought to an end, we have in fact witnessed the birth of a new kind of individual. (Dahlke 1964: 18–19)

After the consolidation of the inner-German border during the 1960s, the cinematic representation of love relationships spanning the two German states soon became a thing of the past. In the East, the discourse of love in such films as Egon Günther's *Der Dritte/ The Third* (1972) and Heiner Carow's *Die Legende von Paul und Paula/ The Legend of Paul and Paula* (1973) was exploited primarily as a means of tackling themes of personal isolation in a society that, during the 1970s, was undergoing a period of radical technological change. In the West, the New German Cinema movement was primarily concerned with exploring the Federal Republic's relationship to the past, and it is striking that, despite the anti-capitalist rhetoric of the new generation of left-wing film-makers in the West, the GDR itself is a topic conspicuous for its absence in their films. However, with the collapse of the GDR in 1989 and German unification in 1990, film-makers from both East and West were faced with a new challenge; namely that of creating a new sense of German identity while at the same time exploring what it meant to be 'East German' in a world in which the GDR no longer existed. Indeed, when seen in the wider context of Europe as a whole, the situation in Germany assumed a particular significance: for nowhere did the question of European identity in the post-Soviet world come so sharply into focus as in the new Berlin Republic. And just as, during the late 1940s and early 1950s, German film directors had set out to explore questions of national identity via the representation of love affairs spanning East and West, so too, in the founding years of the new Berlin

Republic, the West German director Margarethe von Trotta and her scriptwriter Peter Schneider were to return to this tried and tested formula in *Das Versprechen/The Promise* (1995).

In *Das Versprechen*, a film that might be regarded as a belated attempt on the part of the New German Cinema to deal with the social reality of the former GDR, von Trotta presents the love affair between an East German couple who, for over thirty years, are separated by the Berlin Wall as a means of tracing some of the key moments in the history of the Cold War. As the film unfolds, we follow the lovers' fortunes from the early 1960s, when Konrad's (Anian Zollner/ August Zirner) undone shoelace prevents him from fleeing to West Berlin with his girlfriend Sophie (Meret Becker/ Corinna Harfouch), right up to the night of 9 November 1989, where the two are on the point of being 'reunited' in a moment of mutual recognition on the Glienicker Brücke following the opening of the border between East and West Berlin. *Das Versprechen* contains many echoes of *Der geteilte Himmel*, a film to which it specifically alludes on more than one occasion; but, in stark contrast to Wolf's film, in which the reasons for Rita's decision not to follow her lover Manfred to the West are clearly spelled out, von Trotta's film remains deeply ambivalent about Konrad's reasons for staying in the East (and at no point does he ever actively endorse socialism). Indeed there is a sense in which *Das Versprechen* can be read as a critical postscript to *Der geteilte Himmel* and as a tragic account of a love relationship that, as the film's unremittingly bleak presentation of the demise of the GDR suggests, has been sacrificed in vain. For when the lovers catch sight of each other after a separation of thirty years, the moment is undermined through the inclusion of a brief sequence in which an East German woman remarks: 'For me this comes too late. When, after thirty years, the cage is opened, you can no longer fly'. Not surprisingly the film's treatment of the GDR attracted considerable criticism, notably from Corinna Harfouche, the East German actress playing Sophie: 'For me, what has emerged is an absolutely negative appraisal of the GDR. I can no longer recognize my country in this film' (Brug and Junghänel 1995). At times, the film's portrayal of the love affair presents the protagonists not as individuals in control of their own destiny, but rather as passive victims of historical determinism, a view borne out by Peter Schneider's concise formulation of the film's main thrust: 'What does history do with people it has more or less taken hostage?' (Matthies 1994: 142) And, as we shall see, it was precisely this sentimentalized concept of East German victimhood that was to be so radically challenged in Wolfgang Becker's groundbreaking post-unification comedy *Good Bye, Lenin!* (2003).

## The comedy of love

*Good Bye, Lenin!* is perhaps the most successful of a series of comedies focusing on life in the former GDR and the impact of German reunification that started to appear towards the end of the 1990s; a time when the New German Cinema was in a phase of sharp

decline and a new generation of writers and film-makers was emerging who possessed the confidence to take a much more ironic and irreverent view of the post-unification process than their predecessors. The clearest evidence of this is to be found in the popular success of the comedy *Sonnenallee/Sun Alley* (1999), a collaboration involving a West German director Leander Haußmann and an East German writer Thomas Brussig that dealt with teenage life in the GDR. Brussig's explanation of the premise underlying *Sonnenallee* – 'I grew up in the GDR. That doesn't make the GDR any better. But I still have fond memories of that childhood' (Maischberger 1999: 12) – is symptomatic of a more widespread trend of nostalgic feelings for the former GDR that, in the mid-1990s, came to be known as 'ostalgia'. As Fredric Jameson has suggested, it is tempting to see the phenomenon of nostalgia itself as 'an elaborate symptom of the waning of our historicity, of our lived possibility of experiencing history in some active way' (1991: 21). Originally coined as a pejorative term to refer to the avalanche of television shows about life in the former GDR that appeared on German TV screens in the early 1990s,[5] 'ostalgia' would appear to be yet another attempt on the part of Germans to distance themselves from the uncomfortable realities of the past. Yet, as Anthony Enns has argued, to condemn nostalgia as something essentially regressive and naïve that fails to provide any critical distance from the past is to overlook the ways in which 'nostalgia […] retains the potential to foster a critical distance from the present' (2007: 477). Seen in this context, the critical analysis of 'ostalgia' in Becker's *Good Bye, Lenin!* represents an important contribution to contemporary debates about the importance of memory (and memories of the GDR past in particular) in the construction of a new sense of German identity in the post-unification period.

*Good Bye, Lenin!* is a comedy in which Alex (Daniel Brühl), the film's young East German protagonist, embarks on what is possibly the ultimate ostalgic fantasy: the reconstruction of a fake GDR within the confines of his family's apartment. Ostensibly his plan is designed to spare his mother (Katrin Saß) the trauma of finding out that, while she has been lying unconscious in a coma, the East German state to which she was so passionately committed has collapsed. At the heart of *Good Bye, Lenin!* lies a love story – the unconditional love between a mother and her son – that is of a quite different order to the kind of relationships discussed above. By focusing on the love between Alex and his mother, Christiane, and by showing how each constructs a web of lies to protect the other, Becker's film presents the viewer with a theme that, on the surface at least, would appear to transcend the ideological divide between the two German states. As the scriptwriter Bernd Lichtenberg comments, 'I'm sure that such families where people deceive each other and where lies obscure the truth – that's something you find in both East and West' (Holighaus 2003: 149). At the same time, however, by setting this 'universal' love story within a specifically GDR context, the film simultaneously offers viewers two distinct modes of spectatorship. On the one hand, for non-GDR viewers it 'corrects' the received picture of the GDR by reminding them that family relationships in the East were not fundamentally different from those in the West. On the other hand, for viewers from the

former GDR, the fact that this 'universal love story' is set in the former East presents them with an opportunity to draw on the insider knowledge necessary to decode the numerous references to a specifically GDR way of life, and thereby affirm a sense of their cultural identity as something unique and distinctive. Moreover, through the use in key roles of well-known DEFA stars such as Katrin Saß, Michael Gwisdek and Christine Schorn, Becker's film is itself a guarantee of the survival of East German film-making traditions in a post-unification world. Indeed it is precisely the insistence with which *Good Bye, Lenin!* creates multiple positions of spectatorship that makes it possible for the film to occupy a quasi-transnational space with respect to German-German debates on national identity, and goes some way to explaining its international appeal.

Although Alex embarks on his project out of love for his mother and the belief that she needs to be protected from the new world order, it becomes increasingly clear that it is in fact he who cannot come to terms with the abrupt loss of his idyllic childhood – a loss symbolized by the collapse of the GDR. Just as Christiane's temporary awakening from her coma provides the young protagonist with an extended opportunity to prepare himself for the eventual trauma of losing his mother, so too the 'extra time' the 'GDR' enjoys gives him an opportunity to make the transition from the old to the new world order. Indeed the way in which the East-West divide in the film is articulated in terms of gender relations is particularly striking: while the Federal Republic in Alex's imagination is bound up with nightmarish images of his absentee father, his memories of childhood and of growing up in the GDR are firmly rooted in the idealism of his mother. In psychological terms, the relationship between mother and son is presented as a utopian realm of the imaginary from which all the contradictions of the symbolic order have been banished. And in a manner that calls to mind Jean Paul's celebrated remark that 'memory is the only paradise from which we cannot be expelled' (1978: 820), Alex's attempt to recreate the GDR from his memories of the past is one that seeks to correct the contradictions of 'real existing socialism': 'The GDR I created for my mother increasingly became the one I might have wished for'. That is to say, his memory work assumes a utopian dimension as he seeks to construct an imaginary version of what a genuinely socialist GDR could have been like and, in the process, creates a monument to the hopes and aspirations of those who, like his mother, pursued an ideal only to be betrayed by the regime itself. Accordingly, rather than obscuring history through a series of de-historicizing acts of nostalgic memory, Becker's film combines 'ostalgia' with humour and irony, and does so in a way that not only articulates a critique of GDR history from within, but at the same time maintains a position of critical detachment from the euphoria of post-1990 political discourses in the new Berlin Republic.

Seen in this light, *Good Bye, Lenin!* is a rite-of-passage movie in a double sense, for the successful conclusion to Alex's development takes place at both a personal and a political level. What we witness is a process of mourning for both his mother *and* for the GDR: at a personal level he succeeds in transferring his emotional attachment from his mother to his Russian girlfriend Lara (Chulpan Khamatova); at a political level, he is able to come

to terms with the end of the GDR and thereby embrace the new future symbolized by the firework display on the eve of unification that he watches together with Lara from the hospital rooftop. Moreover, this relationship with the Russian Lara, a relationship that, in terms of the East-West oppositions running through the film, stands in marked contrast to his sister Ariane's (Maria Simon) relationship with the West German Rainer (Alexander Beyer), hints at a determination on his part not to abandon his GDR identity altogether, but to embrace a future in which his 'eastern' heritage might yet be preserved in a heterogeneous concept of post-Soviet European identity. This moment of personal and political transition is further underscored in the penultimate sequence in the film in which he scatters his mother's ashes across both East and West, using one of the model space rockets of his youth (see Figure 11). At the same time, the elision of this sequence with the concluding section of Super 8 footage (an idyllic collage of childhood memories) reminds the viewer that, for any individual to make a genuine transition to a new future, memories of the past must be overcome rather than simply obliterated.

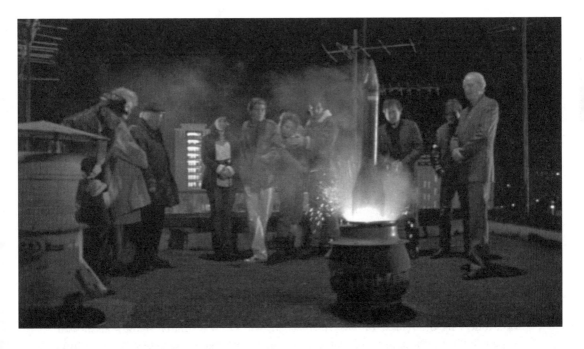

Figure 11. The funeral – *Good Bye, Lenin!* (Becker, 2003).

## The (love) lives of others

While *Good Bye, Lenin!* caught the public's imagination both in the Federal Republic and beyond, its success was to be eclipsed just three years later by Florian Henckel von Donnersmarck's *Das Leben der Anderen/The Lives of Others* (2006). Set in the GDR in 1984, the film focuses on the love affair between a (fictitious) East German couple – the playwright Georg Dreyman (Sebastian Koch) and his actress lover Christa-Maria Sieland (Martina Gedeck) – whose every move is monitored by the state security services in the person of the Stasi lieutenant Gerd Wiesler (Ulrich Mühe). Although Sieland is eventually coerced into betraying her lover Dreyman, the depth of their feelings has a profound effect on Wiesler and prompts him, in turn, to betray his political masters. And while *Das Leben der Anderen* represented a radical break with the humorous portrayal of the GDR in both *Sonnenallee* and *Good Bye, Lenin!*, the attempt to produce a serious film about the GDR past (and about the Stasi in particular) was warmly welcomed even by those whose names had become synonymous with the earlier 'ostalgic' comedies. Writing in the *Süddeutsche Zeitung* on 21 March 2006, the author Thomas Brussig, whose novel *Am kürzeren Ende der Sonnenallee/At the Shorter End of Sonnenallee* (1999) had provided the basis for Leander Haußmann's comedy, observed:

> As co-author of the film *Sonnenallee* I'm sure I'm going to be told repeatedly that we 'can't' approach the GDR past as we did in *Sonnenallee*, because it 'must' be done the way it has been in *Das Leben der Anderen*. Of course that's rubbish. It isn't a question of doing it this way or that; it can be done both ways. It's not the fault of the earlier comedies that the image of the GDR has been distorted; the reason for that is precisely the absence of films like *Das Leben der Anderen*. And that's why I welcome the film because at last that particular gap has been filled. (Brussig 2006)

In addition, just before the release of *Das Leben der Anderen*, it seemed that life was indeed imitating art when Ulrich Mühe (the East German actor cast in the role of Wiesler) accused his former wife, the well-known actress Jenny Gröllmann, of having spied on him for the Stasi during their marriage. These allegations were vigorously denied by Gröllmann, who insisted that the files referring to her had been falsified, and subsequently obtained a court injunction preventing Mühe from repeating the allegations in public. Seen in the context of an increased readiness on the part of some former Stasi-employees to defend their past actions in public, the acrimonious dispute between Mühe and Gröllmann serves as a reminder of just how sensitive an issue the legacy of the GDR past, and of the Stasi in particular, remained.

Anxious to avoid the kind of errors for which Margarethe von Trotta had been taken to task following the release of *Das Versprechen*, von Donnersmarck spent a great deal time painstakingly researching his subject matter, and engaged a team of expert costume and set designers (many of them from the former GDR) to ensure that his film seemed

as authentic as possible. Indeed it is striking that the publicity material for the film places a great deal of emphasis on its 'unprecedented authenticity'. However, while reviewers from both East and West were unanimous in their admiration for the way in which the selection of locations and props, together with the use of a subtle palette of predominantly orange and brown tones, succeeded in conveying the look and feel of the GDR in the mid-1980s, opinions were sharply divided regarding the radical transformation that takes place in the Stasi officer during his surveillance of the couple. In an attempt to justify the decision not to allow von Donnersmarck's team to film on location in the Stasi's infamous Hohenschönhausen prison, Hubertus Knabe, director of the memorial centre that now occupies the buildings, commented: 'Portraying the Stasi interrogator as a hero is something that will hurt the feelings of many Stasi victims and mislead viewers' (Malzahn and Weiland 2006). Writing in *The Guardian* on 5 May 2007, Anna Fulder, author of the novel *Stasiland* (2003), welcomed the film as 'the first realistic portrayal of the GDR', but was at pains to emphasize that '[the] story is a fantasy narrative that could not have taken place (and never did)'. As many historians of the GDR confirmed (see Wilke 2007), there is no archival evidence to suggest that any Stasi officer had ever acted in the way Wiesler does in the film.

*Das Leben der Anderen* is, of course, anything but an apology for the GDR and the Stasi. Starting with the chilling sequence in an interrogation cell, it pulls no punches in exposing the hypocrisy and corruption of those in power. Nonetheless it is hard not to feel that von Donnersmarck's unremittingly bleak picture of the GDR is no less one-sided than the perhaps overly optimistic portrayal of the GDR in the earlier comedies against which his film is pitted. The extent to which the historical reality of the GDR can in fact be mapped onto the GDR as represented in the film remains an open question; despite its much trumpeted authenticity, *Das Leben der Anderen* is perhaps best approached not as a historically accurate account of the GDR itself, but rather as a study of the potential of love as an instrument of resistance and redemption in an abstract totalitarian milieu. Seen in this light, the reason for von Donnersmarck's act of poetic license regarding Wiesler's transformation (and an explanation of the film's appeal to non-German audiences) is hinted at in an article on the film published in *Die Welt* on 22 March 2006 by the East German singer-songwriter Wolf Biermann in which he remarks: 'We are all desperate for evidence that human beings can change for the better and embrace what is morally right' (Biermann 2006).

In his portrayal of the love relationship between Dreyman and Sieland, von Donnersmarck offers us a glimpse of a potentially utopian space within the bleak and oppressive atmosphere of an Orwellian-like state. While the strength of their passion renders the lovers so vulnerable in their society, it is precisely this vulnerability that defines their essential humanity and sets their existence in such stark contrast to the mechanical efficiency of the ruthless state security apparatus. Although the amphetamine-dependent Sieland initially appears to be the weaker of the two, ultimately she demonstrates a far keener understanding of the limited capacity of any human being (and above all herself) to withstand pressure than the overly idealistic playwright Dreyman. This difference is,

of course, conditioned by gender: as a female artist in a totalitarian, patriarchal society, Sieland is a victim in a double sense and, having been coerced into a sexual relationship with the unscrupulous minister Hempf as a condition for continuing to perform on-stage, she has had firsthand experience of the pressure that can be brought to bear on an individual. Dreyman, by contrast – a man for whom, as Wiesler's superior Grubitz puts it, 'the GDR is the most wonderful place in the world' and who enjoys a reputation as a successful author in both East and West – has never really been tested. And, of the two, it is Sieland who, by denying the minister his will, exposes herself to the greatest risk: a selfless act that inspires Dreyman to abandon any further attempts to reach a compromise with the state and to embark on his dissident project instead. Yet Sieland pays for the redemption of her lover with her life; what kills her is Dreyman's reproachful gaze when he believes that she has betrayed him, a look that drives her from the apartment and into the path of an oncoming lorry. And like so many (female) victims of the violence of (male) Others, she blames not the real perpetrators of the crime, but herself. Her dying words – 'I was too weak' – are a telling indictment not of herself, but of the inhumanity of the world she inhabits, and Dreyman's final 'Forgive me!' represents a tacit acknowledgement of his own contribution to her downfall, and of the devastating consequences of his momentary failure to trust her. Commenting on Sieland's role in the film, Claudia Lenssen suggests:

> At the heart of this drama only the woman remains a passive, submissive, frail figure, who has to remain weak for the sake of the plot; a classic female victim whose self-willed death is quite in keeping with her character […]. In this fictional version of the GDR the women are reduced to clichés: there is Christa-Maria [Sieland] as an allegory of the oppression of art and beauty in a dictatorship, there is a frightened mother, and there is a whore. (Lenssen 2008)

And while Lenssen is surely correct to criticize the film for its primary focus on the film's male protagonists, the very 'impossibility' of Sieland assuming an active role serves, nonetheless, as an important reminder of the essentially patriarchal character of all totalitarian societies.

Given the involvement of both Dreyman and Sieland in the world of the theatre, it is hardly surprising that issues of spectatorship and performance should feature so prominently in *Das Leben der Anderen*. But while Dreyman, Sieland and even the flamboyant Grubitz can never quite resist the opportunity to put on a show for others, the dour Stasi surveillance officer Wiesler is, at least to begin with, an individual wholly content to remain within the parameters of his allotted role of observer. However, when Wiesler starts monitoring Dreyman and Sieland, he is confronted with something that goes far beyond what he has experienced hitherto and, unbeknown to the 'performers', their love affair becomes a spectacle for his consumption. Initially, Wiesler attempts to compress his experiences into the unforgiving parameters of the Stasi-discourse: 'they then presumably have sexual intercourse', he types in his report, a wholly arid summary of the spontaneous outburst of

passion that has just enveloped Dreyman and Sieland. Crucially, however, the context in which Wiesler observes the couple is radically altered when he discovers that his surveillance operation has nothing to do with defending socialism and is simply designed to further the minister's private interests. No longer under any illusions as to what motivates his superiors, Wiesler's observation of the relationship awakes an awareness of everything his own life lacks and, as a result, he becomes increasingly involved in the performance he is observing. This is visually underscored when he traces the outline of their apartment on the floor of his attic hide-away and even projects himself into the physical posture Dreyman adopts. In one desperate attempt to experience for himself the passion he has just witnessed, he begs a Stasi prostitute (unsuccessfully) to stay a while after their soulless sexual encounter. But the key turning point occurs following the news of the blacklisted theatre director Jerska's (Volkmar Kleinert) death. As we watch Wiesler listening to Dreyman's rendition of the (fictitious) 'Sonata for a Good Man', which Jerska had given Dreyman shortly before his death, the tear running down his face underlines his capacity to empathize with the music as an expression of Dreyman's feelings of love and pain, the significance of which is underlined by Dreyman's remark: 'Can anyone who has heard this music, I mean truly heard it, [...] really be a bad person?' Dreyman's observation – an allusion to Lenin's famous remark that he could not listen to Beethoven's *Appassionata* for fear that the experience would soften his resolve – perfectly encapsulates the faith of von Donnersmarck's film in the redemptive power not only of art and music, but also of love. This is further underlined the following morning when Grubitz greets Wiesler saying, 'We have a lot to gain from this love-story. And a lot to lose'. Just how radical the transformation is in Wiesler is made clearer in an earlier version of the script in which Wiesler reminds his Stasi cadets that 'in interrogations your subjects are enemies of socialism. Never forget to hate them'. (von Donnersmarck 2006: 21) Although at the end of the film Wiesler might be said to have saved Dreyman (by concealing the evidence of the typewriter from Grubitz), ultimately it is the love affair between Dreyman and Sieland that 'saves' Wiesler as a human being. Moreover, the symbiotic relationship in which the two men are locked – a relationship in which the simplistic binary distinction between perpetrator and victim is continually blurred – is underscored by the film's highly distinctive editing whereby we see first one and then the other protagonist projected into essentially the same frame. Nowhere is this more clearly the case than when Wiesler, in a Pietà-like tableau, embraces the dying Sieland (see Figure 12), only to be displaced seconds later by Dreyman, who adopts a near identical pose (see Figure 13).[6] As the use of such religious iconography suggests, the discourse of love in *Das Leben der Anderen* is a crucial part of the film's quasi-Christian agenda in which no individual is beyond redemption. For while the film does not articulate its moral agenda in explicitly religious terms, it draws nonetheless on a long tradition in which the concept of European civilization – in both East and West – is defined in terms of a commitment to an essentially Christian concept of ethics.[7]

At first sight *Das Leben der Anderen* would appear to commend itself as a key film for the new Federal Republic in the post-unification era, for it is a film in which the love affair

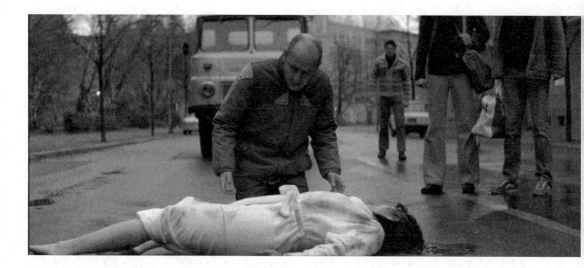

Figure 12. Pietà I: Wiesler with the dying Sieland – *The Lives of Others* (von Donnersmarck, 2006).

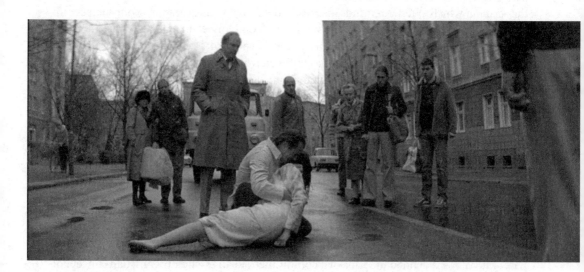

Figure 13. Pietà II: Dreyman with the dying Sieland – *The Lives of Others* (von Donnersmarck, 2006).

between Dreyman and Sieland highlights both the inhumanity of a totalitarian regime and yet holds out the possibility that, even in a totalitarian state, the discourse of love can triumph over the discourse of hatred that Wiesler initially espouses. Only by tackling the horrors of the Stasi head-on, the film appears to suggest, can we arrive at a more differentiated understanding of those most severely compromised by such regimes. Seen within the wider context of Europe as a whole, the film might also be regarded as making an important contribution to post-Soviet life in a number of Eastern European states. At the same time, however, it is hard to overlook the striking similarities between von Donnersmarck's treatment of Wiesler, the 'good German' from the GDR, and the recent wave of films about World War II in which 'good Germans' caught up in the Third Reich are ultimately redeemed. Indeed, in blurring the distinction between perpetrators and victims, *Das Leben der Anderen* is part of a new trend in contemporary German cinema that reflects the desire of a new post-1968 generation to 'normalize' the German past and renegotiate an understanding of German national identity in terms that circumvent the discursive terms of conventional Cold War politics.

## Conclusions

Whereas in the early postwar films discussed above the discourse of love was explicitly deployed as a means of constructing a new (and specifically East German) identity, the love relationship between Alex and his mother in *Good Bye, Lenin!* and that between Dreyman and Sieland in *Das Leben der Anderen* are presented as transcendent utopias in which ideological difference, if not actually erased, is at least temporarily suspended. Nonetheless, the melodramatic pathos of *Das Leben der Anderen* serves as a reminder of the starkly contrasting concepts of identity that lie at the heart of the two films.[8] Indeed there is something almost expressionist about the manner of Wiesler's rebirth in the film; a throwback to the classical humanist agenda of individual moral regeneration through a combination of art and love. In *Good Bye, Lenin!*, however, the comic events set in motion by Alex's love for his mother are the trigger for an exploration of the performative character of identity and of the complex role played by memories of the past in our self-understanding. For in a post-Soviet Europe in which all ideologies are relentlessly called into question, to be 'Other' is no longer to be cast in the role of victim but rather to adopt a position from which the contradictions and absurdities of the dominant structures of society might be exposed. Seen in this light, the redemptive morality underpinning *Das Leben der Anderen* draws on an essentialist notion of humanity shared by all; by contrast, the comedy of identity in *Good Bye, Lenin!* suggests ways in which the complex positions of spectatorship, that are themselves the product of an increasingly heterogeneous society, might be negotiated in the future.

# References

Allan, S. (2010), 'Projections of history: East German film-makers and the Berlin Wall', in T. Hochscherf, C. Laucht and A. Plowman (eds), *Divided But Not Disconnected: German Experiences in the Cold War*, Oxford: Berghahn, pp.119–33.

———— (2011), '"Sagt, wie soll man Stalin danken?": Kurt Maetzig's *Ehe im Schatten* (1947), *Roman einer jungen Ehe* (1952) and the cultural politics of post-war Germany', *German Life and Letters*, 64: 2, pp. 255–71.

Berghahn, D. (2009), 'Remembering the Stasi in a fairy tale of redemption: Florian Henckel von Donnersmarck's *Das Leben der Anderen*', *Oxford German Studies*, 38: 3, pp. 321–33.

Biermann, W. (2006), 'Die Gespenster treten aus dem Schatten', *Welt Online*, 22 March, http://www.welt.de/print-welt/article205348/Die_Gespenster_treten_aus_dem_Schatten.html. Accessed 8 October 2009.

Brug, M. and Junghänel, F. (1995), 'Interview mit Corinna Harfouche', *Wochenpost*, 10 February.

Brussig, T. (2006), 'Klaviatur des Sadismus. Die DDR in *Das Leben der Anderen*', *Süddeutsche Zeitung*, 21 March.

Dahlke, G. (1964), 'Hauptreferat', in Deutsche Akademie der Künste zu Berlin (ed.), *Probleme des sozialistischen Realismus in der darstellenden Kunst behandelt am Beispiel des DEFA-Films 'Der geteilte Himmel'*, Berlin: Henschel, pp. 3–22.

Delanty, G. (1995), *Inventing Europe: Idea, Identity, Reality*, London: Macmillan.

Enns, A. (2007), 'The politics of *Ostalgie*. post-socialist nostalgia in recent German film', *Screen*, 48: 4, pp. 475–91.

Evans, O. (2010), 'Redeeming the demon? The legacy of the Stasi in *Das Leben der Anderen*', *Memory Studies*, 3: 2, pp. 164–77.

Funder, A. (2007), 'Tyranny of terror', *The Guardian*, 5 May, http://www.guardian.co.uk/books/2007/may/05/featuresreviews.guardianreview12?INTCMP=SRCH. Accessed 8 October 2009.

Holighaus, A. (2003), 'Eine Familiengeschichte: Gespräch mit dem Drehbuchautor Bernd Lichtenberg', in M. Töteberg (ed.), *Good Bye, Lenin!' Ein Film von Wolfgang Becker*, Berlin: Schwarzkopf and Schwarzkopf, pp. 148–51.

Jameson, F. (1991), *Postmodernism, or, the Cultural Logic of Late Capitalism*, Durham, NC: Duke University Press.

Jean Paul (1978), 'Impromptus, welche ich künftig in Stammbücher schreiben werden', in N. Miller (ed.), *Jean Paul. Sämtliche Werke*, sec. 2, vol. 3, no. 29, Munich: Hanser, pp. 814–23. First published 1812.

Lenssen, C. (2008), '*Das Leben der Anderen*: Filmkritik und Rezeption in Deutschland', in *Vortrag anläßlich der Podiumsdiskussion 'STASI und Sicherheitsdienst in der Volksrepublik Polen – Parallele Wesen' im Goethe-Institut Warschau*, http://www.goethe.de/ins/pl/war/acv/flm/2007/de2045379.htm. Accessed 8 October 2009.

Maetzig, K. (1987), 'Über die Liebe in unseren Filmen: Eröffnung einer Diskussion', in G. Agde (ed.), *Kurt Maetzig: Filmarbeit. Gespräche/Reden/Schriften*, Berlin: Henschel, pp. 243–46. First published as 'Warum gibt es keine Liebe in unseren Filmen?', *Neues Deutschland*, 1 February 1953.

Maischberger, S. (1999), '*Sonnenallee* – Eine Mauerkomödie: Interview mit Leander Haußmann und Thomas Brussig', in L. Haußmann (ed.), *Sonnenallee: Das Buch zum Farbfilm*, Berlin: Quadriga, pp. 8–24.

Malzahn, C. C. and Weiland, S. (2006), '"Das Problem liegt bei der PDS": Interview mit DDR-Experte Hubertus Knabe', *Spiegel Online*, 15 September, http://www.spiegel.de/politik/deutschland/0,1518,437210,00.html. Accessed 8 October 2009.

Matthies, O. (1994), 'Interview mit Margarethe von Trotta und Peter Schneider', in P. Schneider and M. von Trotta, *Das Versprechen oder Der lange Atem der Liebe. Filmszenarium*, Berlin: Volk und Welt, pp. 140–45.

Urang, J. G. (2006), 'Realism and romance in the East German cinema, 1952–1962', *Film History*, 18: 1, pp. 88–103.

von Donnersmarck, F. H. (2006), *Das Leben der Anderen. Filmbuch*, Frankfurt: Suhrkamp.

Wilke, M. (2007), 'Wieslers Umkehr', in F. H. von Donnersmarck, *Das Leben der Anderen. Filmbuch*, Frankfurt: Suhrkamp, pp. 201–13.

## Notes

1. Translations from the original German are my own.
2. DEFA (Deutsche Film-Aktiengesellschaft) was set up in the Soviet sector of Berlin in the spring of 1946 and became the state-sponsored production studio for cinema in the East following the founding of the German Democratic Republic (GDR) on 7 October 1949.
3. Ufa (Universum Film AG) was the main production studio in Germany from 1917–45.
4. For a more detailed discussion, see Allan 2010: 124–27.
5. The best known of these were ZDF's *Die Ostalgie Show*, hosted by Andrea Kiewel and Marco Schreyl, and RTL's *Die DDR Show* co-hosted by, among others, the former GDR Olympic skating champion, Katharina Witt.
6. For a series of similar examples, see Berghahn 2009: 327–29.
7. In his history of European identity, Gerard Delanty argues that, despite the increasing secularization of Europe from the late seventeenth century onwards, 'the principle components of European identity were the ideas of progress, civilization, and Christian redemption' (1995: 69).
8. For a discussion of the film's incorporation of generic conventions (including melodrama), see Evans 2010: 170–75.

**Chapter 8**

Exiled memories: transnational memoryscapes in recent French cinema

Liliana Ellena

A t the end of the 1980s and in the early 1990s, the dividing line between colonial and anti-colonial cinema was challenged by a number of changes taking place in and beyond the film industry. Cultural, social and political processes related to the end of the Cold War, to European unification and to growing mobility from outside and within Europe's borders saw the emergence of colonial memory as a key concern – whether in the form of the search for a lost past, feeding on nostalgia, or of the recoding of certain national memories resulting from the new emphasis on border-crossing discourses. At the same time, the increasing presence of exilic, diasporic and postcolonial film-makers working in Europe has disrupted the colonial/anti-colonial dichotomy by challenging the national as the privileged time-space in which cultural identities and imagined communities are embedded.

These changes have impacted on the frameworks of collective memory conventionally grounded in national formations and codified in narratives dealing with major historical figures, mass movements and events. By contrast, European cinema of the early 1990s registered a 'return to colonial history' that privileged heterogeneous narratives dealing with memories of spaces or subjects that had been marginalized or seldom recognized as fully European. This included memories of women, *Pied-Noirs* or other returnees, and generations marked by transcontinental experiences, or of spaces like the Mediterranean, which in the postwar period was considered peripheral to Europe. These new forms of memory work have occupied a shifting terrain bordered by public invisibility on the one hand, and the private cult of exoticist nostalgia on the other.

With this new emphasis on individual memory and fragmented identity, the exploration of transnational connections or intercultural exchange between former imperial metropoles and colonial territories has found in 'return narratives' a crucial format for representing the colonial past and diasporic present from a European point of view. Return stories may be considered a specific genre of travel narrative that engages both the temporal and spatial dimensions of experiences of displacement, exile and uprooting. In this respect, they offer a privileged site for investigating the distinctive ways in which the memory of colonialism intersects with cultural identities. To explore this connection I will discuss two French films – *Chocolat/Chocolate* (Denis, 1988) and *Exils/Exiles* (Gatlif, 2004) – which engage with the quest for memory by diasporic subjects in the form of a counter-journey to Africa (Cameroon and Algeria, respectively). In both films, the movement between present and past and between Europe and Africa is represented through a love relationship; this provides a crucial narrative paradigm able to

connect the private and public spheres. In the first case, the impossible colonial romance is evoked and subverted as an allegory of the unspoken trauma haunting memories of colonialism in late 1980s France; in the second case, where the 'memory trip' is enacted through a love relationship between the son of French *Pied-Noirs* and the daughter of Algerian Arab immigrants in France, the narration foregrounds the relational nature of postcolonial memory as a process which activates past scars within new configurations.

As a figure which cuts across private and public memory quests, travel calls into question the relation between movement, emotion and cinema. As Giuliana Bruno has suggested in her work on the cultural history of visual representations, cinema memoryscapes may be read as complex maps plotted in terms of motion and emotion, charting physical and sensorial tracks across continents and times (Bruno 2002). This theoretical perspective opens up new spaces for rethinking the interplay between love, Europe and the memory of colonialism, taking into account decolonization's impact on their dynamics and cultural representation. Romance narratives based on interracial relationships have been employed recurrently in classical cinema to construct colonial and imperial allegories mobilized for different ideological and political ends. Drawing on the use of the romance format in nineteenth-century 'foundational fictions' to align personal and national sentimental attachments (Sommer 1991: 41), film narratives have built up metonymic associations between, on the one hand, sexual and affective relationships that need the state's approval and, on the other, the political legitimation of imperial rule and intercultural encounter. These associations have been articulated in terms of a 'vocabulary of love' conjugated within multiple discursive formations ranging from passion and desire to affection and family ties. Relatively little attention has been paid to considering how these legacies have been challenged or recycled in the postcolonial present when global migration processes, blurring the binary opposition between former colony and metropole, foreground new connections between – and new configurations of – journeys, stories and subjects.

## *Chocolat*: memories of colonialism and impossible desires

Claire Denis' first feature film of 1988, *Chocolat*, portrays the return of a young, white woman called France (Mireille Perrier) to her homeland in Africa, evoking memories of French colonial life at an outpost in Cameroon in the mid-1950s during the final years of empire. The subject is closely related to Denis' personal biography and film-making career. She spent her childhood in various parts of sub-Saharan Africa, where her father worked for the French colonial administration, and may herself be considered a child of decolonization since she was brought back to Paris in the early 1960s as a teenager. Later on, after a long apprenticeship working as assistant director to Costa Gavras, Jacques Rivette and Wim Wenders, her first feature allowed her to find her place and stylistic mark by moving back to the French colonial past (Streiter 2008: 56). Her personal experience of feeling a stranger both overseas and in the metropole would run through her

subsequent work, with its recurrent emphasis on experiences of homelessness, uprooted subjectivities on the move, and a politics of place and displacement filtered through the lens of desire and guilt. However, even if later works like *Beau travail/Good Work* (1999) and *White Material* (2009) would again be set in Africa, they would not repeat *Chocolat's* combination of remote locations and the historical mode of address (Beugnet 2004: 13).

In this respect *Chocolat* occupies a specific, distinctive place within French film culture and discourse on the representation of the colonial past. The autobiographical inspiration and female perspective were fundamental features shaping cinematic representation of France's overseas territories in the late 1980s and early '90s – a period that saw a clear move beyond the domination/resistance paradigm that had marked the long postwar period. In 1990 Brigitte Roüan, who grew up in Algeria and Senegal, made her first feature film *Outremer/Overseas*, dramatizing the stories of three *Pied-Noir* sisters between 1946 and 1964. White women protagonists would feature in Marie-France Pisier's *Le bal du gouverneur/The Governor's Ball* (1990); Régis Wargnier's *Indochine* (1992), which enjoyed considerable national and international success, winning the 1993 Oscar for Best Foreign Film; and Jean-Jacques Annaud's *L'amant/The Lover* (1992), based on Marguerite Duras' bestselling novel.

Compared with this group of movies, what is perhaps most noteworthy in *Chocolat* is the attention paid to the elusiveness of memory, conveyed through interruptions to conscious perception and temporal breaks, showing the impossibility of disentangling the real from the fantasized. The complex interplay between the political and private dimensions of the process of remembering and reassembling the past plays a crucial role in the film's narrative and formal structure. It opens and concludes with a conversation in contemporary Cameroon between the adult France, looking for her childhood home, and Mungo, a black man who offers her a ride. These two sequences frame the main narrative, which is thereby constructed as a long flashback: a colonial family romance that explores the subtle, discreet workings of power, desire, betrayal and dependency involved in colonial relationships from a child's perspective. The subjective perspective is established from the first static long shot showing a man and a child playing in the ocean, followed by a 180-degree pan as the camera follows the line of the horizon, finally settling on a young white woman who we will discover is the protagonist. This mobile camerawork is duplicated in a later sequence where the landscape works as a surface for the projection of the protagonist's private memories, transporting the viewer into the past as France, in the back seat of a car, leafs through the sketches, jottings and roadmaps in her father's diary. This sequence exploits the link between cinema and transportation, constructing the viewer as a passenger journeying through a slice of the past. However, this travel experience does not serve to tame history, nor to carve a reassuring linear path through a story of progress. Rather, the past confronts the viewer in a disruptive fashion.

The main focus of France's memory is Protée (Isaach de Bankolé), the African houseboy and her only friend, who stands at the junction of the intimate and public relationships in which France's family, the servants and the family guests are imbricated. The tensions

between these three groups do not unfold within a linear plot but are revealed through the detailed visual portrayal of everyday life, which maps the terrain of intimacy, desire and affection in the remote outpost where France's family lives. The setting itself contrasts the boundless space of the African landscape traversed by France's father on a tour of the district with the spatialized boundaries of race inscribed in the house, emphasizing the claustrophobic atmosphere in which the characters are trapped. If the white family home is depicted as a series of private spaces, the places where the black servants eat, shower and chat are represented as public spaces – a visual field constantly on display to the colonialist gaze. The servants' intrusion into white privacy through their responsibility for the organization of domestic life and the intrusion of the white gaze into the everyday life of Africans resulting from colonial power relations combine to show how private and public spaces are deeply sexualized and charged with desire on both sides. Hilary Neroni has noted that, by mapping these tensions through gazes, movements, gestures and emotions, the *mise-en-scène* not only traces the politics of desire forged by colonial power relationships, but suggests that they are articulated not at the level of the verbal, but in the field of the visible (Neroni 2003). In this respect, cinema becomes a powerful medium for the representation of empire as a desiring machine, which, following the line of Robert Young's argument, serves to bring to light 'the material geopolitics of colonial history as, at the same time, an agonistic narrative of desire' (1995: 174).

The conflict between the fields of desire and colonial power relationships is made explicit through the attraction between France's mother Aimée (Giula Boschi) and the African houseboy, a desire which is bound to fail as soon as it enters public space, which traps the characters in the colonial master/slave paradigm. In a crucial sequence it is Luc (Jean-Claude Adelin), a guest from the white colonial community, who brings this sexual attraction explicitly into the 'public' realm. This spatial transgression leads to a scene where Aimée tries to get physically close to Protée by touching his calf. Protée's rejection triggers a chain of betrayals: that by Aimée who asks her husband to banish Protée from the house, and Protée's betrayal of France. Anxious about losing her only friend, France approaches him in the garage and asks whether the generator pipe is hot; Protée tricks her into burning her hands by laying his on the boiling-hot pipe.

Denis subverts the logic behind the trope of the 'impossible couple' by grounding the impossibility of intermixing not in imperial ideology but in the colonial subject's refusal. Colonial cinema, alongside literature (Ruscio 1996), has repeatedly offered interracial love stories doomed to failure as an allegory of the nation in order to spectacularize colonial desire and at the same time fix racial and imperial boundaries perceived as under threat (see Chapter 5). Denis makes visible this legacy by using camera framings as a kind of visual archive. Protée's beautiful and sensual body, glistening with sweat or soapy water, is shown repeatedly, while at the same time his colonized body contained within domestic space occupies a deeply feminized position. These images are denied suture by displacements and interruptions that challenge the viewer's positionality and assumptions with regard to colonial pleasure. The static long takes, the unspoken feelings, the temporal

176

uncertainty, the almost tangible texture of the bodies saturate every frame with sensuality without sex, constantly deferring desire. When Aimée asks Protée to lace up the bodice of her evening dress, the scene is shot from the point of view of the mirror in which she is looking at their image (see Figure 14) and is infused with narcissistic, sadomasochistic pleasure, emphasizing the scopic regime that constitutes racial difference. This mirror sequence, prompting Protée's refusal, gives embodiment to the psycho-affective realm, explored by Frantz Fanon, that composes and decomposes the segregated worlds of colonialism – a realm in which the black body is forcibly objectified by exposure to the European gaze and thereby forced to inhabit an alienating, fragmented reality by the depersonalizing, discriminatory gaze of racist recognition (Fanon 1967). The desire born out of colonialism, *Chocolat* suggests, cannot but be perverse. Ultimately Protée's refusal embodies the film's disturbing secret: the anti-colonial resistance articulated in the off-screen space of memory, a resistance that can be felt and enacted only through the body. The film's disquieting interpretation of the impossibility of intermixing proved a serious obstacle to raising money for the film, as Denis has publicly stated:

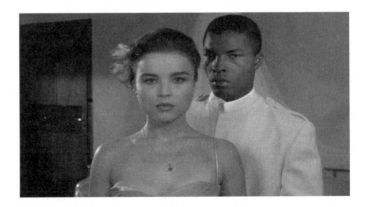

Figure 14. Aimée and Protée look at each other in the mirror – *Chocolat* (Denis, 1988).

I was strongly advised to construct an affair between Protée, the male black servant in the film, and the white woman. The producers saw this outcome as good box office [...]. I know this was a big disappointment for the production company, because they really wanted me to re-shoot the scene and to change it, but Protée's refusal was the purpose of the film. (cited in Petrie 1992: 67)

The explicit denunciation of colonial power structures is illustrated by the title *Chocolat* itself, which refers to the word's meaning of 'being cheated' in 1950s French slang, as well as being an obvious reference to blackness. Many critics have noted the dissonance between this critique and the overwhelming sense of loss and melancholy that marks the visual narrative, suffused with an unfulfilled longing haunting the impossible love affair with the colony. Alison Murray, for example, has remarked that 'its circular narrative motion, unspecified time frame and long silences give it the timeless air of a nostalgia film' (Murray 2002: 240). While acknowledging the work's melancholic overtones, Murray's interpretation undervalues the fact that the movie's critical strategy relies precisely on the disruption of codes and expectations, and is marked by the questioning of cinema's specific relation to the representation of time and history. This disruption and questioning take shape in the movement between present and past, as well as in the interlacing of sexual desire and political allegory.

While the temporal breaks are inscribed within the image of the African landscape, and while Denis's camera shoots from the young France's viewpoint, a careful look at the film's *mise-en-scène* reveals that what appears to be a flashback is not quite that. Indeed, several scenes could not have been witnessed by France, most notably that in which Aimée tries to seduce Protée. The flashback structure is a cinematic device that foregrounds the fluctuations, ambivalences and uncertainties already inherent in the decision to focus on childhood memories. Who is telling the story? What is this past that is apparently being remembered? By mobilizing the tension between memory, consciousness and temporality, the film problematizes any possibility of connecting directly with the 'truth' of the past, and opens up an enquiry into the role played by fantasy and reverie in the attempt to explain the conflict between the mother and the black houseboy which the protagonist could not understand as a child. Denis, in other words, pushes to the extreme the deployment of the codes of the nostalgia film, while at the same time revealing the role of fantasy in what has been called the French '*syndrome d'empire*' ('empire syndrome') (Murray 2002: 235). The term – which Murray borrows from Henry Rousso's analysis of the 'Vichy syndrome' (the insistent reference to the Vichy years) (Rousso 1991) – highlights the obsessive representation of Africa as a lost homeland in which nostalgia fixes the memory of empire in a monumental timelessness. If this awakening of personal memories and the representations of the colonial period they generate acknowledge decolonization as the break which produces a sense of loss and regret, they leave it off-screen, fixed in the timeless present of trauma and exiled from European historical narratives. In the attempt to redeem the individual past from a

colonial legacy that has become unacceptable, the dissociation between decolonization and the public history of colonialism leads to a short-circuit of memory; as a result, representations of the past become frozen as private fantasies. In this sense, *Chocolat* may be read as a critical intervention which makes visible that which has been left off-screen, exposing the wounds that underlie the scars.

The film's exploration of the inaccessibility of the past also dislocates the connection between sexual metaphor and political allegory unequivocally inscribed from the film's start in its characters' names: Aimée, the loved one; Protée, the protean servant/protector/lover; and France, the nation that returns to Cameroon in search of something in its past that has been lost. The allegory becomes explicit in the final present-time dialogue between the adult France and Mungo. It is Mungo, on seeing the burn scars on France's palms which make them impossible to read ('someone with no past and no future,' he calls her), who reveals how her personal relationship with the past is troubled by the ghost of the postcolonial relationship between France and its former colonies: in both relationships, the past and the future have been obliterated as the result of a wounding. It is after this dialogue that Mungo refuses the invitation advanced by the French woman to have a drink together. Mungo's refusal restages Protée's refusal within the flashback and pushes France into abandoning the idea of visiting her former family home. This final sequence, which brings together individual and political memory as many critics have noted, frustrates viewers' desire for narrative resolution. By working as a negative allegory, standing not for some kind of ideal but rather for a failure, it ratifies the refusal of absolution by probing the impossibility of an unproblematic postcolonial re-encounter between colonizer and colonized. Denis' denial of narrative closure enables the movie's fictional space, framed by hidden individual feelings of guilt and responsibility articulated in the impossible journey to the past, to question non-diegetic realities.

What troubles the relationship with the past is France's postcolonial love affair with its former colonies, whereby colonial structures of domination continued to mark French ambitions to restructure Franco-African relations through new discursive frameworks in the age of decolonization. During the 1980s, the projects of *Francophonie* and *Françafrique* underpinned and consolidated – culturally and politically, respectively – France's claim to continue to be considered a world power in the postcolonial era in the name of a supposedly exceptional and special bond between the metropole and its former colonies, which was seen as a relation of mutual benefit. It is another 'outsider' to Africa, the African-American Mungo, searching for his roots in his adopted 'homeland' of Cameroon, who renders visible the impossibility of recovering the past. Africa, whose landscape fills every frame of the film, is indeed absent – silent and inaccessible to both France and Mungo. Africa is the screen onto which quests for identity and feelings of dispossession are projected. Instead of offering a possible reconciliation, the triangulation between France, Cameroon and the African-American diaspora insists on the extent of the problem by evoking the multiple trajectories of diasporic movements connecting Africa with modernity, grounded in various forms of racism which have denied and silenced African subjectivities.

Denis constructs memory as a liminal zone inhabited by heterogeneous spaces and temporalities and by feelings of longing, desire and fear, attachment and guilt. European viewers are taken on a journey through a process of self-estrangement: having started out with the illusion of being privileged participants in a re-enactment of the past, they are left, in the final long sequence, in the position of a stranger observing, through a slat in a window, African airport workers enjoying each other and life, whose voices they cannot hear. Ultimately, as Stuart Hall has noted when commenting on European film-making on Africa which puts the European experience at its centre: '*Chocolat* suggests that this may be the only kind of film European film-makers should be making about Africa just now. It may be time for Europeans to confront what colonization has done to *them* rather than instantly taking on the white man's burden, once again, of speaking for the "other"'. (Hall 1992: 51)

## *Exils*: new loves and transcultural space

Born in Algiers to a Kabyle father and Roma mother of Andalusian origin in 1948 (the same year that Claire Denis was born) Tony Gatlif has made travel one of the recurring themes of his oeuvre from its beginnings. Starting in the outskirts of Paris, his 'Gypsy triptych' (*Les princes* [1983]; *Latcho Drom*, [1993]; *Gadjo Dilo/The Crazy Stranger* [1997]) took a musical journey tracing the Roma's westward migration from northern India to Spain, ending in post-Ceausescu Romania. The trilogy brought him international success, his public image as a Gypsy auteur providing him with the symbolic capital needed to gain access first to the European film festival network and then to the field of commercial cinema (Capussotti and Ellena 2010: 237–39). With *Exils* (2004), Gatlif drew on many of the stylistic and formal features of his previous work, such as the prominent role of music, the travel narrative format, and the centrality of experiences of marginality and displacement, in order to address physical and historical movements between the two shores of the Mediterranean. Beyond its connections with the director's personal and artistic biography, *Exils* deserves attention on account of the specific context to its release. The film won Gatlif the Best Director Award at the 2004 Cannes Film Festival, at which, to commemorate the fiftieth anniversary of the start of the Algerian War of Independence, Gillo Pontecorvo's controversial film *The Battle of Algiers* was screened and shortly after re-released in French cinemas. Other commemorations relating to colonial history took place in the same year: for example, the bicentenary of the slave revolt in the French colony of Haiti and the fifty-year anniversary of France's defeat at Dien Bien Phu, showing an increasing tendency to acknowledge the injustices perpetrated by the French state against former colonial and slave populations. However, this advocacy of a moral stance towards past crimes was the other side of a manipulation of memory through a self-congratulatory focus on France's role as moral leader on the global stage, rather than on anti-colonial revolts and resistance movements as such. The confinement of France's

colonial legacy to the past tied it to a neoliberal agenda in a disavowal of the present-day enforcement of border controls and anti-immigration laws (Till 2006: 339).

*Exils* questions the break between Europe's colonial past and its postcolonial present at many levels. The techno rap that plays over the opening scene set in a Paris suburb – 'It's time to speak about those who are absent/It's time to speak about those who are wrong/It's important to question those who are absent/Those who live without democracy/In general' – invokes a plurality of absences, echoed by the film's title. *Exils* is a road movie which follows a young couple's journey from Paris to Algiers, passing through southern France, Spanish Andalusia and Morocco: a counter-journey that reverses the familiar south-north migratory pattern from North Africa to Europe. One of its most powerful, oneiric images occurs in the scene where the two protagonists, on arrival in Algeria, find themselves walking against the flow of an interminable crowd moving in the opposite direction in order to leave the country (see Figure 15). The scene is anticipated by the encounter in Spain with an Algerian brother and sister who are slowly making their way north to Paris. This double movement maps colonial memory onto contemporary migration, thereby challenging the erasure of history implied by use of the figure of 'the migrant' as a metaphor, grounding the internal boundaries of European citizenship in geography.

The film engages explicitly with the question of European memory not only by casting the narrative as an intercontinental journey, but especially by depicting its two protagonists as European and, as such, oblivious of the colonial past and unaware of the

Figure 15. Zano and Naïma battle their way through the flood of emigrants on arrival in Algeria – *Exils* (Gatlif, 2004).

power relations that position them in relation to other people and spaces. The naivety of their adventure is made evident at various points. Having illegally boarded a ship in southern Spain, they enthusiastically mark their departure with the cry 'Adiós Europa!', only to discover they are on the wrong ship and are heading for Nador (Morocco) instead of Algiers. Shortly after, they discover that the Moroccan-Algerian border has been closed for years, and so have to enter Algeria illegally. However their discovery of their identity takes place mainly through chance encounters with migrants, labourers and Gypsies along the way. *Exils* suggests that this discovery process has asymmetrical consequences for old and new Europeans. It is only during the journey, when Naïma (Lubna Azabal) repeatedly meets Arab migrants who remind her that her name is Arabic and ask why she does not speak the Arabic language, that she is forced to face the trauma which denies her access to her past: 'Nobody taught it to me. My father didn't want to speak Arabic with us. He didn't want anyone to go on talking about his country'. The disconnection from her Algerian origins goes hand in hand with her self-representation as fully French. When a policeman asks for her ID, she angrily replies: 'Dickhead! I'm French!' refusing to be mistaken for a non-European migrant.

By depicting the connection between European memory and colonialism through the love relationship between the son of former colonial settlers and the daughter of former colonial subjects, both considered as Europeans, the narrative breaks with temporal linearity and spatial dichotomies. It introduces us to quite different positionings, which relate to power relationships in contemporary memory politics. Zano's (Romain Duris) and Naïma's respective engagements with memory differ quite remarkably. Zano's enthusiasm from the start about getting to Algeria where his parents were born contrasts with Naïma's empty past. Once in Algiers, while Zano is warmly welcomed by the new tenants of the house where his parents used to live, Naïma, with no 'home' to be reclaimed, feels alienated from the local female community – first forced to cover her body, then to wear a veil, she later violently refuses to comply. Outside European space she finds herself doubly dislocated: from the Algerian colonial past and from Algeria's present. The connection between disaffiliation, linked to issues of memory and trauma and young postcolonial women's subjectivity, serves as a counterpoint to dominant discourses that bind border control practices and the ethnicization of social conflict in post-September 11 France to the position of Franco-Maghrebi women. Repeated debates on the *hijab*, sexual violence in the *banlieues* and the failure of mixed marriages have mobilized Islamophobic discourses that cast men of North African and Muslim origin as barbaric and uncivilized, merging with neocolonial discourses focused on the liberation of Muslim women (Ticktin 2008; Mas 2010). These tensions surfaced in the film's reception at the Cannes Film Festival, when many critics read *Exils* as a mirror of the memories of its Algerian-born director, who escaped to France during the War of Independence. Pressed by journalists asking him if *Exils* was mainly a movie about Algeria, Gatlif retorted angrily: 'The film I have made is not an Algerian film and much less a film about Algeria. That is precisely what it is not. It's a French film about the children of exiles in search of

their roots' (Anterrieu 2004). At his official Cannes press conference he insisted: 'The film is about a new generation that is part of this mixing of cultures, of this ongoing process of fusion. These young people of Maghrebi or African origins, or from South America, are adding an extraordinary richness, from every point of view; these young people from the 16th *arrondissement* in Paris who listen to Arabic music without speaking the language [...]' ('Conférence de presse: *Exils*' 2004).

Contrary to European cinema's habit of falling into the *Romeo and Juliet* 'tragic love affair' formula or alternatively of celebrating successful interethnic love relationships as a metaphor for harmonious multicultural coexistence, Gatlif articulates a romance narrative in order to map the connection between memory, subjectivity and intimacy. *Exils* dramatizes the complex acknowledgement of personal traumas and painful memories within the framework of a difficult love affair. Zano and Naïma are strangers to each other. As they leave behind their urban context, they can find little common ground and for much of the film they seem on the verge of splitting up. What opens up a space for emotional communication and transcultural exchange is the journey that sets in motion not only their bodies but also their fragmented memories. This translates visually into an ongoing link between landscape and body, introduced already in the opening sequence. Here an extreme close-up of Zano's naked back scrutinizes his body scars, and then opens up to show him standing in front of a window looking onto a bleak, soulless suburban landscape. It is a journey through a landscape full of scars, in the form of industrial ruins inhabited by migrants in Spain or of an earthquake-ravaged Algiers, leading to the discovery of mental and bodily scars left by the past. Zano explains to Naïma that the scar on his leg is the trace left by the car accident in which his parents died. Later on Naïma shows her facial scar and the one on her lower back. Shortly after she tells Zano, 'I dreamt we'd arrived in Algeria. All the streets were covered with blood. There was blood everywhere. Everything was red because of the blood'. The intersection of a traumatic individual and collective past is projected onto the physical space of Algeria, haunted by a repressed history of violence which connects the events (never spelt out) that forced her father to flee the country, the colonial past and Algeria's present.

The landscape of the southern European border links the two protagonists' subjective trajectory with a series of other marginalized stories grounded in economic exploitation and political regimes resulting from colonialism and globalization. Non-European migrants, seasonal labourers and Gypsies embody diverse diasporic or exilic experiences undoing or redrawing European borders. The movements crossing this trans-Mediterranean space envision intersubjectivity as the constitutive ground of both love and memory. The journey's affective geography, connecting inner and outer landscapes, reveals the mimetic relationship between bodies and cultural spaces (Bruno 2002: 40), transporting the characters – and viewers – through embodied spaces and situated narrations.

By grounding love and memory-work in conflict and trauma, the film refuses the 'consolatory imaginary' whose colonial resonances surface in many mainstream European productions that address multiculturalism through the lens of an interethnic

love relationship. Analysing European films of the 1990s, Anneke Smelik aptly notes that this kind of discourse, 'while addressing the dismal consequences of postcolonialism or globalisation', sticks firmly to a national framework by casting the story in terms of the binary 'natives vs. ethnic minorities' (Smelik 2003: 71). This binary thinking reworks forms of national and colonial allegory in which conflicts and inequalities are resolved – in practice erased – by the romance narrative. The exoticization and consumption of the 'ethnic Other' joins hands with the opposition between romantic European love, based on freedom of choice, and arranged marriages – for example, in *Bend it Like Beckham* (Chadha, 2002) or *Jalla! Jalla!* (Fares, 2000) – reinforcing the binary logic which pits modernity against tradition. Through a problematic re-articulation of colonial and postcolonial racism, such representations hold ex-colonial migrant communities accountable for resisting assimilation so as to cling to their homogeneity and cultural integrity.

Gatlif's film resists the allegorization of love by undoing most of the binaries underpinning the metonymic association between romance and cross-cultural encounters, which includes, besides the spatial insider/outsider boundary, the temporal boundary underpinned by the logic of 'then' and 'now'. Travel here stands mainly for multiple renegotiations of individual and collective memories. In this sense, *Exils* temporalizes space, revealing its multiple historical sedimentations; at the same time it breaks the linearity of time by inscribing a multiplicity of temporal layers within its counter-journey narrative. The spatial and historical movements visualized by Gatlif suggest new ways of linking the histories of victimization of different social groups, avoiding the contradictions of competing memories. What allows the activation of old scars is precisely movement; in this case, contemporary transnational mobility, which breaks with traumatic fixation and reification. The surfacing of new memories is facilitated not by an impossible return to a past outside Europe, but rather through the intervention of a third space comprising the trajectories followed by modern-day migrants. The young Algerian woman whom the protagonists meet in Spain gives a note to Naïma addressed to her elderly mother in Algiers, in which she asks her family to take care of the couple 'since they are forming new memories'. This sets up a three-way relationship made especially complex by the fact that, when the couple arrive in Algiers, the note is read out in Arabic in front of the family gathered round the two European guests. Neither of the two protagonists can understand it, nor could any non-Arabic-speaking viewer. The most obvious reading invited by this scene is that of memory as a 'gift' from contemporary migrants, whose very presence on European soil might help to name and eventually elucidate past wounds – the suggestion being that Europeans are unaware of this gift. However, this scene also suggests something more complex, relating to the connection between intersubjectivity and mobility. New postcolonial European memories are being shaped through bodily practices of movement, connecting meanings and histories from within, across and without Europe. These new memories combine the traditional spatial focus on diaspora with the tensions between different temporalities.

## Narratives of memory and love across European borders

The increasing importance of return narratives in French cinema from 1988 to 2004 – the time frame spanned by the two films discussed here – evidences the difficulty of managing the aftermath of colonialism. This was aggravated in this period by the conflictive politics of memory arising from the asymmetrical painful histories which surfaced with the demise of the Iron Curtain and the end of the postwar international order. Claire Denis' and Tony Gatlif's critical engagement addresses the ambivalence underpinning dominant discourses on Europe's overseas entanglement, which oscillate between pathological postcolonial melancholia and the neocolonial consumption of cultural difference. Working within specific visual codes, Denis critiques dominant representations of colonial landscape and bodies encrypted in the fantasmatic texture of French postcolonial memories of Africa. In the process, a post-hegemonic European perspective emerges mainly in a negative form, through acknowledgment of France's impossible love affair with its former colonies in the aftermath of decolonization. Fifteen years later, Gatlif's critique operates in the context of post-September 11 memory politics. Its focus is the historical legacies encoded in spatial mobility across Europe's southern borders, whose intercultural dynamic undoes binary thinking and counters the discontinuity between contemporary exclusionary practices and colonialism asserted by the neoliberal agenda.

A comparison of the two films offers important insights into the emergence of distinctive forms of collective memory that exist alongside memories that are nationally bounded. This calls into question the place of postcolonial memory – still fundamentally inscribed within a national imaginary – within transnational cinema. Though transnational cinema has been discussed for some time, mainly with reference to questions of production, distribution and exhibition, the focus has recently shifted to the politics of representation involved in the movement between individual and collective narratives (Higbee and Lim 2010: 11). Indeed, the categories and contexts through which transnational production has been addressed can reproduce problematic presuppositions and dichotomies. My consideration of Denis as a diasporic director aims to undermine the tendency to apply this label almost exclusively to non-European film-makers: a habit that, yet again, reinforces normative assumptions about what constitutes Europeanness. On the contrary, I have examined how, in contemporary Europe, even the 'national' may be 'accented' (Naficy 2003) and 'provincialized' (Chakrabarty 2000).

The connections highlighted by the narrative and visual structure of both *Chocolat* and *Exils* may be interpreted as symptoms of the emergence of new ways of addressing issues relating to European history and memory. Within the respective contexts in which they were released, the two films not only signal something new within the cinema of the old continent, but indirectly anticipate something latent or not directly visible at other levels of cultural and public discourse. The visual images and the narratives they generate create a disquieting effect which, although not immediately discernable, unsettles the audience's spatial and temporal moorings. What is called into question here is the situatedness not

only of European spectators but also of the cinematic subject. These filmic explorations of memory represent important changes in how cinema addresses audiences and identification processes. In confronting the traumatic break between present and past, *Chocolat* shows how the spatiality of historical narrative is inescapably entangled with the disjunction between the former colony and the former metropole. The film's staging of an impossible return presupposes and unsettles an audience eager to identify with feelings of nostalgia on the part of both France the protagonist and France the country. Through its articulation of multiple embodied subjects of memory engaged in reworking the past, *Exils* evokes multilayered forms of European identification, in which the creative potential of transcultural subjectivities is grounded in acknowledgment rather than erasure of the power differentials structuring their proximity.

By exploring the tropes through which memory is represented and mediated by narratives of love and desire, cinema offers a privileged site from which to critique the 'structures of feeling' inscribed in colonial representations, and their legacy within a postcolonial politics of consumption of cultural difference. While the pursuit of *métissage* as a geopolitically-inflected sexual politics has a long history in French culture, *Chocolat* and *Exils* disrupt imperial allegories rooted in narratives connecting interracial romance and travel by adopting different strategies. Their exploration of conflictive and asymmetrical positions brings to light a very different understanding of desire, intimacy and love, which contests fusion, assimilation and mastery of the Other. These 'homecomings' do not recover a home, nor a sense of being at home with Others. As Svetlana Boym has suggested, diasporic intimacy 'is dystopian by definition', being constituted by uprootedness and estrangement (1998: 499). What Protée and France share in *Chocolat* is a wound – their burnt hands – that inscribes on the body the impossibility of being together, and at the same time the desire for encounters with the Other. At the end of *Exils* we do not know if Naïma and Zano will stay together, nor whether they will go back to France, but in coming together and in crossing the paths of others they have been diverted from their respective trajectories. The realm of love explored by these visual narratives is a space where what is absent and unspoken becomes palpable, captured by the discomforting feelings and yearnings of bodily subjectivities and corporeal vulnerability. Ultimately, it is the common experience of dislocation that makes intimacy possible, anticipating the 'inoperative community' that Jean-Luc Nancy – a thinker with whom Denis would later strike up a productive intellectual dialogue (Streiter 2008) – has, in a seminal work, postulated as the community based on impossible communion (Nancy 1991).

## References

Anterrieu, J. (2004), 'Conférence. *Exils*', *FilmDeCulte*, http://archive.filmdeculte.com/entretien/exils.php. Accessed 7 October 2010.

Beugnet, M. (2004), *Claire Denis*, Manchester: Manchester University Press.

Boym, S. (1998), 'On diasporic intimacy: Ilya Kabakov's installations and immigrant home', *Critical Inquiry*, 24: 2, pp. 498–524.

Bruno, G. (2002), *Atlas of Emotion: Journeys in Art, Architecture and Film*, London: Verso.

Capussotti, E. and Ellena, L. (2010), 'Memories as a battleground for postcolonial Europe: cinema, colonialism and migration', in R. Frank, H. Kaelble, M-F. Lévy and L. Passerini (eds), *Un espace public européen en construction. Des années 1950 à nos jours*, Brussels: Peter Lang, pp. 221–47.

Chakrabarty, D. (2000), *Provincializing Europe: Postcolonial Thought and Historical Difference*, Princeton, NJ: Princeton University Press.

'Conférence de presse: *Exils*' (2004), *Cannes Film Festival*, http://www.festival-cannes.com/fr/article/41643.html. Accessed 7 October 2010.

Fanon, F. (1967), *Black Skin, White Masks* (trans. C. L. Markmann), New York: Grove Press.

Hall, S. (1992), 'European cinema on the verge of a nervous breakdown', in D. Petrie (ed.), *Screening Europe: Image and Identity in Contemporary European Cinema*, London: BFI Publishing, pp. 45–53.

Higbee, W. and Lim, S. H. (2010), 'Concepts of transnational cinema: towards a critical transnationalism in film studies', *Transnational Cinemas*, 1: 1, pp. 7–21.

Mas, R. (2010), 'Secular couplings: an intergenerational affair with Islam', in L. Passerini, L. Ellena and A. C. T. Geppert (eds), *New Dangerous Liaisons: Discourses on Europe and Love in the Twentieth Century*, Oxford: Berghahn Books, pp. 269–88.

Murray, A. (2002), 'Women, nostalgia, memory: *Chocolat, Outremer*, and *Indochine*', *Research in African Literatures*, 33: 2, pp. 235–44.

Naficy, H. (2003), *An Accented Cinema: Exilic and Diasporic Filmmaking*, Princeton, NJ: Princeton University Press.

Nancy, J-L. (1991), *The Inoperative Community*, Minneapolis: University of Minnesota Press.

Neroni, H. (2003), 'Lost in fields of interracial desire: Claire Denis' *Chocolat* (1988)', *Kinoeye: New Perspectives on European Film*, 3: 7, http://www.kinoeye.org/03/07/neroni07/php. Accessed 10 November 2010.

D. Petrie (ed.) (1992), *Screening Europe: Image and Identity in Contemporary European Cinema*, London: BFI Publishing.

Rousso, H. (1991), *The Vichy Syndrome: History and Memory in France since 1944* (trans. Arthur Goldhammer), Cambridge, MA: Harvard University Press.

Ruscio, A. (1996), *Amours coloniales. Aventures et fantasmes exotiques de Claire de Duras à Georges Simenon*, Brussels: Éditions Complexe.

Smelik, A. (2003), '"For Venus smiles not in a house of tears": interethnic relations in European cinema', *European Journal of Cultural Studies*, 6: 1, pp. 55–74.

Sommer, D. (1991), *Foundational Fictions: The National Romances of Latin America*, Berkeley: University of California Press.

Streiter, A. (2008), 'The community according to Jean-Luc Nancy and Claire Denis', *Film-Philosophy*, 12: 1, pp. 49–62, http://www.film-philosophy.com/2008v12n1/streiter.pdf. Accessed 10 November 2010.

Ticktin, M. (2008), 'Sexual violence as the language of border control: where French feminist and anti-immigrant rhetoric meet', *Signs: Journal of Women in Culture and Society*, 33: 4, pp. 863–89.

Till, K. E. (2006), 'Memory studies', *History Workshop Journal*, 62: 1, pp. 325–41.

Young, R. J. C. (1995), *Colonial Desire: Hybridity in Theory, Culture and Race*, London: Routledge.

# Chapter 9

## Migration, attachment, belonging: filming the Mediterranean in Spain and Italy

Enrica Capussotti

The dramatic turn from emigration to immigration that occurred in southern European countries during the 1970s and 1980s has become a key factor in analysis of today's multicultural reality (King et al. 2000). This shift has been addressed in different ways: it has been used to stress the 'newness' of the immigration process and therefore to justify the ongoing 'inadequacies' in the reception of labour migrants and their families; or it has been invoked to support demands for a more humane attitude towards women and men undergoing the kind of displacement previously experienced by fellow nationals. In countries like Greece and Italy, in particular, the memory of earlier national diasporas has become fundamental to understanding the discussion and representation of today's migrations (Capussotti 2007; Laliotou 2004).

This chapter focuses on two films, *Poniente/ Wind from the West* (Gutiérrez, 2002) from Spain and *Tornando a casa/ Sailing Home* (Marra, 2001) from Italy, which are significant for an understanding of how memory, attachment and belonging are invoked to tell stories of solidarity and recognition, and of exploitation and inequality in a transnational world. To this end, the Mediterranean provides a repertoire of images that are renegotiated to critique the present as well as to prefigure future outcomes. I will argue that, while it is important to remember previous national diasporas, their invocation in the context of current immigratory flows runs the risk of erasing the specificity of the different power positions and forces which, in the past and present respectively, have produced and impeded the mobility of women and men. The issue of positionality is crucial if one is to avoid falling into an ahistorical understanding of migration and migrants.

I have deliberately avoided drawing comparisons between the two films as if they were somehow indicative of the two different 'national spaces' involved. Cinema, as a cultural expression embedded in transnational practices ranging from co-productions to cross-cultural reception, has always challenged the notion of fixed national borders. Nonetheless, 'national' cinema is a category still widely used, influencing critics' and audiences' expectations, publicity and film studies. The persistence of the national paradigm is particularly strong in the case of 'European cinema', which tends to be seen, beyond its conventional opposition to Hollywood, as the sum of its various 'nationally defined' cinemas. While this approach has been challenged particularly by the study of co-productions and markets, there is still insufficient theoretical and methodological understanding of cross-national reception (Bergfelder 2005). It is beyond the scope of this chapter to fill this gap. My aim is rather to explore how these films open up fissures in the notion of a stable national space, despite the fact that both of them were nationally

financed (in *Poniente*'s case, by the Spanish companies Amboto Audiovisual S.L., Amboto Producciones Cinematográficas, Antena 3 Televisión, Olmo Films S.L. and Vía Digital; in the case of *Tornando a casa*, by the Italian production company Classic).

Cinema production in Spain and Italy is still dominated by the work of 'native' directors; so-called 'ethnic minority' or 'accented' film-makers (Naficy 2001) have limited access to self-representation. Only since the 1990s have stories concerning migrants and cultural 'difference' begun to reach audiences in these two countries (Elena 2005; Parati 2005; Wood 2005; Santaolalla 2005 and 2007). Such films belong to different genres but a consistent number evidence a realist and social critical intent, denouncing the abuses faced by migrants in their 'host' societies.[1] Films focusing on migrants' experiences have rarely become box-office hits. Rather, many of them belong to a sort of 'halfway cinema' – what Morreale (2006) has called *cinema medio d'autore* ('semi-auteur films') – meaning films of 'good' quality produced on a reasonable budget and which can expect good-to-medium box-office success. These films are usually well-distributed in a circuit of urban theatres and are generally directed towards an audience of educated, urban, middle-class women and men.

The theme of migration in Europe has also been addressed by a younger generation of film-makers whose careers have been launched thanks to the niche-marketing afforded by the new multiculturalism.[2] For the most part, such films have been made on low budgets, whether self-funded or supported by public money, relying on the participation of friends and non-professional actors and using digital technology. Their distribution is supported by public institutions or limited to a few copies screened at film festivals and cinema theatres that promote auteur and/or experimental cinema. Small film festivals and exhibitions linked to political activism and anti-racist campaigns are an important space for their dissemination.[3] As a result, these films attract an audience that is best described as a socially and culturally active sector of the viewing public that is motivated to see films as social texts and to interpret cinema as an instrument for political and cultural action. In this context, aesthetic choices and debates take a back seat.

*Poniente* and *Tornando a casa* can be considered 'realist' cinema but they negotiate this label in different ways. *Poniente* juxtaposes its denunciation of migrants' labour conditions in Almería in south-east Spain with the love story between Curro (José Coronado) and Lucía (Cuca Escribano), both Spanish citizens played by professional actors. The realist intent that largely shapes the content and dénouement of the film – which denounces the anti-migrant riots which took place in El Ejido, in Almería province, in 2000 – is echoed in its linear narrative and continuity editing typical of the Hollywood classical fiction film. By contrast, Marra was successful in achieving a documentary-like objectivity in *Tornando a casa* through the use of static camera, direct sound and sparse dialogue; its non-professional actors talking in Neapolitan dialect; and its 'naturalistic' sequences of life on a fishing boat – features singled out by critics who praised the film lavishly for its neorealist poetics.

Both film-makers set their stories on the Mediterranean coast and both come from the south of their respective countries. Chus Gutiérrez is from Granada and migrated with her family to Madrid at the age of eight; Vincenzo Marra is from Naples and moved to Rome as a student. The southern regions of both Spain and Italy are historically associated with economic underdevelopment, poverty and mass emigration. In the present-day mainstream media, they are branded with the image of being the main point of entry into the country for migrants. The island of Lampedusa in Italy and the Straits of Gibraltar in Spain are represented as the porous frontier that exposes the nation and Europe to the assaults of desperate women and men.[4] *Pateras* and *carrette del mare* (the terms used in the Spanish and Italian press respectively to refer to the small boats in which migrants cross the Mediterranean) are words associated with a sense of invasion and alarm. These narratives successfully generate fear and demands for security, masking problematic questions such as the legitimacy of Spain's possessions in Morocco (the long-standing colonial territories of Ceuta and Melilla) and evidence which shows that most migrants enter Italy by land (Caritas 2007). Fiction film, documentaries, music and art have been at the forefront of critical discourses aimed at combating and countering dominant narratives of the so-called invasion of aliens and the poor. Diverse media (photography, video art, theatre amongst others) have narrated the stories of women and men who are crossing borders, calling into question the indifference of Europeans towards the thousands of victims that have turned the Mediterranean into a 'solid sea'.[5]

Specific to Italy's history is the 'othering' of the South within the process of nation building (Dickie 1999). Since Italy's national unification in 1861, the South has been identified as standing in a precarious equilibrium between modernity and backwardness, Europe and Africa (Moe 2002); and southerners have been the object of a process of racialization that is specific to racial thinking in Italy. In Spain the process has, if anything, been even stronger, given the identification of Andalusia with the eight centuries of Islamic rule in al-Andalus (from 711–1492), as evidenced in so much nineteenth-century northern European and American travel writing, but also internalized in Spanish representations of the nation's 'South'. This Orientalizing image, evoking an exotic, primitive past, remains a major selling-point in tourist publicity for southern Spain today. This racialized stereotype has been compounded by mass emigration, from the late nineteenth century on, from Andalusia and Murcia to the industrialized areas of Barcelona and Bilbao – paralleling emigration from Italy's *mezzogiorno* to the industrial North. What both 'Souths' share is their relegation to the position of 'periphery' by hierarchically-organized forms of Eurocentric thinking. Southern European countries – and even more so their internal 'Souths' – are conceptualized as part of 'the Mediterranean', a trope which homogenizes the area as a repository of stereotyped identities (Moe 2002). They also constitute a space which has become a cultural battleground and locus of critique challenging traditional cartographies of modernity through an interrogation of what modernity has meant (Chambers 2008).

*Poniente* and *Tornando a casa* are two examples of cultural products that aim to critique racist and Eurocentric visions of identity and culture. They do this by narrating stories in which the attachment to place and persons and the search for belonging are open to cross-cultural experiences and solidarity. The Mediterranean is the spatial and cultural landscape in which new forms of subjectivity are elaborated in a multicultural setting. The territories represented in the two films, although clearly located on the Mediterranean, elude stereotypes and conventional expectations, presenting the viewer with multifaceted and polysemic spaces, practices and characters. This chapter explores the relevant themes common to the two films. It discusses the entanglement of space and difference: space is an essential element around which diversity is organized and understood, whilst difference shapes the ways territories are constructed and experienced. It also considers how love for a place (rural community, the sea) constitutes a reflection on belonging and a commitment to solidarity and a shared humanity. Additionally, it analyses how the representation of bonds of attachment between individuals is used strategically to challenge prejudices and violence, and as a basis for recognition. In such a scenario, Europe and the nation-state are both peripheral and ubiquitous: although they are not directly addressed, they shape the characters' destiny, conditioning inclusion and exclusion.

## Attachment to place and belonging

Gutiérrez's *Poniente* explores an unconventional Mediterranean landscape. On one side it is bounded by the sea, rough and indomitable. Facing this sea is a land covered by plastic greenhouses, forming part of the agro-industrial complex. The film opens by deconstructing the stereotypical image of the Mediterranean: the credits appear over an image of blue sky, palm trees and bright sand that is actually a small-scale model being carried by two young students around a busy Madrid. Lucía, the main female character, discovers the striking transformation undergone by her homeland when she goes back for her father's funeral. She had left seven years before, after her elder daughter drowned in the sea. The rough sea is a place of tragedy and grief, while the landscape is divested of any picturesque qualities. Lucía finds a region that is materially and socially transformed by intensive agricultural production accompanied by the massive employment of migrants. Space is central to the visualization of Gutiérrez's social critique. In the film, migrants (mostly men) are forced to live outside the village in dilapidated old houses, sharing beds and a few rooms, surrounded by plastic and dirt tracks. When two young Moroccans try to move into the village, and again when they try to enter a nightclub, they are violently rejected. Bars are segregated along ethnic and gender lines: the locals on one side of the line, the migrants on the other, and women absent in both instances. The greenhouses are the only space the migrants can enter. Viewers also discover that migrant labour operates in a legal vacuum: migrants are employed illegally below the minimum wage, there are no negotiated salaries and no rights. Moreover the film shows how the labour market

is modelled according to ethnic preferences: some employers prefer Latin Americans because – as one says in the film – 'they are more docile and Christian'; others only hire people from sub-Saharan Africa because 'they are better than the *moros*' (the derogatory Spanish term for North Africans, referring to the previous Muslim inhabitants – 'Moors' – of al-Andalus). The shots of the village, the greenhouses and the landscape are alternated with images of the restless sea, as if the water were absorbing all the tensions and conflicts evacuated from the land.

In this fragmented and segregated location, Curro and Lucía alone cross physical and emotional boundaries, entering the immigrants' spaces and developing a sincere relationship with 'them'. Curro's humane stance is tightly bound up with the fact that he is the son of an emigrant and grew up in Switzerland as part of an ethnic 'minority'. In the film, Spanish labour emigration is represented through a black-and-white Super 8 home movie, which records the migration of Spaniards in the 1960s, at the same time introducing a self-reflexive comment on film's testimonial function. This home movie is a compendium of the images of intra-European migrations which have lodged themselves in the collective imaginary: stations and trains packed with people and suitcases; dark, gray clothes, hats and scarves; adults and children; crowded, dingy houses and bedrooms; whole families doing piecework. The Super 8 film is presented as a forgotten object saved only by Curro's curiosity and personal initiative. He finds it, in fact, in the garbage, fixes the projector and watches it with Pepe (Idilio Cardoso), an old friend of his father's and himself a fellow former emigrant. The old man cries as he watches the images, which bring back his memories of the pain, dislocation and discrimination suffered in northern Europe. While Pepe tries to forget his painful memories, it is Curro, who was born abroad and decided to return to his father's homeland, who forces him to remember in his own search for roots, happiness and a sense of belonging. The film likewise forces spectators to remember, displaying in the public arena images and emotions contained within private, family narratives. In the past, the film suggests, we can uncover the language and sentiments that make interaction with today's migrants possible.

Curro's interrogation of his roots builds a space of intimacy between earlier and contemporary migrants, firstly with Pepe, who confesses how he was unable to endure the pain of displacement, while Curro admits his frustrations: 'In Switzerland I've always felt different and I feel different here too; it hasn't helped to get to know where I'm from'. It is during this exchange that Curro finds the home video that Pepe is throwing away. Secondly, Curro's speculations about belonging have as their main interlocutor his friend Adbembi (Farid Fatmi), a North African worker. The scene in which the two men talk about their project of opening a bar is also the moment at which Adbembi reveals that he belongs to a people (Berber) spread across North Africa, with 5,000 years of history. Adbembi's solid sense of origins provokes Curro's envy but he is reminded of the common roots shared by Spain and North Africa, opening up new vistas in his quest for identity. In *Poniente*, it is not only the materiality of human activities that transforms space; the intimacy and affection between Curro and Adbembi, as well as between Curro and Pepe,

configure spaces that are clean and tranquil: for instance, on the beach where Curro and Adbembi rest and talk, and in front of Pepe's home, located in the green area outside the village. The temporal and spatial dimensions intersect. Santaolalla (2005: 74) notes that the film makes 'the Spanish spectator experience cross-cultural dialogues and/or conflicts in three time frames simultaneously': the cohabitation of Moors and Christians from the eighth to the fifteenth centuries; the hardships experienced by Spanish migrants in northern Europe in the 1960s; and present-day conflicts with immigrants.

In Spain, *Poniente* is one of the few cultural products to address the memory of labour emigration.[6] Memory debates have been dominated by the Spanish Civil War and the ensuing Francoist repression and Republican diaspora (Labanyi 2008: 120). Past labour migration has largely remained outside of public discussion. Chus Gutiérrez has stated that she wanted to challenge this silence, focusing on 'the topic of human migration [in order to] recover our historical memory as a country of emigrants'.[7] As she comments: 'Spain has always been a land of emigrants and I wanted to show that, when people have to leave their country because they don't have a future, we all have the same lost, wretched look of pariahs of the earth' (Intxausti 2002).

Figure 16. The migrants' final departure – *Poniente* (Gutiérrez, 2002).

Gutiérrez's vision of the parallels between past and present migration, so fundamental to *Poniente*, is partly contradicted by the film's end. After the 'locals' have attacked the immigrants, destroying their living quarters and belongings, they have to restart their journey. The film reproduces a familiar iconography, echoing other representations of refugees and exiles: in the background the rough sea, in the foreground a line of women and men, poorly dressed, laden with trussed-up packages, walking in single file and fighting against the strong wind (see Figure 16). Adbembi is the last in the line, the only one who stops to look back, maybe because only he can look back to a dream and a friendship. At the same moment, Curro and Lucía are reunited, bruised in their bodies and emotions after the night of violence, but alive and together.

The end reveals how a spatial hierarchy conditions who is forced to leave and who can stay, who loses everything and who has a future. In this scenario, the memories of past Spanish migration, presented as analogous to North African migration in the present, are swept away by the violence of present power relations and forces. In *Poniente*, as the script repeatedly states, migration is about endless searching and sorrows. But the film's end shows that the discrimination suffered by Spanish migrants in northern Europe in the past, and the discrimination suffered by North African migrants in Spain in the present, are of a different degree.

## Mobility, solidarity and personal attachment

Vincenzo Marra's *Tornando a casa* looks to the Mediterranean to address forms of subjectivity in a multicultural space. Briefly, the film tells the story of four fishermen – three from Naples (Franco [Aniello Scotto D'Antuono], Salvatore [Salvatore Iaccarino] and Giovanni [Giovanni Iaccarino]) and one from Tunisia (Samir [Azouz Abdelaziz]) – who work together on a fishing boat (the *Marilibera*) that every night crosses the border between Italy and Africa to go fishing in more abundant North African waters. Early on in the film, Rosa (Roberta Papa), Franco's beloved young wife, is killed in Naples. Franco is shattered by the event, to the point that, after a failed suicide attempt, he goes missing at sea together with a man he tried to save. Subsequently, having been picked up by a boat of immigrants, Franco destroys his identity card and 'becomes an immigrant' in Italian police custody, following the destiny of his companions as they are forcibly repatriated to their country of origin.

In this film there is no place for any picturesque or nostalgic *mise-en-scène* of southern landscapes and inhabitants; we do not see Mount Vesuvius or the ruins of the old city. It tells the story of the subaltern and their work, which is both their passion and their destiny, and which requires physical and emotional sacrifice. It narrates their fight to survive against the *camorra* regulating the fishing economy, the police patrolling the frontier, the politicians deciding the governance of immigration, and the widespread violence which crystallizes in a child's killing of his teacher, Rosa. In this context, mobility,

bringing together subaltern men from different 'Souths', is a resource as well as an imposed identity: Neapolitan fishermen have to move south to earn more money; Samir has to move from Tunisia to Italy; Franco wants to go to America to work in a pizzeria in order to have a better life with Rosa; unknown men cross the Mediterranean and die in it. Mobility becomes a network of peoples and routes that are embedded in history and in the contemporary experience of Italians – such as Franco's hope of joining a relative in the United States – and it takes on different meanings according to the relations of power. The mobility of the three fishermen from Naples is different from that of Samir who, having crossed national borders without the required legal documentation, has no citizenship or social rights.

The film's title literally means 'going home', and it plays with the concepts of deterritorialization and reterritorialization as tropes of the migrant condition in which 'home' is a volatile place both spatially and conceptually. The narrative problematizes the issue of which place is home for whom in a material and emotional landscape that is constantly shifting. The sense of belonging is intrinsically linked to the sea, a place of work and of attachment where life is lived in all its aspects and nuances, from harshness to tranquility. It is a beloved sea despite the hardships it imposes, and the three fishermen could hardly live away from it.

The Mediterranean is also the material and symbolic element that suddenly sends the film's storyline in a new direction. Franco jumps into the sea to save another man's life and is reborn. By destroying his identity card he becomes a foreigner, but it is the fact that he is found in a boat with 'migrants' that transforms him into the eternal Other with no rights and no future within Italy and the European Union. In the narrative, the rules of national citizenship, as well as the geopolitical factors that force people to cross the Mediterranean while at the same time preventing them from doing so, are the elements that condition identity and recognition in 'host' societies. By contrast, the Mediterranean is the space where the characters are situated without reference to a national dimension (see Figure 17). The nation-state disappears in the representation of processes of identification and subjectification: the characters are from Naples or North Africa, they speak mostly in dialect and in Arabic – Samir is the only character, save the policemen, who speaks Italian – shaping a new language and a new identity. The nation-state exists off-screen at the level of legislation and police control.

In this context solidarity is not constructed from a common social position but is instead derived from friendship and personal attachments. While Giovanni shows hostility towards Samir – an antagonism that, like many expressions of racism, seems semi-conscious – and Salvatore, overwhelmed by financial worries, seems indifferent to human relations, Franco and Samir share a bond that is intense and everyday. The feelings implicit in the relationship between them are effectively defined by the filmic language. In one of the film's first scenes, the camera frames Franco and Samir together on the boat, then moves closer to alternate their close-ups in line with the rhythm of the conversation. This scene recalls Curro's and Adbembi's talk on the beach in *Poniente*. Marra forces the

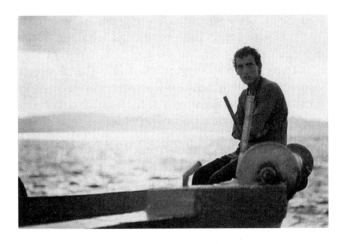

Figure 17. The Mediterranean as home – *Tornando a casa* (Marra, 2001).

viewer to contemplate Franco's and Samir's emotions, arising from their mutual trust and intimacy. As a way of showing his recognition of Samir's sorrow, Franco tries to learn some Arabic; the sentence *salam aleikum* ('may peace be with you') that he acquires will symbolize his return to language after the silence following Rosa's murder.

These scenes end with a very intense close-up of Samir's profile: the camera assumes the position of Franco's gaze and dwells upon Samir's eyes and mouth, forcing the spectators to follow the trajectory of Franco's stare. Montage and camera movement determine a gaze – binding together Franco and the public – that is mobile and articulate. It is a loving gaze that invites us to recognize the common humanity at the core of any discourse on difference. In keeping with Paul Gilroy's (2004) insistence on the importance of cosmopolitan solidarity and moral agency, we can say that Marra represents the possibility of an intersubjective exchange that is founded on the assumption of equal value and on an acceptance of difference that is irreducible to hierarchical comparison. This recognition of a shared humanity is based on the equally important recognition of emotions and dreams as a space for social action and individual exchange (Appadurai 1996).

At the end of the film, when the migrants are escorted back to an unknown destination, Franco is with them. The end, though left open, seems to suggest that Franco takes on Samir's position on the journey to his country. Samir's mediation is fundamental to Franco's return to language and life. The phrase *salaam aleikum* symbolizes the possibility of communication with others as well as a greeting addressed by Franco to himself. Franco's decision to lose his legal identity can also be interpreted as a form of identification with other victims of suffering. In joining the migrants as they are forcibly expelled, Franco assumes their role by abandoning a Europe that is unable to recognize the right of less wealthy populations to look for a better existence. Marra seems to suggest the political necessity of departing from Europe in order to communicate with those who are not allowed to stay.

Marra's dramatization of this 'becoming the Other' represents a political move rooted in New Left politics: slogans such as 'we are all Vietnamese', 'we are all blacks', 'we are all homosexuals' dominated the political campaigns of the late 1960s. This move presupposes assuming the position of the marginalized or oppressed group. Although this rhetoric is still used today, 'oppressed' voices have criticized this discursive strategy for ignoring the different positioning of different subjects in terms of power relations and their material effects. Audre Lorde, commenting on her white lover's claim that white and black lesbians share a common position, effectively illuminates the problematic nature of this identification:

> We are all niggers, she used to say. And I hated to hear her say it. It was wishful thinking based on little fact; the ways in which it was true languished in the shadow of those many ways in which it would always be false. (1982: 203)

## Conclusion

The emphasis on attachment and intimacy as constituent forms of identification and solidarity is one of the most interesting contributions that *Poniente* and *Tornando a casa* make to cinema and debates on migration. In my opinion this is particularly true of Marra's film, in which the deployment of mobility across borders, emotions, experiences and languages leads to the representation of new configurations of subjectivity and intersubjectivity in changing scenarios. And while both films at a basic level question the fixed, stereotype-laden classifications of 'otherness' that dominate the mediascape, they add something new and important through the ways in which they problematize feelings of attachment to place. There is no nostalgia or idealization in the representation of Mediterranean sites that are loved. Instead the narratives operate against binary oppositions between the modern and the traditional, between current and archaic practices. The characters are firmly placed within their modern context and there are no

references to an idealized past. More problematic, in both films, is the issue of positionality. In *Poniente*, this crucial aspect of critical discourse is overlooked by the emphasis on the experiences of past Spanish labour emigration. The representation of contemporary North African migrants through the experiences of past European migrants depicts similarities that ignore the specificity of today's transnational migrant subjects, thus failing to recognize the particular forms of agency and constraints that operate in our globalized world. Moreover, the emphasis on previous diasporas places contemporary migrants in the past of the host country's national history, duplicating a temporal narrative in which 'they', the new immigrants, embody poverty, backwardness and a lack of integration into capitalist society. In similar ways, *Tornando a casa* represents the illusion that becoming the Other is tantamount to taking a critical position on 'Fortress Europe'. But the film's attempt to translate the entanglement – the concatenation of multiple temporalities, spaces, connections and belongings – that shapes the subjects' experiences into a cultural narrative leaves open the possibility of further exchanges. In essence, Marra's film, by renegotiating the traditional tropes of otherness allocated to the Mediterranean area, has given us alternative readings of traditional images in which 'old' understandings (such as the illusion of 'becoming the Other') can coexist with current issues of belonging and recognition which are inevitably linked to migration, insecurity in the job market and power relations in the global world. *Poniente* recalls the historical hierarchies that shape Europeanness and the mobile nature of borders of exclusion, moving them further south; while *Tornando a casa* suggests leaving Europe so as to be reborn into a new life. In the two films, the theme of mobility is treated differently, with *Poniente* stressing the painful experience of being uprooted and *Tornando a casa* suggesting that the common experience of displacement may be the basis for new, mobile attachments.

## References

Appadurai, A. (1996), *Modernity at Large*, Minneapolis: University of Minnesota Press.

Bergfelder, T. (2005), 'National, transnational or supranational cinema? Rethinking European film studies', *Media, Culture and Society*, 27: 3, pp. 315–31.

Capussotti, E. (2007), 'Sognando Lamerica: memorie dell'emigrazione italiana e processi identitari in un'epoca di migrazioni globali', *Contemporanea*, 4, pp. 633–46.

Caritas (2007), *Dossier statistico immigrazione*, Rome: Caritas.

Chambers, I. (2008), *Mediterranean Crossings: The Politics of an Interrupted Modernity*, Durham, NC: Duke University Press.

Dal Lago, A. (2002), *Non-persone. L'esclusione dei migranti in una società globale*, Milan: Feltrinelli.

Dickie, J. (1999), *Darkest Italy*, Basingstoke: Palgrave.

Downing, D. H. and Husband, C. (2005), *Representing Race: Racisms, Ethnicity and the Media*, London: Sage.

Elena, A. (2005), 'Representaciones de la inmigración en el cine español . La producción comercial y sus márgenes', *Archivos de la Filmoteca*, 49, pp. 54–65.

Gilroy, P. (2004), *After Empire: Multiculture or Postcolonial Melancholia*, London: Routledge.

Intxausti, A. (2002), 'Cuatro películas españolas, en Venecia', *El País*, 30 August, http://www.elpaiscom/articulo/revista/agosto/peliculas/espanoles/Venecia/elpepirdv/20020830elpepirdv_2/Tes. Accessed 10 October 2010 .

King, R. et al. (2000), *Eldorado or Fortress? Migration in Southern Europe*, Houndmills, UK: Macmillan.

——— and Wood, N. (eds) (2001), *Media and Migration: Constructions of Mobility and Difference*, London: Routledge.

Labanyi, J. (2008), 'The politics of memory in contemporary Spain', *Journal of Spanish Cultural Studies*, 9: 2, pp. 119–25.

Laliotou, I. (2004), 'Cultural production of migration in the Mediterranean context', in *Fifth Annual Mediterranean Social and Political Research Meeting*, Robert Schuman Centre for Advanced Studies, Working Paper n.14.

Lorde, A. (1982), *Zami: A New Spelling of My Name*, Berkeley: Crossing Press.

Moe, N. (2002), *The View from Vesuvius: Italian Culture and the Southern Question*, Berkeley: University of California Press.

Morreale, E. (2006), 'Splendori e miserie del cinema medio', *Brancaleone*, 1, pp. 24–31.

Naficy, H. (2001), *An Accented Cinema: Exilic and Diasporic Filmmaking*, Princeton: Princeton University Press.

Parati, G. (2005), *Migration Italy: The Art of Talking Back in a Destination Culture*, Toronto: Toronto University Press.

Santaolalla, I. (2005), *Los 'Otros'. Etnicidad y 'raza' en el cine español contemporáneo*, Zaragoza: Prensas Universitarias.

——— (2007), 'A case of split identity? Europe and Spanish America in recent Spanish cinema', *Journal of Contemporary European Studies*, 11: 1, pp. 67–78.

Wood, M. (2005), *Italian Cinema*, Oxford: Berg.

## Notes

1. For instance Montxo Armendáriz's *Las cartas de Alou/Letters from Alou* (1990), Michele Placido's *Pummarò/Tomato* (1990), Imanol Uribe's *Bwana* (1996), Vittorio De Seta's *Lettere dal Sahara/Letters from the Sahara* (2006), to cite just a few.

2. Fatih Akın, today an internationally acclaimed film-maker, started his career in this multicultural niche (see Chapter 3). Exemplary Italian film-makers, including Matteo Garrone (*Terra di mezzo/Middle Earth*, 1997; *Ospiti/Guests*, 1998) and Vincenzo Marra (*Tornando a casa/Sailing Home*, 2001), are now celebrated as innovative auteur figures. Others like Francesco Munzi (*Saimir*, 2004), Antonio Bocola and Paolo Vari (*Fame chimica/Chemical Hunger*, 2003), Vittorio Moroni (*Le ferie di Licu/Licu's Holidays*, 2006) and Marina Spada (*Come l'ombra/As the Shadow*, 2006) are examples of directors who have dealt with migration in original ways.

3. In Italy, I am thinking of events such as the 'Meeting anti-razzista di Cecina' (a small town in Tuscany) or the networks created within the alter-globalization and anarchist movements.

4. 'Assault', 'invasion', 'emergency' are key terms used in the mainstream media to describe the arrival of immigrants. The critical literature on the role of the media in supporting xenophobic attitudes against migrants is now extensive (see, for example, King and Wood 2001; Downing and Husband 2005).

5. The Italian collective Multiplicity coined the term 'solid sea' as a result of its multidisciplinary research into the Mediterranean as an area of surveillance and separation, crossed daily by disconnected flows of migrants, tourists, military, fishermen and goods. Their installation 'Ghost Ship' reconstructs the case of the fishing boat which sank with 400 migrants on board off the Sicilian coast on Christmas Day 1996. For five years, Italian and Greek authorities denied the tragedy despite the survivors' testimonies and the daily presence of human body parts in fishing nets. A report in the Italian newspaper *La Repubblica* forced politicians and public opinion to recognize the tragedy although very little has been done to recover the bodies or to assist the families of the dead. See www.multiplicity.it. News of the daily deaths in the Mediterranean barely reaches the mainstream media in southern European countries and is mostly ignored in the rest of Europe. Large-scale deaths are reported but mostly in a way that reinforces the feeling of a threat to privileged European citizens.

6. Exceptions are Carlos Iglesias' *Un franco, 14 pesetas/Crossing Borders* (2006), which focuses on Spanish migration to Switzerland, and the documentary *El tren de la memoria/Memory Train*

(Arribas and Pérez, 2005) which follows the journey of a Spanish woman back to Nuremberg to which she had previously migrated at the age of 18.

7. Translations given in this essay are my own.

8. The policy of forced repatriations has been strengthened by the Italian government with the tacit support of the European Union and other European governments. Since spring 2009, migrants are not allowed to enter Europe, where they could eventually apply for asylum, but are intercepted in the middle of the Mediterranean and escorted back to Libya. The walls of 'Fortress Europe' keep moving further south in defence of the privileges of citizens of the European Union.

## Part IV

Cultural re-inscriptions

# Chapter 10

## Luis Buñuel and explosive love in southern Europe[1]

Luisa Accati

This chapter aims to analyse Buñuel's film *Cet obscur objet du désir/That Obscure Object of Desire* (1977) as a cultural document that enacts historical processes. Specifically, it considers what the film's treatment of the concept of the Immaculate Conception can tell us about the impact on heterosexual love relations of the Catholic privileging of the mother-son bond – a cultural issue I have explored elsewhere (Accati 2007). At the same time, by focusing on symbolic analysis of narrative (in this case, disruption of narrative) and iconography, I hope to produce a new reading of this cinematic text. My argument will be that the film's protagonist, Mathieu, is represented as both a son figure and a father figure, and functions as a projection of the cult of the Immaculate Conception instilled into Buñuel by his Jesuit education.

I am not the first to stress the religious aspects of Buñuel's work. A number of film critics have addressed the director's Jesuit education and highlighted the specific religious references in his films (Carnicero and Salas Sánchez 2000; Oms 1985; Farassino 2000; Gubern 2003; Pérez Turrent and de la Colina 1993; Rodríguez Blanco 2000). No-one, however, has analysed the meaning of these references. This absence is especially striking in *Cet obscur objet du désir*, which does not explicitly deal with the cult of the Immaculate Conception and yet, as I hope to show, is centred on it. Farassino explains the last scene in the film as a reference to Buñuel's mother's loss of her virginity, yet he does not acknowledge the connection between this loss and the Marian cult (Farassino 2000: 305–10). Other critics who have examined Buñuel's films from a psychoanalytical point of view (Argentieri and Sapori 1988; Gámez-Fuentes 1998; Evans 1995; Metz 1977; Stam 1983; Williams 1981) see the female characters as projections of the director's desires (Williams 1981: 196) and the narrative flow as a dramatization of his sexual drives, but do not take historical or religious factors into account. Thus, for example, Williams does not consider the role of the Marian cult in shaping these female characters. Evans lists the allusions to the Virgin Mary in Buñuel's films but is not specific about *which* Virgin he is referring to (Evans 1995: 41; 56; 82; 88). In Spain, there are at least ten 'Virgin Maries' and they all bear different meanings. My proposal in this chapter will be that *Cet obscur objet du désir* cannot be understood without taking into account the specific references to the Virgin of the Immaculate Conception. In arguing this, I shall view the film not as a straightforward projection or dramatization of the author's unconscious, but in terms of Chasseguet-Smirgel's (1984) suggestion that art can function as a mechanism of self-defence.

If most critics address Buñuel's films from either a historical-religious or psychoanalytical point of view, I believe that, to understand his work, it is necessary to position oneself at

the intersection of these two approaches. *Cet obscur objet du désir*, I will argue, explores the link established in Catholic sentimental education between the real mother and the ideal mother, the Virgin Mary. In his autobiography, Buñuel stressed the orthodox Catholic environment in which he grew up, both during his childhood in the Aragonese village of Calanda, and subsequently at a Jesuit boarding school. He commented specifically that '[t]he omnipotence of religion was evident in all aspects of life [and that] the highest virtue, so we were taught [by the Jesuits], was chastity' (Buñuel 1982: 21; 23).[2]

## The Immaculate Conception: history of a concept

When the sixteenth-century Reformation produced a schism in European Christianity, it created a division between two different European conceptions of love: Catholicism, which continued to value celibacy as the highest human condition, projected the mother-son bond onto the heterosexual couple as the blueprint for marital relations; Protestantism, in abolishing celibacy as a requirement for the priesthood, elevated the status of the conjugal relation between husband and wife. The relationship between mother and child is hierarchical; the son depends on his mother completely. The Catholic Church – an institution premised on hierarchy – identifies with this absolute power and takes the Virgin Mary as its symbol. The conjugal relationship, by contrast, is a consensual agreement between two adults. In privileging the concept of the Virgin Birth, the Catholic Church centres the symbolic order on parthenogenesis (conception without parental intercourse) – an authoritarian project in which love is grounded in dependence. By contrast, Protestantism focuses the symbolic order on the parental couple – a contractual model of human relationship based on the autonomy (albeit relative and unequal) of the two persons involved. With the exception of Natalie Zemon Davis (1975), modern historians have tended to play down the opposition between the Reformation and the Counter-Reformation, viewing them rather as two aspects of modernity (Prosperi 1999; Skinner 1978). However, the figurative arts, including cinema, provide a rich storehouse of images and representations of love which bear witness to the cultural difference between the two belief systems.

Within this Catholic emphasis on the Virgin Mary, it is important to consider the emergence of the cult of the Immaculate Conception. Mary's eternal virginity, as it was proclaimed in the fourth century,[3] separated her from her husband Joseph, and separated Christ from Joseph, his Jewish father – though his Jewish ascendancy remained affirmed through his mother. The eleventh-century Gregorian reforms introduced celibacy as a requirement for the priesthood and religious orders. In the twelfth century, a new cult closely connected with the monasteries became widespread, taking further the implications of Mary's virginity: this was the cult of the Immaculate Conception. This cult, declaring Mary to have been miraculously conceived without her parents transmitting original sin to their daughter, separated Mary from her Jewish forefathers, thereby annulling Christ's

Jewish inheritance and making Mary a pure container without heritage or history: the ideal Mother of a son conceived in God's mind.[4] The cult of the Immaculate Conception was prominent in Spain in the sixteenth and seventeenth centuries when, thanks to Franciscan and Jesuit support, the image of the Immaculate Conception was declared the icon of the Counter-Reformation. This coincides with the Counter-Reformation's affirmation, at the end of the sixteenth century, that celibacy was a morally superior condition to marriage. In this period, Protestantism abolished celibacy for the clergy together with the worship of sacred images and the cult of Mary. The Immaculate Conception was formally declared a dogma of the Catholic Church by Pope Pius IX in 1854. My argument is that this doctrinal divergence between Catholicism and Protestantism has left profound marks on attitudes towards love in northern and southern Europe, through to the contemporary period – marks which can be traced in cultural representations.

In southern European countries, since the Counter-Reformation the dominant image in religious figurative art has been the mystical union between Mother and Son. In addition, marriage is not considered a positive institution but a 'remedy' to sexual desire for those too weak to control their instincts. Catholic doctrine makes it almost impossible to think of the father as the mother's chosen love object. Rather, the focus is on the mother-son relation, seen as fulfilling while fostering dependence. My contention is that *Cet obscur objet du désir* deals with the difficulties of a man, Buñuel, who has been raised by Jesuits and has imbibed the dogma of the Immaculate Conception. Those who knew the director have confirmed that he often spoke of the great impression this particular cult made on him as a result of his Jesuit education. For example, his collaborator Julio Alejandro recalls, '[T]here is something that deeply moves him [Buñuel]: the dogma of the Immaculate Conception. Not as dogma, but as an inclination and longing for purity. For him purity is very important. So in the mystery of the Immaculate Conception he [...] sees an externalization of this sentiment' (1980: 5). Many of Buñuel's films include references to the cult of Mary. However *Cet obscur objet du désir* deals specifically with the Immaculate Conception. The female protagonist not only proclaims her virginity on several occasions but is called Conchita, the familiar form of the name 'Concepción' ('Conception'). Conchita is also the diminutive form of 'concha' ('shell'): the symbol of the Immaculate Virgin and of Venus.

## Desire and chastity

*Cet obscur objet du désir* is based on a fruitless repetition. The protagonist Mathieu (Fernando Rey) engages in repeated, vain attempts to seduce Conchita (Carole Bouquet/ Ángela Molina). The film also contains a series of arbitrary and fruitless bomb outrages. The apparently realist narrative is repeatedly punctured by mental images (a rat, a fly, a piglet) which intrude without warning. Our faith in the realist register is further undermined by the fact that the object of Mathieu's desire is played by two different

actresses. Conchita is one character with two different semblances: the perfect, ethereal beauty of Carole Bouquet, and the earthy physicality of Ángela Molina. Throughout the film, the same situation is endlessly replayed: Mathieu tries his utmost to make love to Conchita but never succeeds. We never see the sexual act performed, not even between Conchita and her alleged lover Morenito (David Rocha). Conchita declares, 'I'm a virgin' and so she remains, however implausibly.

In the film's final scene, Mathieu and Conchita are in a Paris shopping arcade. They look into a shop window at a woman who is mending a nightdress. The nightdress is torn and bloodstained as if it belonged to a virgin bride; that is, as if it were the sign of a deflowering, of a conception. The seamstress repairs the tear and the nightdress looks immaculate, as if the tear had never happened. At the end of the shopping arcade is a hotel. While they are looking into the shop window, Conchita is Carole Bouquet, but when Mathieu follows Conchita towards the hotel, she is Ángela Molina. An enormous explosion creates a red cloud, hiding Conchita and Mathieu from our view as they reach the hotel entrance. The hotel at the end of the arcade is the hotel where Buñuel's parents stayed on their honeymoon. The film-maker believed and recounted that he was conceived there.[5] This biographical information helps us understand why the film repeatedly, and at the end spectacularly, denies us the sight of sexual intercourse. Behind the camera is the mischievous, affectionate gaze of a son who imagines that there was something going on between his parents. He would like to watch but he dare not.

Mathieu never succeeds in viewing the sexual union of Conchita and Morenito, and providentially placed obstacles repeatedly obstruct his own sexual access to Conchita: an impenetrable chastity belt, leafy fronds, nighttime shadows, gates and, above all, Conchita's bad moods. It is as if the gaze behind the camera and Conchita were in connivance. Regardless of whether the 'conception' Mathieu is pursuing is Conchita as Ángela Molina or Conchita as Carole Bouquet, she eludes him as the director plays endless cruel tricks on him. Throughout the film, this elegant gentleman is mercilessly mocked with a mix of irony, envy and tacit sympathy. However, the young, sensual Morenito is equally rejected by Conchita. If Mathieu is too old, Morenito is too young, and Conchita remains a virgin.

Buñuel did not trust psychoanalysts and their therapies, and was sceptical about using psychoanalysis to interpret his films (Farassino 2000: 21; 33), yet he valued Freud's work and admitted that the discovery of the unconscious was 'very important for me when I was young' (Buñuel 1982: 240–41). In choosing to base *Cet obscur objet du désir* on the 1898 novel by Pierre Louÿs, *La femme et le pantin* (Louÿs 1990), Buñuel confronts us with a classic Freudian scenario: the Oedipal temptation on the son's part to destroy the father so as to possess the mother (Freud 1957; 1960; 1961a; 1961b).

In a Catholic Counter-Reformation context, where the imagery of the sacred family does not admit sexual intercourse between the father (St. Joseph) and the mother (Mary), the first and foremost difficulty for a man who wants to move beyond his relationship with his mother is how to find a way to save his father so as to be able to identify with him. In *Cet obscur objet du désir* there is no literal father figure; rather, Mathieu simultaneously

plays the role of figurative father (elderly gentleman) and figurative son. In Freudian terms, we may say that actor Fernando Rey, playing the part of Mathieu, epitomizes the father figure as both the son's rival and the son's role model (Chasseguet-Smirgel 1988; 1990; Grunberger 1971; McDougall 1994). The eye behind the camera wants to identify with this elegant gentleman and, at the same time, to eliminate him in order to get to Conchita.

Despite Conchita's taunts, Mathieu never loses his gentlemanly dignity. His repeated attempts to buy Conchita are disturbing but not sordid; indeed, Conchita's devout Catholic mother encourages such commercial transactions. But, at the same time, the Jesuit-educated director seems panic-stricken at the thought of occupying his father's place. To overcome his fears, Buñuel imagines that his father, Fernando Rey, never had sex with his mother and that she remained a virgin despite having given birth to him. This idea is consonant with the director's Catholic background and functions as a way to elude the explosive sentiments stirred up by his jealousy at his mother's love for, and his own rivalry towards, his father. Buñuel needs to gain time until, at the end of the film, he is able to bear these explosive feelings. The filmic narration is, I suggest, the director's way of re-educating his sentiments and gradually freeing them from their religious straitjacket.

## The iconography of the sacred

The film's dominant register is irony, yet at certain moments we encounter the dramatic register of the sacred. For example, after the scene in which Conchita is encumbered by a chastity belt and Mathieu's travelling companions laugh about it after he has related the story to them on the train, the camera returns to the bedroom where, unexpectedly, we witness a complete change of mood. No more irony, no more risqué jokes. The gaze has changed, and the image is reminiscent of the most moving scenes in religious art. Dressed in a long white nightshirt, Mathieu is sitting on the edge of the bed crying. Conchita holds him tenderly from behind, her arms wound around him, trying to comfort him. The intertwined pair form an *Imago Pietatis*, somewhere between the Italian Renaissance and the Spanish Counter-Reformation (see Figure 18). The perfect beauty of Carole Bouquet's face conveys sadness for Mathieu's suffering just as the Virgin partakes in her Son's Passion. Here Mathieu is cast in the role of son. We could read this scene as Buñuel's attempt to address the terrible pain that mother and son have to endure in giving each other up: Carole Boquet says, 'I don't like what I'm doing either yet the only thing you want is what I refuse to give you, and not what you've already got'. She is completely devoted to her son. He can stay with her like a bridegroom but, to avoid incest, he will have to remain celibate, even though this will make him suffer: 'You just have to wait. You know that I'm yours and only yours, what more do you want?' In Catholic education, the eternal Virgin Mother has no real husband; she is imagined with the Son-priest always at her side, celibate forever.

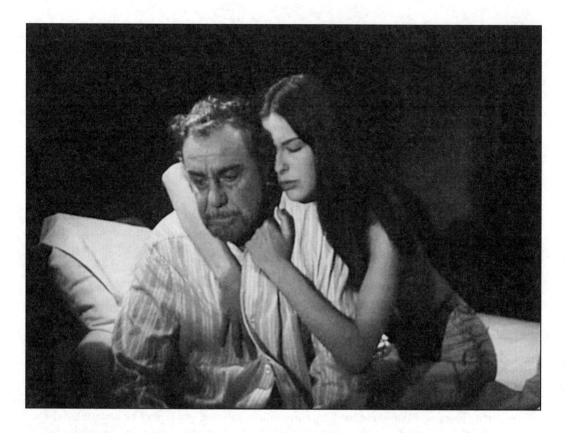

Figure 18. Conchita (Carole Bouquet) cradles Mathieu in her arms – *Cet obscur objet du désir* (Buñuel, 1977).

Visual representations of the Pietà reveal the unsettling solitude governing the bond between Mother and Son; an extreme seduction in which love and death coincide. The relationship is eternally incomplete, desire replaces union, chastity is the only option. Conchita proposes a mystical marriage to Mathieu and he accepts: they will live together and she will keep her virginity. The chastity belt scene explains why the son's inability to think of his parents' sexual union splits his image of the mother into two. Buñuel can think of his parents' sexual union only if he acknowledges that his mother has two countenances: the inaccessible semblance of the mystical-religious icon embodied by Carole Bouquet with her unresolved, paralysed and paralysing sensuality; and the real mother, the primary love object represented by Ángela Molina, whose sensuality

constitutes the son's initiation into life. In a brief interval between two long sequences of *coitus manqué* with Conchita-Carole Bouquet, Conchita-Ángela Molina says to Mathieu, 'Can I ask you something? Why do you want to make love to me at all costs? We live together. I hug you, I caress you. You have my legs, my mouth, my breasts. Why do you *also* want to make love to me?' Maternal devotion grants everything but love-making. There is something naïve and at the same time good-natured about Conchita-Ángela Molina; she asks the question affectionately, as if saying, 'I'm your mother, why do you ask something impossible of me?'

## Sacrifice and violence

All the rules that Conchita-Carole Bouquet imposes upon Mathieu regarding the times and ways in which he can have access to her remind us of the Catholic practice of confession, in which every detail of the sexual relationship has to be considered. Conchita-Ángela Molina also refuses Mathieu, but for most of the film she is much less strict. She refuses him because she does not feel well or because he does not understand her. It makes sense that the encounter towards the film's end when Mathieu hits Conchita should be with her and not with the unmovable Carole Bouquet. This scene opens with Mathieu and Conchita walking into the house the morning after Mathieu has witnessed – in the dark and from a distance – what he believes to be a sexual encounter between Conchita and Morenito. As they cross the threshold, Conchita is Carole Bouquet but, when the camera frames the couple inside the house, Conchita has become Ángela Molina. She says to him: 'I want to explain what really happened last night'. She yells at Mathieu overbearingly. Does he think he can do anything he wants just because he has given her a house? Well, he's wrong. He doesn't understand women. 'You're not listening to me!' she snaps. At this point, without saying a word, Mathieu slaps her in the face and starts hitting her in silence. Frightened, Conchita tries to make excuses. 'Morenito isn't my lover, I just pretended he was!' she cries. By now, Mathieu has lost control and keeps hitting her until she falls to the ground, her nose bleeding. 'Now I know you love me, Mathieu. I'm still a virgin,' she says and hands him the key to her house. 'Take it. So you can come whenever you want'.

In the novel, this scene marks the beginning of a sadomasochistic relationship: Conchita is capable of loving only when she is beaten (Delon 1990). Louÿs relates how the depravity of the two protagonists finally destroys them. In choosing to depict Mathieu's increasingly destructive relationship with Conchita as a flashback, narrated from the time frame of his departure from Seville by train in a vain attempt to escape her pull, Buñuel is able, from the film's start, to hint at the violence into which the relationship will slide as the film progresses. First we see Mathieu's untidy living room, as he returns after buying his train ticket, with shoes and underclothes strewn everywhere and traces of blood visible. Then, at the railway station, Mathieu throws a bucket of water at Conchita-Carole Bouquet to stop

her boarding the train (a scene that will be repeated in inverted form as Conchita-Ángela Molina, towards the end of the train journey, pours a bucket of water over him). Mathieu first attempts to win Conchita over with money, bowing to her mother's logic. When this fails and after being provoked by the two Conchitas, and specifically after Conchita-Ángela Molina becomes aggressive, Mathieu finally reacts and behaves like a man, like a father. He performs the sexual stereotype of the dominant male. Apparently, violence is what Conchita really wants; she seems to prefer violence to money.

The Counter-Reformation stresses condemnation of sexuality; not even marriage can transform it into something good. Marriage is a remedy that chaste men grant to the weak and impure. Buñuel, aware of Tridentine norms, commented in his autobiography: 'For Saint Thomas, lovemaking between husband and wife was almost always a venial sin' (Buñuel 1982: 23). As to women, they must sacrifice their immaculate virginity for the love of children. The Christian priest does not kill the lamb on the altar like Greek, Roman and Jewish priests, but delegates this responsibility to the husband, who will perform the sacrifice on the wedding bed, far away from the church. In the world of celibate men, violence is the only thing that is left to fathers. The mother has no sexual desire nor does she have any choice in the matter. She is totally passive – the son's flesh, the handmaid of the Lord (*ancilla Domini*).

Let us return to Buñuel's violent scene, bearing in mind these mariological considerations. The humiliated image of Conchita-Ángela Molina on her knees weeping can be read as a projection of the son's despair at giving up his mother as the object of sexual desire to the violent father. The visual construction of her gesture as she hands over the key to the powerful angry male is imbued with all the grief of the son-child who compares himself with his grown-up father and admits, with unspeakable pain, that no one but his father can open the gate to Conchita/conception. The blood running from Conchita's nose indicates the violent deflowering by the father-Mathieu, which prohibits access to the mother by the son-Mathieu, for whom she remains an eternal, unattainable virgin. The son imagines the sexual relationship between his parents as his mother's rape. This helps to cover up his own sexual impotence and to protect him from the unbearable thought of being inadequate for his mother (Grunberger 1971; Chasseguet-Smirgel 1988; 1990). The son can accept being excluded only if he represents his mother as a victim: she gives her consent because she is forced to submit. The father's love is violent; it is not the child who is inadequate. The castrated son utilizes the maternal image to justify his submission to his father. Fortunately, however, the film does not end here.

## Love and terrorism

After the scene of the argument, the camera returns to the train compartment and to the frame tale in which Mathieu tells the story of his relationship with Conchita to his fellow passengers on his flight from Seville to Madrid: 'This happened yesterday morning. Now

it's all over. Now you know my whole story and you can understand why I talked about killing her'. Indeed something is over, but for Mathieu to surrender his mother to his father and accept that his own conception was not the result of a virgin birth, Conchita-Ángela Molina has to overcome her humiliation and teach him a lesson by showing that she is not a passive victim. Standing in the train corridor with a black eye and her face covered in sticking plaster, she nonetheless makes a powerful, threatening figure. With a bucket in her arms, she strides purposefully towards Mathieu's compartment and throws water right into his face. At this point, he can no longer view Conchita as the ideal mother, the sacrificial virgin, but must recognize her as a woman who has agency, and who can say no of her own free will. This is a decisive moment, yet the long process of initiation is still incomplete.

In the next scene, we see Mathieu and Conchita-Ángela Molina exiting the train station in Madrid. Like any other bourgeois couple, they go to the taxi rank followed by their servant and a great amount of luggage. When their taxi sets off, we are no longer in Madrid but in Paris; Conchita is no longer Ángela Molina but Carole Bouquet. Like many other tourists on their honeymoon, they walk along the Tuileries and go to the Rue de Rivoli, not far from the Louvre. They enter the Paris shopping arcade at the end of which stands the hotel where Buñuel's parents stayed on their honeymoon. As they look into the shop windows, they hear a public announcement. The combination of words and images lays bare Buñuel's final moment of resistance; the son's last attempt to consider himself the sole object of the mother's love before he is forced to admit his parents' sexual union, a union from which he is excluded.

The intense closing sequences elucidate the connection between love and terrorism that we have witnessed throughout the film. We hear political slogans shouted from a megaphone while viewing images of domestic objects such as nightgowns. This juxtaposition suggests a parallel between the father's private impotence (in the bedroom) and the terrorists' public impotence (on the streets). Neither are capable of reaching their objective; rather, they are compelled to engage in a fruitless repetition. Throughout the film, Morenito functions as the link between these two discursive grounds: like Mathieu, he fails as Conchita-Ángela Molina's lover, yet he is also a terrorist (after one of the attacks, we learn that he is wanted by the police and that Conchita hides him in Mathieu's house).

In the first violent episode at the beginning of the film, we see a man dressed like Mathieu who is involved in an explosion and, for a moment, we believe that he is dead. It seems that Buñuel thought of eliminating the father, but then, as the film progresses, shows us his gradual acceptance of him. The flames of the terrorist outrage reveal the upsetting nature of his sentiments. In the course of the film, five other terrorist episodes (sabotages, robberies and shootings) punctuate Mathieu's failed attempts to have sex with Conchita, as if *entr'actes* to the main plot.

The negative political consequences of dependence on the mother become evident, together with the Mother Church's role in fostering an emotional constellation that prolongs infantile feelings of dependence into adulthood. The public announcement says:

According to police information, an unusual alliance has come into being. A group of far-left international organizations already known to the public, the POP, has unexpectedly formed an alliance with the Armed Revolutionary Group of the Infant Jesus in order to start a violent campaign of terrorist attacks [...]. These senseless attacks are bound to cause total confusion in our society. It appears that many groups on the extreme right have decided to counter these actions by the extreme left, thereby contributing to this total and permanent subversive undertaking.

Where the conflict between the dominant and the dominated models itself on the relation between mother and son – as when the far left joins forces with the Armed Revolutionary Group of the Infant Jesus – there is no space for the personal growth that is necessary to affirm individual rights. All that is possible is confused attempts to subvert power relations by momentarily asserting dominance through a terrorist attack.

In this film, Buñuel does not set out to condone or condemn violence, but uses it to express the explosive and contradictory nature of emotions derived from an educational model based on the negation of the father's natural role and on the paradox of the Virgin Mother. This paradox determines the roles of both Mathieu and Morenito: the religious institution forces all men into a position of dependence regardless of their social status. As the megaphone declares, all political projects are 'senseless'. The Catholic Church has no interest in anyone – rich or poor, left-wing or right-wing – finding a meaningful way out of its constraints.

As the megaphone makes its announcement, a woman in one of the shop windows opens a bag. The bag looks like the various other bags we have seen throughout the film. Walking by the river, Mathieu had thrown a bag over his shoulder. As he walked out of the door in Seville, we heard a servant remind him not to forget his bag. His valet, Martin (André Weber), reveals the significance of these mysterious recurring bags. When in Seville, Mathieu had asked him what he thought of women and Martin had replied that a friend of his, who loved women very much, had described them as 'bags of excrement'. We discover that the bag at the end of the film contains women's nightgowns. They are pure white and the woman in the shop window takes them out and spreads them on chairs. The public announcement continues:

The archbishop of Siena, Monsignor Fiesole, is in a coma. During last week's attack, one of the bullets penetrated his carotid artery and his condition is critical. Cerebral activity has practically ceased, though the blood flow through his tracheal artery is normal. Monsignor Fiesole could remain in this state for months.

At this point, Mathieu calls Conchita-Carole Bouquet over to the shop window with the nightdresses. Just as the announcer describes the bishop's blood flow, the seamstress in the window takes out the torn, stained nightgown and starts to mend it. This timing foregrounds the Catholic Church's role in constructing sexual intercourse as a 'stain': as

the camera zooms in, we see that it is a lace bridal nightgown with a tear and bloodstain caused by a deflowering. We are only a few steps away from the hotel where Buñuel's parents spent their honeymoon. As Buñuel himself stated in an interview: 'That stained bridal gown seems to refer [...] to a maternal hymen, a personal mythology of birth' (Farassino 2000: 311). Having made this admission, Buñuel then backed away from it: 'The last scene – in which we see a woman's hand repairing a lace gown covered with blood (my last shot) – greatly affects me but I can't explain why' (Farassino 2000: 311).

Mathieu holds Conchita's hand, unable to take his eyes off the needle and thread that are engaged in sewing up the tear until it finally disappears. The loudspeaker announces: 'The protest by the cardinals of the Roman curia has received widespread support and the Communist Party has also condemned the heinous crime. And now some opera music'. As the bishop lies dying, the 'bag of excrement' is opened and its relationship to vaginal intercourse – 'deflowering' – is exposed to public view in the shop window.[6] It now becomes possible to think of conception as the result of vaginal intercourse. Mathieu and Conchita-Carole Bouquet set off for the hotel where Buñuel believed he was conceived. At this point, Conchita-Carole Bouquet becomes Conchita-Ángela Molina. Just as they reach the hotel entrance, there is a terrible explosion, and billowing smoke and flames conceal them from view.

In the last scene of this last film of his career, Buñuel makes a reference to his first film, *Un chien andalou* (1929). The director continues to be a surrealist (Chavot 2001; Egger 2002) and to use violence and provocation as a way to express himself, but he now does it with a fair amount of self-irony and the confidence of an elderly man. In this last film, he adopts a playful tone, as if offering a balanced reckoning of his life, his work and even his country, finally freed from dictatorship two years before *Cet obscur objet du désir* was made. In 1929, when he began his career, he filmed a man slicing a woman's eye, an unjustifiably violent action that seems gratuitous. 48 years later, the last sequence in *Cet obscur objet du désir* recalls this and another scene in *Un chien andalou*. The woman who mends the nightgown in the shop window is a clear reference to Vermeer's 'The Lacemaker'. In *Un chien andalou*, the female protagonist drops a book in which we see this painting by the Dutch artist.[7] Moreover, the shape of the woman's eye in *Un chien andalou* is round like the seamstress's darning hoop in *Cet obscur objet du désir*, while the cut in the nightgown recalls the cutting of the eye. When the man (played by Buñuel) performs this terrible act in *Un chien andalou*, we see a cloud covering the moon. The moon is the symbol of the Immaculate Conception.[8] The covering of the moon can be seen as a metaphor of the need to conceal the act of conception. The cutting of the eye represents both the mother's defloration and the son's blinding, like Oedipus, when he tries to see what he is not allowed to see. The seamstress mending the tear in *Cet obscur objet du désir* concludes Buñuel's Oedipal journey. After 48 years and many other films in which he addressed the relationship between women and men, the director stitches up the cut and significantly enlarges the cloud. The red smoke produced by the terrorist outrage prevents us from seeing the act of conception, yet this time it is not an abstract

theological metaphor. Behind the red cloud there is a real mother, the sensual Conchita played by Ángela Molina, and at her side a real father, the gentlemanly Mathieu played by Fernando Rey, who reach the door of the hotel where Buñuel's parents spent their honeymoon. The dangerously blazing smoke separates the son (Buñuel) from his parents once and for all, and conveys the explosive force of his jealousy and envy towards the father's privilege and imminent pleasure – an explosiveness that constitutes a recognition of the fact of conception.

## References

Accati, L. (2007), *Scacco al padre. Immagini e giochi di poetere*, Venice: Marsilio.

Alejandro, J. (1980), 'Colaborar con Buñuel', interview with F. Llinás and J. Vega, *Contracampo*, 16, pp. 3–45.

Argentieri, S. and Sapori, A. (1988), *Freud a Hollywood*, Turin: Nuova ERI.

Buñuel, L. (with J-C. Carrière) (1982), *Mon dernier soupir*, Paris: Robert Laffont.

Carnicero, M. and Salas Sánchez, D. (2000), *En torno a Buñuel*, Madrid: Academia de las Artes y las Ciencias Cinematográficas de España.

Chasseguet-Smirgel, J. (1984), *Éthique et estétique de la perversion*, Seyssel: Champ Vallon.

——— (1988), *Les deux arbres du jardin. Essais psychanalytique sur le rôle du père et de la mère dans la psyché*, Paris: des femmes.

——— (1990), *La maladie d'idéalité. Essai psychanalytique sur l'idéal du moi*, Paris: Éditions Universitaires.

Chavot, P. (2001), *L'ABCdaire du surréalisme*, Paris: Flammarion.

Delon, M. (1990), 'Préface', in P. Loüys, *La femme et le pantin. Roman espagnol*, Paris: Gallimard, pp. 7–24.

*Dictionnaire de spiritualité* (1932–95), 'Marie Sainte Vièrge', Paris: Éditions Beauchesne.

Egger, A. (2002), *Le surréalisme. La Révolution du regard*, Paris: Scala.

*Enciclopedia cattolica* (1948–54), 'Maria', Vatican: Ente per l'Enciclopedia cattolica e per il libro cattolico.

Evans, P. W. (1995), *The Films of Luis Buñuel: Subjectivity and Desire*, Oxford: Clarendon Press.

Farassino, A. (2000), *Tutto il cinema di Luis Buñuel*, Milan: Baldini e Castoldi.

Freud, S. (1953), 'The Interpretation of Dreams', in J. Strachey (ed.), *The Standard Edition of the Complete Psychological Works of Sigmund Freud*, vols 4–5, London: Hogarth Press and Institute of Psycho-Analysis. First published 1900.

——— (1957), 'A Special Type of Choice of Object Made by Men', in J. Strachey (ed.), *The Standard Edition of the Complete Psychological Works of Sigmund Freud*, vol. 11, London: Hogarth Press and Institute of Psycho-Analysis. First published 1910.

——— (1958), 'The Disposition to Obsessional Neurosis', in J. Strachey (ed.), *The Standard Edition of the Complete Psychological Works of Sigmund Freud*, vol. 12, London: Hogarth Press and Institute of Psycho-Analysis. First published 1913.

——— (1960), 'Three Essays on the Theory of Sexuality', in J. Strachey (ed.), *The Standard Edition of the Complete Psychological Works of Sigmund Freud*, vol. 12, London: Hogarth Press and Institute of Psycho-Analysis. First published 1905.

——— (1961a), 'The Ego and the Id', in J. Strachey (ed.), *The Standard Edition of the Complete Psychological Works of Sigmund Freud*, vol. 19, London: Hogarth Press and Institute of Psycho-Analysis. First published 1923.

——— (1961b), 'The Infantile Genital Organization', in J. Strachey (ed.), *The Standard Edition of the Complete Psychological Works of Sigmund Freud*, vol. 19, London: Hogarth Press and Institute of Psycho-Analysis. First published 1923.

——— (1963), 'Introductory Lectures on Psycho-Analysis', in J. Strachey (ed.), *The Standard Edition of the Complete Psychological Works of Sigmund Freud*, vols 15–16, London: Hogarth Press and Institute of Psycho-Analysis. First published 1915–17.

Gámez-Fuentes, M. J. (1998), *Ese oscuro deseo del objeto. Una lectura de Buñuel*, Valencia: Episteme.

Grunberger, B. (1971), *Le narcissisme*, Paris: Payot.

Gubern, R. et al. (2003), *Historia del cine*, Barcelona: Editorial Lumen.

Le Bachelet, X. and Jugie, M. S. (1902-70), 'Immaculée conception', *Dictionnaire de théologie catholique*, vol. 7, pt. 2, Paris: Letouzey et Ané, pp. 2-120.

Loüys, P. (1990), *La femme et le pantin. Roman espagnol*, Paris: Gallimard. First published 1898.

McDougall, J. (1994), *Plaidoyer pour une certaine anormalité*, Paris: Gallimard.

Metz, C. (1977), *Le signifiant imaginaire. Psychanalyse et cinéma*, Paris: Union Générale d'Éditions.

Oms, M. (1985), *Don Luis Buñuel*, Paris: Cerf.

Pérez Turrent, T. and de la Colina, J. (eds) (1993), *Buñuel secondo Buñuel*, Milan: ubulibri.

Prosperi, A. (1999), *Il tribunale della coscienza*, Turin: Einaudi.

Rodríguez Blanco, M. (2000), *Luis Buñuel*, Paris: BiFi/Durante.

Rucar de Buñuel, J. and Martín del Campo, S. (1990), *Memorias de una mujer sin piano*, Mexico City: Alianza Editorial Mexicana.

Skinner, Q. (1978), *The Foundations of Modern Political Thought: The Age of Reformation*, vol. 2, Cambridge: Cambridge University Press.

Stam, R. (1983), 'Hitchcock and Buñuel: desire and the law', *Studies in the Literary Imagination*, 16, Spring, pp. 7–27.

Williams, L. (1981), *Figures of Desire: A Theory and Analysis of Surrealist Film*, Urbana: University of Illinois Press.

Zemon Davis, N. (1975), *Society and Culture in Early Modern France: Eight Essays*, Stanford: Stanford University Press.

# Notes

1. My thanks to Ilaria B. Sborgi for translating this chapter into English.
2. All translations from non-English language sources are my own.
3. For an overview of Mariology, see the entries 'Marie Sainte Vièrge' in *Dictionnaire de spiritualité* (1932–95), and 'Maria' in *Enciclopedia cattolica* (1948–54, vol. 4).
4. For the debate on the Immaculate Conception (twelfth to nineteenth centuries), see Le Bachelet and Jugie (1902–70).
5. The hotel where Buñuel's parents stayed is the Hotel Ronceray in the Passage Jouffroy (Farassino 2000: 311). For technical reasons, the film was shot in another *passage*. See also Rucar de Buñuel and Martín del Campo (1990: 120).
6. According to Freud, during childhood the vagina and the anus are considered a single cavity; we discover that they are separate only later on (Freud 1953; 1958; 1963).
7. Johannes Vermeer (1632–75), 'The Lacemaker', Louvre, Paris. See also Farassino (2000: 311).
8. See, for example, the many paintings of the Immaculate Conception by Esteban Murillo at the Prado Museum in Madrid.

# Chapter 11

## Love and belonging in *Western*

Lucy Mazdon

M anuel Poirier's *Western*, with its apparently slight and somewhat rambling narrative, was a rather surprising box-office success upon its initial release in France in 1997. However as I shall argue in this chapter, this seemingly slight tale conceals a complex and moving negotiation of the nature of identity. Via a number of different discourses, Poirier's film explores the plurality of identity and suggests its always unfinished nature, positing identity as a constantly evolving process. Moreover the film seems to suggest that identity and a sense of identification or belonging are essentially bound up with love and emotion. Thus, the film maps identity on to the specific geographical terrain of the diegesis while simultaneously inviting us to place the characters' quest for love within broader discourses of regional, national and European identity. In so doing it posits a very clear connection between love and identity construction, making it an ideal case study for this book's broader exploration of the relationship between Europe and ideas of love.

## On the road with Paco and Nino: cinematic intertexts

The film tells of the rather aimless journey of its two central male protagonists, Paco (Sergi López), a Catalan shoe salesman living in France, and Nino (Sacha Bourdo), a Russian hitchhiker. Nino steals Paco's car and the shoe samples it contains, causing Paco to lose his job but meet and fall in love with Marinette (Élisabeth Vitali), an inhabitant of a Breton coastal town, Le Guilvinec. By chance Paco spots Nino in the town and beats him so badly that Nino is hospitalized for a week. Paco's essential decency leads him to the hospital to check on his victim's progress. A brief montage reveals his developing relationship with Marinette alongside his growing friendship with Nino. When, having learnt that Paco has lied to her about his marital status, Marinette announces that they must separate for three weeks in order to test the strength of their feelings for one another, Paco accepts Nino's invitation to accompany him on the road. The two set off and the great majority of the film's subsequent meandering narrative deals with the gently comic incidents that arise from Nino's fruitless attempts to attract women, set against Paco's seemingly effortless success. The film is quite long at nearly two-and-a-quarter hours and this creates a sense of slowness matched by the characters' increasingly directionless itinerary.

Poirier announces this negotiation with his choice of title for the film. In naming his film *Western* he draws our attention to the film's referencing of this cinematic genre. The film's wandering protagonists and, albeit aimless, quest narrative loosely resemble the classical Hollywood Western and recall 'the original genesis of the Western as a representation of migration, adventure and national identity' (Shiel 2005: 1207). Strikingly the film is shot in CinemaScope and this provides a sense of epic spectacle that Poirier himself believes 'honours his modest characters with something worthy of their own expansiveness' (cited in Rosenbaum 1999), while simultaneously bringing to mind the visual style of the classical Western genre. His explicit allusion to this genre also functions to suggest the transnational or hybrid discourses which, as we shall see, feature so heavily in the film's narrative and stylistic concerns. The Western is of course predominantly associated with America; however, its production within a number of different cultural and historical contexts and its evident transportability in terms of audience appeal reveal a genre identity which stretches well beyond national boundaries.

The Western is not the only cinematic genre referenced in Poirier's film for it can also be seen as a road movie. While there are of course examples of non-American road movies,[1] like the Western this is also typically perceived as an American genre. Timothy Corrigan links its emergence to postwar American culture and specifically to the breakdown of the family unit and the resulting destabilization of male subjectivity, and to the growing mechanization of society in which the artefacts of this mechanization become 'the only promise of self in a culture of mechanical reproduction' (Corrigan 1991: 146). *Western* echoes the road movie via its representation of the male protagonists' journey. This is a journey which is both physical and emotional and, as Shari Roberts remarks in her analysis of the road-movie genre, '[I]t is not the case that the external journey replaces the internal quest, but rather that the two are instead interdependent' (Roberts 1997: 54). Paco and Nino's movement through the Breton landscape is precipitated by their emotions and a subsequent destabilization of the ego. As this journey proceeds the two become increasingly intertwined, the aimlessness and circularity of the physical movement mirroring their emotional insecurity. This sense of destabilization and fluid, disassociated spatial geography positions *Western* alongside a number of notable road movies, for example Wim Wender's *Paris, Texas* (1984) and Gus Van Sant's *My Own Private Idaho* (1991). While its gentle comedy seems to set Poirier's film apart from these more serious works, they do share a concept of space which acknowledges that it is rather more than a blank canvas to be filled by those who act upon and within it. In the words of Stuart C. Aitken and Christopher Lee Lukinbeal:

It is not difficult to argue that social relations constitute, form and manage space but, in a very real sense, space is more than an end product of these processes; it is itself a process. It may follow, then, that the reproduction of space parallels the reproduction of other forms of identity. (1997: 351)

In other words their journey through this fluid 'space' can be seen to symbolize a simultaneous journey through 'layers of repressed memory' to a deconstruction of any sense of fixed identity (Aitken and Lee Lukinbeal 1997: 356).

Thus *Western* draws upon two cinematic genres that deal with constructions of identity (particularly male identity) and, in the case of the Western, with an articulation of the ways in which masculinity and national identity are intertwined. This is significant as it underlines the ways in which Poirier's film can be read as a negotiation of identity construction. However, rather than a simple mirroring of these genres, *Western* appears to reconfigure or even disrupt many of their conventions. We have already seen that this is a road movie that follows a distinctly non-linear trajectory. While Poirier does show two striking shots in which Paco and Nino stand at the crest of a hill and the camera travels back away from them, along a straight country road, this depiction of linearity is not generally evident in the film. Instead, as we have seen, their movement appears to be increasingly random, criss-crossing the Breton landscape. It is perhaps significant that, in the shots just mentioned, the camera moves backwards and away from the protagonists, reducing any sense of forward movement on their part and thus simultaneously referencing and disavowing the linear progression of the 'traditional' road movie. *Western* is also a road movie without cars. Indeed it is the very removal of the car at the start of the film that sets the narrative in motion and leads to the protagonists' journey. Here again we can see the film renegotiating the traditions of the genre. While according to Corrigan the car becomes central to male identity in the typical road movie, here it is the removal of the car that enables the friendship and love that lead to new forms of identity for Nino and Paco. Interestingly, Nino steals the car in an attempt to seduce a woman; thus it is his desire for a woman that actually precipitates the narrative. In losing his car Paco loses the trappings that establish him as part of the capitalist world of work. His increasing dishevelment and confusion as the film progresses reveal his bewilderment at the loss of this status and his need to find new identities and new ways of belonging through radically different forms of identification. Paco begins the film as a driver. Early shots of Paco and Nino in his car establish a clear hierarchy in terms of size (Paco is much bigger than the diminutive Nino) and activity (Paco drives, Nino is his passenger). After the theft, Paco himself becomes a passenger in Marinette's car. He is no longer dominant or in control and is indeed dependant on Marinette (hinting at the role of women in the creation of new male identities). By the end of the film Nino drives and Paco is the passenger. However, the hierarchies are less obvious: Nino may drive but Paco remains dominant in terms of size and the car they drive belongs to Nathalie (Marie Matherton), Nino's new love. In other words, their journey has led them to new relationships and new identities that incorporate elements of their previous selves transformed by their recent experiences and encounters.

## Representing regional, national and European identities

Poirier similarly reconfigures the Western genre, most noticeably through his geographical shift from the American frontier to Brittany, in western France. The choice of Brittany as the location for the film is rich with significance. By choosing to reference two cinematic genres perceived as essentially American – the Western and the road movie – in a film that embarks upon an exploration of the construction of identity, Poirier already suggests the role of American cultural products in the construction of European culture.[2] By making Brittany the 'West' of his 'Western', Poirier extends this discourse to an examination of the role of the United States in the construction of regional, national and European identities. The geographical space we see in the film is clearly France. On a very simple level this is made apparent by the fact that most of the characters, including Paco and Nino, speak French. Yet this is the very edge of France, France's own 'Far West', a liminal space where France and indeed Europe meet the Atlantic. It is a space open to the Atlantic and to the lands beyond and this is underscored visually by the film's frequent shots of coastal towns, harbours, ports and boats coupled with the sound of seagulls' cries. In other words, France is shown to be somehow open and unfinished, defined by that which lies beyond her borders. By referencing the United States in the film's title and by using CinemaScope to create a vision of France, or more specifically Brittany, which recalls the vast landscapes of the American West, Poirier reminds us of that dominant Other and its role in the construction of French and European identities.

But of course Brittany is also a region with a strong sense of its own identity.[3] This is made very apparent in the film as we hear the use of the Breton language and witness joyful manifestations of Breton culture (the wedding sequence for example). If Poirier's invocation of the United States via the Western recalls the macro-discourses that shape constructions of European identities, here we are shown the regional micro-discourses that arguably play an equally important role in this process.

This reading of the film as a negotiation of constructions of European identity is supported by its most visible markers of cultural identity – Paco, Nino, and later the character of Baptiste (Basile Siekoua). The very fact that Poirier makes his main protagonists non-French (and chooses non-French actors to play these roles) underlines that this is an exploration of identity – and of the role of love and friendship within the construction of identity – which extends beyond national frontiers to the broader European context. Paco and Nino meet Baptiste in a bar as they prepare the opinion poll that they hope will lead Nino to his ideal woman. Baptiste is black and disabled, thus clearly marked as an outsider. They introduce themselves: Nino describes himself as 'Russian, of Italian origin,' Paco as 'Spanish, of Catalan origin' and Baptiste as 'from the Ivory Coast, of Breton origin'.[4] In other words, each insists upon the hybridity of his identity and locates what could arguably be seen as the 'minority' component (Nino's Italian ancestry, Paco and Baptiste's regional identities) as the 'origin' of this identity. Moreover, there is no sense of confusion here. Each character embraces this plurality, none more so than Baptiste who, despite his

evident lack of the physical traits which typically mark the 'true' Breton, affirms on more than one occasion, 'I'm a Breton'. Interestingly Poirier (who himself has dual French/ Peruvian nationality) extends this sense of hybridity at the end of the film as he appends national flags to each of the names in the closing credits. In an interview at the time of the film's release, Poirier explained the reasons for this insistence on difference:

> All my films are political in their own way. I come from Peru myself. I cast two foreigners as my main characters, and the characters they meet come from all sorts of different places. This diversity was reflected in the crew. Mixing colors, flags, was initially a poetic idea, not a political one, but now that we have the government's campaign against illegal immigrants it does remind audiences what France is made of. (cited in Rosenbaum 1999)[5]

## Looking for love in *Western*

So *Western* does then appear to offer up a nuanced negotiation of cultural identity based upon fluidity and difference. The characters' physical movement coupled with their own plurality underlines identity as something unfixed, always in process. The fact that their movement takes place within a region which is itself liminal furthers this representation. Just as Paco is neither straightforwardly French, Spanish or Catalan but rather a complex combination of all three, so the geographical space he inhabits is simultaneously Brittany, France, Europe and the other lands and cultures with which it is shot through.

This would seem to suggest a rather utopian vision of 'melting pot' Europe in which all cultures, all races can coexist in harmony. Certainly there exists very little in the way of hostility towards difference in the film. The main protagonists embrace their own plurality and, for the most part, other characters seem fascinated by their difference. When Nino attempts to seduce Guenaëlle (Mélanie Leray), he initially meets very little in the way of response. It is only when he mentions that he hopes to make an international telephone call that he succeeds in attracting her attention. When he and Paco later eat with Guenaëlle and her friend, the women seem fascinated by Paco's Spanish origins and Nino's increasingly desperate attempts at seduction involve frequent references to the traditions of his Russian background.

However, it would be misleading to read the film as a simple embracing of a multicultural Europe. Certainly the film does embrace plurality. It can be argued that every character in this film is in some way diasporic. This is evident in the characters of Nino, Paco and Baptiste, but even those characters who are more clearly rooted within Breton culture are themselves hybridized by this identity: they are diasporic in relation to the nation (France); to Europe; and, as the film's title reminds us, to its Others, notably the United States. The film appears to posit this plurality as *natural*. Despite their heavy accents

and itinerant lifestyle, Nino and Paco meet no hostility and are accepted by the Breton communities.

Nevertheless, while the film may offer plurality and difference as natural and desirable forms of identity, it also suggests that rootlessness and transience are far from ideal. The journey undertaken by Paco and Nino is motivated by a search for love: Nino seeks the woman of his dreams; Paco tests his feelings for Marinette. This search for love is in itself symptomatic of a desire to put down roots. In other words, love becomes a motivating force in an attempt to anchor identity. This does not mean a rejection of the plurality we have already described, but rather an attempt to situate this plurality within a stable sense of community and self enabled by loving relationships.[6] In other words, love enables a utopian European identity which permits a sense of community bonds and a simultaneous acceptance of difference.

Both Paco and Nino begin the film as travellers. As a salesman Paco has a sense of self based upon his allegiance to the capitalist world of work, but the very work he engages in is itself nomadic. When he loses his job, his lack of a clear sense of identity or belonging becomes immediately apparent as he seems overwhelmed by what has befallen him and, bereft of his possessions, has nowhere to go and nothing particular to do. His encounter with Marinette provides a possible solution to this lack. He is taken into her home and, as they fall in love with one another, he gradually finds a place in the Breton community: accompanying Marinette to the ship chandlery at which she works (itself a marker of Breton identity); exploring Le Guilvinec; and establishing a friendship with Nino's fellow patient at the hospital. When Marinette sends him away, these fledgling roots are destroyed and Paco finds himself adrift, both physically and emotionally. As he tells Nino over a meal in the hotel they visit after their first day on the road, 'I feel like a fool who has lost his car and his job [...]. But most of all I feel like a guy who has got a girl on his mind and doesn't know what to do'.

Nino also seeks stability and an anchoring of identity through love. Unlike Paco he has no job and no real possessions from the start of the film. We learn that he came to France from Russia to marry a French woman. She left him before the wedding day and, as he explains to Paco, he 'lost his taste for stability' and took to the road. Thus, failed love has led him to this wandering, rootless existence and his search for a new, requited love is clearly bound up with an accompanying desire for some sense of permanence and fixity.

It is striking that most of the women who become the objects of this quest are, unlike Nino and Paco, firmly anchored within the Breton culture and community. This is made apparent in a number of ways. First and foremost the choice of names is significant. Marinette herself tells Paco that she believes names to be important, that they can change your life. Her name carries connotations of the sea, furthered by her residence in the coastal town of Le Guilvinec and her work at the ship chandlery. All of this relates her to Brittany's sea-faring traditions, a key element of Breton identity. Her fair skin and blonde hair also mark her as 'typically' Breton, and her avowal that she prefers *crêpes* to crayfish suggests a real affinity with the traditions of her region. Guenaëlle also bears a name and

physical traits that are typically Breton. She works in a hotel in which she converses with her regular customers in Breton, and she invites Paco and Nino to a family wedding in which local traditions of costume and music are celebrated. Thus, the search for love here becomes bound up with regional identity, reinforcing the sense that this quest is as much about putting down roots and anchoring plural identities as it is about heterosexual romance.

## Love and belonging

So where does this leave us? With a film that on the one hand seems to be a celebration of plurality and a multicultural Europe, while on the other it calls for fixity and permanence within a clearly delineated region. However, it seems to me that Poirier is suggesting that these two apparently competing discourses may in fact be able to work in harmony. This is perhaps best illustrated by the game invented by Baptiste and introduced to Paco and Nino as a sure-fire way of meeting women. The game is entitled '*Bonjour la France*' and, as Baptiste explains, it involves greeting passersby and winning points for each greeting earned in return. Greetings from women earn double points and Baptiste reveals that he met his own partner while playing the game. Paco and Nino ask why the game is called '*Bonjour la France*' and Baptiste replies that this is because the passersby are French. They point out that they are not French and wonder if this makes their participation in the game problematic. Baptiste laughs off their concerns, saying, 'Everyone can play. Not everyone in France is French' (see Figure 19).

The game then becomes a metaphor for the film's broader negotiation of identity. These three outsiders cement their own friendship and seek for love in a playful game of nationality. By participating in the game and receiving replies from those they greet they become part of 'France', part of the community. Yet their difference is not erased. Strikingly it is during the game that we hear the film's one hostile reaction to difference, a passerby who tells Baptiste 'to go back to where he belongs'. However in keeping with the film's overriding tone of optimism and acceptance, Baptiste simply laughs this off and affirms once again, 'I'm a Breton'. Thus the game, like the film, seems to suggest that difference and belonging can go hand in hand and that the very sense of belonging will come about through the forming of emotional bonds.

The film's closing sequences further underline this reading. The unravelling of Paco's sense of identity appears to have reached its final point: he has lost the last of his possessions and has no money; he is unshaven and limping due to a struggle over a chainsaw with Nino. As he wanders through yet another small coastal town he is hit in the leg by a car door. The woman driver apologizes and offers him a lift. The woman, Nathalie, is blonde and physically not dissimilar to Marinette. The car also resembles that driven by Marinette at the start of the film and, like Marinette, Nathalie takes Paco back to her home. As they drive Paco remarks that the town looks like Le Guilvinec.

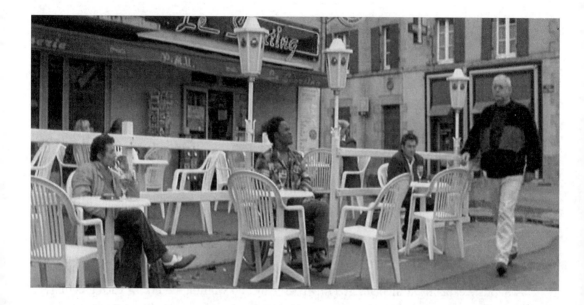

Figure 19. Paco, Nino and Baptiste play 'Bonjour la France' – *Western* (Poirier, 1997).

Once at her house, Paco lies about his reasons for being on the road ('it's a philosophy') and mistakenly reveals that she didn't really hurt his leg at all. There is a real sense of circularity here. Paco has come back to where he started: the Breton woman; the coastal town; the lie which echoes his dishonesty in telling Marinette that he is married (an untruth which propels her decision to ask him to leave). And yet of course he is not the same. His identity has been deconstructed through his time on the road and the loss of the markers of his previous status. And this time it is not Paco who wins the woman but Nino. The two go to Nathalie's house for dinner and find her surrounded by four of her five children. Nino is immediately at ease, crouching down on the floor to play with the children at their level. Paco is much less comfortable, sitting awkwardly on the sofa and attempting stilted small talk with one of the older children. Later, Nino prepares a meal and shows himself to be equally at ease in the domestic space of the kitchen. That night, Nino shares Nathalie's bedroom and, evidently impressed by his ease within and with her family, she asks him to return alone the following evening. Paco's jealousy when he learns of this suggests that he has not entirely lost his sense of powerful male ego, yet the

strength of his relationship with Nino prevents his anger and makes him accept that his failure to seduce on this occasion is 'just the way things happen'.

Nino and Nathalie fall in love and form a relationship. Paco returns to Le Guilvinec to find out if Marinette still wants him. He sends Nino in to speak to her and it is Nino who must tell him that she has fallen in love with another man. The relationship between the two men is thus reversed: Nino now drives the car and Paco is the passenger; Nino has found love and Paco is alone. The emotional and physical journey precipitated by Nino's act of theft and Paco's dishonesty with Marinette (both of them pretending to be something they were not) has enabled the breakdown of the existing sense of self and the construction of new forms of identity.

The film culminates with a lingering shot of Paco, Nino and Nathalie sitting at a dinner table surrounded by children of apparently different races. This invocation of family as a solution to the film's narrative could be read as a rather retrograde affirmation of patriarchal structures. However, this is not the typical 'nuclear' family. It comprises two men and one woman and, strikingly, the growing affection between Paco and Nino is shown to be just as important in the anchoring of identity as their relationship with women. Moreover, the apparent diversity of the children disrupts any notion of the 'typical' family of patriarchal culture. When Nathalie and Nino first sleep together she tells him that her five children each have a different father and that none of the fathers has any knowledge of their existence. These men, she say, were simply passing through. Like Nino and Paco they were rootless and always on the move. She, however, has gained permanence and stability through her children. By joining this family and, one assumes, fathering more children, Paco and Nino also finally achieve the rootedness they have sought throughout the film.

The importance of family in the anchoring of male identity is a theme that Poirier has explored in other works, most notably *Les femmes... ou les enfants d'abord.../Women or Children First* (2002). Here the family is clearly held up as a solution to Paco and Nino's quest. Love for Nathalie, for one another and for the children appears to provide a sense of belonging. Yet, in line with the film's apparent celebration of difference, this is at once a loving, tight-knit family group and a sprawling, hybrid multiplicity. Rather than simply reaffirm the conventional family unit and the centrality of the male patriarchal subject, Poirier offers us a version of family that combines different forms of love in a complex network of relationships. In other words, a family group which, in its easy combination of plurality and community, mirrors or even enables the version of cultural identity that the film appears to embrace. *Western* advocates a sense of cultural identity which moves beyond the confines of the nation to Europe and its Others while simultaneously embracing internal diversity. In other words, a sense of 'being European' which is fully cognisant of the diasporic nature of such an identity. The family unit that closes the film also offers a social and communal bond formed through the embracing of diversity. By showing us his 'outsiders', Paco and Nino, moving through the 'Far West' of the Breton landscape to a sense of belonging gained through the multiple loving relationships of

this unconventional family, Poirier advocates these very relationships as a means of establishing and anchoring broader cultural identities. The loving, non-patriarchal family rooted within the region but also embracing diversity can be interpreted as a positive model for European identity.

## References

Aitken, S. C. and Lee Lukinbeal, C. (1997), 'Dissasociated masculinities and geographies of the road', in S. Cohan and I. Rae Hark (eds), *The Road Movie Book*, London: Routledge, pp. 349–71.

Corrigan, T. (1991), *A Cinema Without Walls: Movies and Culture After Vietnam*, New Brunswick: Rutgers University Press.

Passerini, L. (1999), *Europe in Love, Love in Europe: Imagination and Politics in Britain between the Wars*, London: I. B. Tauris.

Roberts, S. (1997), 'Western meets Eastwood: genre and gender on the road', in S. Cohan and I. Rae Hark (eds), *The Road Movie Book*, London: Routledge, pp. 45–69.

Rosenbaum, J. (1999), 'Where they're coming from', *Chicago Reader*, 8 September, http://www.chicagoreader.com/movies/archives/1999/0499/0499.html. Accessed 2 May 2009.

Shiel, M. (2005), 'Westerns', in B. Marshall (ed.), *France and the Americas: Culture, Politics, and History*, vol. 3, Santa Barbara: ABC-Clio, pp. 1205–07.

## Notes

1. Examples include the German/Franco/British *Paris Texas* (Wenders, 1984), the Australian *The Adventures of Priscilla, Queen of the Desert* (Elliot, 1994) and the Mexican *Y tu mamá también /And Your Mother Too* (Cuarón, 2001).
2. It is worth mentioning the important role that the American West and the Western has played in French imaginings of the United States, from the popularity of Buffalo Bill's Wild West Show at the Exposition Universelle in Paris in 1889, to the work of Joë Hamman (1883–1974) whose fascination with the West led to a period living in Nebraska as a cowboy and a return to France to star in French silent Westerns such as *La conscience de Cheval- Rouge/The Red Man's Honour* (Roudès, 1912) and *La ville souterraine/The Subterranean City* (Hamman, 1913), to the *Cahiers* critics' focus on the Western for their renegotiation of American cinema and the relationship between the United States and American culture (see Shiel 2005: 1205–06).

3.  Brittany was not formally annexed to the French crown until 1532 and retained a degree of semi-independence until well into the seventeenth century when the region's strategic position in trade routes and the slave trade was recognized by the French state.
4.  Translations from the original French are my own.
5.  Poirier refers here to the draconian laws introduced by the French government in the early 1990s to combat 'illegal immigration' which led to 300 undocumented migrants taking refuge in a Parisian church in 1996 in an unsuccessful attempt to avoid forced deportation. A number of leading film-makers, actors and other artists became actively engaged in a very public protest at these laws and the expulsion of the immigrants.
6.  The fact that Paco's journey is the result of Marinette's decision to send him away in order to 'test their feelings' recalls in some ways the traditions of courtly love. This is suggestive given the reading of the film I am attempting here. As Luisa Passerini (1999) points out, courtly love is a founding myth in Europe and played a central role in defining European notions of 'love' and 'romance'. However, as some scholars have revealed, the traditions of courtly love are not confined to European culture alone but can be traced to Arabian, Persian, Indian, Chinese and Japanese cultures (Passerini 1999: 9), suggesting that this is a form of love which is at once specific and universal. The 'love' depicted in this film, love that embraces the specificities of regional identity and the plurality of different national and ethnic backgrounds, and indeed different forms of loving, echoes this dual identity making the suggestion of courtly love quite tantalizing.

# Chapter 12

## A conflicted passion: European film

Karen Diehl

T his chapter explores the relationship between the passions shown on-screen and
the passions shown towards the films exhibited in European cinema, considering
how their conjunction gives a complex and conflictive answer to the question: what
is European film? To illustrate the first category – on-screen passions – I have chosen two
groups of films. In the first group, European culture and history are played off against
each other. These films thereby go against virtually everybody's – the characters' and also
the spectators' – expectations. The films in the second group tell stories about love of
cinema itself, but these declarations of love are contradicted by narrative. With regard to
the second category – passion for film – the chapter analyses the support mechanisms for
cinema at the European level (primarily European Commission and Council of Europe),
their impact on film production in Europe, and how these policies relate to the choices
made by audiences at the box office. As in Elsaesser's opening chapter on cinephilia and
the emergence of film studies in Europe, here too US cinema looms large. Whether one is
talking about individual films, policies or audiences, to speak of European cinema more
often than not requires reference to that other cinema. Consequently the term 'European
film' can be conceptualized historically only in terms of its opposition to or synergy with
US cinema.

In using the term 'European film', my discussion follows Elizabeth Ezra and Terry Rowden's
deployment of the term 'transnational cinema' as 'a critical tool for dialectical engagement
with – rather than simple rejection of – ideas of the national' (Ezra and Rowden 2006: 13).
In bringing together policy frameworks, audience consumption, theories of genre and close
readings of a corpus of films, the term 'European film' takes on a multitude of meanings for
the parties involved. This, I will argue, generates conflict – between the stories told, the films
that get to be made, those that get distributed and audience consumption.

## Narrative and genre

In a cinematic narrative that follows the structure defined as the 'classical' mode – a form
perfected by the US studio system – both the action and the characters' position within
it are regulated: characters are exposed to a dilemma in the first quarter of the movie,
they are embroiled in it for the second and third quarter until, three quarters of the way
through the film, the resolution starts to be disclosed, with the characters in the last
quarter of the film emerging from the dilemma if not as new subjects then at least as more

aware subjects than they were at the start (Bordwell, Staiger and Thompson 1985: 174–93; Bordwell 1985; Dancyger and Rush 2006: 16–19).

For the purposes of production, consumption and (critical) reception, such narrative cinema can be categorized in terms of genres such as the Western, comedy, melodrama or film noir. The characters' emotions and passions are subject to narrative regulation depending on the genre to which the film belongs: romantic comedies offer a happy end, while melodrama or film noir end with the main character renouncing something, whether a loved one, society or life itself. Characters are endowed with passions in accordance with the type of story told. This serves as an orientation at the level of both production and consumption. Audiences know more or less what to expect; producers aim to make a profit by reworking a successful generic formula. However, for a new film to be successful it has at the same time to be different from what went before since audiences are also motivated by the desire to see something new. Thus, genres not only demand repetition but are also instigators of difference. Just how much fluctuation is considered permissible in this respect is something that is continuously renegotiated between producers, audiences and critics.

Since what is at stake here is both economic and cultural capital, film has been a field in which nations have tried to protect their own film industries and cinemas from too many foreign imports. On a supranational level, this dispute has been going on between the United States and Europe since the 1920s when US film production came to dominate the industry globally, after a decade when European countries had at times been the dominant film exporters (Bakker 2000). Quotas, support schemes for cinemas and local funding for production have been some of the instruments employed. Responses from the US film industry have included co-production and the setting up of European production branches so as to access funding and markets (Murphy 1992: 7). In addition to the threat from foreign film production, the massive popularization of television in the '70s and '80s led to the development of various supranational European Union programmes aimed at supporting films made for release in Europe, as well as the cinematic infrastructure necessary for their circulation. Not unlike the Film Europe initiatives which attempted to internationalize film production in Europe in the 1920s (see Chapter 2), so various institutions at the European level initiated a range of programmes to support the production and distribution of film in Europe, and to promote European art house cinema as a cultural alternative to US cinema. The European Union thereby functions as both producer/distributor and critic. It does this through various initiatives. The first was MEDIA (since 1991 the European Commission's programmes MEDIA I, MEDIA II, MEDIA plus and MEDIA 2007, followed in 2011 by MEDIA mundus), which supports training, pre-production, distribution/promotion, festivals and cinema theatres. The second was Eurimages (a Council of Europe programme initiated in 1988), which funds co-production, cooperation, distribution and, since 2007, also the digitalization of films previously subsidized by Eurimages. The third was the European Audiovisual Observatory (created in 1992, with a current membership of 36 European states plus

the European Union as a further member) which documents and supplements these initiatives.[1] It could further be argued that the European Union functions as the audience of its own films through the presence of European Union politicians and civil servants at festivals such as Cannes, or at functions such as the European Film Awards which, since 1988, take place in a different European city each year.

European film as promoted by the EU is to a great extent narrative cinema. Certain films could then be grouped together as a specifically 'European genre' on the basis of a number of shared narrative features; for example, romantic comedies playing on their lovers' cultural differences. Films made in Europe (including those specifically designated as European by the fact of receiving European Union funding) are usually divided into genres based on their particular kind of 'Europeanness': they could be art house films appealing to intellectual audiences; they could be comedies or tragedies based on a narrative of cultural difference; they could be based on historical events or contemporary history; they could be an adaptation of a well-known work of literature; and they could, of course, be a mixture of several of these categories. But for policy-makers to term a film 'European' does not necessarily entail success with audiences. This is because audiences in Europe go to see movies for varied reasons and because what constitutes a film as European for the purposes of European institutional policy corresponds to two very different goals: on the one hand, that of protecting the European cultural heritage as represented in and by European films; on the other hand, that of enhancing the industry's competitiveness (Beurrier 2004: 40–43). The MEDIA 2007 website sets out the following goals pertaining directly to film production: first, 'to strive for a stronger European audio-visual sector, reflecting and respecting Europe's cultural identity and heritage'; and second, 'to increase the circulation of European audio-visual works inside and outside the European Union'. The difficulty of arriving at a definition of what constitutes a European film has been illustrated in publications of the European Audiovisual Observatory itself (Ohlig 2003). European policy representatives uniformly claim film to be an expression of cultural identity, but more often than not it is left to national or regional support programmes to consider such matters. The European Union bases its support measures on financial criteria and on the requirement that these films be multinational collaborations. It does not, therefore, primarily promote European identity via film, but strives mainly to strengthen the industry in Europe by supporting production, infrastructure and film professionals, as well as the distribution in countries other than the country (or countries) of origin of films (co-)produced in Europe (Wasilewski 2009: 313–16). For policy purposes, an art film with few chances of commercial success and a film aimed at wide consumption by international audiences both count as European. Both are eligible for various support programmes, and both are expected to be seen by as many viewers as possible, especially beyond their national boundaries. These policy measures, however, are not genre markers for audiences: a film's financing structure or distribution support are not factors taken into account by film-goers when they are making up their minds about what film to see. Audience interest is aroused by content or by the name of a director or actor.

In theories of genre, the dyad industry/audience correlates to that of production/ reception. Content, however, is analysed both on the industry/production side and the audience/reception side. Writings on film genre – or on genre in other art forms, since film is by no means the only medium to be categorized generically – offer a range of approaches. Formalist literary theories tend to insist more on the formal characteristics that a work shares with other works (Todorov 1971). Studies of US cinema focus either on the industrial side (Schatz 1981) or on the social significance of a certain cinematic corpus, e.g. noir or Westerns. The latter are also popular genres, recognized and referred to by audiences when choosing or categorizing films. The corpus of films belonging to a particular genre and the number of genres recognized by audiences may alter over time. The genres recognized by audiences and the corpus of films included in them may also differ from those established by film scholars and critics: in her oral history work on 1930s British cinema-going, Annette Kuhn pointed out that the star vehicles for Jeannette MacDonald and Nelson Eddy often followed similar plots which few viewers today would be able to relate to, but which at the time generated intense emotions among her interviewees (Kuhn 2002: 196–98). Theories of the author – which in film studies gave rise to auteur theory – are also generic categories created by critics rather than by audiences seeking popular entertainment, although auteur cinema has found its niche among European audiences. Studies on genres such as transnational cinema or (another recent coinage) hybrid genres attempt to focus on both industrial production and artistic value, insisting that such films comprise a particular genre in that they share certain characteristics, but that they are also products of a single – in this case auteurist – production mode (Naficy 1994; Jaffe 2008).

The importance of genre for my discussion in this chapter resides not so much in its function as a tool for categorizing films, but rather in the way that this categorization process brings together audiences seeking to satisfy their specific scopophilic desires, the industry seeking to meet its commercial targets and art/auteurist cinema seeking to create films of artistic merit – all at the same time. This process also creates a cinematic memory:

> Any one genre is, simultaneously, a coherent and systematic body of film texts, and a coherent and systematic set of expectations. As well as providing a means of regulating desire across a series of textual instances, and of offering an ordered variety of the discursive possibilities of cinema itself, genres also provide a means of regulating memory and expectation, a means of containing the possibilities of reading. (Neale 1980: 54–55)

The increasing failure to compete with US cinema has been blamed on Europe's inability to provide for such desires:

> The decline of the ordinary genre film has meant the loss of a main source of fantasy and of the mythic dimension which Americans film possess and European films, often, do not. What European cinema has tended to oppose to the Hollywood 'dream factory'

has, besides realism, been an alternation between modernism and 'heritage' filtered through classics of European literature. (Nowell-Smith 1998: 13)

European cinema's strategy of countering the influx of US films into its markets by abandoning the fantasy or imaginary element in favour of realism and heritage has thus backfired because it deprives audiences of what they crave when they go to the cinema:

> The cinematic institution is not just the cinema industry (which works to fill cinemas, not to empty them), it is also the mental machinery – another industry – which spectators 'accustomed to the cinema' have internalised historically and which has adapted them to the consumption of films. (Metz 1975: 18)

European film history sees a tendency in European film production post-World War II to make distinctly non-generic films such as those of the various New Waves; that is, films that do not comply with such standardized ideas of popular genres. European film production as seen by the European Union ideally consists of films that retain a specific identity or promote a European, national, regional and/or cultural heritage. This cultural specificity may be expressed by defining the film temporally or spatially through a precise historical or regional element, or by giving national or cultural traditions an important role in the narrative. Such features are regarded as intrinsically more valuable than the standardized commercial fare of US film production. But this neglects the power that films have when they are generically recognizable:

> [...] certain of the most long lasting and international of film genres could be approached as narrative elaborations of spectator experiences from film's first decades. Originally these experiences seemed to have little to do with the actual content of the films, but rather relate primarily to the cinematic illusion itself. (Gunning 1995: 58)

I would argue that European cinema today – especially European art cinema – provides an indirect comment on such definitions of what constitutes a 'proper European film' through what might be seen as a play upon genres in combination with cultural specificity. These films purport to tell a story about a nationally-defined context and/ or historically-defined moment. However, the emotions ascribed to their characters displace this specificity, raising issues of genre through the narrative framing instead. Refusing generic categorization, these films use various genres to tell impossible stories. In stories about hate and death, love occupies a pivotal place in the narrative. In a film on politics, a plot hinging on sexual identity replaces the action plot. Furthermore, one can note in European film production of the 1990s a spate of films telling stories about the experience of cinema itself, thus introducing a cinematic self-reflexivity that is anathema to the cinematic illusion traditionally demanded by narrative cinema. Thus, it is logical that negativity should feature prominently in the narratives of such films.

## First sight: *Non ti muovere, Matador, The Crying Game*

The interconnection between genre, narrative and desire in (the act of experiencing) cinema – an interconnection predicated on gender inequality – has become a fundamental axiom of film analysis. This 'illusion cut to the measure of desire' (Mulvey 1975: 17), originally describing a male gaze directed at a female body, has been developed to allow the possibility of gender reversal, thus levelling the score between male and female spectators consuming the body of the other. In Chapter 4 of this volume, Laura Mulvey shows how the confluence of the gaze of female audiences, the representation of modern characters on the screen and the cinematic modes of staging these narratives render this gaze multiply mobile. The three European films of the 1980s, 1990s and 2000s discussed in this section of my chapter give this cinematic gaze a decidedly perverse angle, while deploying genre in unexpected places. Following the popular phrase 'love at first sight', this section analyses various types of 'first looks' in these three films: the opening scenes where spectators are given a first gaze at the film they desired to see, and the climactic scenes where the protagonists look at each other and their desirous gaze propels the narrative in unexpected directions.

In the film *Non ti muovere/Don't Move* (Castellitto, 2004), the relationship between the male and female protagonists starts with rape. The scene in which they first meet presents the doctor Timoteo (Sergio Castellitto) as utterly helpless and completely out of his depth when his car breaks down in a derelict no man's land on the city outskirts. His act of raping the woman (Penélope Cruz) who takes him into her home is an extreme attempt to reassert supremacy by a rich and powerful man, but it seems to be devoid of any emotion throughout. The abuse of her hospitality is continued in their next encounter when once again the initially friendly intention to apologize results in sexual abuse. But while he treats her as a prostitute, she perversely insists on treating him as a guest, inviting him to stay, cooking dinner. The name of the woman raped is Italia, although she is of Albanian origin. Thus, the rape not only signifies the extreme subjugation of a woman, but also the male protagonist's need to possess his own geographical and social identity in a situation where he finds himself at the mercy of people of non-Italian or unclear identity in an area where the state seems absent. This is further supported in narrative terms through the opposition drawn between his wife Elsa (Claudia Gerini) and Italia. Italia is poor, a seasonal worker, living in an urban wasteland and dreaming of travelling. Elsa is a well-groomed, educated professional, the owner of a large apartment and constantly travelling. In terms of narrative construction, they are also related to opposing elements: while Italia stands for land and earth to be possessed with or without consent, Elsa is continually defined in terms of water or sea, as something eluding capture by a man.[2] Accordingly, Timoteo's confession to the rape, the only moment when he reveals the other woman's existence to his wife, is written on the border between the two, on the seashore. But his wife walks past him without reading the text, her gaze fixed on the far horizon. Yet it is her child, Angela, that will be born, and not that of Italia. If genre is understood as a border or boundary phenomenon and as a

tool for social analysis or critique (Gledhill 2000: 221–22; 230), the two women desired by Timoteo not only represent the binaries of land/sea, upper-/lower-class, but through their differences establish genre itself as the film's metanarrative. Timoteo's struggle is not only to find proper emotional responses and to reconcile the various oppositions in his life; this struggle also corresponds to the field of genre as a tool of analysis.

As the ghost of Italia comes to haunt him during the anxiety-ridden days of his daughter's accident, a red shoe appears in his imaginings – the shoe he gave Italia as a luxurious present. Not only are his imaginings a disturbing instance of visual excess disrupting verisimilitude in the film (Neale 1995: 160), they additionally bind *Non ti muovere* to film history. Ever since Michael Powell and Emeric Pressburger's 1948 movie *The Red Shoes*, such shoes stand in cinematic memory for both the fulfilment of absolute desire and the renunciation thereof, with death resulting from the choice. Clasping that shoe and thereby accepting his 'love' story, Timoteo can finally become emotionally complete as a character. The spectator in turn receives a full cinematic fantasy of genre film – perversely in the absence of any clear genre that this particular film may be attributed to.

Just as *Non ti muovere* starts with an overview shot of an accident scene introducing the spectator to a spectacle of death, so the first scene of *Matador* (Almodóvar, 1986) features death but frames it in a series of media images and shifting gazes: the video tape of a murder has a man masturbating while watching it; a woman stalks her male prey, seduces and kills him as she reaches sexual climax; and future bullfighters learn the rules of the kill. Just as the naming of Italia ties *Non ti muovere* to a national context, so the introduction of bullfighting as both profession and fashion accessory (the murderess' cape and the hairpin as her chosen weapon) binds this film to a Spanish historical and cultural context. The tradition of bullfighting here coexists with a sexually liberated, utterly modern society; just as in bullfighting the bullfighter marks the spot where he will eventually thrust his sword between the bull's shoulder blades, María (Assumpta Serna) marks the spot for her hairpin on her lovers' bodies with lipstick (see Figure 20). While the lead characters (the female murderer María and the male murderer Diego [Nacho Martínez]) have carried the sexual liberation of the post-Franco era to a perverse extreme, the film includes other characters who inhabit different points on the scale: a fashion model openly has a full sexual relationship condoned by her career mother – these two represent modern Spain; the bigoted Opus Dei mother and her repressed son, studying to become a *torero*, represent old Spain. Just as the daughter Angela in *Non ti muovere* is the innocent product and catalyst of the narrative, so the male character Ángel (Antonio Banderas) in *Matador* is an unwitting tool of the murderous couple. In the very first scenes offered to the spectator, *Matador* forcefully indicates that traditions may perpetuate their inherited meanings but at the same time can be invested with diegetic shocks and be put to use for entirely different narratives. These transgressions continue throughout the film as it thoroughly subverts the genres of crime movie, romance and slasher movie. The investigation of the crimes is ridiculed: the rape of which Ángel accuses himself is hilariously deflated by the testimony of the victim and her mother; the murder

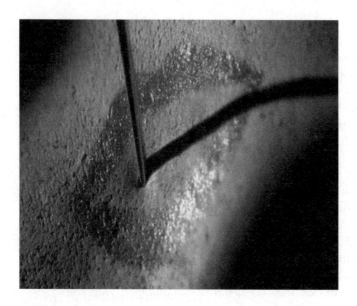

Figure 20. María marks the spot for the kill with lipstick – *Matador* (Almodóvar, 1986).

investigation progresses on the basis not of clues but of Ángel's dreams and hallucinations while undergoing psychiatric treatment. To arrive at reality – the hard facts of crime – the police and the law have to be helped by fantasy. The fantastic elements of dreams and clairvoyance bring the crime plot to its narrative conclusion just as the fantastic helped the protagonist of *Non ti muovere* to achieve emotional equilibrium.

Rather than define *Matador* as a generic hybrid (Allison 2001: 155), I would see it as a metacommentary pitting narrative form and emotional content against each other; a perverse framing of characters and spectators alike. The narrative equilibrium and disequilibrium are achieved by subverting genre expectations: the suspense of the thriller/crime story is sidetracked into dreams, psychology and murder-romance; the romance plot is set up between impossible lovers as two Black Widow characters prey on each other with loving abandon; the slasher movie plot is led off course *ad absurdum* as spectators realize that, if their violent narrative desires are fully realized, two murderers will die instead of innocent victims.

*The Crying Game* (Jordan, 1992) oscillates between the genres of thriller and romance. The first scene is a fairground in Ireland where a black man and a white woman are shown hitting it off. But this scene of romance then reveals itself as a trap, as the black US soldier becomes an IRA hostage. The presence of a black soldier at an Irish fairground is already unusual. The film, a British production with Japanese and European co-funding, has even been grouped together with US terrorism thrillers – albeit as an atypical example (Nelson 2006: 188). Additionally, this first scene indicates that the proffering of female bodies for sexual consumption contains unexpected layers.

As the hostage, Jody (Forest Whitaker), then tries to escape from Fergus (Stephen Rea), his kidnapper/executor-turned-friend, he is run over by a tank. Going underground, Fergus assumes a new life as a construction worker in London. Here, the movie transforms itself into a romance, where the former kidnapper falls in love with Jody's former girlfriend, Dil (Jaye Davidson). Seeing her body naked for the first time shocks him: it is a male body he has desired all along. In the remainder of the film Fergus has to redefine himself both as lover and as IRA member upon discovering Dil's sexual identity. *The Crying Game* ties contemporary conflict to a narrative where the emotional choices and sexual orientation of the male protagonist are not only at odds with each other, but also collide with his political-national loyalties and his religious and social upbringing. The subversion of genres here is doubly powerful because in both *The Crying Game* and *Matador* national tradition and national history provide the spectator with a 'real' referent – what has been termed the social efficacy of genre – against which the fantasies operating within the films are pitted. To return to the moment when Dil's nude body is uncovered: this moment is so disturbing because what is 'perverted' at the moment of seeing Dil's naked male body is the central tenet of narrative cinema; that is, the voyeuristic gaze at a body supposed to satisfy our desires. *The Crying Game* not only literally writes the process of repetition and difference essential to genre onto Dil's body, but makes what prior to this (primal) scene was a cinematically proper female body (the 'right' object for scopophilia) turn into the abused body.

This film made in Europe could lay claim to being 'European' because it is about national identity and intranational political conflict rooted in European history. But the unusual body at its core dislodges the narrative rooted in the bloody history between Ireland, Northern Ireland and Great Britain by simply casting off a silk dressing gown. What is remembered first and foremost about this film is the breaking of Fergus' sexual fantasy and political beliefs and the shattering of spectators' assumptions – assumptions made due to a history of viewing conventions based on the consumption of female bodies. Following this scene in which Fergus responds with disgust, he is then more or less gently seduced by Dil to at least like her again. Likewise, the film seduces the audience back into the dramatic thriller plot.

The characters' emotional choices that go against genre in *The Crying Game* and *Matador* thus pass judgment on those traditions and their historico-political context. Traditions still set up a cultural framework within which characters formulate their

desires, and the sociopolitical reality still offers a range of choices. In the two narratives, however, the choices once made and the traditions that frame them diegetically are at odds with the emotions expressed. Because of this, all three categories (tradition, history and emotions) take on subversive meanings.

## European self-projections: *Ulysses' Gaze*,[3] *L'uomo delle stelle*, *Nuovo Cinema Paradiso*

The term 'perverse' has been employed in reception studies (Staiger 2000: 28–42) to describe instances of audience reaction to films that deviate from the expected. Staiger deploys the term to mark a difference from her previous work with Bordwell and Thompson on classical narrative cinema, and also from a cultural studies model of preferred, negotiated and oppositional readings. For Staiger, choosing the term perverse serves to highlight the spectator's freedom of choice. Accordingly, such viewings can be the expression of a politics of heterogeneity. However, the term simultaneously implies a level of 'official' reading; that is, a context within which these readings are defined as deviant. This finds a counterpart, firstly, in the European Union's divergent agendas with regard to films made in Europe; and secondly, in the response to different types of films by European viewers, which construct a similarly conflictive panorama. Both stories – the heterogeneous and the official – are told by distribution figures and box-office receipts.

The three recent films discussed in this section treat the cinematic medium itself as a narrative component. These films, projected in European cinemas, thus offer spectators stories of themselves and of the film medium. Each film takes a different angle. To earn a living, the itinerant protagonist of *L'uomo delle stelle/The Star Maker* (Tornatore, 1995), played by Sergio Castellitto, pretends to be a talent scout for a film studio, cheating his clients not only out of their money but also out of their dreams: the rural population of Sicily speaks onto nonexistent demo tapes for a distant film industry in the big city because they see the film medium as an avenue of escape and the promise of fame and riches.[4] In *To vlemma tou Odyssea/Ulysses' Gaze* (Angelopoulos, 1995) lost masterpieces of early cinema become the object of a quest and their projection comprises its finale. But, as the narrative progresses, the protagonist also relives the controversies of his life and his work as a film-maker, searching for a wider meaning through this quest while travelling through the Balkans, including a war-ravaged Sarajevo. In *Nuovo Cinema Paradiso/Cinema Paradiso* (Tornatore, 1988), the projection of feature films in a Sicilian picture house in the 1950s and '60s brings the world of consumption and modernity to the island and later opens up a career opportunity to Totò (Marco Leonardi) as he grows up with the medium.

It is significant that all three of these films deal with a medium of the past: they are either set in the past or look back at a past. In contrast to the perverse emotions in *Matador*, which put into generic play the tradition and ritual of bullfighting, or *The Crying Game*, which offsets a drama of national conflict with a story of sexual and emotional belonging,

the characters are more or less emotionally coherent with respect to genre. However, the narratives about the film medium within these films are stories of loss, conflict, absence and greed – and they are always told in retrospect. They are thus stories of Europe looking for its own cinematic past and defining itself by using what André Bazin termed *le septième art* (cinema as a seventh art form) as in-built critique. Cinema here serves as an instrument of self-projection.

Unlike the protagonist of *Ulysses' Gaze*, European films (both art films and commercial films) do not travel well across borders. They are rarely projected on screens outside of their country or countries of origin. Even within their own markets, European films attract smaller audiences than US films. That being said, the late '90s were a period in which national film production figures in Europe increased steadily and national films seemed to fare better nationally than before. The report *Focus 1998* estimates that between 1995 (the year of production and national release of *Ulysses' Gaze* and *L'uomo delle stelle*) and 1997, around 100 more films were produced (up from 446 to 531) and in 1998 this figure went up by another 20. The same report attributes the increase in audience numbers largely to the advent of multiplexes but also to the stronger performance of national films (European Audiovisual Observatory 1998: 21–23).

In his article on the film year 2004 in Italy – the year *Non ti muovere* was produced – Paolo Merghetti points out that, despite a rise in box-office receipts, the percentage of Italian films fell overall (from 22 to 20.5 per cent) and the three most successful domestic films were commercial films ranked at 8th, 10th and 11th place (Merghetti 2005: 70-72). Another study, *Focus 2005*, points out the drop in market share of Italian films (albeit by 1.5 per cent from 21.8 to 20.3 per cent) – with an overall increase of 12 per cent in ticket sales (totalling 97.8 million tickets). These three successful domestic films were *Il paradiso all'improviso/Suddenly Paradise* (Pieraccioni, 2003) (2.18 million tickets sold), *Christmas in Love* (Parenti, 2004) (1.9 million) and *Tu la conosci Claudia?/Do You Know Claudia?* (Venier, 2004) (1.77 million). All three were entirely nationally produced, had wide national release and were successful at the Italian box office, but were not released in other European Union or non-EU European countries other than at one film festival (a festival of Italian film in Switzerland) or at the Cannes Marché du Film. The European Union's annual report *Focus 2005* lists *Non ti muovere* as occupying 16th position with just over 1.47 million tickets sold in 2004 (1.79 million tickets sold by 2008). This Italian-Spanish-British co-production thus had roughly half as many Italian viewers as *Spider-Man 2* (Raimi, 2004) in the same year (ranked 3rd at 3.2 million tickets sold, with *The Lord of the Rings: The Two Towers* [Jackson, 2002] topping the ranking at 3.75 million tickets). It was one of fifteen Italian-majority co-productions (that is, where the Italian share of production financing was the largest) of the year out of a total of 134 films produced in Italy, of which 34 were financed entirely by Italy and 23 were Italian-minority co-productions. Unlike the three films just mentioned, *Non ti muovere* did achieve release in other European countries.[5] Taken together with national box-office figures amounting to half of those for *Spider-Man 2*, this seems to be quite a good box-office performance for

a European art house film. However, ticket sales outside of Italy, according to Lumière, totalled just under 200,000 tickets – translating into roughly 10 per cent of the film's total box-office receipts for 2004–2008, and comprising a mere fraction of the ticket sales for US films in those countries.[6]

The commercial non-exportability of European films applies to both commercial domestic productions (such as the three Italian films mentioned in the previous paragraph) and art house productions such as the films analysed in this section. As far as distribution support is concerned, the European subsidy programmes want all the various kinds of films made in Europe to be screened in the maximum number of theatres in as many countries as possible. Judging by the rhetoric profusely uttered at festivals and in declarations, this appears to be a sincere desire. By contrast, distributors calculate the viability of films for their specific markets. The commercial film that did very well nationally is often completely uninteresting to other national markets: *Il paradise all'improviso, Christmas in Love* and *Tu la conosci Claudia?* were not bought by any distributor outside Italy. On the other hand, national stars do not always guarantee an audience and art house directors sometimes create their faithful audiences across borders: in Spain almost as many viewers chose to see the three-hour film *Ulysses' Gaze*, a Greek-French-Italian production starring US actor Harvey Keitel, as those who chose *Non ti muovere* starring the Spanish actress Penélope Cruz.

The reasons why viewers choose to see a film are as diverse as the number of viewers themselves and as the numbers of films available. It is not generic recognizability that creates these pockets for films like *Ulysses' Gaze*. In this case, spectators made their choice based on the director's name rather than on the type of story he was telling with this particular film. If viewers cannot discern anything that attracts them in an international film, they do not go to see it. The desire to see films such as *Christmas in Love* lies in their attraction as light, local holiday fare: for Italian audiences such films are a staple ingredient of the Christmas or summer holidays. Other European countries make similar seasonal films for consumption at a purely national level. These types of films are so firmly embedded in the lives of audiences that national producers and distributors can rely on national audiences to generate sufficient revenue. While critics and internationally- or artistically-minded policy-makers may lament the success of such films, they are recognized generically and welcomed by audiences, and evidently satisfy scopophilic desires.

In the report *Focus 2005*,[7] the 2004 breakdown of market share according to provenance of films released theatrically was as follows: across the board, an average of 26.5 per cent were European films, 71.4 per cent were US or US-EUR films,[8] with the remaining 2.1 per cent being of other origin. If one looks at distribution figures within individual countries, there are variations. In France, one of the European countries with the strongest national production and the lowest US market share, films from the US made up 47.2 per cent, domestic films 38.4 per cent, and films from other countries (European and rest of the world) 14.4 per cent. In Italy, US films constituted 61.9 per cent of the films released in

theatres, domestic films made up 20.3 per cent, and 17.8 per cent were films from other countries. For the UK, 83.8 per cent came from the US, domestic films made up 12.4 per cent, with the remaining 3.8 per cent left for other countries. In Spain, US films made up 78.4 per cent, domestic films 13.4 per cent and other 8.2 per cent. According to a UNESCO report, for Ireland, with an average annual production of 17 films and with 33 imported films shown in cinemas, the market share of national films in 1995 was roughly 30 per cent; for Greece, with an average annual production of 25 and with 160 imported films, the market share of national films was roughly 13 per cent (UNESCO 2000: 25–26)

Overall, the statistics given in the European Audiovisual Observatory's *Focus* reports seem to show a gradual decrease in the US market share. The first report of 1998 set the market share of US and US-EUR productions at roughly 75 per cent. The 2009 and 2010 reports estimate the share at roughly 65 per cent. However, this trend is often the result of one or two singularly successful films from one of Europe's major film-producing countries. For example, in 2003 this was Wolfgang Becker's *Good Bye, Lenin!* from Germany, a film, in effect, about the preservation of fantasy.

In 2008 the French film *Bienvenue chez les Ch'tis/Welcome to the Land of Shtis* (dir. Dany Boon) secured record ticket sales both nationally and Europe-wide. It was thus a very rare instance of a nationally financed (that is, not co-produced) film that made it to 5th place among the 25 most successful films in Europe – a list usually featuring only US, US co-produced or (intermittently) British productions. If British releases in other European film markets are excluded, the percentage of non-domestic films of European provenance screened in European countries is on average less than 2 per cent. The sheer number of films produced makes it impossible to release them all. Comparing the figures in the first *Focus* report with the 2009 and the most recent 2010 report, the number of films that the European Union member states (referring here to the EU-15) are producing and supporting through infrastructural measures has more than doubled, from roughly 500 in the late '90s to about 1000 in 2009 (plus roughly another 200 from the rest of the EU-27) and 1168 in 2010 (EU-27). Even at the national level, many films fail to secure a theatrical release slot. For example, Germany produced 127 full-length films in 2007 (as well as co-producing another 45). The first figure included no fewer than 60 documentaries. According to the Filmförderungsanstalt (FFA), only 100 German films reached cinema theatres that year (Hoecherl 2009: 300–01). Industry representatives lament this overproduction.

The predicament of European audio-visual policy is that it aims to achieve too many and too varied goals at the same time. It tries to get as many films as possible produced which makes it impossible to get all of them screened in cinemas. Like the never-made films of the fake talent scout in *L'uomo delle stelle*, the censored kisses in *Nuevo Cinema Paradiso* and the lost masterworks of cinema in *Ulysses' Gaze*, they remain unseen by the public. The support given to commercial films means that they have an edge not only over the US competition but also over other smaller European art house films. The

failure to secure non-national audiences is perhaps the most serious, since it implies that, despite all the efforts, European audiences are not drawing closer together. It may not be coincidental that the three films that centre their narrative on cinema strongly emphasize negative emotions: subconsciously, European films may be narrating audio-visual policy's story of conflicting goals – certainly, in looking back at cinema in the past, these films suggest that a brighter present or unified future has yet to be attained. Yet, if one compares the range of choice offered to large segments of the European public by their local cinema to the range available to US audiences – with practically no foreign films of any kind getting screened in the US outside the big cities – then it becomes clear that the range of films available to audiences in Europe is significantly more varied. One may lament that, out of ten films screened in France, Italy, Germany or Spain, seven will be US films, only two or three will be national films, and occasionally one non-US foreign film may be screened, but the fact remains that Europeans can at least choose to see a non-US film – and will always be aware that this ability to choose defines a film made in Europe as an alternative to US cinema. Furthermore, the ability to choose makes it possible to differentiate between different types of European film. One film-goer may favour a film like *Tu la conosci Claudia?* while another may pick *Non ti muovere* – both choices must be counted as European.

## Final cut

On the surface, the two films *Matador* and *Nuovo Cinema Paradiso* seem to have little in common. As argued above, the former is a film that delights in breaking rules of genre and in presenting perverse passions. By contrast, *Nuovo Cinema Paradiso* respects conventions and offers a melancholy yet emotionally straightforward ending: Totò watches the reel his late mentor-friend bequeathed him. These are the clippings of all the cinematic kisses and scenes of (naked) desire the Catholic priest demanded to have cut from the films (see Figure 21).

The final images of both films pose the question of censorship on two different levels. The reel of kisses and nudity invokes cinema history with its practices of censorship; it evokes childhood, youth and loss; and it evokes the cinematographer who kept the clippings and, as a final legacy of love, gives his cut of films to Totò. At this moment of fulfilled desires on the part of both protagonist and spectator, the film reaches its conclusion where the two wants – the want for the pleasure of the process and the want for the pleasure of its closure (Neale 1980: 26) – are collapsed into each other. In *Matador*, the female murderer María, too, lovingly and ecstatically offers a final cut to her counterpart Diego; a cut that will kill him, fulfilling their extreme fantasies. For this film too, the question of censorship poses itself through the rating system that decided which age groups could view it. As *Nuovo Cinema Paradiso* increasingly gained critical recognition, especially after it was awarded the Academy Award for Best Foreign Language Film, its romantic take on Sicily

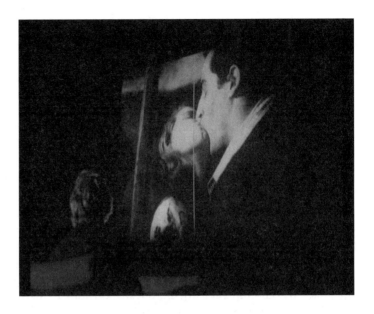

Figure 21. Watching screen kisses – *Nuovo Cinema Paradiso* (Tornatore, 1988).

and its narrative about film consumption won recognition from film audiences and it was re-released in a director's cut version. *Matador*'s graphic depiction of violence and sex prevented it being shown to wider audiences. It was, however, the first Almodóvar film to receive state funding (in this case from television). Together with *La ley del deseo/ Law of Desire* (Almodóvar, 1987), it was also one of his first films to win the director and his cast awards: in 1987, both these films and their director won awards in Europe and the US. It is also from this time on that Almodóvar's films increasingly came to be financed internationally. They now generate most of their revenue outside of Spain (Wood 2007: 55–57). This is linked both to recognition of the director and to his stylistic development. When it is argued that Almodóvar's film style began to 'evolve towards a slicker, more voluptuous texture from *Matador* (1985 [sic]) onwards' (Ezra 2004: 255), the supposition is that the turning point for the director in terms of audience popularity was brought about by his becoming more American. Almodóvar became a European auteur by increasingly incorporating Hollywood-style film-making into his films.

While *Matador* is obviously a product of a post-Franco modern Spain, it is also an example of state intervention in film production (in the form of subsidies) and of film

awards raising public interest in the film and its director. It was also produced just three years after a new law had been introduced in Spain that raised domestic screen quotas, thus further protecting Spanish cinema against foreign film imports (Kinder 1993: 388–440). The protectionist measures and support networks developed for European films intensified over most of the next two decades following this film's making in 1986. Between EURIMAGES' first year (1992) and 2009, its budget grew from €6,194,004 to €20,079,491, and the number of films co-produced as a result rose from 15 to 57. In the mid-1980s, the GATT II negotiations saw some of the most acerbic exchanges between the political delegates on the issue of exempting culture – particularly cinema – from free-trade agreements. These disagreements continued in further trade agreements such as GATS and the successive rounds of the WTO (Herold 2003).

The film *Matador* serves as a perfect illustration of 'European' cinema's predicament. *Matador* shocks and amuses with a plot that fills a classical generic structure with perverse content, while also making pronounced reference to the production country's cultural specificity. Thereby it doubly distinguishes itself from mainstream films because, unlike these, it does not aim to get an 'All Audiences' or 'Parental Guidance' rating. *Matador* integrates the contradictions of European film into its narrative, precisely because it inscribes generically perverse emotions into the hypertext of classical narrative cinema, and also into cinema history by showing extracts from US films. By using these conventions and quotations as a reference point, it declares classical cinema, with its industry-regulated conventions, to be its desired referent, but also shows how its characters and emotions will not fit into that form without conflict.

That this can be a contradictory or even perverse desire can be seen in the funding stipulations of EURIMAGES. One crucial condition is that, to qualify for funding, films must be co-produced by at least two countries, which can work against culturally specific narratives or reduce the minority partners to mere moneylenders facilitating another country's narrative. Incidentally, the 2005 *Focus* report's editorial was devoted to the problems involved in ascertaining a film's nationality for statistical purposes; this, of course, ultimately decides a film's eligibility for European, regional and national support programmes.[9] Furthermore, the money is given on condition that, should the film recoup its production costs at the box office, EURIMAGES must be repaid before all the other co-funders. When such stipulations are set against the vociferous defence of the value of European film as a non-commercial and highly artistic cinema that does not aim to make money but to accrue cultural capital, there does indeed appear to be a perverse relationship between official rhetoric and production practice – the latter being the last to give and the first to cash in on 'cultural value'. The different desires of policy – to be artistically valuable, culturally specific and competitive – clash visibly.

Similar contradictions over cinema's value to the nation and the measures needed to help a nation's film production fare well abroad surface also in a 2000 UNESCO survey, in a passage noting the correlation between excessively low GNP and film production: 'With a GNP of less than US$1200 and/or a United Nations Development Indicator (HDI) of

0.600, some 88 countries of a total of 185 have never had their own film production' (UNESCO 2000: 17–18). The survey establishes the need for finance, and a protectionist legal framework to provide for and protect national film production seen as vital to the cultural imaginary. If, due to a low GNP, films are not produced, the survey asks: 'Does this mean that 465 million people in the world will not be able to see their own image reflected?' (ibid.). It notes that this could be a major problem if imported images take their place since 'an excess of imported images [...] would erode the social texture and the sovereignty and the cultural identity of a country' (ibid.). At the same time, the report points out that those countries with the highest film export rates are precisely those which receive the least state aid – the US, India and Hong Kong (UNESCO 2000: 6; 17) – all three of which produce many generic films catering to scopophilic desires. Thus competitiveness bears no direct relation to the level of subsidies.[10] European film support can thus be said to both help and hinder European cinema. It does, however, help those small film companies and small film-producing countries to get films made at all, and to have them seen by other audiences.

As noted in the previous section, the narratives about cinema in *L'uomo dell stelle*, *Ulysses' Gaze* and *Nuovo Cinema Paradiso* could be said to be charged with negative emotions because they are subconsciously expressing a failure of policy. At the level of spectator choice, this negativity may point also to the impossibility of satisfactorily defining what a European film is, or to an unwillingness to accept and embrace European films simply because they were made in Europe, or simply to a whimsical preference for this film over that – in the majority of cases opting for the US film. The films discussed in the first section – *Matador*, *Non ti muovere* and *The Crying Game* – may contribute a more fitting narrative on how to grasp the complexity of the term 'European film' by bringing together national tradition and history, genre film and perverse emotions.

Policy-makers need to acknowledge that the policies pursued are conflictive. Treating film as an industry not only results in an overproduction that cannot be absorbed by the distribution sector (this holds true for initiatives at national and regional levels too), it also models Europe on the US film industry – though the question of which became the 'big' industry first is more complex. It also entails European art house films having to compete against European commercial films. More often than not, policy-makers assume that they speak for audiences who then make entirely unexpected choices at the box office.

When choosing to view a European film, European audiences are almost by definition likely to be deciding against viewing a US production. This choice is possible, and so is the opposite choice to see the US film. In opting for a European production like the latest Almodóvar movie, their expectations are that the film will show stories about European characters on-screen as well as offering sleek, stylish film-making – cinema Hollywood style. What EU production and distribution policies have given audiences at another level of choice are internationally co-produced films where distribution subsidies may be what gets these films across European borders – even if the statistical status quo (that is, the

numerical under-representation of European films) leaves much to be desired. National audiences may actually value a director from another European country more highly than a national star – as was the case with the preference for *Ulysses' Gaze* over *Non ti muovere* in Spain.

It may be going too far to say that audio-visual policy displays an inadequate emotional response in maintaining that all its goals are compatible, and to argue that most European audiences make the wrong choices about their cinemas gets us nowhere. Nonetheless, it might be fruitful to ask whether an adequate response to the question of what European cinema has been, is and could be might not lie precisely in acceptance of the possibility that such conflicted passions coexist – as they do in the scopophilicly joyous climactic moment of *Matador* where to love is to kill.

## References

Bakker, G. (2000), 'America's master: the decline and fall of the European film industry in the United States (1907–1920)', in L. Passerini (ed.), *Across the Atlantic: Cultural Exchanges between Europe and the United States*, Bern: Peter Lang, pp. 213–40.

Beurrier, P. (1992), *Les politiques européennnes de soutien au cinéma. Vers la création d'un espace cinématographique européen?*, Paris: L'Harmattan.

Bordwell, D. (1985), *Narration in the Fiction Film*, London: Routledge.

———, Staiger, J. and Thompson, K. (1985), *The Classical Hollywood Cinema: Film Style and Mode of Production to 1960*, New York: Columbia University Press.

Dancyger, K. and Rush, J. (2006), *Alternative Screenwriting*, 3rd edition, Boston: Focal Press.

European Audiovisual Observatory (1998), *Focus 1998: World Film Market Trends*, Strasbourg: European Audiovisual Observatory.

——— (2003), *Focus 2003: World Film Market Trends*, Strasbourg: European Audiovisual Observatory.

——— (2005), *Focus 2005: World Film Market Trends*, Strasbourg: European Audiovisual Observatory.

——— (2008), *Focus 2008: World Film Market Trends*, Strasbourg: European Audiovisual Observatory.

—— (2009), *Focus 2009: World Film Market Trends*, Strasbourg: European Audiovisual Observatory.

—— (2010), *Focus 2010: World Film Market Trends*, Strasbourg: European Audiovisual Observatory.

Evans, P. W. (2004), 'Contemporary Spanish cinema', in E. Ezra (ed.), *European Cinema*, Oxford: Oxford University Press, pp. 250–64.

Ezra, E. (2004), *European Cinema*, Oxford: Oxford University Press.

—— and Rowden, T. (eds) (2006), *Transnational Cinema: The Film Reader*, London: Routledge.

FFA (2008), *Geschäftsbericht 2007*, Berlin: FFA, http://www.ffa.de. Accessed 7 July 2008.

Gledhill, C. (2000) 'Rethinking genre', in C. Gledhill and L. Williams (eds), *Re-Inventing Film Studies*, London: Arnold, pp. 221–43.

Gunning, T. (1995), 'Those drawn with a very fine camel's hair brush: the origins of film genres', *IRIS*, 20 (Autumn), pp. 49–61.

Herold, A. (2003), 'European public film support within the WTO framework', *IRIS plus*, supplement to *IRIS* 6, http://www.obs.coe.int. Accessed 3 July 2003.

Hoecherl, U. (2009), *Kinohandbuch 2009*, Munich: Entertainment Media.

Jaffe, I. (2008), *Hollywood Hybrids: Mixing Genre in Contemporary Films*, Plymouth: Rowman and Littlefield.

Kinder, M. (1993), *Blood Cinema: The Reconstruction of National Identity in Spain*, Berkeley: University of California Press.

Kuhn, A. (2002), *An Everyday Magic: Cinema and Cultural Memory*, London: I.B. Tauris.

Merghietti, P. (2005), 'Triste peleton/new law old films', in *Atlas du cinéma/World Cinema Atlas Edition 2005*, special issue of *Cahiers du Cinéma*, April, pp. 70–72.

Metz, C. (1975), 'The imaginary signifier', *Screen*, 16: 2, pp. 14–76.

Mulvey, L. (1975), 'Visual pleasure and narrative cinema', *Screen*, 16: 3, pp. 6–18.

Naficy, H. (1994), 'Phobic spaces and liminal panics: independent transnational film genre', *East-West Film Journal*, 8: 2, pp. 1–30.

Neale, S. (1980), *Genre*, London: BFI Publishing.

——— (1995), 'Questions of genre', in B. K. Grant (ed.), *The Genre Reader*, Austin: University of Texas Press, pp. 159–83.

Nelson, J. S. (2006), 'Four forms for terrorism: horror, dystopia, thriller, and noir', in E. Ezra and T. Rowden (eds), *Transnational Cinema: The Film Reader*, London: Routledge, pp. 181–95.

Nowell-Smith, G. (1998) 'Introduction', in G. Nowell-Smith and S. Ricci (eds), *Hollywood and Europe: Economics, Culture, National Identity 1945–1995*, London: BFI Publishing, pp. 1–16.

——— and Ricci, S. (1998), *Hollywood and Europe: Economics, Culture, National Identity 1945–1995*, London: BFI Publishing.

Ohlig, S. (2003), *'Europäisches Audiovisuelles Werk'. Definitionen eines Schlüsselbegriffs des Audiovisuellen Sektors im geltenden Europäischen Recht*, Strasbourg: European Audiovisual Observatory.

Schatz, T. (1981), *Hollywood Genres: Formulas, Filmmaking and the Studio System*, New York/Philadelphia: Random House/Temple University Press.

Staiger, J. (2000), *Perverse Spectators: The Practices of Film Reception*, New York: New York University Press.

Todorov, T. (1971), 'Théories de la prose', *Poétique*, 7, pp. 385–89.

UNESCO Culture Sector (with the assistance of the UNESCO Institute for Statistics) (2000), *A Survey on National Cinematography*, Paris: UNESCO.

Wasilewski, V. I. (2009), *Europäische Filmpolitik. Film zwischen Wirtschaft und Kultur*, Constance: UVK Verlagsgesellschaft.

Wood, M. P. (2007), *Contemporary European Cinema*, London: Hodder Arnold.

## Notes

1.  Additionally, the 'Television Without Frontiers' Directive (1989 and subsequent updates) contains regulations protecting the interests of film rights holders.
2.  His wife is out swimming as he desperately tries to call her. In the scene where they have sex, she wears a shimmering silk nightgown that ripples over her body, and as she leans over the table she dives into a mass of seashells. While Italia prepares him a traditional Italian dish of spaghetti, his wife cooks him a curry, an overseas dish. When talking about having a child, the wife says she does not want to bring a child into the world ('*nel mondo, in questo mondo*'), referring to the man-made political realities that as a water-creature are repugnant to her.
3.  Angelopolous' film *Ulysses' Gaze* will be referred to by its English title for the benefit of readers unfamiliar with Greek.
4.  See also the Brazilian film *Cinema, aspirinas e urubus/Cinema, Aspirins and Vultures* (Gomes, 2005), which featured the narrative of an itinerant cinema vendor, set in 1942. In this film, the protagonist travels around the country screening Aspirin commercials as entertainment and then selling aspirin to the population.
5.  The Lumière Database of the European Audiovisual Observatory lists Belgium, Bulgaria, Switzerland, Denmark, Spain, France, Great Britain, Iceland, the Netherlands, Portugal, Romania and Sweden.
6.  The US Top 20 of the year featured one film where the US is neither sole nor majority producer (*Bridget Jones: The Edge of Reason* [Kidron, 2004], a British-US-American-French-German-Irish co-production). In twelve cases the US was sole financer, in the remaining seven cases it was the majority producer. As for the European Top 20, the US was sole or majority producer of all but two of the twenty most successful films of 2004. The two films where this was not the case were *Bridget Jones: The Edge of Reason* in 19th place (here the US was the second producer after Britain) and *Notting Hill* (Curtis, 1999) (a British production according to the *Focus Report*).
7.  It is estimated that 764 films were produced in the European Union in 2004.
8.  Of these, 11.7 per cent were US-EU co-productions.
9.  In this editorial, André Lange refers to the Oliver Stone film *Alexander* (2004), 'shot in Thailand and Morocco at Warner's initiative' and 'partly financed thanks to European, Japanese and Korean pre-sales organized by the British subsidiary of a German group'. He goes on to note: 'Some of the cast are European (including Alexander, who speaks with an Irish accent!) and the post-production phase took place in France' (Lange in European Audiovisual Observatory 2005: 4).
10. However, the US funding schemes for theatres in other countries, e.g. in Brazil where many cinemas are backed by US majors, often concentrate the available screens in US company hands. This results in the exclusion of locally-produced films from cinemas. This can arguably be seen as a way of skewing the competition.

# Notes on contributors

**Luisa Accati** teaches Modern History and Ethno-History at the University of Trieste. She has studied in France and has published articles in journals such as *Annales, Gender and History, Historia Social, Quaderni Storici* and *Studi Storici*. She is the author of two books: *Beauty and the Monster: Discursive and Figurative Representations of the Parental Couple from Giotto to Tiepolo* (2006) and *Scacco al padre. Immagini e giochi di potere* (2007).

**Seán Allan** studied at Emmanuel College, Cambridge and at the Humboldt University, Berlin. He is currently Reader in German Studies at the University of Warwick. He is co-editor (with John Sandford) of *DEFA: East German Cinema, 1946–1992* (1999) and has written a wide range of articles on representations of East Germany and post-unification German identity in contemporary German cinema. He has also written extensively on eighteenth and nineteenth-century drama, including *The Plays of Heinrich von Kleist: Ideals and Illusions* (1996) and *The Stories of Heinrich von Kleist: Fictions of Security* (2001).

**Tim Bergfelder** is Professor of Film at the University of Southampton. He is the author of the monograph *International Adventures: Popular German Cinema and European Co-Productions in the 1960s* (2005). His most recent books are *Film Architecture and the Transnational Imagination: Set Design in 1930s European Cinema* (2007, with Sue Harris and Sarah Street), *Destination London: German-Speaking Émigrés in British Cinema, 1925–50* (2008, co-edited with Christian Cargnelli), and *The Concise CineGraph: Encyclopaedia of German Cinema* (2009, co-edited with Hans-Michael Bock).

**Enrica Capussotti** obtained her Ph.D. at the European University Institute, and has held teaching positions in Italy and the UK, most recently as Lecturer in European History at the University of Newcastle. She is currently writing a book on the history of racism in Italy, focusing on the racialization of southern workers who migrated to the north in the 1950s and 1960s. She has published widely on youth culture and consumption, cinema and migration, memory and oral history, and the history of social movements. Her books include *Gioventù perduta. Gli anni cinquanta dei giovani e del cinema in Italia* (2004) and

*Women Migrants from East to West: Gender, Mobility and Belonging in Contemporary Europe* (2007, co-edited with Luisa Passerini, Dawn Lyon and Ioanna Laliotou).

**Karen Diehl** is a freelance author in film. From 2005–2006 she was Research Fellow at the University of Turin for the project *Immagini dell'Europa 1989–2006. Per una storia culturale dell'Europa a traverso il cinema*. Her Ph.D. thesis 'Imagining Proust: A Case Study of Adaptation as a Cultural Practice' at the European University Institute, Florence is currently being revised for publication for the centenary of the publication of the first volume of Proust's *À la recherche du temps perdu*. She has taught at the Free University Berlin, where she was founding editor of the literary journal *Fassungen*, and has been a Visiting Researcher in Film Studies at the University of California, Berkeley. She has worked for various film festivals in Germany and Belgium, and from 2007 to 2010 worked in the film industry as Assistant CEO at Bewegte Bilder, Tübingen.

**Liliana Ellena** is a historian working at the University of Turin. For 2002–2004 she was a Research Fellow at the Kulturwissenschaftliches Institut, Essen for the project 'Europe: Emotions, Identities, Politics'. Her work focuses on the fields of gender and cultural history, exploring links between visual sources and new research objects and approaches, with a particular interest in postcolonialism and transnational history. She has written widely on the intersection between sexuality and race in Italian colonial cinema and postcolonial memory. Her book publications include her edition of a new Italian translation of Frantz Fanon's *Les Damnées de la terre* (2000), a co-edited monographic issue of the journal *Zapruder* (2007) on transnational women's movements, and *New Dangerous Liasons: Discourses on Europe and Love in the Twentieth Century* (2010, co-edited with Luisa Passerini and Alexander C. T. Geppert).

**Thomas Elsaesser** is Professor Emeritus of Film and Television Studies at the University of Amsterdam, and since 2005 Visiting Professor at Yale University. Among his books as author are *Weimar Cinema and After* (2000), *Metropolis* (2000), *Studying Contemporary American Film* (2002, with Warren Buckland), *Filmgeschichte und frühes Kino* (2002), *European Cinema: Face to Face with Hollywood* (2005), *Terror und Trauma* (2007; English edition forthcoming), *Hollywood heute* (2009) and *Film Theory: An Introduction Through the Senses* (2010, with Malte Hagener).

**Andrew Higson** is the Greg Dyke Professor of Film and Television and Head of the Department of Theatre, Film and Television at the University of York. He has published extensively on British cinema, from the silent period to the present, on transnational cinema in Europe in the 1920s and 1930s, and on the concept of national/transnational cinema. His publications include *'Film Europe' and 'Film America': Cinema, Commerce and Cultural Exchange, 1920–1939* (1999, co-edited with Richard Maltby), *English Heritage,*

*English Cinema: The Costume Drama since 1980* (2003) and *Film England: Culturally English Filmmaking since the 1990s* (2011).

**Jo Labanyi** is Professor of Spanish at New York University, where she directs the King Juan Carlos I of Spain Center. She has published widely on nineteenth- and twentieth-century Spanish culture, including most recently the volume on *Spanish Literature* in OUP's Very Short Introduction series (2010). She is currently co-authoring a *Cultural History of Modern Spanish Literature* and co-editing a *Companion to Spanish Cinema*. She directed the collaborative research projects 'An Oral History of Cinema-Going in 1940s and 50s Spain' (funded by the AHRB) and 'Film Magazines, Photography and Fashion in 1940s and 50s Spain' (funded by the British Academy), and was a partner in the international research project *Europe: Emotions, Identities, Politics* directed by Luisa Passerini.

**Lucy Mazdon** is Reader in Film Studies at the University of Southampton. She has written widely on film and television. Her publications include *Encore Hollywood: Remaking French Cinema* (2000), *France on Film: Reflections on Popular French Cinema* (2001), *The Contemporary Television Series* (2005, co-edited with Michael Hammond) and *Je t'aime, moi non plus: Franco-British Cinematic Relations* (2010, co-edited with Catherine Wheatley). She has recently completed an AHRC-funded project researching the history of French cinema in Britain from 1930 to the present

**Laura Mulvey** is Professor of Film and Media Studies at Birkbeck, University of London. She is the author of: *Visual and Other Pleasures* (1989 & 2009), *Fetishism and Curiosity* (1996), *Citizen Kane* (1996) and *Death 24x a Second: Stillness and the Moving Image* (2006). She has made six films in collaboration with Peter Wollen including *Riddles of the Sphinx* (1978) and *Frida Kahlo and Tina Modotti* (1980), and with artist/film-maker Mark Lewis *Disgraced Monuments* (1994).

**Luisa Passerini** is Professor of Cultural History at the University of Turin, External Professor of History at the European University Institute, Florence, and Visiting Professor at Columbia University, New York. She was Director of the research group 'Europe: Emotions, Identities, Politics' at the Kulturwissenschaftliches Institut, Essen, as recipient of the Research Prize of Nordrhein-Westfalen for 2002–04. Her current research interests are: European identity; the historical relationships between the discourse on Europe and the discourse on love; gender and generation as historical categories; memory and subjectivity. Among her recent books are *Europe in Love, Love in Europe: Imagination and Politics Between the Wars* (1999), *Il mito d'Europa. Radici antiche per nuovi simboli* (2002), *Memory and Utopia: The Primacy of Intersubjectivity* (2007), *Love and the Idea of Europe* (2009) and *Sogno di Europa* (2009). Her edited volumes include *Figures d'Europe: Images and Myths of Europe* (2003), a special issue of the *European Review of History*

(2004 [11: 2]) entitled *Europe and Love – L'Europe et l'amour* (2004, with Ruth Mas), *Fuori della norma: Storie lesbiche nell'Italia della prima metà del Novecento* (2007, with Nerina Milletti) and *La laicità delle donne* (2008, with Luisa Accati).

# Index